W9-DBP-817

CONVERSATIONS WITH CÉZANNE

THE DOCUMENTS OF TWENTIETH-CENTURY ART

Jack Flam, *General Editor*
Robert Motherwell, *Founding Editor*

Other titles in the series available from
University of California Press:

Flight Out of Time: A Dada Diary by Hugo Ball
John Elderfield

Art as Art: The Selected Writings of Ad Reinhardt
Barbara Rose

Memoirs of a Dada Drummer by Richard Huelsenbeck
Hans J. Kleinschmidt

*German Expressionism: Documents from the End of the
Wilhelmine Empire to the Rise of National Socialism*
Rose-Carol Washton Long

Matisse on Art, Revised Edition
Jack Flam

Robert Smithson: The Collected Writings
Jack Flam

Pop Art: A Critical History
Steven Henry Madoff

The Collected Writings of Robert Motherwell
Stephanie Terenzio

CONVERSATIONS WITH

Cézanne

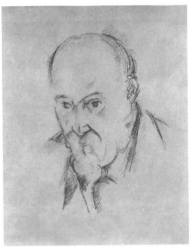

Edited by Michael Doran

Translated by Julie Lawrence Cochran

Introduction by Richard Shiff
Essay by Sir Lawrence Gowing

UNIVERSITY OF CALIFORNIA PRESS
Berkeley · Los Angeles · London

University of California Press
Berkeley, California

University of California Press, Ltd.
London, England

Library of Congress Cataloging-in-Publication Data
Cézanne, Paul, 1839–1906.
 [Conversations avec Cézanne. English]
 Conversations with Cézanne : Emile Bernard, Jules Borély, Maurice Denis . . . / Michael
Doran, editor; translated by Julie Lawrence Cochran; introduction by Richard Shiff.
 p. cm. — (Documents of twentieth-century art)
Includes bibliographical references and index.
ISBN 0-520-22517-1 (cloth : alk. paper) — ISBN 0-520-22519-8 (pbk. : alk. paper)
 1. Cézanne, Paul, 1839–1906—Interviews. 2. Cézanne, Paul, 1839–1906—Philosophy.
 3. Cézanne, Paul 1893–1906—Friends and associates. I. Doran, P. M. (P. Michael)
 II. Title. III. Series.

ND553.C33 A35 2000
759.4—dc21
[B] 00-028716

Printed in the United States of America

09 08 07 06 05 04 03 02 01

9 8 7 6 5 4 3 2 1

The paper used in this publication meets the minimum requirements of
ANSI/NISO Z39.48-1992 (R 1997) (Permanence of Paper). ∞

Title page illustration: *Self-Portrait*, pencil, 1880–82

*The publisher gratefully acknowledges
the generous contribution to the cost of translating this book
provided by Charlotte Hyde and Jean Sherman
and by the Art Book Endowment of the Associates of the
University of California Press, which is supported by a
major gift from the Ahmanson Foundation.*

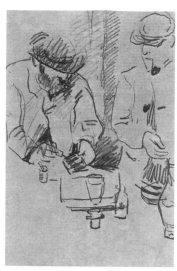

Self-portrait with Dr. Gachet, 1873

CONTENTS

PREFACE

In this volume we republish the most important of the eyewitness texts which illustrate the last decades of Paul Cézanne's life. Though vital for the study of Cézanne, these have usually been hard to find in complete versions, even in large libraries, and they are here presented together in as accurate a form as possible.

They give us the precise flavor of the character of Paul Cézanne in his late years (that is, from 1894 to 1906), with its paradoxical alternations of edginess with affability, of defensiveness with bonhomie. Some of our material is already partially known through the biographies of Gerstle Mack and of John Rewald (the latter, in its various forms and editions, valuably updated from time to time): our volume is not intended to compete with those works (which the reader is recommended to have to hand as he uses the present compilation), but simply to give the serious student of Cézanne's art convenient access to significant documents.

We have chosen texts that give useful biographical data, or that offer evidence for Cézanne's attitude to his painting and for his theories about it. Evidence of this kind only becomes abundant in the period from 1894 onwards, and in the interests of consistency and unity, therefore, we have usually adhered to this starting point, and have made in our notes no substantial citation of material illustrating the pre-1894 period.

Wherever possible, we have used the earliest publication of any given text, departures from this principle being explained in the short introductions to individual texts. Misprints have occasionally been corrected in our

versions, and a few textual emendations have been made: these are indicated in our notes to the texts.

The principal eyewitness texts in the section "Documents" are given, not in order of publication or of composition, but chronologically, according to the date of the visit or of the encounters they describe.

The section "Interpretations" includes three texts which are less direct in intention, and which either fabricate conversations with Cézanne on the basis of more factual material, while departing very far from it, or offer detailed discussion of data gleaned during actual meetings with Cézanne. My original intention with the Joachim Gasquet and the Maurice Denis texts in "Interpretations" was to offer only short excerpts, to illustrate concisely both Gasquet's imperious editing methods and Maurice Denis's remarkably perceptive extrapolations from the meeting of January 1906. However, at the particular insistence of the publisher of the French edition, full texts of Denis and of "What He Told Me . . . ," Gasquet's appendix to his Cézanne biography, were included: I am particularly grateful to Yve-Alain Bois for substantial aid in the analysis of the Gasquet material—a large part of the research for the Gasquet notes was done by him, and is a valuable contribution to the understanding of this important but exasperating document. Perverse and unscholarly though Gasquet's methods are, his "conversations" are important evidence of a particular phase in Cézanne's life: we have not solved all the problems involved in interpreting them, but I believe that it is useful to offer them again here, with our critical notes, for the benefit of the student of Cézanne.

Our general aim has been to make these texts easy for the general reader to examine in the order in which we have presented them, and to that end the short introductions briefly describe the author of each text, give some assessment of its reliability, and set the scene. Many of the detailed annotations give brief explanations of points within the text which may puzzle the general reader; but others go into considerable detail on the theoretical and aesthetic matters which are raised (by Cézanne or by his acquaintances) in the documents.

A major justification for making these texts available together in English is their richness in direct or indirect reports of Cézanne's own statements about his art. Our notes endeavor, by discussing Cézanne's technical vocabulary, and above all by linking together the scattered references to any given theoretical concept, to bring out the coherent and organic nature of his artistic principles. It is not, however, a polished aesthetic philosophy that emerges here, but rather the naturally interrelated thoughts of

the man standing at his easel, thoughts which, fitfully rather than exhaustively, illuminate and explain his art.

Our annotations of points of theory are meant to be indicative rather than definitive, to avoid doing violence to the delicate balance of Cézanne's concepts. In addition, certain famous notions (the *motif, réalisation, sensation,* for example) have not been given a full commentary, either because their meaning emerges plainly from the contexts given, or because they do not feature significantly in the documents of this period.

The reader who requires a more comprehensively expounded Cézannian "system" will find excellent (but usually differing) accounts of the ideas behind his art in the 1977 Museum of Modern Art publication (see Reff 1977 and Gowing 1977 in the bibliography, the latter being republished in the present volume), and in the writings by Ratcliffe, Shiff, and Bois cited later in this preface.

Such a systematic account will not be again attempted here; but I now add a few notes on possible relationships between those notions which have emerged prominently in the annotations to our texts.

Cézanne rejects, almost equally strongly at this period, on the one hand the ruthless systems and stylizations of post-impressionism (and most of all those of Gauguin and his various followers), and on the other the "passive" eye of impressionism. Sensation, always (and long before the period of these texts) the basis of his art, remains its basis; but it has nothing to do with simple receptivity. It concerns innate predispositions as much as the stimulations of the natural world: "The eye and the brain"[1] function together.

The interior and exterior worlds, which are thus to be reconciled and held in balance, are the first of a series of opposites which, in his art, are to be preserved in their integrity, rather than merged. He permits "imitation and even a little *trompe-l'œil,*"[2] but will not "slavishly copy the objective."[3]

In its details the theory will define and specify a number of technical devices by which certain elements in the art of painting, not usually thought of as capable of coexistence, remain distinct and equally active in his work.

Motifs are chosen in circumstances in which a direct response can be made to their colors and forms, without the disruptions caused either by violent color-reflections between one object and another, or by a dramatic general illumination, directly from the sun.

In the translation of motif into paint, the notion of the painting as an equivalent, a parallel, rather than a slavish imitation, is firmly held in mind. A primary but subtle stylization lies in the insistence on vision in terms of

color alone: the neutral black/white scale is abandoned, and there is a de-
termination to see all optical stimuli in terms of their chromatic content.

Similarly, the graduations and fluidities of chromatic change are them-
selves replaced by sequences of distinct (if often closely related) color-
patches: the integrity of the object, which must not be attacked by a
violent exterior light, is matched by the integrity of each single brushstroke
or paint area.

But so fierce a concentration upon "color sensations"[4] compromises in
two ways the process of representation, which he will not relinquish, for
he is not indifferent to his subject matter.

Drawing itself, "the configuration of what you see,"[5] cannot be aban-
doned. He cares variously for an exact or a fluent or even a "baroque" first
outlining and later redefining of objects: but in his painting the linearity is
preserved in an obsessive attention to the interlocked edges of the painted
areas.

Volume too, in the reduction of gradation to sequences of related and
distinct color-patches, may be lost. For this reason he will address him-
self intensely to the ways in which color intervals can directly suggest both
the curvatures of solid objects and their distance from the beholder's eye,
and the aim is always to preserve these aspects of the real situation con-
fronting the painter, however much they are threatened by the accidents
of appearance.

There are signs, especially in the later watercolors, and in the texts given
in this book, of a systematization of the pigments used in painting into a
simple spectral series, and of a recognition that this gives rise, almost in-
evitably, to color harmonies of a particular kind. But it remains uncertain
whether "harmony" is seen as a specific effect procured intentionally, or as
a class of relations which are emergent, which arise from the limitations in
lighting and coloring and paint application already adopted. There is men-
tion of a "balance of luminous areas and shaded ones,"[6] which, given that
Cézanne would have seen this balance chromatically, hint at the kind of
harmony he sought.

These are the outlines of Cézanne's theory as it emerges in our texts
and in the annotations we have made upon them. But, in important re-
spects, we must indicate why the late theories must not be taken as either
entirely coherent or as self-sufficient.

First of all, there are intimations of unassimilated impressionist thinking
in the theoretical material. For example, it is not clear at present why a
desire to indicate the effects of atmosphere by "sufficient blues"[7] should

survive in an art whose procedures had firmly confined themselves to the lucidity of "light gray"[8] conditions and of "local colors."[9]

But the painting itself, done in real, not theoretical, situations, always powerfully bears the traces of the struggle between the ephemeral and the enduring, the definite and the indefinite, and it is fitting that Cézanne's own utterances should, taken all together, be other than rounded and Euclidian. They are, rather, fragmentary, terse, and sometimes, given the deep preoccupation with oppositions and with process, almost Heraclitean in tone.

There are vital technical issues which are not touched upon, or barely touched on, in the texts, but which will loom large to anyone who studies the works of Cézanne. One is the whole issue of the "constructive stroke" (see our note 10 to Geffroy): although it originates fifteen years before the earliest of our documents, it still influences the painting technique, so often systematic and modular, of the last decade. It remains one of the oddest inventions in the history of oil painting: but it remains largely unexplained, and our present texts offer virtually nothing which sheds light on the subject. The "constructive stroke" is something other than an ordinary stylizing procedure, but it is difficult to say exactly in what way this is so.

The late Cézanne also offers something which runs counter to all our texts have to say on painting from the object (and objective painting is on the whole what they are most concerned with). This is, in the *Bathers* compositions, a prolonged, indefatigable attempt to create an imposing imaginative work from largely interior resources only. Guesses may be made, and have been, about the biographical and possibly erotic motivations for this grand project: our texts contribute little. The *Bathers* are, of course, not entirely *sui generis,* and it may be feasible to regard much of Cézanne's other painting and drawing as a preparation for them. If this is the case, then our texts, in their theoretical aspects, are about the preparations for the *Bathers,* but do not form a central comment upon them.

The theoretical topics here broached, and discussed in some detail in the notes, have been treated as a closed system, having regard more to their internal interrelations than to their possible sources and analogues in the thought of Cézanne's acquaintances and of the nineteenth century in general. But it is quite certain that a definitive understanding of them will only be reached in those wider contexts, for although an artist's ideas will feel to him (and sometimes to us) like a self-contained system, their full force and dynamism, the *process* by which they enter his consciousness and operate, with varying strength, within it, can only be understood within the

tradition to which they belong. And only if we know that tradition can
we distinguish an artist's primary aesthetic inventions from what he has in
common with others of his time.

I have, from time to time in the notes, indicated points where the artis-
tic tradition offers analogues for Cézanne's own thought (Vollard note 3,
on painting in light gray conditions, is an example) and in doing this have
largely confined myself to references to Bracquemond's treatise. I believe,
however, that a proper understanding of Cézanne's aesthetic as an open
and mobile system, rather than a closed one, can only be reached by an
extensive survey of the artistic theory of his period: adumbrations of such
an approach will be found in Robert Ratcliffe's unpublished thesis and in
the published dissertation (and later writings) of Richard Shiff, the former
author concentrating on a few works which Cézanne himself is known to
have read, and the latter surveying widely the aesthetic thought of Cé-
zanne's time. (For these, see the bibliography, where I also cite a recent es-
say by Yve-Alain Bois, Macula's editor for the original French edition of
Conversations with Cézanne.) In the present volume the publishers have
also reprinted the Lawrence Gowing study of 1977, "The Logic of Orga-
nized Sensations," to which my notes make reference, and which consti-
tutes an important reconsideration of some of Cézanne's key statements,
closely discussed in relation to individual paintings.

I do not, however, believe that texts are more important than paintings
and am certain that none of these matters can reach a satisfactory conclu-
sion until far more is known, in an exact and scientific way, about the
physical character of Cézanne's works, and about the processes by which
he made them.

In the meantime, it is hoped that the enthusiast of Cézanne's work will
peruse the texts we present, not for their own sake, but as an instrument
towards further understanding of the paintings and drawings of Cézanne
(for example, I am sure that a close study of the paintings, bearing in mind
Bernard's own statement in *Souvenirs* about the color-tone transitions,[10]
together with Cézanne's reaction, and our related note 22, will be found
instructive and fruitful).

I believe that this is the right approach to these documents; for, al-
though Cézanne scholarship, often for very good reasons, has traditionally
handled the "theoretical" materials with great caution, Cézanne himself
quite certainly—as these texts show—took his theorizing seriously, while
making an important distinction: "I don't have a doctrine like Bernard, but
you have to have theories, sensations and theories."[11] May the reader of

this book enjoy, as did Edmond Jaloux, not only a sight of the man him-self, but also . . . "wide-ranging formulations, fertile, and that whet the ap-petite . . . technical insights, unexpected, knowledgeable, and ingenious."[12]

• • •

The above preface, originally written for the Editions Macula French edi-tion of 1978, has been only slightly revised for this English-language ver-sion. Similarly the individual introductions to the main texts, and the detailed notes to those texts, have been corrected or added to in minor ways only. Much remains in those documents that invites explanation or discussion, but major revision, further analysis and research, and the inclu-sion of more source documents have not been possible on this occasion. However, further details about individual works of art have been added in a number of places: in particular, the index to works of art (always se-lective because of the vagueness or relative unimportance of some of the allusions in the texts to individual works) has been supplemented and tidied up a little.

Some spelling anomalies were deliberately preserved in the French edi-tion. The significant anomalies are of two kinds: those which attempted phonetic transcription of Cézanne's Provençal accent (e.g., the Vollard quotation in note 91 to Gasquet), and those in Cézanne's own letters which seemed indicative of a state of mind or a particular pattern of asso-ciations (the major case of this is discussed in note 1 to Cézanne's letter 5 to Bernard). In this translation, no attempt has been made to reproduce these irregularities.

A few necessary additions have been made to the bibliography, but it should be stressed that it is essentially linked to the study of the texts which are the *raison d'être* of this publication, and is not a general Cézanne read-ing list as such.

Michael Doran
30 June 2000

ACKNOWLEDGMENTS

I would like to express my gratitude to Michel-Ange Bernard-Fort, Claire Denis, the Galerie Bernheim-Jeune, and Catherine Dobuzinskis-Larguier for originally permitting Éditions Macula to publish the basic texts of Émile Bernard, Maurice Denis, Joachim Gasquet, and Léo Larguier; the late John Rewald, the late Adrien Chappuis, the late Douglas Cooper, and Professor Peter Lasko, formerly director of the Courtauld Institute, for permission to reprint other copyrighted material; Anita Brookner, Michael Evans, Dominique Jaffrenou, Robert Ratcliffe, and Clive Phillpot and Pearl Moeller of the Museum of Modern Art, New York for photocopies, or loans of publications; the late Sir Lawrence Gowing, Robert Ratcliffe, and John Rewald for help with specific points of information.

Special thanks should remain on record to Sir Lawrence Gowing and to Robert Ratcliffe, both of whom gave, through their lectures and conversations over the years, indispensable encouragement to my enthusiasm for Cézanne studies; to Yve-Alain Bois, the editor for the Macula French-language edition, who made very substantial contributions, especially in the interpretation of the Gasquet text; to my late father, William Doran, for invaluable aid in the construing of the German text of Osthaus; and, above all, to my family for bearing, with fortitude and kindness, the neuroses of authorship.

In particular I dedicate this English-language version to my wife Rosemary, whose affectionate support has been unfailing through the many years of my involvement with Cézanne texts, and to the memory of my youngest brother, Adrian, who died while this version was being prepared.

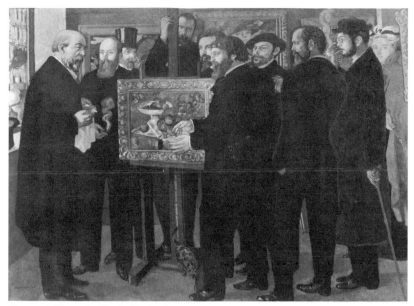

Hommage à Cézanne by Maurice Denis, oil, 1906

INTRODUCTION

[Cézanne] is the painter of apples. . . . He makes apples his own. . . .
They belong to him as much as an object belongs to its creator.

(Thadée Natanson, 1895)[1]

Some say that when he represents three red apples on a blue plate,
it's enough to cause you to kneel down before it. (Paul Gsell, 1907)[2]

Cézanne's apples were explosive. And the most shocked by the explosion
was Cézanne. (Francis Jourdain, 1956)[3]

CAUTION: CÉZANNE AT WORK

Paul Cézanne did more than inspire his contemporaries: he mystified
them. "I have never heard an admirer of Cézanne give me clear and
precise reasons for his admiration," wrote Maurice Denis in 1907,
himself an ardent admirer.[4] For us, a century later, the situation is hardly
different. Cézanne's technique converted his most banal subjects, just "a
few apples," into enduring provocations which neither commentary nor
familiarity have yet to defuse—"those famous apples."[5]

The young Cézanne of the 1860s was a provincial Frenchman attempting to become established in the Parisian capital. To exhibition juries he presented not apples but outrageous figure compositions. In defense of his art, Cézanne defiantly proclaimed the "strength" of his "sensations," both optical and emotional; it seems that shock and notoriety, as much as faithful representation, were the effects he desired.[6] This was certainly not his aim during his final years when, suffering from diabetes, he sought to guard his privacy and whatever working time he had left.[7] In 1896, having avoided his young acquaintance Joachim Gasquet, Cézanne made this excuse: "An artist wishes to elevate himself intellectually as much as possible, but the man should remain obscure. Gratification ought to come [only] in working."[8] As passionate as ever to "realize" his sensations of nature, Cézanne kept aloof from his public and claimed to be unaffected by its attentions, so long in arriving.[9] In his case, history enjoyed its customary irony: just when the artist was most determined to avoid the spotlight, it fell on him. Having wittily declared his intention to "astonish Paris with an apple," Cézanne never expected to be "shocked" in turn by the intensity of the city's reaction.[10]

Paris had its first opportunity to view Cézanne's art in quantity only in November 1895, when the dealer Ambroise Vollard accurately perceived that the market, at least a part of it, was prepared to accept the painter's idiosyncratic style. Cézanne was already fifty-six years old and had little more than a decade to live. Before Vollard staged his exhibition, the artist's presence had been shadowy, his existence a matter of rumor. Advised by a colleague to study Cézanne, probably around 1890, Denis found it "hard to locate his work" and had to ask himself "whether this invisible painter was not a myth."[11] In 1894, the critic Gustave Geffroy characterized Cézanne as "a person at once unknown and famous, having only rare contacts with the public and taken up as an influence among disaffected investigators of painting—known only to some, living in determined isolation, reappearing, disappearing abruptly before the eyes of his intimates."[12] Cézanne succeeded at this evasiveness by dividing his time between Paris (as well as other northern locations) and his permanent home in Aix-en-Provence, a southern commercial and cultural center not far from Marseilles. In Paris, sightings of Cézanne occurred only "by chance."[13] Around 1900, as his reputation grew exponentially, a certain number of artists, writers, and collectors, piqued by the paintings, decided to investigate the painter. While some were able to encounter Cézanne in Paris, most of those who managed to speak with him traveled to Aix to do so; there they

had the advantage of observing his most beloved landscape motifs, such as the valley of the Arc and Mont Sainte-Victoire. Although described as timid, self-deprecating, near paranoid, and dissatisfied and moody enough to slash his canvases, Cézanne could be surprisingly receptive and even sanguine, occasionally inviting younger artists to join him as he painted ("nice boys," one imagines him thinking).[14] It may be that he was more open with those new to him, as opposed to those who shared his troubled history, and certainly more at ease in Aix than among Parisians, whom he "mistrusted."[15] His witnesses in Provence often arrived unexpectedly and were therefore all the more likely to depart well informed, Cézanne's usual suspicions having had no time to develop. Like the startling pictures of apples (products of both Paris and Aix), the accounts recorded by Cézanne's visitors are a primary constituent of his historical legacy.

These "conversations" reach beyond Cézanne and are among the most significant documents to have influenced the history of twentieth-century art; they affected not only the record as it was constructed after the fact, but also the very development of modernist art, for which Cézanne and what was known of him so often served as a guide. By 1904 (the year Emile Bernard, among others, traveled to Aix), critics could refer to *Cézannisme* as more than merely a trend; it was a cult and even a dogma.[16] Fragments of the exchanges between Cézanne and his admirers were beginning to be quoted—first as gossip, then as part of the expanding written record.[17] In August 1905, a broad survey in *Mercure de France,* a leading journal of the arts, featured the question "What do you make of Cézanne?" Charles Camoin, a young painter whom Cézanne regarded warmly, included in his reply that the master aimed "to bring Poussin back to life by way of nature."[18] At that moment, the seventeenth-century art of Nicolas Poussin symbolized the highest ideal of the French tradition (a new Golden Age) as well as a Mediterranean classical spirit that extended back to the Roman era and even to the Greek (an initial Golden Age). Although there were previous allusions to Cézanne's interest in classical and Baroque painting as a recurring topic of his conversation, Camoin's statement seems to be the first concrete reference to what the public soon took to be Cézanne's most particular ideal, captured in the phrase *vivifier Poussin sur nature.* Endlessly ambiguous (whether in French or English), these words can be read with at least two competing senses: either that Cézanne wished to restore a Poussinesque compositional rigor to the disorderly impressionist naturalism of his peers; or that he desired to (re)animate a moribund, formulaic classicism by means of his personal sensation

of nature.[19] Such ideas—not necessarily contradictory—enhanced Cézanne's mythological stature, as did his persistent obscurity. Logically enough, within several months of his death (October 1906), it could be said that no French painter was being "more debated."[20] Cézanne's image and its influence then spread to the English-speaking world when the British critic Roger Fry translated Denis's eulogistic essay of 1907.[21] And the custom of quoting the authority of Cézanne, both in words and pictures, continues.

This book reprints the most important witness accounts and the initial interpretive texts at length; it restores a discursive context to statements that have often appeared as isolated sentences. The longer texts of Bernard, Denis, and Gasquet contain many well-known pronouncements, but also include statements one would not expect to be compatible within any single document. Despite inconsistencies between as well as within the various documents, the "conversations" collected here report the artist's views, with much represented through his own words. At times this is done precisely, as comparison with Cézanne's surviving correspondence proves; at times it seems that the general spirit of the painter is preserved, if not his actual language (needless to say, tape recorders were not an option); and at times, we suspect, there is significant distortion, motivated by the writer's personal interests. Editor Michael Doran's commentary offers a superb guide to the degree of reliability of the individual writers and of their particular statements. If any collection of texts promises to elucidate Cézanne's thought, it is this one. Yet no one would deny that ambiguities and contradictions persist. Cézanne's "conversations" remain alive and at work within our culture, their meaning still evolving. As with his art, so with his documentation: use creatively and with caution.

IRONIES OF THE ARTIST

To assess the status of these writings is to realize that Cézanne's effect was multivalent from the start. One cause of this is a certain generation gap. Those who wrote extensively about Cézanne began to do so only during the 1890s, spurred by the increasing visibility of his art. The oldest author included in this collection is Geffroy, sixteen years Cézanne's junior. His attention was drawn to the "invisible painter" by Claude Monet, a far more successful artist at the time, who was so in awe of Cézanne's talent that in moments of self-doubt he could hardly bear to view Cézanne's work.[22] Several of the prime witnesses were only in their early twenties and had grown up in a different world, with different expectations for art

and life. They were unlikely to complain of changes in fashion or of urban electrification, as Cézanne did, or of other features of the material, industrial modernity that must have seemed natural to them.[23] Yet they may have been more sensitive than their elder to the lure of primitivism and classicism. Around 1900 and especially in this context of a problematic modernity, "primitive" connoted any early, naive, exploratory stage in an artistic development (rather than referring to tribal or folk art); and "classical" connoted a timeless harmony and order, devoid of superfluity. However much in conflict with prevalent notions of technological progress, both the primitive and the classical offered young artists liberation from an impressionism that in their eyes had become formulaic and banal, even somewhat academic. The youngest among Cézanne's visitors, such as Francis Jourdain or Léo Larguier, were not yet born in 1874, the time of the first Impressionist exhibition. For their generation, much of the appeal of Cézanne's technique lay in its look of genuine naiveté, a roughness or awkwardness of handling removed from either impressionist or academic refinements.

Denis, the most influential of the witnesses, claimed that Cézanne arrived at his "classical" order "spontaneously," without artifice or calculation. His was a classicism that retained a "primitive" character, with figures that were "Poussinesque" but "awkwardly" so.[24] Such a judgment put a critic at risk because the high cultural value placed on naiveté might cause it to be seen where it did not exist. "A naive art of spontaneous awkwardness," another writer of the time warned, "becomes a pointless conceit when deliberately created by modern painters, motivated by a mentality entirely different [from that of true primitives]."[25] Chronologically, Cézanne was neither "primitive" nor "classical," but "modern." How did he manage to have the naiveté other moderns lacked, while lacking their aesthetic self-consciousness and predictable propriety? In a statement of 1920 on Cézanne's artistic "influence"—not all of it for the better—Denis readily admitted the possibility that he and everyone else had never been sufficiently scrupulous to represent Cézanne as true to himself: "Such is Cézanne, complex and diverse, that each one expects from him the confirmation of his own system."[26] The painter's followers interpreted him to make him appear as their predecessor; they consciously created the authority or source their own position required, claiming to discover it in this neglected master of their immediate past. Cézanne, a universal benefactor, licensed everything for everyone.

To the distortions resulting from the writers' desires and preconcep-

tions, we must factor in Cézanne's own contrariness and the nature of his wit. According to an anecdote transmitted through Monet, when the young Cézanne met Edouard Manet, he removed his ever-present hat, saying, "I don't offer my hand, Monsieur Manet; I haven't washed in a week."[27] It would be wrong to interpret this as Cézanne humbling himself before the older artist's success and genius. Manet was quintessentially the Parisian—elegant and even somewhat dandified. Although both men were raised with every bourgeois comfort and advantage, Manet's urbanity represented the antithesis of the earthy Provençal culture Cézanne was determined to keep. So from Manet, as from Paris, Cézanne maintained a ceremonial distance, forgoing the intimacy of physical contact while addressing his nominal better with (one assumes) tones of subtle irony. According to Théodore Duret, early biographer of the Impressionists, Cézanne "always remained attached to his native land . . . in Paris, he assimilated nothing of the Parisian."[28]

Indeed, Cézanne was especially marked, voluntarily and proudly so, by his regionalisms. The writer Edmond Jaloux, a witness in Aix and a Provençal himself, insisted that the character of Cézanne's speech and humor was entirely specific to Provence. To the historian, there should be nothing troubling about such ethnic identity, except for the fact that, as Jaloux put it, the typical Provençal is likely to be making a fool of anyone willing to take him at his word: "Many of the naive statements attributed to [Cézanne] should be understood in the sense of a subtle mockery of which the listener would have been the unwitting target . . . With people from Provence, you never know who's joking and who's fallen for it."[29] This suggests that virtually every memorable statement Cézanne made—extending even to responses he committed to writing in his famous letters to Bernard—cannot safely be regarded literally, or without reference to a specific context of human exchange.[30] Apparently, the disgruntled, irritable painter was highly skilled at using verbal wit as an aggressive form of play, if not a defense. At times of equanimity, he might simply be funny. Jaloux, Camoin, and Larguier—all three stationed in Aix for military service—independently recalled the day Larguier, leading a uniformed squadron, encountered Cézanne and ordered his men to present arms, rifles in this case, as an honorific gesture. Feigning fright, the painter immediately threw his hands in the air and cried out, "They aren't loaded, are they!" Such banter continued: from Camoin, the able-bodied soldier-painter, Cézanne—vulnerable target of critics, dealers, and the curious—said he expected "protection" when in Paris.[31]

Given Cézanne's suspiciousness and desire for isolation, he may well have deployed his verbal intelligence to deflect penetrating inquiries. It is likely that he repeated language he heard others use regarding himself or his cultural milieu; this would quickly satisfy questioners by confirming what they already believed. Putting it more positively, we might say that Cézanne's statements were always appropriate to the listener. To Bernard in 1904, who was seeking a master-pupil relationship, Cézanne said he could himself be no more than "the primitive of the way [he had] discovered"; presumably, it would be the mission of Bernard and others to go further.[32] The notion could only be flattering to the younger man, but may also have represented false modesty on Cézanne's part since he clearly felt superior to Bernard.[33] In conversation with R. P. Rivière and J. F. Schnerb in 1905, Cézanne referred (ironically?) to his technical failings, labeling himself "a primitive."[34] The two cases of the painter's allusion to the primitive character of his art are somewhat different; but, in either instance, was the word "primitive" truly his own? In a publication of 1891—as if an early-warning advisory—Bernard had already compared Cézanne to past "primitive masters" such as Giotto.[35] More immediately, during the late 1890s, Cézanne had been talking to Gasquet; this young Provençal poet happened to be involved with a literary group whose motto was "We are without doubt the Primitives of a future race."[36] Gasquet later repeated Bernard's version of Cézanne's statement ("primitive of my own way"), disingenuously referring to it as "reported."[37] It remains unclear whether Cézanne was actually in the habit of calling himself a primitive. If he was, the idea might nevertheless have stemmed from Gasquet, despite Gasquet's having borrowed the phrase back from Bernard. This issue, like many others, is of undecidable origin; the trace is circular, touching several sources at once.[38]

Combine the jokes and sarcasms with the deflections—all being generated by Cézanne's impromptu wit accompanied by his "pleasant yet mischievous smile"—and the documentary chaos becomes daunting.[39] Monet, always sympathetic but a Northerner, recalled Cézanne's snickering and the heavy southern accent that sounded funny even in the direst situation; he confided that he "had never been able to distinguish the seriousness from the irony in Cézanne's statements."[40] At the very least, the record reveals inconsistencies, which nevertheless do not render any particular reports erroneous. According to Denis, posterity merely got what it deserved: "Cézanne was a thinker, but one who was not thinking the same thing every day. All those who approached him led him to say whatever they

desired of him."[41] Jourdain put the onus back on the artist: "Coherence was not the most evident virtue of Cézanne's words." But the same writer also suggested that "Cézanne's greatness" lay in his having "been able to resolve in and through his work the contradictions that filled his conversation."[42] Even this point might be debated, for Cézanne's visual statements prove as paradoxical as his verbal ones.

IRONIES OF THE ART

If Cézanne the artist—consciously or not, consistently or not—answered a new generation's desires and expectations, so did his art. According to Georges Lecomte, young friend of Camille Pissarro, this was the greatest historical irony: "at two successive stages of art"—impressionist naturalism (Pissarro, Monet) and symbolist idealism (Paul Gauguin, Bernard, Denis)—Cézanne's style "had the strange fate of being lauded less for its good qualities than for its faults."[43] The year was 1899. It should come as no surprise that the "faults" were errors of awkwardness and omission which could readily be taken as signs of primitivistic naiveté and sincerity: Cézanne's neglect of anatomical detail and perspectival projection; his failure to apply value contrast and color gradation in the service of spatial illusion; the irregularity of his surfaces, with some sections painted thick and others thin. Lecomte had an astute explanation for the acceptance of Cézanne, warts and all. In his view, as far as the older generation of Impressionists was concerned, Cézanne's awkwardness signified a heroic rejection of the conventions of academic art risked for the sake of observing nature directly, even if a final resolution never came. To the younger symbolists, this same awkwardness indicated a return to techniques of the European primitives (late Gothic and early Renaissance masters) as well as to the classicism to which many of Cézanne's visitors would refer; Cézanne was reasserting principles to be derived from a faded but grand Mediterranean culture. Here the implications of the Cézanne-Poussin connection, already a persistent matter of gossip when Lecomte reached his understanding, become relevant.[44]

Cézanne's somewhat oversized brushstroke was the key to his representational irregularities, his "faults." Each stroke tended to remain visibly distinct from its neighbors, causing viewers to become conscious of the painting as a constructive process, perhaps at the expense of its appearing as a coherent, fixed image. Such assertive marking had an advantage: it facilitated the artist's response to a succession of momentary sensations (as opposed to advancing a descriptive plan); these sensations constituted the

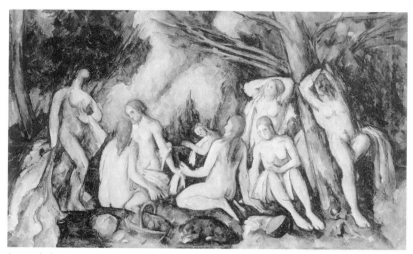

Les grandes baigneuses (Bathers), oil, 1894–1905

painter's "vision," which always incorporated emotion. "I see by marks [of color]," Gasquet reported Cézanne to say.[45] Cézanne's energetic physical involvement in the act of painting—his reworkings, hesitations, multiple failures, excessive corrections—indicated an intensity of experience, the convergence of subject and object in the very life of the work, which would continue to evolve as long as more marks were being added. In *Les grandes baigneuses*, 1894-1905, the first of a series of three unusually large compositions of bathers, visitors to Cézanne's studio witnessed the bizarre consequences of his rhythmic marking developed to the detriment of rationally delineated figures: "arms, torsos, and legs were extended and reduced [repeatedly], acquiring inconceivable proportions," wrote Denis.[46] "His nudes are never academic studies . . . what ignorance!" exclaimed an early viewer of some related paintings, actually applauding Cézanne's distortions because they seemed naively expressive.[47] Feeling was there, rather than rules and regulations. Cézanne's insistent mark violated the contours of bodies, mountains, and even apples, while its repetitiveness caused diverse segments of the pictorial order to combine unexpectedly. In a still life, the plane of a table might seem to merge with a wall, as a pattern of strokes led the eye along. What should have been whole was fragmented; what should have remained separate was united. Yet a growing cadre of sympathetic viewers sensed a compelling pictorial order in even the slightest of Cézanne's studies. "He can't put two strokes of color on a canvas

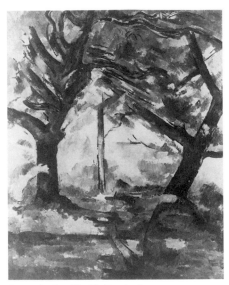

Les grands arbres (The Big Trees), oil, 1902–04

without it already being very good," Auguste Renoir told Denis, who had just seen the densely compacted *Les grandes baigneuses*.[48]

Consider a typical late landscape, *Les grands arbres,* 1902-04: this is presumably a southern scene because of the reddish cast of the earth and therefore another painting visitors such as Denis might have observed in progress. Here the drawn contours of branches become a self-sufficient rhythmic motif, without the constraint of linear perspective. Although Cézanne's landscapes often capture localized details of specific trees, such elements are adjusted so many times that, like the forms of his bathers, they assume an existence independent of any possible model. Similarly, despite the suggestion of a central vista in *Les grands arbres,* juxtapositions of warm and cool hues and light and dark values occur too abruptly to create a consistent fading of light into a distance. Color and illumination seem to develop on the painting surface instead of following nature, as if the artist were leaving color to its own devices, to react to itself. Such observations by no means preclude Cézanne's having attempted to render the motif of *Les grands arbres* in accord with his immediate "sensation." Rather, they elicit a very flexible notion of what might actually constitute a "sensation" or a "motif " under the direction of this painter's probing eyes and active hands. From the start, his motif is on the canvas as well as in the world. Its

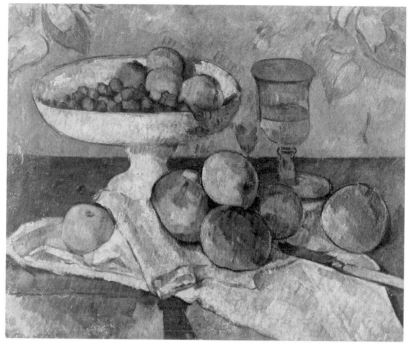

Nature morte avec compotier (Still Life with Compote), oil, 1879–80

linear rhythms and chromatic harmonies emerge from Cézanne's physical manipulation of the materials of depiction.[49]

A painting by Cézanne is peculiar in so quickly achieving this life of its own, independent of, but not negating, the represented world of mimesis and the invented world of imagination. Bernard wrote presciently in 1891: "[Cézanne] opened to art this amazing door: painting for itself." And in 1904: "The more he works, the more his work removes itself from the external view [and] the more he abstracts the picture."[50] Such "abstraction" is pictorial and formal, as opposed to thematic and conceptual. It requires our close attention, for it would pursue Cézanne and haunt the afterlife of his critical legacy. Paul Sérusier, an artist inspired by Gauguin and himself an inspiration for Denis, had his own variant of the idea: "[Cézanne] is a pure painter . . . Of an ordinary painter's apple, you say 'I could take a bite out of it.' Of Cézanne's apple, you say 'It's beautiful.'"[51] The first "apple" is an illusion on canvas, its success dependent on affinities to real apples that lie on tables. The second "apple" evokes no contingency of this sort; its

abstract beauty of form and color creates a reality "for itself " (as Bernard put it). Critics entertained the possibility of such abstract, autonomous reality despite abundant evidence that Cézanne devoted himself to nature as much as to painting. The duality of his commitment—to nature and painting, painting and nature—was manifest in his complaints about the new generation who studied art ready-made inside museums, neglecting nature outside; Bernard's adherence to theories of art, to ideas rather than sensations, was, Cézanne believed, an instance of the problem.[52] Theory removed painting from reality, "abstracting" it. And the topic of "abstraction" separated Cézanne from many of his admirers.

When Lecomte evaluated Cézanne so intelligently in 1899, "abstraction" had not yet settled into its twentieth-century, formalist definition. Nor had images called "abstract" abandoned representational reference, as they would begin to do not long after Cézanne's passing. The meaning of "abstraction," circa 1900, was fluid and confused, an amalgam of contested notions. Regardless of anything Cézanne said, it was his technique that caused many of his witnesses to link the autonomy of his form and the purity of its beauty to a process of abstraction. This turn in interpretation entailed a certain irony: "form" and "beauty" were conceptual entities suited to endless verbal philosophizing, precisely what Cézanne disliked in Bernard among others. To reconcile abstraction, itself an "abstract" notion, with the very physical nature of Cézanne's painting, most of those familiar with him claimed that *his* abstraction developed from the senses, not the intellect—more intuitive harmony than science of color, more spontaneous rhythm than planned geometry.[53] This variant of "abstraction" broke from the term's nineteenth-century connotation of intellectual excess (we still say that certain arguments are "too abstract," or that a mentally distracted person has an "abstract" look[54]). Lecomte's perception that Cézanne's style satisfied antithetical demands coming from impressionist naturalism and symbolist idealism was ingenious and should have been adequate to the situation; but other commentators began to acknowledge somewhat different alignments, cognizant of competing notions of "abstraction." For Denis, the conflict between Monet's impressionism and Gauguin's symbolism amounted to a dispute between sensualist lovers of nature and rationalist devotees of abstract form. Reacting to attitudes that troubled him in others, Denis complicated matters by switching sides in the ongoing debate. First he praised, then he denigrated abstraction, lamenting Cézanne's inadvertent role in furthering it.

Why all this happened is crucial to the historical fortune of Cézanne's

art. At the beginning of the twentieth century, Denis (like many others) observed that artists of his own age were being dehumanized by the leveling effects of modern urban life—mechanization, commodification, standardization, social regulation—all leading to impoverishment of both intellectual and spiritual experience. He argued that the remedy could be found in an "abstract ideal, the expression of inner [mental] life or a simple decoration for the pleasure of the eyes."[55] Under the circumstances, the representational arts would strive to mask out dull environmental realities, "evolving toward abstraction."[56] However much this kind of "abstraction" might appeal to the intellect and imagination (subjective "inner life"), it would retain a distinct material component, located in a purified form and a straightforward procedure (the objective "beauty" of "a simple decoration"). Cézanne was exemplary because his marks appeared independent of any strict mimetic function and were also very physical, therefore representing a *material* (not conceptual) abstraction of the painting process. This was an aestheticized, humanized materialism, intense in both sensation and spirit; it seemed fit to counter the anesthetizing materialism of modern bourgeois existence.

Once manifest as a technique and articulated as a critical principle, material abstraction of this sort had no clear limit. With the advent of Henri Matisse's fauvism and Pablo Picasso's cubism—styles generally perceived as deriving from Cézanne's—Denis decided that "abstraction" had shifted from a liberated aesthetic expression to an intellectual aberration. Adding a negative spin, he described such work as "painting apart from any contingency, painting in itself . . . schematic compositions [with] marks as far removed from any concrete representation as possible."[57] In short, "abstraction" and "form" had been pushed so far that neither sensible reason nor human feeling, but only misguided theories, could justify these practices. In 1907, Denis salvaged Cézanne from such associations, explaining that the painter had never "compromised" his pictorial synthesis "with any abstraction"; his art remained rooted in nature.[58] It was instead Gauguin who abstracted: "He rendered Cézanne's models flat. . . . The reconstruction of art that Cézanne had begun with the materials of impressionism, Gauguin continued with less feeling but more theoretical rigor."[59] For better or worse, the art properly called "abstract" was now a product of theory, not sensation. Denis kept restating this theme during subsequent decades—a position consistent with Cézanne's own attitude as expressed in his correspondence.[60]

"The false strokes that [Cézanne] neglects to efface while searching for

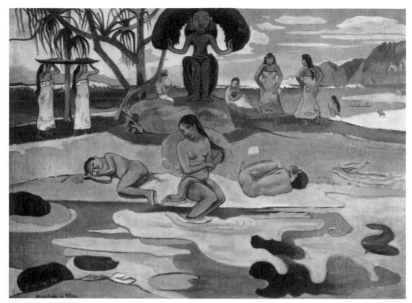

Mahana no Atua (The Day of the God) by Paul Gauguin, oil, 1894

[the proper] form have nothing to do with a system or a geometry," Denis insisted, late in his career. For him, Cézanne's final historical irony was to have been a "slave to nature and to the model . . . while having authorized every audacity, every abstraction, every negligence, and all the systems" that followers incorrectly derived from the master's procedural detritus, the leftovers of painting surfaces he summarily abandoned.[61] Denis was imagining works like *Les grands arbres,* where a bowed line seems, irrationally, to extend the contour of a tree deep into ground that should instead lie in front of it. Denis never determined—nor can we now—whether Cézanne regarded such a "false stroke" as essential to an emerging pictorial design he happened to leave suspended, or whether the stroke might instead mark a moment of extreme pictorial frustration. Denis raised such an issue because the unfinished look of Cézanne's art had been imitated all too often, uncritically.[62]

At stake was a general observation made with increasing frequency during the early twentieth century: material features of painting sufficiently prominent to draw attention to themselves—whether disturbingly "false" or compellingly "beautiful"—interfere with the representational image.

Modern works, characterized by such interference as much as by anything else, began to divide viewers along two lines of interpretation, inducing them to choose between "painting for itself " (the medium, the form) and depiction (the image, the content). Throughout the twentieth century, much of the writing on Cézanne splits in just this manner: some treat figures like those in *Les grandes baigneuses* as allegorical themes for cultural analysis as well as fantasized bodies for psychoanalysis; others treat the same figures as rhythms and geometries for formal analysis. As for the idea of an "abstraction" in art, it has continued to drift from its older sense of intellectualization (never entirely lost) to a new complex of meanings linked to the experience of artists who allow themselves to become immersed in the materiality of painting; in their practice, eye and hand are guided by the medium as much as by any theory of vision or vision of nature. Cézanne was surely not the only artist whose work provoked the possibility of "painting for itself "; but he received most of the historical credit as well as the blame, perhaps because the corresponding social problems (commodification, standardization, urban *anomie*) dominated consciousness at the very time his art received its first shock wave of notice, from around 1895 to around 1910.

"This man thought only of painting, loved only painting," Monet, a worldlier type, said of Cézanne long after his revered Impressionist confrere was gone.[63] It was, in fact, a common observation, one shared in 1907 from less temporal but more personal distance by Charles Morice, the critic who asked the survey question, "What do you make of Cézanne?"[64] Morice set the significance of the recently deceased artist into the context of modernity: "We hardly dare say that Cézanne lived; he painted... [His is] painting estranged from the course of life, painting with the [sole] aim of painting . . . [His art constitutes] a tacit protest, a reaction . . . He put everything in question."[65] How does painting—of a nude, a tree, a mere apple—"put everything in question"?

Like Denis, Morice believed that scientism, materialism, and technocratic efficiency were deadening all spiritual life; this tempted artists to abandon the decaying remains of humanistic principle and withdraw into pure sensory experience. Although the critic did not advocate it, he saw such aestheticized isolation as Cézanne's proper "reaction": it was symptomatic, he thought, that the artist belittled his petit-bourgeois postman for "being involved with politics and discussing socialism."[66] Cézanne purged his life—that is, his painting—of all such "moral values," for which he substituted "color values" (Morice's clever turn of phrase, worthy of the artist's

own mordant wit).[67] This indicated not that Cézanne lacked political, religious, or philosophical belief, but rather that theoretical and ideological concerns could no longer guide his practice. It was left to the technique of painting, not its representations, to become the means of a "tacit protest." Twentieth-century critics, having learned from Bernard, Denis, Morice, and other early commentators, later held either of two conflicting views of Cézanne's actual achievement: he had pursued his abstraction of the medium, to beat "science" at its own materialistic game, inspiring cubist and constructivist followers; or, he had intensified his involvement with organic forces, to return sensation to dehumanized living, inspiring fauvist and expressionist followers. By either means, Cézanne's "sublime gesture" (Morice's term) signaled the corruption of the intellectual and moral bases of modern society, whose authority his art disdained. Acknowledging the impenetrable mystery of Cézanne, Morice added parenthetically: "Was [his act] fully conscious? I don't know."[68]

"He takes his secret to the grave," remarked Bernard to his wife, upon receiving word of Cézanne's death; "he wrote me that he wanted *to tell me everything,* and I don't know what he meant by that." Regretting his failure to visit Aix in 1906 as planned, Bernard knew that Cézanne, only a month before, had suggested that both men would better "explain themselves" whenever they finally met again in person. Even more poignantly, Bernard could recall the cryptic promise Cézanne included in a letter of the previous year: "I owe you the truth in painting [*en peinture*], and I will tell it to you."[69] Like Bernard—like Cézanne himself—we struggle to know.

Richard Shiff
April 2000

DOCUMENTS

GUSTAVE GEFFROY
1894

The encounter with the critic Geffroy (1855–1926) was a stage in that process by which, during the 1890s, Cézanne widened his circle of acquaintances, and became (within limits) a more accessible figure than hitherto. He had been largely out of the public eye since 1877, and had exhibited only twice (1882 and 1889) in the following decade.

The writer Geffroy, liberal (and even anarchist) in his political sympathies, was a firm friend of Monet's, and was introduced by him to many of the impressionist painters at the monthly dinners held at the Café Riche from 1890 to 1894. Possibly prompted by Monet, Geffroy wrote a sympathetic article about Cézanne in Le Journal, 25 March 1894. *This pleased Cézanne (letter of 26th March 1894, to Geffroy) and there followed the meeting at Monet's on 28th November 1894, described in the following extract (pages 196 to 198) from* Claude Monet, sa vie, son temps, son œuvre, 1922 (*published again in two volumes in 1924 with the title* Claude Monet, sa vie, son œuvre.).

Excerpt from *Claude Monet, His Life, His Times, His Works*

In 1894, Monet began to see his friend Cézanne again, and Cézanne came to stay a while at the inn at Giverny. Monet invited several friends to a gathering in his honor, and wrote to me on November 23:

(. . .) It's all set for Wednesday.

I hope that Cézanne will still be here and that he will join us, but

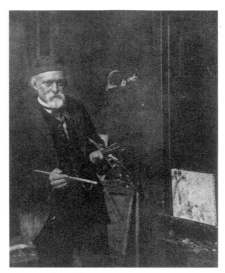

Cézanne in his studio in Paris, 1894

he is so shy, so afraid of meeting new people,[1] that I am afraid that he might let us down, even though he wants very much to meet you. How sad it is that this man hasn't had more patronage in his life! This is a true artist who has come to doubt himself far too much. He needs to be cheered up, so he was quite touched by your article.

Cézanne renewed his friendship with Monet, then, after years of separation. Settled in the inn, Cézanne kept busy painting in the surrounding area and agreeing from time to time to come to the home of his old friend, where one day he found himself in the company of Rodin, Clemenceau, Mirbeau, and me at Monet's.[2] He appeared to us immediately to be a loner, shy yet violent, emotional in the extreme. Among other things, he demonstrated the measure of his innocence (or of his confusion), by taking Mirbeau and me aside to tell us, with tears in his eyes, "He's not proud, Monsieur Rodin; he shook my hand! Such an honored man!!!" Even better, after lunch, he actually knelt before Rodin, in the middle of a path, to thank him again for having shaken his hand. Hearing such things, one could only feel sympathy for the primitive soul of Cézanne, who was, at that moment, as sociable as he was capable of being and seemed, with his laughter and his witticisms, to be having a good time in our company. Clemenceau, with whom Cézanne conversed

4

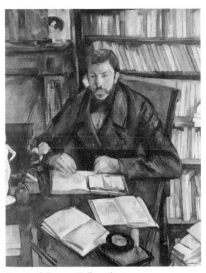

Portrait of Gustave Geffroy, oil, 1895

later, regaling him with jokes, had a special gift for making him open up and relax.

Cézanne told me one day that he could not become a supporter of Clemenceau, which I had not asked him to do, in any case. And he gave me this astonishing reason: "It's because I'm too weak! . . . And Clemenceau could not protect me! . . . Only the Church can protect me!"[3] I do not believe, however, that, as Ambroise Vollard wrote, Cézanne renounced finishing my portrait because of Clemenceau.[4] It was not exactly that. In fact, it was not that at all. Cézanne seemed to like me as a friend and asked to paint my portrait with the hope of exhibiting it in "Bouguereau's Salon," as he called it. "Perhaps," he added, "we will win a medal!"[5] So he came almost every day for three months to my apartment, on the heights of Belleville where I lived at that time, lunching cordially with my mother and my sister or allowing himself be taken to the restaurant at the lake of Saint-Fargeau. He worked during this time on a painting, which, in spite of its unfinished state, is one of his most beautiful works. The library, the papers on the table, Rodin's little plaster model, the artificial rose[6] which he brought at the beginning of our sittings, everything is first-rate. There is also a person in the scene, painted with meticulous care and richness of tone, and with incomparable harmony. He had only sketched in the face, and he would always say, "We'll leave that for the end." Sadly, there was no

end.[7] One fine day, Cézanne sent for his easel, his brushes, and his paints, writing to say that this task was too great for his powers, that he had made a mistake in attempting it and apologizing for abandoning it. I insisted that he come back, convincing him, as I truly believed, that he had begun a very beautiful work of art and that he had to finish it. He came back, and, for a week or so, he seemed to work, building up, as only he could do, those slender films of color, always maintaining the fresh and brilliant appearance of his canvas. But his heart was no longer in it. He left for Aix and a year later, on April 3, 1896, sent again for his painting equipment. He never came again, leaving the portrait as he left so many other paintings which are no less admirable in conception or realization[8] for being unfinished. The degree of finish of a painting does not reflect negatively on the skill of the painter who, nonetheless, shows the full measure of his art in so many ways.

As for me, I shall always remember the times at Belleville when I had the pleasure of seeing Cézanne paint with such passion and faith! I shall always see him, mumbling words under his gray mustache, laughing and crying again as he did at Monet's, and uttering infinitely true and ingenious things about painting. He was very critical of his contemporaries, except for Monet, whom he deemed "the strongest of us all." He would say, "Monet! I would place him in the Louvre!"[9] He became angry at another painter whom he accused of having "stolen his little 'sensation.'" He harped on it incessantly: "I had only one little sensation, and Monsieur Gauguin stole it from me!"[10] Cézanne, who was such an innovator, had no sympathy for the current discoveries and doctrines in painting, saying, "I like Baron Gros,[11] how can I take these farces seriously?" It is true, he loved the old masters, the Venetians, the Louvre so much, that he might stop by the museum before coming to my place to confirm what I had told him about the silvery aspect of *The Lace Maker* by Van der Meer.[12] What I loved most of all in him was his enthusiasm. He would proclaim, "I will astonish Paris with an apple!"[13]

AMBROISE VOLLARD

1899

The Creole Vollard (1867–1939), having frequented the Paris shop in the rue Clauzel of Tanguy, a seller of painters' materials, had there seen works of Gauguin and Cézanne, for whom Tanguy was the sole dealer in the early 90s. Vollard established himself as a dealer in the rue Laffitte in 1893.

He made his way in the art world with cunning and pertinacity, advised at first by Pissarro and by Degas. He held exhibitions of drawings by Manet and by Forain, and at the latter caught sight of Cézanne, but with out knowing who he was.

Pissarro (with Monet, Renoir, and Guillaumin) persuaded Vollard to organize a one-man exhibition of Cézanne's works. Tanguy had now died, and Vollard, making contact only through Paul Cézanne Junior, put on a large Cézanne exhibition (December, 1895). In 1896 he became Gauguin's dealer, and so—in a sense—Tanguy's successor. In May and June, 1898, after a visit (1896) to Aix, when he finally met Cézanne, Vollard mounted a second exhibition of his works. He became his dealer, and at the sale in 1899 of the collection of Chocquet, one of Cézanne's first important patrons, bought for him a Delacroix watercolor of flowers which the painter had always admired and of which he subsequently made a copy in oil (Bouquet de Fleurs, 1900–03, Moscow, Pushkin Museum, RP893 V757). Cézanne undertook the painting of Vollard's portrait in the same year.

By Vollard's account, they seem not to have met often after 1899 (though he records a meeting in late 1905): nevertheless he was now firmly entrenched as his dealer. "Vollard takes all as the work is done" (Denis, Journal).

Vollard's Paul Cézanne *of 1914, pages 94 to 96 of which are here reprinted, should in part be seen as a luxurious example of an art dealer's publicity, rather than an accurate monograph. Vividness, effectiveness, picturesqueness are striven for at all costs, and there is a particular stress upon the uncouthness of Cézanne's manner and language, presumably regarded as a sign of artistic genius, and resulting in a figure that has been called the* Cézanne-Vollard-Ubu *(Rewald, 1939, 11, citing Huyghe).*

Vollard's way with his sources is a ruthless one. Reff (1960, 154–5) has given examples of transformations of material from Cézanne's own letters. It may also be noted that Vollard may have had access to Maurice Denis' Journal, *or talked with Denis himself, for he offers a version of the 1906 encounter between Cézanne and Denis on the steps of Saint-Sauveur at Aix, misleadingly placed in a chapter headed "1899." The original* Journal *entry is elsewhere in this volume.*

Vollard also made use of Emile Bernard's early writings on Cézanne (again demonstrated by Reff, 1960, 155) and without acknowledgment derived his account of the Cézanne of 1860–70 from Guillemet (Rewald, 1961, 622).

It is also possible, but not probable, that the episode of the dog (given in this excerpt) is an invention based upon a reference by Royère (1906, 379–80), to Cézanne's dislike of barking dogs: but it is much more likely that Vollard and Royère are giving independent accounts. However, Vollard may sometimes have used Royère, for elsewhere (36, not in this excerpt) he has Cézanne quoting from Bacon a definition of art as Homo additus naturae, *whereas in Royère (1906, 379) it is Puvis de Chavannes who makes the Baconian citation. Nevertheless much in Vollard is direct and convincing, and his account of the painting of his portrait by Cézanne, although open to some criticism (see note 4), is given here.*

The splendid volume of 1914 was followed by cheaper editions in 1919 and 1924 (see bibliography). In these the text was a little altered from that of 1914: the "revue et augmentée" 1924 version in fact had only unimportant additions. In these early publications of the work, the utterance "[. . .] all, in nature, is spherical and cylindrical," derived from Denis Journal, *29, stands intact: in at least one late edition (in English, New York, Crown Publishers, 1937), the sphere becomes a cube, presumably to stress the affinities between the respective styles of Cézanne and of the cubists.*

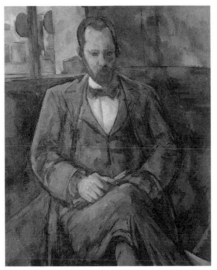

Portrait of Ambroise Vollard, oil, 1899

Excerpt from *Paul Cézanne*

Whenever he began a sitting or took up his interrupted work, Cézanne, his brush raised, always looked at me with an unyielding, fixed gaze. This time he seemed disturbed. I listened to him mumbling with rage between his clenched teeth, "That Dominique [Ingres] is damned talented!" Then, making a stroke with his brush and stepping back to judge its effect, he added "but he bores the shit out of me!"[1]

Every afternoon Cézanne would go to the Louvre or to the Trocadero[2] to sketch the old masters. Sometimes, around five in the afternoon, he would stop by my place, his face glowing with happiness, and say, "Mr. Vollard, I have good news to tell you; I am so satisfied with this afternoon that if the weather tomorrow provides a pale gray light I think that our session will go well."[3] It was one of his principal preoccupations at day's end: what will the weather be tomorrow? Since he went to bed early, often he would wake up in the middle of the night. Always haunted by this idea, he looked out the window at the sky. Then, once decided on this important matter and before going back to bed, carrying a candle he would go and review the work in process. If he felt good about it, he would go at once to share his satisfaction with his wife. He would awaken her and afterward,

to make up for having disturbed her, he would invite her to play a game of checkers before going back to bed.

But before a sitting had any chance of succeeding, it was not enough that Cézanne was satisfied with his study at the Louvre and that the light was pale gray. Other conditions were necessary, notably that there had to be silence in the factory of pile-drivers. This "factory" was the noisy elevator next door, to which Cézanne had given this name. I refrained from correcting him and from telling him that when the noise had stopped, it was because the elevator was out of order. I allowed him to hope that the firm would declare bankruptcy one day. The silences, in truth, were frequent, and he believed that the hammering stopped because sales were poor.

Another noise that he could not stand was that of dogs barking. There was a dog in the neighborhood that made noise sometimes—just a small bark—but for sounds he felt to be disagreeable, Cézanne's hearing became extremely acute. One morning, as I arrived, he came toward me joyously saying, "That Lépine (the Police Chief) is a fine man! He gave the order to arrest all dogs; it's in *La Croix."* We gained several good sittings from this great news. The sky stayed light gray and, by a fortunate coincidence, both the dog and the factory of pile-drivers were quiet at the same time. But one day, just as Cézanne repeated again, "That Lépine is a great man," we heard a faint "woof, woof, woof!" Immediately he dropped his palette and cried in discouragement, "The bugger, he has escaped!"

Very few people had seen Cézanne paint. He could barely stand to be watched while he was at his easel. For those who had not seen him paint, it is difficult to imagine how slow and difficult this work was on some days. In my portrait, there are two little places on the hand where the canvas is unpainted. I drew this to his attention, "If this afternoon's session at the Louvre goes well," he answered, "maybe tomorrow I'll find the right tone to cover these white patches. But please understand, Mr. Vollard, if I were to put just any color there at random, I would be forced to take my picture and leave!" And that prospect made me shudder.[4]

LÉO LARGUIER
1901–02

The poet Larguier did his military service in Aix, leaving the town in Sep-tember 1902 after a stay of almost two years (Larguier, 1925, 16). He was a friend of the writer Joachim Gasquet, who had in March or April 1896 succeeded Geffroy as Cézanne's intellectual patron and friend, and moral support, and it was at Gasquet's that Cézanne met Larguier. The relation-ship with Cézanne seems to have been an untroubled one, and Larguier and Paul Cézanne Junior were apparently on the best of terms (Larguier, 1925, 123).

Larguier's Le dimanche avec Paul Cézanne *(Sunday with Paul Cé-zanne), 1925, is the source for the excerpts that follow: we give some bio-graphical passages and end with the sayings ascribed by Larguier to Cézanne. The main text of the book is chiefly valuable for its evidence of Cézanne's character and activities at this time: its view is benevolent, and there are relatively few signs of the painter's misanthropy and touchiness. There is a certain determination to see Cézanne in Balzacian terms.*

The book is not rich in conversational utterances of Cezanne: those given in the main part are, in fact, largely derived from Vollard (1914), the only work in which, Larguier says (1925, 156), he recognizes Cézanne as he himself knew him.

The collection of theoretical statements, which Larguier claims to have been given by Cézanne's son, and to have in no way altered or augmented, offers special problems. The claims of the 1925 volume about these statements have to be matched against the slightly different account in Larguier's 1947

book on Cézanne, where he writes of having made his own notes, to which the son then added. Pages 131–32 of the 1947 volume imply, furthermore, that the axioms or sayings that make up the collection date from 1902. If this is so, and if they are accurate and authentic, then they constitute the first of the three substantial collections of theoretical material ascribed to the last years of Cézanne, the other two being the "opinions" collected by Bernard in 1904, and the systematic account of his theories derived from the 1905 visit of Rivière and Schnerb (both reprinted in this volume).

Much in the Larguier collection corresponds to Cézannian theories known from other sources. The phraseology, however, is troubling at times, being occasionally both lofty and banal: see, for example, in XV, "the elevation of thought," and, in XXIII, "the elevation of spirit." John Rewald indicated to me his view that such thoughts are to be ascribed to the intermediaries who recorded the sayings, rather than to Cézanne himself. These banalities may yet be authentic, however, for Osthaus, in his independent report, puts some emphasis upon Cézanne's mention of erhebung, elevation.

And in fact it is salutary to read the collection in its entirety, not only to discover possibly earlier versions of those technical and aesthetic notions of Cézanne which have become best known in the forms transmitted by Bernard or by Cézanne's own letters, but also to see those notions within the context of art terms, like "effect," which are now largely outmoded and forgotten. On the parallels to be found between these axioms and material published by Emile Bernard (parallels which, if they are evidence of plagiarism, alter the overall acceptability of the sayings), see note 15 to Bernard's 1904 article in L'Occident.

In his two later publications on the painter (1936 and 1947, see bibliography), Larguier respectively condensed and elaborated the contents of his 1925 volume, but added little new information.

Excerpt From *Sunday with Paul Cézanne*

People in the town where I did my military service thought he was crazy. He walked around in a cape worn over a paint-smudged brown wool sweater where he must have pressed his palette on his way home from painting. He greeted me formally, removing his hat and bowing, a gesture not destined to put me at ease. Common soldiers are not accustomed to such greetings, so I was overcome with embarrassment. I could see that he was bald with a corona of fine silver hair.

He has been described a hundred times.

Some people think he looked like a gruff old major general; others thought he looked like a wild-eyed vagrant, with a purple nose and red eyes, foul-mouthed and always angry.

None of these portraits is correct, and those that depict Cézanne as hairy and filthy are poor caricatures made by artists who know nothing of provincial France. People in the provinces could hardly be called elegant; they dress comfortably in a casual way. [. . .] They don't follow fashions like Parisians do, but they are not ridiculous. Older men don't waste money on fancy clothes and apparently like to wear the same ties they had when they were twenty.

I can't say if Aix has become an elegant town since those days, but around 1900, it seemed to me, Cézanne was better and more comfortably dressed than most of the local people.

[. . .] I believe that if [. . .] Balzac himself saw Cézanne's dining room, without being told that a great painter dined there every day, he never would have thought so. He probably would have thought that those bare walls, six chairs, the round, waxed walnut table, and that humble buffet, decorated with a wine bottle and a plate of fruits, belonged to some modest person of independent means, without mementos—a widower or bachelor—because nothing suggested that a woman lived there. Ah! old Cézanne was hardly a collector of trinkets.[1] He would never have dreamed of assuming artistic airs or of creating one of those fashionable painter's interiors [. . .]. He possessed only what was necessary for an older man who lives alone, who eats a bite and doesn't linger after his meal smoking oriental cigarettes while sipping coffee.

A Cross of Honor hung in a frame on the wall and a pipe lay on the mantel. You would have thought that you were in the home of an old retired sea captain. With his housekeeper Madame Brémond's black cloak lying on a chair, even the infallible sorcerer of the *Human Comedy* would have believed he was in the country home of a widow of modest means . . .

It was mother Brémond, as Paul Cézanne referred to her, who opened the door for me the Sunday that the master had invited me to lunch. Usually cooks who take care of solitary old men do not much like having guests, but Madame Brémond was very kind to me right away, probably because of my uniform. In France the military inspires confidence.

She was in those days—and I hope that she is still alive—an honorable woman, hardy and round, who took care of Cézanne with the most re-

spectful concern. The painter, who was not in the habit of mincing his words and who did not pick them from the perfectly raked flower beds of the Academy, spoke to her with kindness and consideration. He called her *Madame* Brémond, when he addressed her, and this housekeeper of Aix-en-Provence retained his confidence until the end.

Cézanne greeted me, raising his arms and reciting a few playful verses probably written in 1880 by some forgotten rhymster whose muse mostly frequented cabarets. Unfortunately, I cannot remember this song. He shook hands with an extravagant gesture, like a peasant who agrees to—and then seals—a deal at the marketplace. Then we sat down to eat immediately. Madame Brémond brought small warm pâtés that came from the famous pastry chef of Aix, a large man who looked like Balzac, in spite of his curly hair. He also resembled an old Roman jurist, decked out as he was in a kitchen boy's enormous hat.

Cézanne told me the most harmless stories, and when he had finished he would let his arms drop with an overwhelmed expression saying, "Life is terrifying!"

Then immediately he confessed to me that he had no will and that he never finished anything. He told me that I seemed very stable to him and that I should come often because I would bring him moral support. Since his diabetes did not allow him to have the bread that I was eating, he dunked a special diet biscuit into a bowl of bouillon next to his plate. This biscuit, which he then ate with a spoon, was nothing more than a thin, puffed crust which seemed as fragile as a piece of porcelain. Madame Brémond served us chicken fricassee with olives and little mushrooms. Cézanne poured wine for me and, with his eyes half-closed, recited entire passages of Horace and several sentences of the School of Salerno which men of his generation knew by heart. His memory surprised me. And the Latin came easily to him.

[. . .] In the autumn of 1902, after my discharge from the service and after my departure from Aix, Paul Cézanne, accompanied by Madame Cézanne and their son, came to spend several days at my family's home at Cévennes. My father received them as well as he could, though he knew nothing of this illustrious visitor. People have often said—proving their opinions with supporting anecdotes—that the old master from Aix was rather unsociable and difficult to be with, but he was always even-tempered toward me, and during his stay with us he was charming. He was self-confident and not suspicious of anyone. However, thousands of little things could make him agitated.

I had told my father, this is a great artist who is much talked about in
Paris and I lunched or dined with him several times a week when I was in
the service . . . My father, an unaffected, straightforward, and somewhat
old-fashioned man, paid no attention at all to painters and their work. Yet
he gave the good bourgeois from Aix who had treated his son with so
much kindness a customary country welcome. It was hunting season, and
brown boletus and red Caesar's mushrooms with their round, perfumed
caps circled the ancient chestnut trees. At that time, a local woman worked
in our house who knew how to prepare game and to fry mushrooms per-
fectly in smooth, rich olive oil. I can still see Cézanne in the kitchen, his
back turned toward the same stove where I used to warm my cheeks when
I had a toothache as a child.

[. . .] I am writing all this to show that I knew Cézanne not merely in
passing, that I did not just drop in on him occasionally for brief visits the
way some of his admirers did. I had visited him often in Aix and afterward
he stayed a while in my parent's home, as comfortably as an old relative
who comes to visit for a family celebration.

He often told me that he wanted to paint my portrait, but soldiers
hardly ever got to go out except at night, and on Sundays I suppose I pre-
ferred leisure activities to the discipline of posing. I don't have the slightest
souvenir of him. At my father's house, one morning, he took a sheet of pa-
per and sketched a few lines while looking at me. He and I were invited
to go on a walk and left the door open. A gust of wind must have carried
away this slight sketch. I have never found it and I would pay a great deal
for it. But I cannot be too disappointed by this loss, since I know very well
how he treated former friends whom he no longer saw often and who did
own "Cézannes."

I must admit, however, that he did give me one gift. He gave me a copy
of [Baudelaire's] *Fleurs du mal* while I was still at the barracks. This volume
was hidden in my pack between my military overcoat and my enlistment
papers. I took good care of it and I still have it today. It is the ordinary
1899 paperback edition published by Calmann-Lévy. At the top of the last
page, Cézanne had written with pencil in Roman numerals:[2]

"VI – XV – XIX – XXVII – XXX – LXVIII – LXXIV – LXXXII"

According to these notations, these are the poems which he must have
reread the most:

 VI *Beacons*
 XV *Don Juan in Hell*
 XIX *The Giantess*

XXVII *Sed Non Satiata*
XXX *The Carcass*
LXVIII *Cats*
LXXIV *The Happy Corpse*
LXXXII *The Taste for Nothingness*

The book's cover is smeared with paint. There are several red and brown spots and maybe a fingerprint made with paint from a palette.[3] That's all I have of Cézanne, a little book spattered with paint and the very vague memory of a sketch that blew away.

CÉZANNE SPEAKS . . .

(I publish [. . .] these notes collected by Cézanne's son without adding one line of my own, not wanting to alter in any way the thoughts, reflections, and opinions of the artist . . .)

I Critics' opinions about art are formulated more on literary principles than on aesthetic ones.

II The artist must avoid literature in art.

III Art is the manifestation of an exquisite sensitivity.

IV Sensitivity defines the individual. At its highest level, it identifies an artist.

V Great sensitivity is the most powerful characteristic of any beautiful artistic creation.

VI The most seductive element in art is the artist's own personality.

VII The artist gives form to his sensibility, to his own, innate individuality.

VIII The nobility of an artist's creation reveals his soul.

IX The artist materializes and individualizes.

X The artist knows the joy of being able to communicate to others his excitement about nature, that masterpiece whose mysteries he believes he has deciphered.

XI Genius is the ability to renew one's emotion by daily contact with nature.

XII For the artist seeing is creating; creating is composing.[4]

XIII Because the artist does not note down his emotions as the bird sings his song: he composes.

XIV The universality of the immediate impact of a work of art does not indicate its importance.

XV Art is a religion. Its goal is the elevation of thought.

XVI He who does not hunger for the absolute (perfection) is content with placid mediocrity.

XVII An intellect's excellence can be judged by the originality of its creations.

XVIII A mind that can organize powerfully is the most precious collaborator with sensibility in the realization of a work of art.

XIX Art is the adaptation of things to our needs and tastes.

XX The technique of any art consists of a language and a logic.[5]

XXI Style is perfect when it is commensurate with the character and grandeur of the subject it interprets.

XXII Style does not result from the slavish imitation of the old masters; it develops from the artist's personal manner of feeling and expression.

XXIII The manner in which a work of art is rendered allows us to judge the distinction of the artist's mind and insight.

XXIV The quest for novelty and originality is an artificial need which can never disguise banality and the absence of artistic temperament.

XXV Line and modeling do not exist.[6] Drawing is the relationship of contrasts or, simply, the rapport of two tones, white and black.

XXVI Light and shadow result from the rapport between colors. These two most important phenomena differ not by their general intensity but by their individual resonance.

XXVII The form and contour of objects are created by oppositions and contrasts which result from their particular hues.

XXVIII Pure drawing is an abstraction. Drawing and color cannot be separated, since all things in nature are colored.

XXIX As we paint, we gradually draw. Accuracy of tone gives an object both its light and shading. The better the color harmonies, the clearer the drawing becomes.

XXX Contrasts and relations of tones are the secret of drawing and shading.[7]

XXXI Nature exists in three dimensions. There is a distance—a plane—between the painter and his model; it is atmosphere. All bodies seen in space are convex.[8]

XXXII Atmosphere forms an enduring foundation. Oppositions of colors divide all the phenomena of light into separate elements upon the screen that is atmosphere. This atmosphere, then, envelops the painting, contributing to its synthesis and general harmony.

XXXIII We can say, therefore, that to paint is to create contrasts.

XXXIV There is neither light painting nor dark painting, but simply relationships of tones. If they are placed well, by themselves they will establish harmony. The more numerous and varied they are, the greater is their effect and the more pleasing they will be to the eye.[9]

XXXV Like all the arts, painting has its own techniques, but beauty of tone and harmonious combinations of sensations depend entirely on the artist's discernment.

XXXVI The artist cannot perceive all these relationships directly; he must feel them.

XXXVII To sense correctly and represent that sensation fully is the foundation of style.

XXXVIII Painting is the art of combining sensations, in other words, of establishing harmony between colors, contours, and planes.

XXXIX This method comes from contact with nature and develops through experience. It consists of searching for the expression of what one feels and of organizing sensations within a personal aesthetic.

XL Schools of art, *a priori,* do not exist.[10]

XLI To paint from nature is to set free the essence of the model. Painting does not mean slavishly copying an object. The artist must perceive and capture harmony[11] from among many relationships. He must transpose them in a scale of his own invention while he develops them according to a new and original logic.

XLII To paint a picture is to compose.

JULES BORÉLY
July 1902

*This text of the archaeologist Borély, though dated "1902," was published in
L'Art Vivant, no. 2, 1926. (A small part of it was already known from
Georges Rivière's* Le maitre Paul Cézanne, *Paris, Floury, 1923,158–60.)
It is an extremely convincing and plausible account of the Cézanne of
those years, and of his views. The enthusiasm for Monet, the references to
Rubens, to Pissarro, and to Degas, above all the mention, possibly unique
in the early biographical literature of the then-unpublished youthful verses
of Cézanne, all support its validity. Only the term "impressions," here
used by Cézanne of his paintings, is unlike his normal phraseology: but we
cannot be sure that he did not in fact speak thus (see note 4 to Borély).*

*This conversation appears to begin on the way to, and within, the Ate-
lier des Lauves (though the building was not completed until September),
and to end in the rue Boulegon apartment.*

"Cézanne at Aix" (L'Art Vivant)

L ast July I went to Aix to see the painter Cézanne. I arrived without
an appointment, learned his address from the keeper of a bookshop
in town, and set off on the road leading up to his country house
around two in the afternoon. Finding the door closed, I strolled under the
blue sky between two dry stone walls, when suddenly, where the path
turned, I saw Cézanne, whom I had been hoping to find.

My God! There was Cézanne, looking like a craftsman returning from

working at a nearby villa, carrying his equipment: a glazier's smock, a pointed hat, a game-bag with a green bottle poking out; in his hands his huge paint box, his canvas and his easel.

"Monsieur Cézanne?"

"Sir?"

And that is how I caught Cézanne off guard, coming along bent over in thought. His face like a potter's, sun-burned, looked startled as the shadow of nearby leaves played over it. He had a small, bony head with rosy skin, lively eyes, and a white mustache, carelessly smeared with prussian blue.

I walked toward him.

"Monsieur Cézanne, I was looking for you, hoping to see your painting again."

My heart broke at the obvious humility that my simple phrase triggered in this dear man. It awoke in me a kind of sympathy that I cannot explain to this day.

"Monsieur," he said, "you are too kind, well! . . . shall I show you some of my attempts? Alas, even though I am already old, I am only a beginner. However, I am beginning to understand, if I may say so; I believe I do understand. So, you like painting. I would like to be able to show you some Monets,[1] but I don't have any. They are very expensive these days. I have a Delacroix.[2] Are you a painter, sir? Oh, you are! Would you believe, I have almost completed formulating principles and a method for my profession?[3] I have searched for a long time; in fact, I am still looking! That's what preoccupies me, at my age. Don't let my ravings surprise you," he added, "I have lapses. Do you want to see my painting?"

"I have heard people speak of your paintings in terms that made me mad with desire to see them," I told him.

Cézanne stopped suddenly. He spoke to me simply:

"Sir, we are alone here in the country, man to man; be sincere, don't flatter me! Yes, I believe myself to be a painter. What's more, others recognize it, don't they, since they buy my impressions.[4] Nevertheless, they are imperfect things. Oh, yes, I say it. The problem is that I don't capture the local colors.[5] Ah! Monet! Do you know Monet? Monet is, to my way of thinking, the most gifted painter of our times in this regard."

We arrived at his country house. He pushed open the door and offered me one of the chairs of white wood, abandoned on the terrace under the pale acacias. He put down his bag, his paint box, and canvas and came to sit near me to look out over the view. Beyond the mass of olives and some

withered trees, the town of Aix appeared, mauve in the light, framed by
the surrounding hills, cerulean, floating . . . Cézanne stretched out his arm
to measure the bell tower of the cathedral between his thumb and index
finger.

"How little it takes to transform this thing . . . I try and it's hard for
me. Monet has that rare talent; he looks and can immediately draw in pro-
portion. He takes it here and puts it there; it's the gesture of a Rubens."[6]

At my request, we went up to the studio. I saw a high, wide room with
empty, inanimate walls and a bay window that opened onto an olive grove.
There, captive and sad, were two easel paintings. One depicted a group of
young female nudes with white bodies against a background of lunar
blues. The other was the head of a peasant wearing a hunting cap; his face
was yellow but his eyes were an intense blue.[7] We came back to the gar-
den. In the hallway I spotted in passing and among twenty watercolors—
all blue and green—carelessly thrown on the floor, the study that Cézanne
had just brought back. On it I could see a sky streaked with apple green.[8]

"These must be trees!"

"Oh, no. I want a very blue sky with a few clouds."[9] He put his head
through the open door, "white clouds," and he added, "Right now the sky
is clear, but maybe I'll have some clouds tomorrow; there's haze on the
horizon."

We sat down to talk more about Monet, Renoir, and Sisley. "Unlike
Monet," said Cézanne, "Renoir lacks a constant aesthetic. His particular
genius and the way he works make it difficult to maintain one . . . Monet
limits himself to a single vision of things.[10] It's easy for him to stay true to
the style he has developed. Yes, a man like Monet is fortunate; he reaches
his aesthetic goals. It's an unfortunate painter who struggles with his talent
too much, who perhaps wrote poetry in his youth . . ."[11] And saying this,
he sighed, then began to laugh looking out over the valley and completed
my confusion by adding, "Painting is a funny thing." Then he turned and
stood up and said slowly, "I lose myself in strange thoughts." He pulled
himself together again and said, "I'm going to take the chairs in, because
the humidity at night will ruin the straw. Do you ever stop and think how
foolish it is to waste what you have?" He was standing between two chairs
holding on to their backs.

"To paint, doesn't that mean to create a harmonious impression? And if
I want to celebrate this light? I know what you're thinking; over there is a
dwindling light that I can never equal on my canvas; but imagine that I

could re-create this impression by another and corresponding[12] impression, even if I have to do it with bitumen!"

We went out. Cézanne had taken off his smock and carried his rustic bag slung across an old frock coat. Locking the door, he started to laugh again and told me, "I am the most unfortunate of men." I noticed that locks of his fine white hair were flying around his head, like Greuze's old men in his paintings of family scenes. We walked down into town.

"Look at this landscape. Isn't it classical?"

It was a chalky path between two sunlit walls, bordered by mulberry trees, deep green against a pale sky. But no, it was nothing at all like those artful compositions which I find so uplifting in classical landscapes.[13] Did he mean to use that term? Certainly nothing escapes Cézanne, and he is horrified only by the bad taste of the times.

"Zola spoke openly of your genius. Did you know him in Paris?"

"Ah, Paris! No, Zola was my childhood friend; we studied together at the Collège Bourbon here in Aix. In his next to last year he was lucky to have a professor who loved poetry (I remember the time he read us *Les Iambes*).[14] Zola already had a marvelous talent for story-telling. One day he wrote his French class assignment in verse. Our professor gave it back to him saying, 'You are going to be a writer.' It sounds like a cliché, doesn't it? This professor,[15] nonetheless, encouraged that writer's genius. But I am talking about Zola, I don't offend you?"

"No, why?"

"Because of his escapade. Do you like Baudelaire?"

"Yes."

"I didn't know Baudelaire, but I knew Manet. As for old Pissarro, he was like a father to me. You could always ask him questions; he was something like the good God."[16]

"Was he Jewish?"

"Yes, he was a Jew. You must be sure to get a good artistic education. Do you like Degas?"

"Oh, yes! Although his is a kind of private or cabinet painting, if I may say that."

"I know what you mean.[17] What's more, if from now on any small thing comes between us, let us come to an agreement over it."

We were in Aix now, in the cool street where Cézanne lived. At five o'clock the lower floors of the buildings were in shadow, but the façade of

a large house glowed yellow against the blue sky like a tall building in a Canaletto.

"Do you like Aix," I asked.

"I was born here; I'll die here. I left after secondary school and went to Paris and, twenty-one years later, I didn't recognize Aix anymore. The faces of the girls that I studied before I left have changed too much. Today everything is changing, but not for me. I live in my home town, and I rediscover the past in the faces of people my age. Most of all, I like the expressions of people who have grown old without drastically changing their habits, who just go along with the laws of time. I hate people's efforts to escape these laws. See that old café owner under the spindle tree? What style he has! On the other hand, look at the young shop girl on the plaza. Surely she's nice—we mustn't say anything bad about her—but with that hair and that clothing, what sham, how banal!"

The sun lengthened the plane trees' wavering shadows on the sand.

"How difficult it is to paint well! How do you approach nature directly? Look, between us and that tree there is a space, an atmosphere, we agree. Then there is that tree trunk. It's palpable, resistant, a body . . . Oh, how I would like to be able to see like a newborn child![18]

"Today our sight is overworked, abused by the memory of a thousand images. And the museums, the paintings in the museums! And the exhibitions! We no longer see nature; we just remember paintings. To see the work of God; that's what I try to do. But am I a realist or an idealist, or just a painter, a draftsman? I'm afraid of being considered a fraud. My situation is very serious. Nevertheless, I am a painter, aren't I?[19] I am recognized as a painter."

I left Cézanne after spending another half hour with him in his chilly house. On a narrow center table in his bedroom three human skulls faced each other, three beautiful, polished ivories. Cézanne told me about a very good painting of them that he had somewhere in his attic. I wanted to see it. He looked in vain for the key to the attic, but the maid had misplaced it.

I take the train tonight and I leave behind this man who is so wonderful to talk with and visit. I have fallen under the charm of his vagabond soul, this soul so simple yet so complicated. I have inhaled the incense of a heart aflame. Goodbye, wise one, who would confound the everyday meaning of life, feelings too unsteady in me! Goodbye affecting passion, benevolence, shrewd intelligence so clairvoyant, modesty, absolute modesty; heart aching with wounded pride . . .

My train rolls through the countryside around Aix: fertile flowerbeds, houses, meadows, farms, reeds, creek, silvery pebbles, soft, flower-covered grass. This land is truly the garden of man surrounded by high hills where Aleppo pines show off their plumed crests. . . . Past one or two parks emblazoned by the setting sun which paints the rose-laurels purple, we approach Marseilles, a great, ocher-washed city, under a tall cluster of umbrella pines . . .

I think with sadness of the awesome talent which, to the misfortune of that great painter, torments his nerves and excites his brush.

EMILE BERNARD
February 1904

Bernard (1868–1941) was an artist, illustrator, poet, and writer on art. He was a pupil, but a rebellious one, of the academic painter Cormon, and thereafter moved through impressionist, pointillist, and synthetist phases. He was on close terms with Van Gogh in 1887, and at Pont-Aven in the years 1888 to 1890 was involved with Gauguin in the formulation of the synthetist aesthetic. He was the largest contributor to the Volpini exhibition of 1889, in which the work of the Gauguin circle first came substantially before the public eye.

At Pont-Aven in 1889–90, Bernard had begun to subscribe to a mystical Catholicism, and in the following years his increasing religious fervor coincided with a movement in the direction of an "idealist" art. He broke with Gauguin in 1891, was associated with the Nabis in 1892–93, and exhibited at the first Salon de la Rose-Croix. In 1894–96 he made engravings for the periodical L'Ymagier, edited by Remy de Gourmont. Increasingly he rejected contemporary art, and became interested in a revival of Renaissance ideals. The years 1893 to 1904 were largely spent in Egypt, but he also traveled in Spain and Italy.

Bernard, without having met Cézanne, had already published in 1891 or 1892 (see Reff, 1960, 153, footnote) a short essay on the painter in the series Les Hommes d'Aujourd'hui *(Men of Today). In February 1904, on returning from Egypt, he went to visit him at Aix. The text given here is from a letter written by Bernard to his mother on the day after his first visit, and was first published in* Art–Documents *in November 1954, page 4.*

The letter has a directness which is to be contrasted with the increasing diffuseness and abstractness of Bernard's later writings on Cézanne, a process which may be followed in the texts published in this volume.

Emile Bernard's writings on art have been reissued in a collected edition (see bibliography, Bernard, 1994).

Letter to His Mother

Marseilles, 5 February 1904

[. . .] I went to Aix yesterday to see Cézanne . . . He's an old man, unpretentious, a bit of a misanthrope, and strange. He was going off to work so I went along with him. He spoke to me familiarly, and kept saying at least a hundred times, "Life is terrifying!" I can't see what he has to complain about; he seemed quite contented. He's a man of independent means and paints as he pleases. What's more, he has his own house outside of town, custom-built according to his design. He took me to it, mysteriously, telling me that he never brought anyone there.[1] If you ask me, I think he's kind of crazy. He's worn down by diabetes and is full of provincial ideas and prejudices of all kinds. He is always talking about people who want "to get their claws into him." In a word, he's a misanthrope, or so it seems to me. When he talks about art, he talks only of painting nature according to his own personality rather than in keeping with principles of art itself.

I looked at his paintings. There was, among others, a large canvas of female nudes—a magnificent work, as much for its forms as for the power of the composition and the human anatomy. It seems that he has been working on it for ten years. What is special about him is that he is a great original, but I don't know what to think of such originality. He talks about the old masters (Michelangelo, Raphael) as many writers talk about Homer, Dante, and Milton—as if they had known them personally. Cézanne never has been to Italy, even though he was born practically on its border. He adores the old masters from studying their works in the Louvre and from engravings. He's an honorable man, a sort of "lord of painting," who works thick impasto as a farmer works rich soil. He professes theories of Naturalism[2] and of Impressionism, and when he talks about Pissarro, he calls him "colossal."[3]

Since I had sent all my work to you, I didn't show him any of my paintings. He thinks I am an "intellectual," knows that I have produced great work, and sees me as an "modernizer." Cézanne says that personality is essential for all innovators, and art, for him, can be summed up essentially as

"la vision optique," or technique. He has devised a system of color progressions, which is tremendously interesting and which he is striving to perfect. He actually sees in subtle tonalities. He paints his canvases by distinct areas, leaving white places everywhere. Actually, he works the way Ingres did, progressing detail by detail and finishing discrete areas before bringing them together.[4] What I have to say moves him a great deal, because he senses that we both approach art from the same point of view, and that we are both interested in the soul of things, even though we also understand the material side of painting.

I came to see him in order to discover what he truly is, so I try not to argue with him too much. Since he can't stand the least contradiction and might lose his temper, I listen to his opinions with great deference.

I'm going to return to Aix and I'll stay there until I learn everything from Cézanne. I hope to acquire something from this man who knows much, so that I can understand in depth the method he created for himself (a code of rules like any other) and reveal it to future generations.

[. . .] I have come back happy to have found Cézanne to be an excellent man, if somewhat strange and eccentric. He is a man saddened by others' lack of understanding of his work, this tenacious man of Art, whose goal, as I understand it, is to realize character like the Greeks and the great masters [. . .]

PAUL CÉZANNE
1904

The texts of more than 230 of Cézanne's letters survive. The majority of those from his earlier years are to friends of his youth, and above all to Emile Zola. In his last decade, however, the letters echo his contacts with a wider world, as more of his work begins to be exhibited and sold. A large proportion are addressed to his son or to his increasing number of visitors. As before, letters deal often with the routine matters of his daily life, but increasingly he is drawn to write of his art and his theories about it, and this is particularly true of the letters written to Emile Bernard.

The nine letters to Bernard, the originals of which are now at the Courtauld Institute, were published by Bernard himself in the two-part article Souvenirs sur Paul Cézanne et lettres inédites, *which appeared in the* Mercure de France *in 1907. In the present volume, they are omitted from the reprint of the* Souvenirs, *and dispersed among the Bernard texts in date sequence, so that Bernard's procedures of interpretation and elaboration may more easily be appreciated.*

The text given in the French edition of this publication was different from that known through Bernard's publications, or in the standard French-language editions of the correspondence (Paris, Grasset, 1937 and 1978). Early publications of the letters presented corrected texts, in which punctuation, spelling, and grammar were regularized, and deletions not necessarily indicated. The transcription used in the Macula edition, first published in the catalogue of the exhibition Impressionistes de la collection Courtauld de Londres *(Paris, Musée de l'Orangerie, 1955), aimed to be, as far*

28

as was possible, a literal one, and was published in Conversations avec Cézanne *with the kind permission of Douglas Cooper, who was the author of that catalogue. The literalness, it was felt, brought out vividly the state of mind in which the letters were written, and sometimes clarified Cézanne's intention. The present English translation cannot of course, attempt so close a match.*

For an account of collected editions of Cézanne's correspondence, the reader should consult the heading "Cézanne letters" in the Bibliography.

Letters to Emile Bernard

Letter 1

Dear Mr. Bernard, Aix-en-Provence, 15 April 1904

When you receive this note you probably will already have received a letter sent from Belgium, I think, and addressed to you at the rue Boulegon.[1] I am touched by the expressions of artistic sympathy expressed in your letter. Let me repeat what I told you when you were here: Render nature with the cylinder, the sphere, and the cone, arranged in perspective so that each side of an object or of a plane is directed toward a central point. Lines parallel to the horizon give breadth, that expanse of nature— or if you prefer, of the landscape—that the Pater omnipotens, oeterne Deus, spreads out before our eyes. Lines perpendicular to the horizon give depth.[2] Now nature exists for us humans more in depth than on the surface. Therefore, into our vibrations of light, represented by reds and yellows, we need to introduce sufficient blues to make one feel the air.[3] I looked again at your study made in the ground floor of the studio; it is good. I think you need to keep working in this way. You understand what must be done and will soon be able to turn your back on the Gauguins and Gogs.[4]

Please thank Madame Bernard for her kind thoughts for the writer of this letter and give a big hug to the children from père Goriot.[5]

All my respects to your fine family,

Letter 2

My dear Bernard, Aix, 12 May 1904

Hard work and advanced age have delayed my answering your letter. You questioned me on such a variety of subjects in your last letter, all hav-

ing to do with art, that I was unable to follow the development of all your thoughts.

I had already told you how much I admire Redon's[6] talent. He and I are of one mind in our sensitivity to Delacroix and in our admiration for him. I am not at all sure if my precarious health will allow me to realize my dream of painting his apotheosis.[7]

I proceed very slowly. Nature presents itself to me with great complexity, and improvements to make are endless. An artist must study his subject, get a firm sense of it, and find a way to express himself forcefully and with distinction. Taste is the best judge, but it is rare. Art is accessible to only a very small number of people. The artist must shun opinions not based on the intelligent observation of essentials. He must avoid thinking like a writer, which so often distracts the painter from his true goal, the direct study of nature, and causes him to waste his time in intangible theories.—

The Louvre is a good book to consult, but it should only be an intermediary. The real and prodigious study to undertake is the diversity of the picture that nature presents.[8]

Thank you very much for sending me your book. I look forward to being able to read it when my mind is more at ease.

Send Vollard whatever he asked you for if you think it's a good idea.[9]

Please give my respects to Madame Bernard, and to Antoine and Irene a kiss from their honorary grandpapa. Cordially,

P. Cézanne

Letter 3

My dear Bernard, Aix, 26 May 1904

I quite agree with the ideas that you plan to develop in your next article for *L'Occident*.[10] But I keep coming back to this: The painter must dedicate himself totally to the study of nature and try to produce paintings which enlighten. Conversations about art are almost always useless. Work, which brings about progress in one's art, is sufficient consolation for being misunderstood by fools.

The writer expresses himself in abstractions, while the painter renders his sensations and his perceptions visible by means of drawing and color. —One cannot be too conscientious, too sincere, or too submissive to nature. But one must be more or less master of his model and, above all, of his means of expression. His goal is to penetrate what lies before him and to strive to express himself as logically as possible.

I send my respects to Madame Bernard, a good handshake to you, and my regards to the children.

Pictor P. Cézanne

Letter 4

My dear Bernard, Aix, 27 June 1904

I received your letter of . . . , which I left in the country. I am slow in answering because I am having mental disturbances which keep me from getting around freely. I still live under the influence of sensations and, despite my age, am totally bound to painting.

The weather is beautiful and I'm taking advantage of it to work. I've got to make ten good paintings and sell them for high prices, because connoisseurs are speculating on them now. —A letter arrived here yesterday addressed to my son which Madame Brémond thought must be from you. I had her forward it to 16 rue Duperré, Paris IX.—

I hear that several days ago Vollard gave a dinner dance where people stuffed themselves with food! —All the young painters were there, it seems. Maurice Denis, Vuillard etc., Joachim Gasquet and Paul ran into each other there. —I think the best thing you can do is to work as much as possible. You are young; you must paint and sell.—

You remember Chardin's beautiful pastel self-portrait in which he is wearing a pair of eye glasses and a visor which served as a shade.[11] (He's a clever one, that painter!) Have you noticed how that thin intersecting plane across his nose enhances the values?[12] —Go verify this for me and tell me if I am wrong.—

Warmest greetings to you and my respects to Madame Bernard. Please remember me fondly to Antoine and Irene.

P. Cézanne

I think that Paul wrote that they[13] have rented a place at Fontainebleau for a couple of months.—

I have to say that, because of the great heat, I have my lunch sent up to the country.

EMILE BERNARD
February–March 1904

Bernard's claim (at the end of his text) was that he wrote this article at Aix in March 1904. But in fact its final form must have been arrived at later, for the article contains substantial quotations from Cézanne's letters of 12th and 26th May.

Although always known to specialists, this article (pages 17 to 30 in the July 1904 issue of L'Occident*) has tended to be overshadowed in Cézanne studies by the two* Mercure de France *texts making up* Souvenirs sur Paul Cézanne . . . *, and their several reissues in book form.*

The L'Occident *article is, to a considerable degree, concerned with Bernard's general views on the state of art, but, in addition to the celebrated collection of* Opinions de Cézanne, *has some other apparently verbatim quotations from him, and some occasionally penetrating remarks about his working methods and his development as a painter. The comments on Pissarro and on the Auvers period seem accurate.*

As to the authenticity of the "opinions," it should be borne in mind firstly that Bernard is fairly careful, elsewhere in this article, to indicate those occasions when he is quoting Cézanne's actual words, and secondly that to the "opinions" proper he appends quotations from letters, thus implying that the whole section consists of authentic citation. In this he differs from his later practices.

EMILE BERNARD

"Paul Cézanne" from *L'Occident*

> Frenhofer is a man who is passionate about our art
> and who sees higher and farther than the other painters.
>
> Balzac (*Le chef-d'oeuvre inconnu*)

It has been almost been twenty years since several young painters, who are much discussed in Paris today, used to make pilgrimages to a small, dark shop on rue Clauzel. There they asked an old Breton man with a philosophical bearing[1] to show them Paul Cézanne's paintings. Even though the walls of the shop were hung with glowing pictures, these artists were not satisfied until, with the back of a chair serving as an easel, the requisite studies showed them the path to follow in their desire to create art. They consulted these works religiously like pages of a book on nature and contemporary aesthetics, like a religious tract through which a prophet, unknown to them, confirmed his sovereignty. Then, amid many admiring discourses, they returned from the shop to their own brushes and canvases, seized by the need to paint, just as paralytics are compelled to walk when the Savior suddenly has performed a miracle for them. Thus, from works virtually copied from their creator (who surely, seeing that they did not conform to his vision, would never have let them leave his studio) was born a school of painting which others, either too ambitious or not artists enough and misled by fantasy and surface, would label with fabricated names.

And what a blessing that *revelation* would have been, if it had been completely taken to heart and understood!

Tremendous strength of character should distinguish painters, and this force must be deep within, not superficial, and must draw from the healing spring of its fountain of youth. Without this compulsive obsession with character,[2] carelessness allows decay to set in. Unfortunately every year we observe the stripping bare of young trees awaiting their vigorous branches. When the leaves fall we find ourselves in a monotonous autumn; all sap flows in vain with the premature approach of winter. One by one our bright suns are extinguished; the lights of our time disappear, and, of our masters, after Manet, after Puvis, only Cézanne remains.

Monet, light's own eye, opened painting's doors onto the infinity of the sky, the sea, and the fields, and created a great body of work which we would be foolish not to recognize. Neither Corot nor Millet ever left the world of the museum; their unquestioned superiority gloriously perpetu-

33

ates the schools of Claude Gellée and Correggio. Monet looked at nature with his fixed gaze and saw it as a painter.

Manet, praising Monet, created this image [in his work]: the old masters (whom Manet's palette perpetuated and whom he honored in his work) recognizing in this student of the sunlight, graced with the most delicate artistic sensitivity, a relative, a brother.[3] Even though would-be classics—in other words, the bad painters—rejected this discoverer's introduction of the newest and most radiant vision, he was a classic in the true sense of the word. In the name of the masters, Monet, ignoring that cowardly act of rejection, extended his hand and his admiration, like the link of a chain that opens in order to attach itself to the link that follows. Claude Monet's influence has been immense, from whatever angle you view it. The fault of his students lay in not understanding his principles and in clinging to pure imitation. The fault of his critics lay in limiting his influence, and that of his admirers, in defining everything by it. It is proper to proclaim the benefits of his principles, to see observation ally itself with great talent through them, and, in short, to recognize their effect on all painting of these last twenty years, not only in France, but throughout the world. From this point of view Claude Monet's victory has been complete: it overthrew the Ecole des Beaux-Arts. And it began in such a simple place: in the little boat studio, which Manet's masterful sketch commemorates, in which Monet meandered along the banks of the Seine.

None of this is related to the naive idea that ancient art has been surpassed! The best painters, whether they are named Courbet, Manet, or Monet, will never make us forget Michelangelo, Raphael, Leonardo, Titian, Giorgione, Tintoretto, Veronese, Rubens. They won't even make the little French, Flemish or Dutch masters tremble; they won't make us forget the primitives. And that is not their intention. These are not anarchists who want to create the world all over again and redate it from their own time. Born gifted, they said to themselves "Contemporary painting is corrupt. Art, since it wandered into museums, has lived by academic rules. The old masters, however, whom we know better than anyone, whom we admire above all others, have nothing to do with these cold, heavy, and lifeless dogmas because they drew their classicism from nature. . . .[4] Let us return to nature!" And these babes pressed their lips to the multiple and milk-filled breasts of the goddess, and have worked like laborers, in villages and provinces near and far: in Normandy, Oise, Provence, the Creuse, or along the Seine, the Ocean, the Mediterranean, they have surpassed what

they desired to do; they have distinguished themselves. In contact with Creation, they became creators.

They purified their eyes' vision and their minds' logic. That's why their work has been excellent and is of capital importance in spite of its simple, objective appearance.

Paul Cézanne was not the first to follow this path, and he willingly recognizes that he owes to Monet and Pissarro his abandonment of the overbearing influence of the museums so that he could place himself under the influence of nature. In spite of these relationships his work is not influenced by them. Only, from the gigantic works he delighted in making, his rough and dark early works, he reduced the proportions in order to work from nature. The master leaves the studio, going morning and afternoon to his *motif,* following the effects of the air on forms and *place.*[5] He analyzes, searches, finds. Soon Pissarro no longer advises him; it is Cézanne himself who makes his mark on the pictorial development of Pissarro. Thus he did not adopt Monet's or Pissarro's way of working; he remained what he was, in short, a *painter,* with an eye that grows clearer and educates itself[6] and is excited by the sky and the mountains, by things and beings. He reinvents what he calls a point of view,[7] since his own was destroyed, carried away by a boundless passion for too many images, engravings, paintings. He wanted to see too much; his insatiable desire for beauty made him consult the multifaceted book of art too often. Then he realized the need to limit himself, to wrap himself up in one idea and aesthetic ideal. If he now goes to the Louvre, if he contemplates Veronese at length, it is in order to peel away appearances and to study the principles; there he learns contrasts, tonal oppositions;[8] he distills his taste, ennobles it, elevates it. If he goes to look at Delacroix again, it's to follow the blossoming of his vivid effects of color. And he affirms, "Delacroix was imaginative and sensitive to colorations," the rarest and most powerful gift. Indeed the artist possesses at times a brain and no eye, at times an eye and no brain. Cézanne cites Manet as an example: a painter's nature, the intelligence of an artist, but a mediocre sensitivity to colors.[9]

After having painted great and powerful canvases under the influence of Courbet, Cézanne withdrew to Auvers near Pissarro to distance himself from all influences and to work face to face with nature. At Auvers he began the stunning creation of that honest and ingenuously wise art that he has since given us.

Now that the paintings of the master have been dispersed into private

collections, it is difficult to speak of the ensemble of his work, what it was before, when he let nothing leave his studio and lived in solitude. One can write at length, however, about his personal contribution, about his aesthetics, his vision, his tastes.

From the day that Paul Cézanne placed himself directly before nature with the intention of *forgetting everything*, he began making discoveries which, from then on, were spread by superficial imitation and had the effect of a revolution on contemporary perception.

But that all happened without his even noticing, because, uninterested in glory, in reputation, or in success, and dissatisfied with himself, the painter withdrew into the inner sanctum of his art, wanting to know nothing of the outside. He mined the hidden depths of his analysis, digging away slowly, forcefully and with concentration, the shovel-loads which would one day reveal the miraculous vein from which would spring total beauty.

This is his method of working: first complete submission to his model; carefully establishing his composition; studying the curves and relations of proportions; then in deeply meditative sessions, heightening the color sensations and elevating form into a decorative concept[10] and color to its most harmonious register. Thus, the more the artist works, the further his work distances itself from the objective; and the further it distances itself from the opacity of the model, which has served as point of departure, the more he enters into the painting stripped naked, with no other goal but itself. The more he makes his painting abstract—after having begun it narrowly, true to the original, and hesitatingly—the more he simplifies it and gives it breadth.

Little by little, the work has expanded and has reached the goal of pure design. In this intense and patient progress all parts are led directly forward, accompanied by the others.[11] It can be said that every day a more exasperating vision comes to superimpose itself on that of the day before, until the weary artist feels his wings melt from their closeness to the sun. In other words, he abandons his work at the highest point to which he was able to raise his art. If he had made as many canvases as he had painting sessions, the result of his analysis would be a quantity of ascending visions, increasingly lively, lilting, abstract, harmonious, of which the most *supernatural* would be the definitive one. However, in only taking one canvas for this slow and ardent elaboration, Paul Cézanne shows us that analysis is not his goal, that it is only a means that he employs just as he uses an easel, and which he maintains only until the destructive and conclusive

synthesis. He claims that this method of working, which is his alone, is the only correct one, the only one leading to a serious result. He mercilessly condemns all preference for simplification which does not pass through submission to nature by means of a meditative and progressive analysis. If a painter is easily satisfied, it is because, according to Paul Cézanne, his vision is mediocre, his temperament practically worthless.

Leonardo da Vinci put forth a similar idea in his treatise on painting when he said, "The painter who has no doubts will profit little from his studies. When a work of art surpasses the judgment of the creator, he who works advances little; but when his judgment rules his works, those works become more and more perfect if inconsistency does not interfere."

The artist will arrive at self-knowledge and the perfection of his art not through patience, therefore, but through love that gives insight and the desire to analyze in greater depth and to improve. He must extract from Nature an image which will be, properly speaking, his own; and only through analysis, if he has the strength to press it to the end, will he make himself known ultimately, unambiguously, abstractly.

Cézanne's expressive syntheses[12] are meticulous and dutiful studies. With nature as his support, he gives himself over to phenomena and transcribes them slowly, attentively, until he has discovered the laws which produce them. Then with judgment and reason, he takes possession of them, and finishes his work with a commanding and living synthesis. His achievement, in harmony with his expansive southern nature, is decorative, in other words, glorious and free.

Madame de Staël writes in her book on Germany: "The French consider exterior objects to be the impulses behind all ideas, and the Germans consider ideas to be the impulses behind all impressions." Paul Cézanne justifies Madame de Staël's opinion about the French, but he knows how to attain a depth in his art which is rare among our contemporaries. As a good traditionalist, he maintains that Nature is our support, that the artist needs to be inspired by her alone, while nonetheless he consecrates himself to improvising with what he has borrowed from her . . .

According to Cézanne, what a painter needs above all is a personal *optique*, obtained only through persistent contact with a vision of the universe. Certainly it is necessary to have frequented the Louvre, the museums, in order to become aware of the elevation of Nature into art. "The Louvre is a good book to consult, but it should only be an intermediary. The artist must devote himself to the monumental and true study of the diversity of Nature's spectacle."*[13]

Copying nature without a personal vision of art is folly, it is clear; but the artist must be wary of limiting his work to repetitions or pastiches and of falling into abstraction and needless redundance. The artist must stand firmly on the ground of observation and analysis, forgetting existing works of art, in order to create the unexpected, derived from the bosom of God's creation.

Paul Cézanne believes that there are two "plastiques," or methods of giving aesthetic form to things,[14] one sculptural or linear, the other decorative or coloristic. What he calls "sculptural form" is fully exemplified by the *Venus de Milo*. What he calls "decorative form" is connected to Michelangelo, to Rubens. One of these methods is servile, the other free; in one, contour prevails, in the other, brilliance, color, and spontaneity dominate. Ingres is the first kind; Delacroix is the second.

Here are some of Paul Cézanne's opinions:[15]

> Ingres is a pernicious classicist; and all who, as a rule, reject nature and copy it with preconceived ideas are looking for a style which imitates the Greeks and Romans.
>
> Gothic art is essentially revitalizing; it comes from our race.[16]
>
> We must learn to read nature and represent our sensations by way of an aesthetic that is both personal and traditional. The strongest among us will be he who sees most profoundly and who represents most fully, like the Venetian masters.
>
> To paint from nature is not to copy an object; it is to represent its sensations.
>
> Within the painter, there are two things: the eye and the brain; they must serve each other. The artist must work at developing them mutually: the eye for the vision of nature and the brain for the logic of organized sensations, which provides the means of expression.
>
> To read nature is to see it beneath the veil of interpretation, to see it by means of color patches, following upon each other according to a law of harmony. Nature's broad coloration is thus analyzed by modulations. To paint is to record the sensations of color.[17]
>
> There is no line; there is no modeling; there are only contrasts. Black and white do not provide these contrasts; the color sensations do. Modeling results from the perfect rapport of colors. When they are

*These are Cézanne's own words.

juxtaposed harmoniously, and when they are all present and complete, the painting models itself.

One should never say "model"; one should say "modulate."

Shadow is a color like light, but it is less brilliant. Light and shadow are nothing more than a rapport between two tones.

Everything in nature is modeled after the sphere, the cone, and the cylinder. If the artist learns to paint according to these simple figures, he will then be able to do all he desires.[18]

Drawing and color are not distinct from one another; gradually as one paints, one draws. The more harmonious the colors, the more precise the drawing will be. Form is at its fullest when color is at its richest. The secret of drawing and modeling lies in the contrasts and affinities of colors.[19]

The "effect" makes the painting, it unifies and concentrates it; and to produce this, a dominant patch is necessary.[20]

The artist must be a laborer in his art and discover early on his means of realization. He becomes a painter through the very qualities of painting itself. By exploring its coarse materiality.

The painter must become classical again through nature, or, in other words, through sensation.

It all comes down to this: to have sensations and to read nature.

There are no longer any true painters these days. Monet provided a vision. Renoir created the woman of Paris. Pissarro was very close to nature. What follows is worthless, it's made by jokers who feel nothing, who perform tricks . . . Delacroix, Courbet, Manet made paintings.

The goal of the artist is to work without worrying about anyone and to become strong; the rest isn't worth the word of Cambronne.[21]

The artist must shun opinions not based on the intelligent observation of essentials. He must avoid thinking like a writer, which so often distracts the painter from his true goal—the direct study of nature—and causes him to waste his time in intangible theories.

The painter must dedicate himself totally to the study of nature and try to produce paintings which enlighten. Conversations about art are almost always useless. Work, which brings about progress in one's art, is sufficient consolation for being misunderstood by fools. The writer expresses himself in abstractions while the painter renders his sensations and his perceptions concrete by means of drawing and color.

One cannot be too conscientious, too sincere, or too submissive to

nature; but one must be more or less master of his model and, above all, of his means of expression. His goal is to penetrate what lies before him and to strive to express himself as logically as possible.

This is Cézanne; this is his teaching on art. Clearly, he distinguishes himself from Impressionism, from which his work derives, but which did not capture and hold his genius. Far from being a spontaneous artist, Cézanne is meditative; his genius illuminates the depths of things. It follows therefore that his character, totally that of a painter, has led him to new decorative creations, to unexpected syntheses. In truth, these syntheses have been the greatest progress to have sprung from the modern consciousness because they struck down academic routine, maintained tradition, and condemned the rash whims of excellent artists whom I have mentioned. In short, Cézanne, on the basis of his works, has proved himself the only master on whom future art can graft its development. But how little appreciated were his discoveries! Wrongly considered by some, because of their unfinished state, as inconclusive researches; by others as oddities ascribable to the solitary imagination of a deranged artist. For Cézanne himself, dominated by an absolute ideal, they were simply bad rather than good, no doubt vexed at seeing himself betrayed in them (he destroyed a great many, and exhibited none); but, just as they are, they nevertheless constitute the finest attempt at a pictorial and coloristic renascence that France has seen since Delacroix.

I am not afraid to proclaim that Cézanne is a painter with a mystical nature and that it is wrong that he is always placed in the deplorable school begun by Monsieur Zola, who, exaggeratedly and in spite of his blasphemies against nature, took for himself the title of *naturalist*. I say that Cézanne is a painter with a mystical nature because of his purely abstract and aesthetic vision of things. Where others busy themselves trying to create a subject, in order to express themselves, Cézanne is satisfied with some harmonies of line and tonality taken from random objects without worrying about these objects themselves.[22] He is like a musician who, disdainful of elaborating upon a libretto, is content instead with chord-sequences whose exquisite nature would unerringly immerse us in a transcendent art inaccessible to his able colleagues. He is a mystic precisely through his disdain for all subject-matter, through his lack of material vision; through the taste which his landscapes, still lifes, and portraits show to be noble and elevated: in short, his style. The nature of his style confirms what I was saying: a quality of giottoesque candor and grace reveal the

essence of the beauty of things. Take any painting by the master; it is, in its truly superlative science and quality, a lesson in sensory and emotional interpretation. Through contact, not with our vulgar instincts, that crave the realistic, but with the contemplative part of our being, which is moved only by the mysterious influence of harmonies dispersed in this world, his painting reawakens in us the rarest sensations one can experience of the divine model. Only a mystic so contemplates the beauty which envelops the world. Rather than letting himself be held prisoner by the very materiality of the world, his paintings tell us that he is the only one to see *well*. The vulgar see beauty and materiality completely differently, whence their opposite attitudes. Undoubtedly, the more a man distances himself from mystical teachings, the more he is inclined toward exterior reality. Art, which originally was the language of divine aspirations, has become progressively artificial and deceitful over the centuries, just like the vulgar man. No longer does he try to absorb a personal expression of the soul or of ideas. No longer is he delighted by pure beauty, but now is satisfied with imitation. The result is the sorry catastrophe of photographic effects which the Ecole des Beaux-Arts inflicts upon us daily and which profoundly blocks our aesthetic insight. What's more, elsewhere the vain words *humanity, vitality, reality*, borrowed from the vocabulary of an insane politics and too often echoed by licensed critics, in the end persuade a brutalized race that art is advanced by imitation. These prejudices, along with others which arise everywhere, whether in the bosom of the official school or in the coteries of young people hungry for glory, will all perish miserably, crushed by the very edifice that shelters them. We admit without hesitation that with regard to painting the obstruction is rather general. Everything points to the fact that the rising democracy will not be at all the salvation of refined minds which conserve under glass the flowers of a hoped-for spring through this wintry era. This democracy, skilled at distortion, will no doubt have enough street entertainers and charlatans to divert attention from the decadent style it holds so dear, decadence without charm, anemic, ignorant, and even disgustingly barbaric.

Thus among the great painters, Paul Cézanne can be called a mystic, because he teaches us lessons on art, because he sees things, not in themselves, but in their direct rapport with painting, or, through the concrete expression of their beauty. He is meditative, he sees aesthetically, not objectively. He expresses himself by sensitivity, or in other words, by the instinctive and sentimental perception of relationships and harmonies. And because in this way his work touches on music, we can repeat irrefutably

that he is a mystic, whose means are supreme, heaven's own art. All art which becomes musical is on the path to absolute perfection. In language it becomes poetry; in painting it becomes beauty.

The word beauty, used with respect to the work of Paul Cézanne, demands an explanation. I would, in this case, define it thus: *"the fullest development of the art employed."* In his portraits, for example, the master painter was hardly concerned with *choosing* a model. He painted the first willing person whom he found nearby: his wife, his son, and more often simple people, a ditch digger, a milkmaid, in preference to a dandy or to sophisticated people whom he hated for their corrupt taste and worldly duplicity.

Here there is no question, of course, of seeking beauty outside the very means of painting itself: lines, tones, colors, thick paint, style, presentation, character. We are certainly far from a conventional or material beauty, and a work of art will only be beautiful for us if we possess a very elevated sensibility, one capable of making us lose sight of the thing represented in order to enjoy it in the aesthetic sense. "The artist must study his subject, sense it clearly, and find a way to express himself forcefully and with elevation. Taste is the best judge, but it is rare. Art is accessible to only a very small number of individuals."[23] These are the master's own words, corroborated by his work; they express his preoccupations. Taste is that special sense (so little cultivated, alas!) to which he addresses himself exclusively.

The master cites tradition as a reference; he knows the Louvre better than any other painter. He has even, he tells us, studied old paintings too much. He recommends that we learn from the old masters their classical and serious method of composing their work intellectually. Nature, however, intervenes in the work of the artist and gives life to what reason alone would leave lifeless; so he counsels, above all, *to start from Nature.*

Of course the artist must be a theorist to be able to take control and guide his work to success; but he must be the theorist of his sensations, not only of his methods. Sensation requires that one's methods be constantly transformed, in order to be capable of intense expression. The artist should never try to force sensation into a preestablished method but instead must place his creative genius at the service of sensations. On the one hand you have the Ecole des Beaux-Arts which returns everyone to a uniform mold, while on the other, you have continuous regeneration. *To organize the sensations,* that is the first precept of Cézanne's doctrine, a doctrine not at all sensualist, but sensitive. The artist will gain in logic without losing expression; he can be surprising while remaining a *classicist through Nature.*

When you really think about it, this doctrine seems the sanest, the best, the least known. It enters into direct opposition to what *officials* have imposed and to what all those who have created "schools" (be they Impressionism, Symbolism, Divisionism, etc.) always tried to do. Some offered conventional methods, others scientific or personal systems; none of them led the procession toward safeguarding the profound study of and respect for Nature. For others, of course, it seemed appropriate to find the means to become something other than a pompous salon painter; and the Ecole des Beaux-Arts is currently more advanced on this road than the most revolutionary of earlier painters. None of its students, however, has realized that there is only one valid doctrine of art, that which tells the painter: *"Sense Nature, organize your perceptions, express yourself profoundly and with order; in other words, classically."*

At a time when we are overrun by those who waste canvas, by subtle daubers, from Mr. Carrière[24] who claims the right to identify with Velasquez, to charlatans who pretend to create a new art, the lesson of Paul Cézanne rises up like a possible deliverance for French painting.

This great artist is a humble man who has understood the ignorance and obstruction which have fallen upon his contemporaries. He has therefore closed his door in order to plunge himself into the absolute. He is uniquely possessed by the love of painting and his life is ruled by this tyrannical and blessed tenacity. He believes that work is sufficient in itself, and therefore he does not crave approval or praise. He detests the literary spirit which made so many harmful intrusions into painting and has distorted the simplest understanding. He knows only his canvas, his palette, his colors, and he certainly would never have let even the slightest study leave his studio if intelligent connoisseurs, however rare, had not carried it away, almost without his knowledge. Since the day Paul Cézanne closed his doors on the world, Mr. Ambroise Vollard, the sympathetic expert of the rue Laffitte, has satisfied our desire to know Cézanne's oeuvre more completely; he is still doing his best.*

Whatever the master thinks of his work, and he judges himself far too severely, it dominates all contemporary production, and imposes its vision by the essence and originality of its insight, the beauty of its substance, its serious and enduring character, and its decorative amplitude. It attracts us through its belief and its sound doctrine; it instills in us the clear truth

*Mr. Vollard is diligently preparing an illustrated catalogue of the work of Cézanne.[25]

which it proclaims and offers itself to us like a healing oasis in the midst of the current degeneration. While attaching itself to Gothic art by its refined sensitivity, it is modern; it is new; it is French; it is the work of a genius. Withdrawn from other painters, worldly people, sophisticates, plotters and poseurs of our miserable century, Cézanne lets only the smallest number of people approach him. The school of life has been so unrewarding that he dreads intrusion. The example he gives us is therefore double, that of a man and that of a master. A simple, regular life with everything arranged around his working hours, an eternally vigilant eye, a mind always in contemplation: that is Paul Cézanne. His frank, naive, honest, and precise painting reveals his artistic genius; his existence, devoid of vanity, reveals his goodness and human humility. What he hopes for is to prove by his work that he is sincere and that he is working for the highest art. Many contemporary glories, proud and stupid, will fall, while science will rise; then, as a Christian and an artist, he will witness the realization of these words of the Magnificat: *"The powerful will be deposed and the humble will be exalted."*

<div style="text-align:center">

Emile Bernard
(Written at Aix-en-Provence, March 1904.)

</div>

PAUL CÉZANNE
1904–06

*The correspondence with Bernard continues after the publication of the
L'Occident article, and after Bernard's second and final visit to Cézanne
in March 1905. Cézanne, it should be noted, is an entirely willing corre-
spondent, for, as he writes to his son on 22 September 1906 (having just
sent Bernard a letter "which shows the effects of my preoccupations"), "one
can, it is true, discuss theories endlessly with Bernard because he has the
temperament of a logician." It should not be assumed, as it sometimes is,
that Cézanne theorized only under pressure.*

Letters to Emile Bernard,
July 1904 to September 1906

Letter 5

My dear Bernard, Aix, 25 July 1904

I received *L'Occident.*—I can only say thank you for what you wrote
on my behalf.—

I am sorry that we can't be side by side, because I don't enjoy being
correct in theory but in view of nature. Ingres, in spite of his style (*estyle* as
we pronounce it in Aix), and his admirers, is only a very minor painter.
The greatest ones, and you know them better than I, are the Venetians and
the Spanish. —As far as making progress is concerned, only nature and an
eye trained by contact with nature are required. Everything becomes con-

45

centric by dint of looking and working.[1] What I mean is that in an orange, an apple, a ball, a head, there is a culminating point and this is always the one point closest to our eye.*[2] The edges of objects fade toward a center on the horizon.[3] With a little temperament a person can be very much a painter. One can make good things without being a great harmonist or colorist. It is sufficient to have a sense of art. And it is just this sense, without doubt, that terrifies the bourgeoisie. —Institutions, stipends, and honors are made only for idiots, pranksters, and rogues. Don't ever become an art critic! Only in making paintings can you find refuge.

> With warm regards from your old comrade.
> P. Cézanne

All my respects to Madame Bernard, and a fond hello to the children.

Letter 6

My dear Bernard, Aix, 23 December 1904

I received your good letter postmarked Naples. I don't agree with you on several aesthetic considerations. Yes, I approve your admiration for the greatest Venetians; we revere Tintoretto. Your need to find moral and intellectual support in the works of those masters who will certainly never be surpassed leaves you constantly on the alert, always in search of the way that will lead you surely to find in nature your means of expression, and when you find them, be assured, you will rediscover without effort and in nature the *means* used by the four or five great ones of Venice. —Here's what is indisputable—I am certain of this, an optical sensation occurs in our organ of vision which causes us to classify *by light*, half-tones and quarter-tones, the planes represented by color sensations.[4] Light, therefore, does not exist for the painter. As long as you go inevitably from Black to White, the first of these abstractions being like a support for the eye as much as for the brain, we get bogged down, we never achieve mastery, self-possession.[5] During this time period (I inevitably repeat myself a bit) we are drawn to the great works that come down to us through the ages, from which we take comfort, support, like a swimmer clinging to a board. —Everything you say in your letter is true. —I am happy to hear that Madame Bernard and the children are doing well. My wife and son are in Paris right now; I trust we'll be together again soon.

*In the margin next to these lines: "In spite of the terrible effects, light and shadow. Color sensations."

46

I hope I've responded as much as possible to the principal points in your fine letter, and I beg you to remember me with respect to Madame Bernard. Give a kiss to Antoine and Irene for me, and for you, my dear colleague, I wish you a good New Year and send you my cordial regards.

<div align="right">P. Cézanne</div>

Letter 7

My dear Bernard, Friday [Aix, 1905]

I'll answer briefly several key points in your last letter. As you write me, I actually seem to have achieved some slow progress in those last studies you saw here. It's nonetheless painful to have to say that any improvement which comes, with understanding nature from the point of view of the painted picture and the development of one's means of expression, is accompanied by age and the weakening of the body.

If the official salons remain so inferior, it's because they employ only more or less worn-out formulas. It would be better to include more personal emotion, observation, and character.

The Louvre is the book in which we learn to read. We must not, however, be satisfied with memorizing the attractive formulas of our predecessors.[6] We must leave the museum to study Nature in all its beauty. We must try to grasp its spirit; we must seek to express ourselves according to our personal temperament.

Time and contemplation gradually modify our vision, however, and, in the end, we receive understanding.

In this rainy season it is impossible to practice these theories out of doors, however correct they may be. —But perseverance leads us to perceive interiors like everything else. Only old rubbish blocks our intelligence, which needs to be shaken up occasionally.

All the best to you, and my respects to Madame Bernard. Remember me warmly to the children.

<div align="right">P. Cézanne</div>

You will understand me better when we see each other again. Study modifies our vision so much that the humble and colossal Pissarro seems justified in his anarchistic ideas.[7]

Go ahead and draw, but remember, it is reflected light that is enveloping. Lighting by reflection in general: *that* gives the envelope.[8]

<div align="right">P. Cézanne</div>

Letter 8

My dear Bernard, Aix, 23 October 1905

Your letters are dear to me from two points of view, the first purely egotistical, because their arrival breaks up the monotony brought on by my eternal pursuit of my one and only goal. This search leads, in moments of physical fatigue, to a kind of intellectual exhaustion. The second permits me to dwell, probably a little too much, on the obstinacy with which I pursue the realization of that part of nature that, spread out before our eyes, gives us the painting. Now, the thesis to be developed is—whatever our temperament or powers in the presence of nature, to re-create the image of what we see, forgetting everything that has gone before.[9] This, I believe, should allow the artist to paint his full personality, whether great or small. —Now old as I am, nearly 70, —color sensations, which make light in my painting, create abstractions[10] that keep me from covering my canvas or defining the edges of objects where they delicately touch other objects, with the result that my image or picture is incomplete.

On the other hand, planes fall one atop the other, and this makes neo-impressionism which outlines forms with a dark line, a defect that must be resisted with all our might.[11] Using nature as our reference gives us the means of reaching our goal. —I do remember that you were at Tonnerre, but difficulties in getting from one place to another force me to depend entirely on the arrangements of my family,* who are concerned with their own convenience and tend to forget about me a bit.—

But at my age that's life; I should be more experienced and use my experience for the general good. I owe you the truth in painting and I shall give it to you.

Please give all my respects to Madame Bernard and the children whom I love. St. Vincent de Paul is the one to whom I should appeal for help.

Your old friend,
Paul Cézanne

Warmest regards and have courage.
—The point of view developing in us, through study, teaches us to see.

*Cézanne originally had written: "but difficulties in moving about made me depend"

Letter 9

My dear Bernard, Aix, 21 September 1906

I find myself in such a state of mental distress, so greatly troubled, I have feared that any minute my feeble reason will fail. After the great heat we have just suffered, milder temperatures brought a little calm to my spirits, and not a moment too soon. Now I think I see better and think more clearly about the general direction of my studies. Will I ever reach what I have so diligently searched for and what I have so long pursued? —I hope so, but as long as I haven't reached it, a vague state of malaise haunts me, and it will only disappear the day I have reached port, that is, when I see things developing better than in the past, and through that becoming theoretically convincing—theories themselves are always easy. All I'll have left to do is prove my theories, and that presents some serious obstacles. So, I continue my studies,—but I have just reread your letter and I see that I have not answered everything. You must excuse me; it is, as I have said, this constant preoccupation with my goal which is the cause.

I still make studies from nature, and it seems that I am making slow progress. I would enjoy having you here with me, because my solitude weighs upon me somewhat. But I am old, sick, and I have sworn to die painting rather than to sink into that degrading senility which menaces most old people, who fall prey to the mind-devouring passions that destroy their reason. —If I have the good fortune to visit with you one day, we'll be able to explain ourselves better in person. Please excuse me for constantly returning to the same subject, but I believe in the logical development of what we see and feel through studying nature, free from preoccupation with methods, methods being only simple means for us to make the public feel what we feel and to make ourselves accepted. The masters whom we admire probably did no more.

Warm remembrances from the stubborn long-lived one who sends his cordial greetings.

P. Cézanne[12]

EMILE BERNARD
1904–06

The Souvenirs, *published in two parts in the* Mercure de France *on the 1st and 16th of October 1907, form the definitive account of the visits of 1904 and 1905.*

As first published, they included the nine letters to Bernard which are reprinted earlier in this compilation, and which are therefore on this occasion omitted from the main text.

There seem to be no significant differences, as far as the main text of the Souvenirs *is concerned, between the* Mercure de France *version, used here, and later publications in separate volumes (in 1912 by the Société des Trente, in 1921 by La Rénovation Esthétique, and in 1925 or 1926 by R. G. Michel). However, although the 1912 version simply follows the* Mercure de France *text, the 1921 volume adds a sentimental passage entitled* Quinze ans après *[Fifteen years later], and the R. G. Michel edition further appends the* Mercure de France *article of 1921, "Une conversation avec Cézanne." We have not reprinted these addenda here, though excerpts from* Une conversation . . . *are given later.*

It should be noted that the text remains unrevised throughout the editions I have listed, and the apparent error "25 rue Boulegon" and the false date of death are found in all versions I have examined.

In spite of its errors, this text is a highly important source for the biography of Cézanne, for many utterances ascribed to him and not found elsewhere, and for valuable information about his technical procedures.

"Memories of Paul Cézanne" (*Mercure de France*)

The writer of these lines was an ardent admirer of Paul Cézanne for twenty years of his life. When ignorance, malevolence, and spite, hostile laughter or deep silence surrounded the works of this artist, whom the writer called his master, he studied passionately the then rare paintings which could be seen in a little boutique on rue Clauzel in Paris. He was far in advance of the resounding success which, since that time, has made even Paul Cézanne's slightest studies objects of special interest. He was annoyed with the silence of the critics, with the contempt of his friends, and the ignorance of the painters, that is, with his contemporaries.

Today everything has changed and the little article that this writer published in *Hommes d'aujourd'hui* ("Paul Cézanne," with portrait drawing by Camille Pissaro) around 1889 and which was one of the first homages of the time to his master, to his teacher from the beginning, seems a meager offering to the painter whose influence has multiplied and grown. At that time it was very difficult to see Cézanne's paintings, and as far as seeing him in person, he seemed absolutely inaccessible, lost in the distant haze of the southern sun in Aix. Everything we knew about him had been told to us by père Tanguy, the kind and generous shopkeeper from Brittany whose store held the only cache, in those long-gone days, of the *painting of the future*. So the passionate pupil who writes here had no fantastic plans to risk exposing his ignorance and his modest person to the master whose works proclaimed their superiority and greatness. At least, then, that is what he thought. His first intent was none other than to continue his absolute admiration which left him intolerant of all other contemporary works and which he calls with pleasure his first initiator. Also it was only twenty years later in 1904, when, returning from Egypt and needing to spend some time in Marseilles, he thought about its proximity to Aix, and went there, hoping to accomplish at last the visit planned so long ago but never made because of timidity and, it must be said, poverty.

Today Cézanne is dead and his pupil has added a few years. Nearing forty and after many exhausting attempts to discover the best art, he finds himself less a novice, less innocently convinced about what he used to admire. He believes above all in a complete, traditional art, disdaining bizarre pursuits. He sets his sights on life, on the realization of truth, because he knows, from having seen Michelangelo, Raphael, Titian, Rubens, and Rembrandt in all their majesty, that art is an invented imitation of nature.

He knows that only beneath life the soul lives and that all theories, all

abstractions slowly dry up the artist just as surely as does manual ability or exercise without inspiration. Supported by the eternal methods from the very beginnings of art, he is suspicious of paradoxes and mental games, however clever, which can only serve to subvert our ancestral patrimony.

To realize, that is everything. And it was Cézanne who told the writer this, when Italy, Flanders, and Spain had already thoroughly convinced him. His oeuvre, in fact, depends not upon its intentions, but upon its realization. The writer's goal here is not to analyze the entire oeuvre of Paul Cézanne or even to pronounce a verdict for or against it as, alas, it is often our misfortune to hear from pitiable painters. The respect the writer bears for the memory of his old master does not allow him to do so. What the student admired in the master is the astonishing gift of originality, of the power of the ensemble, of his chromatic harmony, of his style. He continues to look at him with pleasure and as an enthralling revelation. What he believes himself authorized to speak on is the rather distorted influence that this work exerted in the day of its success. He will endeavor to prove that the great number of imitators, who thought they could call him master, neither knew nor were able to penetrate the wisdom of the painter and their error, to a great extent, caused the failure of what this movement could have had that was honest, renewing, and beneficent, and makes the original seem stripped of the qualities which he possessed to such a high degree. Bringing to light Cézanne's ideas will promote knowledge and will safeguard his contribution at least, while condemning the monstrous image from which he suffered at the hands of those who were rather his enemies than his friends.

And also the author of these memories hopes to tell, through an almost daily journal, of an existence shared with Paul Cézanne during one month, and to reveal the man whose face remains so hidden or so distorted by those who—on rare occasions—approached him. Without pretending to tell everything, he hopes to say many things, because this was a heart which he knew, a nature which he loved. Whatever his affection, today even greater perhaps for the man than for the artist, he will depict his uneven, bizarre, tormented character, whose base was goodness, and which was dominated in the end by misanthropy, as so often happens to those who encounter only malice, self-interest, and spite in this world.

I. OUR ARRIVAL IN AIX

After a beautiful crossing, we arrived in Marseilles in February 1904. This city was flooded with such sunlight that we almost believed that we were

still in Egypt, from where we had just come. I kept thinking we should stay at least a month in the south and wait until the cold weather had abated before going up north. We were in a restaurant eating an exquisite bouillabaisse, the glory of the area, when the waiter told us, I have no idea why, that an electric tram had just been installed between Aix and Marseilles. The name of Aix awoke in me the memory of my old master, the painter of whom I knew only the work and from whom my first attempts in the world of art drew their lessons. Having learned that it was only a two-hour trip from Marseilles to Aix, I resolved to devote the following day to a visit to Paul Cézanne.

The next morning at 7 A.M., carrying the article I had published in *Hommes d'aujourd'hui* for the editor Vanier around 1889, I boarded the famous tram and took my seat for Aix. I was filled with great apprehension; I didn't know Paul Cézanne's address and I didn't know anyone who did know it. It is true that I had thought that a painter who was practically a celebrity in Paris would be fairly well known in his own country; but I had in vain already asked several people in Marseilles, showing my article with a portrait of Paul Cézanne by Camille Pissarro. People returned my paper and always the answer was negative. Then I realized that it might not be a source of pride to know the person or even to know the name of that character dressed as a peasant with such a forbidding look on his face.

No one in the tram from Marseilles to Aix could answer my questions; they were all the same. "You live in Aix? For a long time?" Then summoning up all my courage; "Do you know a great painter, famous in Paris today, the glory of his city: Paul Cézanne?" But the answer, after an appraisal of the ceiling of the car by the eyes of the person being questioned, remained negative. Even the conductor had absolutely no knowledge of the name of Paul Cézanne and was incapable of giving me any information, even though I provided him with copious explanations and showed him at length the portrait by Pissarro. So, upon arriving at my destination, I decided simply to ask the way to the cathedral.

The small city of Aix made an excellent impression on me with its broad promenade planted with beautiful trees, its fountains with warm water spilling out into mossy basins, its houses with classical caryatids, its silent and aristocratic façades. It seemed that the soul of my old master hovered over it in an atmosphere of pleasant privacy. Through twisting lanes, at a place in front of the city hall and its bell tower, I arrived at the cathedral. There saints of a homely naïveté, which hid a profession of faith, made me think immediately of Cézanne. They resembled a reflection of

that simple goodness found in his portraits of common people. I do not know why, but these saints almost made me feel his presence. But since I did not find him there in person, I began once more to question the few pedestrians whose lonely, rhythmic footsteps disturbed this quiet place. The answers continued to be negative. Even in Aix nobody knew or even seemed to know of Paul Cézanne. I was already in despair when a worker came to stand under the entry vault I was contemplating, and, like me, to consult the old naively grotesque saints of the doorway. I asked him, but he could answer me no differently from the others; then, upon thinking about it, he said, "As a last resort you could go to city hall. If this man is on the list of voters, you can get his address." Knowing nothing of administrative procedures, I had never thought of this simple step. I thanked this intelligent passer-by and went straight to the Aix city hall. It was just a few steps away; I had walked past it on my way to the cathedral. There I immediately learned that "Monsieur Paul Cézanne was born in Aix-en-Provence on January 19, 1839, and he lived at 25 rue Boulegon."[1]

I went to that address right away. It was a very plain-looking house with a studio on the top. Doorbells hung on both sides of the entrance and on a plaque was the name: PAUL CÉZANNE. Here it was! At last, twenty years of desire were about to be satisfied! Cautiously I rang the bell and the door opened all by itself. I found myself standing in a cheerful foyer looking out onto a sunny garden with ivy-covered walls. There was a wide staircase in front of me and I began to walk up. I had taken only a few steps when an old man came down the stairs, walking directly toward me. He was wearing a full cape and carrying some kind of notebook at his side. He was stooped over and walked heavily and painfully. When I was close to him, believing that this was my old master but unsure of his likeness to Pissarro's portrait, I asked him, "Mr. Paul Cézanne, please?" He took a step backward, stood still, and bowed, sweeping his hat almost to the floor. Revealing his bald forehead and his face of an old general, he said, "I am he; what can I do for you?"

I explained the reason for my visit and told him of my long and profound admiration, my desire to get to know him, how difficult it had been for me to come here to meet him, and finally my arrival from Cairo. He seemed very surprised at all that and said, "So, you are a colleague?" In view of his age and the talent standing there before me, I had to refuse the title of colleague. "Let's have none of that," he said, "you are a painter, aren't you? Therefore you are my colleague." His tone was very gentle but firm; moreover, his southern accent made the syllables of his words stand

out strangely, giving something amusing to his paternal kindness. After asking my name again, he cried, "Oh! So you are Emile Bernard! You wrote about me. Do you write biographies? My friend Paul Alexis[2] sent me your article a long time ago . . . Signac[3] had given it to him. When I asked about you, he told me, 'He's a man who writes biographies.' But you're a painter, aren't you?" (That's how well-meaning colleagues can create a peculiar reputation for you.) I did not say anything about that though Cézanne was soon to learn the unique truth: that I was his most fervent admirer, his most ardent defender, and—what's more—what interested him the most, that I considered myself his pupil.

However, this entire conversation took place on the stairs and my old master seemed to be about to go out to work. I told him how much I had hoped to spend several hours with him and asked his permission to walk with him. "I was going to my motif," he told me, "let's go together."

Boys in the streets made fun of him and threw rocks at him. I shooed them away. To these kids Cézanne looked like an old thief, which left him open to their taunts. He must have looked to them like the bogeyman. I suffered later from the mean tricks that these little kids in Aix scattered in his path and from their mischievousness.

We walked a long time, conversing:

"So, you aren't a writer of biographies? You are a painter!" He was having trouble persuading himself, because he had believed for twenty years that I worked as a biographer. We left the city after having walked past the cathedral where I told him, "These saints made me think of you." "Yes," he answered, "I like them a lot. An old, local stonecutter made them a long time ago. He's dead now." At the top of a hill, a new house appeared, its façade topped with a Greek pediment.

"There's my studio," he told me mysteriously. "No one goes there but me; but because you are a friend, we'll go there together." He opened the wooden door and we entered a garden which sloped down to a creek, with dusty olive trees and some pines beyond. He took a key out from under a big stone and opened the new, silent house which seemed to be baking in the sun. To the immediate right off the hall was a wide-open room with an antique screen that drew my attention. "I often used to play in this screen[4] with Zola," he told me. "Look, we even ruined these flowers." The screen was an assemblage of panels painted with pastoral scenes, large leaves and scattered blossoms. But the hand that decorated this furnishing was skilled, almost Italian. "Now that's painting," Cézanne said. "It's no more difficult than that. Everything you need to know is there,

everything." On the mantel was the beginning of a bust in red clay meant to represent Cézanne. "Solari[5] did that, a poor devil of a sculptor and a lifelong friend. I always told him he really screwed up by going to his Ecole des Beaux-Arts. He begged me to let him do the bust. I told him, 'You know that I can't stand to pose. If you want, you can come to the room on the first floor; I work upstairs. When you see me, you can observe, then do your work.' He ended up by losing interest in this piece of garbage; it's depressing." Then he took the little bust out into the garden. There, kicking it into large paving stone, he cried, "It's stupid after all!" and he broke it. After leaving his foot, the unfinished likeness rolled on the pebbles, under the olive trees, and there it stayed, disintegrating under the sun, all the rest of the time I was in Aix.

We did not go up to the studio. Cézanne picked up a box in the hall and took me to his motif. It was two kilometers away with a view over a valley at the foot of Sainte-Victoire, the craggy mountain which he never ceased to paint in watercolor and in oils. He was filled with admiration for this mountain. "And to think that pig Menier came here and wanted to make soap for the entire world from it!" With this thought he began to expound on his opinions on the contemporary world, industry, and everything else. "Things aren't going well," he whispered with a furious look. "Life is terrifying!"

I left him at his motif, in order not to disturb his work, and I returned to Aix to have lunch. When I came to meet him again it was four in the afternoon. After taking his box back to the house, he wanted to accompany me to the tram and made me promise to come back the next day to lunch with him. I was all the more pleased to do it because I had the feeling that my old master had become my friend.

II. GETTING SETTLED IN AIX

The next day I arrived in Aix very early, planning to find room and board with a local family for a month. I visited several places and chose a beautiful room with antique charm. There was a very large fireplace, some eighteenth-century paneling, and an armoire full of dishes that one could investigate by climbing on a ladder. I had a mental picture, every time the armoire was open, of an engraving of the time of Louis XV. I envisioned an elegant maid, such as the painters drew back then, standing in this high door with its intricate ormolu, among the fine porcelain compotes and thin, transparent plates. Quite satisfied, I signed a contract and left Madame de S. who had agreed to rent to me. While waiting for eleven o'clock I went to

the museum, which was closed, and I again took the road up to the cathedral to visit the interior. I was thrilled by the Flemish tapestries that decorated the choir. The great cabinets containing Nicholas Froment's precious pictures were closed. I also noticed an altar crowned by a Gothic group including the mythical dragon Tarasque, and also a very fine baptistry.[6]

At eleven o'clock, I rang the bell at the rue Boulegon again. When the door opened, a pleasant-looking, rather plump woman of about forty leaned over the bannister and called for me to come up as soon as she heard my name. The modest apartment was on the third floor. The room where Cézanne was waiting for me was small, covered with old-fashioned wallpaper, and nearly completely taken up by a table and a little wood-burning stove. Hardly had I entered when Cézanne said, "Madame Brémond, please serve lunch." Then the woman who had asked me in began to bring the meal. We resumed our conversation of the day before, and I was able to get a better look at my master and felt more at ease. He seemed very tired for his age and was ill with diabetes. He had to avoid many foods and had to take medicine and follow a diet. His eyes were swollen and red, his features puffy, and his nose slightly purple. We talked about Zola, who had become the man of the hour with his Dreyfus[7] affair. "He had a rather mediocre mind," Cézanne told me, "and was a detestable friend. He was totally self-centered and that's why L'Oeuvre,[8] in which he allegedly portrayed me, is nothing but a hideous distortion, a fiction he created to glorify himself. When I went to Paris to do my pictures of Saint Sulpice—I was so naive that I didn't have greater ambitions and had been raised in the Church—I met up with Zola again. He had been my classmate in secondary school and we played along the banks of the Arc and he wrote poems. I wrote them too, some in French, some in Latin. I was much better than he in Latin and composed a complete play in that language.[9] In those days we studied classics seriously." Our conversation turned to the shortcomings of modern education; then, after quoting Horace, Virgil, and Lucretius, Cézanne returned to his story. "So, when I arrived in Paris, Zola, who had dedicated La Confession de Claude[10] to me and to Baïl,[11] a classmate who died, introduced me to Manet. I was quite taken with this painter and his warm reception, but I was naturally too timid to visit him often. Gradually, Zola, as his reputation grew, became unfriendly and acted rather patronizingly toward me, so much so that I hated to be with him. I went for many years without seeing him. One fine day I received L'Oeuvre. It was a real blow to me to see his innermost feelings about me. When all is said and done, it's a very bad book and

completely false." Cézanne poured himself and me some wine. Conversation turned to drink. "You know, wine has greatly harmed many of us. My colleague Daumier drank a lot. What a great master he would have been if he could have done without it!"

After lunch we went to his studio outside of town. He finally showed me some of his paintings in the room where he worked. It was a large room, painted in gray tempera and facing north with a big window about waist high. It seemed to me that this light would be a problem because it reflected off some trees and a rock onto everything he painted. He told me, "You can't get anybody to do anything right. I had this built here at my expense and the architect never wanted to do what I asked.[12] I am a shy person, a bohemian," he exclaimed, "no one gives a damn about what I want. I'm too weak to fight back. I should be a hermit. At least that way, no one could get their hooks into me." And saying this, he mimicked a hook with his old hand and his clenched fingers.

He was working on a painting of three skulls on an oriental rug.[13] He had been working on it for a month from six until ten-thirty every morning, returning to Aix to have lunch, and then coming back to paint again at his motif until five o'clock. Then he had supper and went immediately to bed. At times I saw him so exhausted from work that he could no longer talk or listen. He went to bed in a disturbing coma-like condition but the next day he had always come out of it.

"What I am missing here," he told me about his three skulls, "is realization. Maybe I'll work it out, but I'm old and I might die without ever having attained this supreme goal: To realize! like the Venetians." Then he took up the idea that he would often mention later: "I would like to be received at the salon of Bouguereau. I know very well what the obstacle would be; it's that I do not achieve enough realization. The perspective isn't there." Certainly he could only detest the master of the fashionable studios. But he expressed with perfect accuracy, that originality is not an obstacle to the understanding of an artist, but the imperfection of his work is. Obviously, the great masters never lacked originality and their skill was all the more perfect because it was more personal. The great pitfall of art is the exact balance of imitation and originality. Imitation satisfies everybody, while originality alone, without imitation, remains a lifeless curiosity, only embraced by a few artists. The main point is the tight bond between nature, individual creation, and the principles of art.

Cézanne's was an intelligence passionate about the new; his style was his alone. Although he was not aware of the fact, his logic complicated his

ability to work to such an extent that it became extremely painful for him at times, even paralyzing. His nature was freer than he thought, and he became enslaved to research. He had no conception of beauty; he possessed only the idea of truth. He insisted on the necessity of an "optic" and a "logic." He had such determination in that brain of his that it eventually curbed his spontaneity, and he believed that he no longer had the power to create. But this was not true. Too gifted, he went too deeply into contemplation and reasoning to be able to work. But if he had worked without such great concern for what would be best, he would never have reached the absolute; he might not have suffered so much, but neither would he have given us works of such grandeur.

I saw him agonize this way over the painting of the skulls, which I believe is part of his great testament, during the entire month I was in Aix. The colors and shapes in this painting changed almost every day, and each day when I arrived at his studio, it could have been taken from the easel and considered a finished work of art. In truth, his method of study was a meditation with a brush in his hand.

On the mechanical easel which he had just had installed, there was a large canvas of female nude bathers. It was in a complete state of chaos. The drawing appeared rather distorted to me. I asked Cézanne why he did not use models for his nudes. He told me that, at his age, it would be improper for him to ask a woman to disrobe so that he could paint her, that he might allow himself to ask a woman of around fifty years of age to pose nude for him, but he was fairly certain that he would not find a woman in Aix who would do it. He looked into some boxes and showed me drawings that he made when he was young at the Atelier Suisse in Paris.[14] "I've always used these drawings," he told me. "They hardly suffice, but at my age I've got to make do." I surmised that he felt constrained by extreme modesty and that this problem had two causes: one, that he was not sure of himself around women, and the other was that he had religious scruples and the firm conviction that these things just were not done without causing a scandal in a small provincial town like Aix. On the wall of his studio I noticed, among several landscapes which were drying without their stretchers, a painting of green apples on a board (What young painter has not painted copies of those apples?); a photograph of Thomas Couture's *l'Orgie Romaine* [Romans of the Decadence], a little painting by Eugène Delacroix, *Agar dans le desert* [Hagar in the Desert]; a Daumier drawing; and one by Forain.[15] We talked about Couture. I was surprised that Cézanne was a great admirer of this painter. I learned later that he was cor-

rect, that Couture was a great master because he had trained such excellent students: Courbet, Manet, and Puvis. What he liked about him was that famous "realization" which I would hear him talk about for a month.

Our conversation turned to the Louvre and to the Venetians. His admiration for them was absolute. He was even more passionate about Veronese than about Titian. I was surprised to learn that he liked the primitives less.[16] In any case he concluded that however great a book the Louvre was, it was better to return to the study of nature. That day again, he worked on his watercolor of Mont Sainte-Victoire; I stayed with him. His method[17] was unique, excessively complicated, and absolutely unrelated to usual procedures. He began with a stroke of umber which he covered by a second stroke which extended beyond the first, then a third, until all these colors, like folding screens, modeled and at the same time colored the object.

I then understood that laws of harmony guided his work and that all these modulations had a goal, determined in advance in his mind. He worked, in fact, the way early tapestry-makers must have worked, arranging related colors in a sequence until they met their contrasting color opposites. But then I felt that to apply a similar procedure to nature would be contradictory, since all rules of reason bend more freely and more easily to a creation than to nature itself. One would have to follow nature with the innocence of a child, have no preconceived ideas, act without deliberation, and observe and study nature, nothing more. Well, his method was nothing at all like that. Generalizing some rules, he drew from them the principles that he applied by a kind of convention, so that he only interpreted what he saw, he did not copy it. His vision was centered much more in his brain, therefore, than in his eye. I had noticed all this in his canvases for years, but being in the landscape with him, I was able to confirm what I had thought. In short, what he created came completely from his genius. If he had had a creative imagination, he could have painted without going to his motif or arranging a still life to look at. But he lacked this imagination which distinguished the old masters. His great power lay in his intelligence working in concert with his taste.

"I rented a room in Aix for a month," I told him while he carefully and thoughtfully applied a wash to his watercolor. "Oh, where?" he asked. "In the home of Madame de S . . . in rue du Théâtre." As it happened, they were friends. He said how much he admired her house.

That evening my dear master accompanied me to the tram to Marseilles. It was dinner time and Madame Brémond, his housekeeper, must have been impatient for him to return. I promised him that I would come

to see him as soon as we were settled, "because," I told him, "I am coming above all on account of you." He shook my hand and went off to his supper. As the train pulled away, I could still see him turning a corner, his cape blowing in the wind.

III. LIFE TOGETHER IN THE STUDIO AND AT HOME

Two days later we moved into the apartment I had rented from Madame de S. . . . Cézanne invited us to his house as soon as we arrived and offered me the lower room at his studio in the country, the room with the screen. I was afraid of disturbing him, so I did not accept. One afternoon when he had taken me to his studio, I noticed that after he had placed his canvas on the easel and prepared his palette, he waited for me to leave. And when I said, "I must be bothering you," he answered, " I have never been able to tolerate anyone watching me paint; I can't bear to do anything in front of anyone."[18] Then he told me stories of unusual local events. When people who had once scoffed at him learned of his success in Paris from the papers, they tried to cultivate his friendship, to become part of his life, even part of his work. "They believe," he told me with a frightening look in his eyes, "that I have a gimmick and they want to swipe it from me,[19] but I have shown them all the door. And not once, not a single one," (and he became more and more furious) "was ever able to get his claws into me."

To watch my master at work was, of course, one of my greatest desires, but I did not insist on it. I left, sensitive to his aversion to being watched. I had come to Aix to honor Paul Cézanne after twenty years of admiration. I wanted to be very careful that he never doubt the sincerity of my visit. For that reason I did not immediately go to work in the room he offered me. I had set up a little still life in my room and worked very hard on it. Cézanne knew what I was doing and wanted to come see it. He was so convinced of what Paul Alexis had said about me on the word of that little pointiste [sic] Signac, that he could still not believe that I was a painter. He wanted to make sure that I was not a biographer, so one day around noon, he came to the house of Madame de S . . . He seemed surprised that I knew how to draw and paint. His first exclamation was that what I was doing was the work of a painter. "You are a painter," he told me with his Provençal accent. Finding several things in my painting which he disliked, he asked me to give him my palette and brushes so he could retouch it. I was very curious about his corrections which were sure to be a revelation to me about his method. When I brought him my palette, which had only four colors and white on it, he asked me, "You paint only with that?"

"Yes." "Where is your Naples yellow? Where is your peach black, your sienna, your cobalt blue, your burnt crimson lake? . . . It is impossible to paint without those colors." It was useless to answer. Cézanne was absolutely adamant. I had only chrome yellow, vermillion, ultramarine blue, madder lake, and lead white; and he named about twenty colors which I had never used. I understood then that Cézanne, instead of mixing many colors, had a set array for his palette,[20] every gradation of color, and that he applied them directly. Also, he was confused by the simple composition that covered my drawing board. He became so irate that my poorly balanced easel succumbed to his furious brush strokes and the painting fell to the floor. The carpet was covered with the colors which had been whipped into a froth with the old master's angry corrections. "You can't work here; it's impossible! You absolutely must come to my studio, to the lower room. I'll expect you this very afternoon."

A little still life by Cézanne which I had bought in Paris at least fifteen years earlier hung on my wall. I showed it to him. "It's terrible," he said. "But it's yours," I replied, "and I find it very fine." "So that's what they like in Paris today? Well, all the rest really must be awful." Cézanne did not like to talk about himself with others. One day I remember I had received a catalogue of an exhibition in Belgium of about twenty of his pictures.[21] He did not even look at it and began to talk about something else. He had absolutely no airs about him, only the belief that the art he produced up to that time was just the beginning of the art that he would create if he lived long enough. "I progress every day," he told me. "And that's all that matters."

I was often confused by what he showed me as proof of his progress, because I sometimes found it inferior to what I had seen of his earlier work. He had his own ideal, however, and without doubt he knew exactly what he meant about his progress. All he needed to do to justify himself would be to finish his paintings, and since he worked very slowly, many paintings were never completed. In a garret attached to the studio on top of his house in the rue Boulegon I saw many landscapes which were neither sketches nor studies but only bare beginnings of color arrays which had been left unfinished. Thus there were quantities of scenes where the canvas was not completely covered. People were wrong to judge Cézanne by his beginnings; even he abandoned them. I became aware of the slow pace of his work once he installed me in his studio in the country. While I was working on a still life which he had arranged for me in the lower room, I could hear him walking back and forth in his studio above. It was

a sort of meditative pacing from one end of the room to the other. He frequently came downstairs, going into the garden to sit down and then rushing back upstairs. I often came upon him in the garden looking very discouraged. He would tell me that something had made him stop. So we would look out before us at Aix, in the sun, with its church tower rising toward the sky. We talked about atmosphere, color, the Impressionists, problems that tormented him, color transitions.

Once I said, "Color transitions originate in reflections;[22] all objects share in the shadowy edges of their neighbors." He found my definition so good that he said, "You know how to see; you'll go far." I was terribly pleased with those words coming from the man I had always acknowledged as my master. About the Impressionists, he said, "Pissarro was close to nature. Renoir painted the Parisian woman. Monet gave us a new way of seeing. Everything else is worthless." He told me a lot of negative things about Gauguin, whose influence he viewed as disastrous. "Gauguin loved your painting," I told him, "he imitated you a lot." "Well, yes! But he didn't understand me," he replied furiously. "I'll never understand his lack of modeling and modulation; it's nonsense! Gauguin wasn't a painter. All he did was make Chinese pictures."[23] Then he explained to me all his ideas[24] on form, color, art, the training of artists: "everything in nature is modeled according to the sphere, the cone, and the cylinder. You have to learn to paint with reference to these simple shapes; then you can do everything you want." He continued, "Drawing and color aren't distinct from one another. Gradually as one paints, one draws; the more harmonious the colors, the more exact the drawing becomes. When color is at its richest, form is at its fullest. The secret of drawing and modeling lies in contrasts and color relationships." He stressed this idea, saying, "The artist has to be a laborer in his art and know early on what are his means of representation. He becomes a painter by virtue of painting. He must use coarse materials."

When I asked him about the Impressionists, I could tell that he tried, out of friendship, not to say anything bad. (How very differently they had behaved toward him!) He believed, however, that one had to go further than they had. "You must become classical again through nature, or, in other words, through sensation," he said. As for critics, how often did I see him attack them. "Most of them are failed writers with no talent at all, and they exist only to tear down people with the talent or genius they lack. They use expressions which have absolutely no meaning. Writers express themselves in abstractions while the painter renders his sensations, his perceptions visible by means of drawing and color." The two means of

expression—writing and painting—being different, it follows that the artist is incomprehensible to the writer, especially in the essence of the qualities that painting involves. He concluded by telling me that "the artist must work without worrying about anyone's opinion and become strong in his art; all the rest isn't worth the word of Cambronne!"

With this last exclamation, he raised his head proudly. I guessed that he had followed his own advice so scrupulously that critics never even reviewed him at all. But he needed attention, after all, for his name at last to have become known and for a market, with its ups and downs, to develop for his paintings. Thus, one way or another, talent gained its place. He was completely unconcerned with all that; he did not even want to be involved in it. An intermediary[25] handled this function, for which he had no aptitude at all. He never thought that his paintings would sell, even far in the future. "My father, who was intelligent and good-hearted, said to himself: 'My son is an artist who will die in misery. I'm going to work for him,' and my father left me enough to live on and paint until I die. He was a hat-maker who coiffed all the aristocracy of Aix, earned everyone's trust, became a banker, and made a quick fortune because he was honest and everyone came to him. When he died, he left me and my two sisters each a respectable income." Thinking about his father brought tears to Cézanne's eyes. When he was young, he thought his father was severe, but in the end he understood the generous wisdom that guided him.

After these conversations we would go back inside to work or back to Aix together to have lunch or dinner. On Sundays we all went to mass. He sat in the church elders' pew and followed the service attentively. As soon as he arrived in the little cloister in front of the church, he was besieged by beggars. He knew them and he never neglected them. He collected all his large coins before leaving home, and gave them out by the handful as he walked into the church. "I'm going to take my helping of the Middle Ages," he would whisper to me near the font. He found the liturgical chants and the unfolding of the episcopal ceremony pleasing; they reminded him of his very pious childhood and also of the awakening of art within him. However, his presence in the church was not only an artistic pleasure. He was a believer and abstained from working the entire day. He also went to vespers. Keeping the Sabbath elated him, so he invited us all to his house. "Madame Brémond, make us a good lunch today," he said to his housekeeper. I can say without exaggeration that Cézanne was thoughtful of others and had a rare generosity; he forgot all about himself.

He was so absentminded that he would walk through the streets with

his vest open. On Sundays he went to mass dressed as well as possible, but he often seemed to have tied on his shirt collar, having lost the collar stud. In spite of a quick brushing, his hat always had several artistic dents and there were always paint smears on his coat. At table he was very cheerful. He possessed a heartfelt gaiety I had never suspected, almost of another era in its unrestrained geniality. At these times, I came to know the man, not the painter, and could see all of his goodness.

At other times he came home with me in the evening; it was a pleasure for us to receive him as best I could. During dinner he often stopped eating to say, "This reminds me of my youth,[26] of my life in Paris," and if anyone played the piano, he would cry, "It's just like in '57. I am young again. Oh! The artist's life in those days!" In fact, music meant nothing to Cézanne. Earlier he had shown a taste for Wagner, whose name remained pleasantly nostalgic for him; but he failed to discern anything in his music other than stately or lively noise. He never took the time to take up anything else besides painting. "Until I was forty I lived the artist's bohemian life; I threw away my life. It was only later, when I knew Pissarro, who worked tirelessly, that an appetite for work came to me." And it came so forcefully it was as if he had fallen into an abyss that swallowed him up. The day of his mother's funeral, he could not follow the procession because he had to go paint. And yet, no one had loved her or wept for her more than he. One evening I spoke to him of Le chef d'oeuvre inconnu [The Unknown Masterpiece] and of Frenhofer,[27] the hero of Balzac's tragedy. He got up from the table, stood before me, and, striking his chest with his index finger, he admitted wordlessly by this repeated gesture that he was the very character in the novel. He was so moved by this feeling that tears filled his eyes. Someone who had lived earlier, but whose soul was prophetical, had understood him. Oh, there was a great distance between this Frenhofer, who was blocked by his very genius, and Zola's Claude, born without talent, whom Zola had unhappily seen in Cézanne himself. When I later wrote on Cézanne for L'Occident* I used as an epigraph Balzac's phrase, which sums up Cézanne and identifies him with Balzac's hero, "Frenhofer is a man passionate about our art who sees higher and further than the other painters."

It could be said that Cézanne was the personification of painting, because there was not a minute in the day when he did not think of himself with brush in hand. At the table he stopped constantly to consider our

*See the issue of July 1904 [and above].

faces under the lamplight and in shadow. Every plate, every platter, every piece of fruit, every glass, every object around him became the subject of his observation and contemplation.[28] "What a sly devil was old Chardin with his visor,"[29] he remarked. Then he put his index finger between his eyes and stammered, "Yes, like that I have a clear vision of the planes." Planes! They were his constant preoccupation. "That's what Gauguin never understood," he continued. For many reasons this reproach should have been aimed at me, and I felt then that Cézanne was right, painting is not beautiful if the surface plane stays flat. Objects must turn, grow distant, live. That is the magic of our art.

At ten o'clock I walked my old master back to the rue Boulegon. We stopped again to talk in the silent, moonlit streets. "Aix is being ruined by the town surveyor; we must go see him soon; everything is disappearing. They've ruined the beauty of these old towns with sidewalks. Most of the ancient streets don't have room for them. Why do you want sidewalks in a city like this anyway? At most two or three streets need them! They could leave the others as they were, but no, there's this mania to make everything straight, to disturb the harmony of the past." So he became angry at this invisible town surveyor, shaking his cane, then falling absolutely silent, after saying, "Let's not talk about it anymore; I am too tired; I should be sensible and stay home and work, only work." Suffering from diabetes, he frequently had these weak spells. I accompanied him to his door, and after shaking my hand, he went inside. Walking back through the deserted streets, I thought about his death. I saw him so old, so tired. It seemed to me that I already saw his funeral procession passing before me. There were only a few people, and in spite of my desire to be there, I had not come. My life had led me elsewhere. I had not been informed in time . . . and that is what happened almost a year ago.

When I arrived back home I was filled with sad thoughts of a life consecrated entirely in its sincerity and its wisdom to civilized man's most noble ambition, to art, and nevertheless he found only derision, scorn, exhaustion, dissatisfaction, and death. No doubt, glory will come some day, late, disputed, focusing on the unshaken effort of this superior intelligence, but a glory abominably travestied by the speculators and distorted by a critical response until that moment mute, then becoming self-interested and venal. In the face of so much sadness and emptiness, hope came to me like a caress, to awaken my heart: Cézanne was a Christian! Surely in a better world, he will find recompense for the life he offered with the sublime self-abnegation of a martyr.

EMILE BERNARD

IV. PROMENADES AND OTHER ADVENTURES

While I painted the still life he had arranged for me in my borrowed studio in the country, Cézanne came down often to discuss the old masters with me. He had Charles Blanc's books on the Spanish and Flemish schools and looked through them constantly with great concentration. Unfortunately, this is mediocre work and the reproductions could not be worse. The editor and the author did not understand that they needed to employ real artists to copy and engrave the masterpieces they wanted to reproduce. But, here, as everywhere in France, the idea of profit won out over the spirit of truth. I was outraged by the grotesque distortions of these wood engravings of the paintings of the masters; hardly anything was recognizable. Cézanne, who had only seen the Louvre and did not know most of the originals, believed in the authenticity of these copies and liked them. I came to understand that he took for authentic some of the defects introduced by the engraver and the copier. I told him my opinion, which he seemed to doubt. He loved the Louvre, but what he saw above all in the pictures was naïveté and color. He was completely seduced by naïveté, even if it was unintentional. Moreover, his childhood had been spent looking through *Magasin Pittoresque*,[30] and he regularly amused himself by copying images from it. One evening he asked me to come to his bedroom to see a volume containing an engraving of one Van Ostade who epitomized his ideal. (He also talked to me a lot about the LeNain brothers.)

There was a beautiful floral watercolor by Delacroix in that room which he had bought from Vollard after the Choquet sale. He had always admired it at the home of his old friend, the collector, and had drawn from it lessons about harmony. He took great care of his watercolor; it was framed, and, to assure that it never discolored from too much light, he kept it turned to the wall within arm's reach. His bedroom was large and light and very simple. The bed was in an alcove and a crucifix hung in the middle of the alcove wall.

Also in the room, just as in the studio, was a new reprint of the treatise on anatomy of the Ecole des Beaux-Arts by Tortebat. The original dates from the time of Louis XIV and the plates have been attributed to Titian. Others say that they are by Jean de Calcar. We talked about the great master anatomists. Cézanne was not especially well-versed in this science; however, he was always fascinated by Luca Signorelli,[31] but much more from the point of view of style than for his study of musculature. And it was exactly anatomy that gave him trouble in his works of imagination. He did not learn form by drawing from a model or from study, and artists

67

who want to master human form cannot study too much. The only painter I know today who is able to construct figures with natural grandeur without a model, and in every conceivable pose, is Louis Anquetin.[32] He can do these things because he patiently practiced on the human body, because for a long time he performed careful dissections and also studied the attachment and articulation of muscles. Painters have become so lazy today that they foster their own weakness by not learning this important area of art. Instead, they treat human anatomy as an exercise and substituting manual skill for practice, they avoid learning what will make their work endure.

Cézanne's youth was spent in idleness and literature. It is true that he painted a lot, but never confidently. He was still trying to find himself through Courbet and Manet. I myself really like the works I know from his youth; they are already works of a true painter. But I find the impasto so heavy that it weighs down the forms which, far from being as noble as they will later become, were thickly painted, like Daumier's. Some time ago, I saw at père Tanguy's shop on the rue Clauzel, a *Reclining Nude*, which, even though rather ugly, was a magnificent work. Its ugliness was inexplicably noble and imposing and caused Baudelaire to write, "The charms of horror intoxicate only the strong."

This immense nude, stretched out to her full length on an unmade bed, made me think of Baudelaire's *Géante* [Giantess]. Her body stood out in the light from the gray background, a wall on which a naive picture was pasted. In the foreground, a piece of red fabric had been tossed over a crude chair. Besides the *Reclining Nude* I saw the *Portrait d'Achille Empéreire* [sic], Cézanne's painter friend.[33] I asked Cézanne several times about this artist, whom he seemed so fond of and whose beautiful academic drawing from the Académie Suisse he had shown me. "He was a very talented boy," he said. "Nothing the Venetians did was unknown to him. Many times I saw works of his equal to theirs. Recently there was a sale of the contents of a café with two of his paintings, but I didn't know the date of the sale. I had decided to buy them, and I'm very sorry that I missed them." Old Tanguy had told me once long ago about Achille Empéreire and his miserable circumstances. He received only fifteen francs a month from his family and had to limit himself to living in Paris on fifteen centimes a day. This misery probably killed him, since he died of sickness and exhaustion when he was still a young man. In my master's portrait of him he is represented in his bathrobe seated in a huge armchair; his thin hands hang from the armrests. His robe is open a little and

reveals thin legs clad only in a pair of drawers. His feet rest on a foot-warmer. Cézanne painted him as he appeared just after his morning bath. His head, larger than normal, is beautiful and expressive and crowned by long hair. His mustache and goatee cover his chin; his large eyes with their heavy lids are full of lassitude. This painting was sent to the Salon, probably after the war, and refused, as was the *Reclining Nude*. I discovered it under a pile of mediocre paintings at Julien Tanguy's who told me the story. He must have hidden it from Cézanne who wanted to destroy it. Eugene Boch, the Belgian painter who specializes in landscapes, owns it in Mon-thyon, near Meaux.

All his life Cézanne wanted to be accepted at the Salon. All his life he suffered from being refused. He still regularly talked about what he would do for Bouguereau's salon. (It did not matter to him that the entrepreneur had died; nothing had changed for him.) He was thinking about an hom-age to Delacroix[34] and showed me some sketches. The body of the Ro-mantic master was being carried away by angels; one carried his brushes, the other his palette. A landscape stretched out below him in which Pis-sarro, standing by his easel, paints from nature. At the right is Claude Monet, and in the foreground Cézanne arrives, seen from behind, with his long walking stick in his hand, his game-bag at his side, and a huge Barbi-zon hat on his head. On the left, Mr. Choquet applauds the angels and in a corner a howling dog (according to Cézanne, a symbol of envy) represents criticism. He honored me by saying he wanted to replace Choquet with me. He even had a photograph made of me in the proper pose, but he died before he could complete his project.

Perhaps we should not feel too bad about this fact. The arrangement was not very original, and the time the painting would have required would have deprived us of beautiful still lifes which are his true glory. Cézanne's imagination was not great but he had a very refined sense of composition. He did not know how to draw without a model, a serious obstacle to credible creation.

I brought up the subject of my use of photography. To my great sur-prise he was not opposed to a painter using photography; but if he painted from photographs, he would still have had to interpret this exact repro-duction in exactly the same way as he interpreted nature. He had made a few paintings using that method.[35] He showed them to me, but I cannot remember them now.

Soon we left the studio to go to our motif. He took me to a view of Mont Sainte-Victoire and each of us began our study, he in watercolor, I

in oil. When we were returning, in order to take a shortcut around the end of a little path, he took me through a very steep and slippery place. He walked ahead and I followed. Once he lost his footing and fell backward. I rushed immediately to catch him. My hand had barely touched him when he flew into a rage, swearing and roughly pushing me away. He ran ahead, glancing back at me from time to time fearfully, as if I had threatened his life. I was totally baffled by this strange behavior. He seemed to mistrust me now every bit as much as he would soon declare himself my friend. I was so upset I did not know what to do.

I had known my old master for too short a time to know all his strange personality traits. As I walked behind him and he walked more and more quickly, I decided not to go back into the studio if he closed the gate. I would go straight back to Aix, even if it meant coming back to the studio in the morning for an explanation. He went into the house leaving all the doors open as if to invite me in. I accepted and went to my workroom and put down my paintbox. Then I heard him open his studio door noisily, and with hurried steps that shook the stairs, he suddenly appeared wild-eyed at my door. "I beg you to forgive me, I only wanted to keep you from falling." He swore at me furiously and frightened me with his horrible glare. Then he exploded, "No one is allowed to touch me . . . no one will get their claws into me! Never! Never!" In vain did I tell him that my intention was friendly and respectful, that I had wanted only to keep him from falling. Nothing worked. He cursed and went up to his studio, banging the door so hard that the whole house shook. Then I heard him repeat, "claws into me" for several minutes. I left the country studio resolved never to go back, heartsick and totally upset by this unexpected and unimaginable incident. I went to my room too sad to have supper.

As I was getting into bed, there was a knock on my door. It was Cézanne. He had come to see if I still had an earache. (I had had an earache for several days.) He was very friendly and seemed to have forgotten what had happened a few hours earlier. I was so upset that I could not sleep the entire night. In the morning he was not at home, so I went to find Madame Brémond. I told her about what had happened and about my great sorrow that Cézanne could have taken my gesture as a lack of respect. "He didn't stop singing your praises all evening," she told me, "however, you mustn't be surprised. He can't bear to have anyone touch him. I have seen that sort of thing happen many times before with Mr. Gasquet, a poet who used to visit him regularly. Myself, I'm under orders to pass to his side without touching him, not even with my skirt."

When I expressed my intention to move out of the country studio, she said, "It would be a great mistake to do that; it would cause him a lot of pain. Since yesterday he hasn't stopped telling me how pleasant your company is for him. You are the only person who has been able to get along with him."

Around eleven I went back to Cézanne's. He was having lunch. At the bottom of the stairs I called to Madame Brémond, "Ask Monsieur Cézanne if he would like to see me." But before she could ask him, and because he had heard my voice, he shouted, "Come, come, Emile Bernard!" Then he got up from the dining table to welcome me. Just as I had done the previous evening, I refrained from mentioning the incident and his anger. He said, "Don't pay any attention; these things happen to me in spite of myself. For a long time I haven't been able to bear for anyone to touch me." He went on to tell me about a mean trick that a boy had once played on him that he had never been able to forget. "I was going down the stairs and some kid slid down the bannister and gave me such a kick in the ass that I almost fell. The unexpected and unforeseen shock struck me so hard that for years I've been obsessed with the fear of it happening again, so obsessed that I really suffer if anyone touches me or brushes against me." We then talked about various things, and about our painting, naturally. He invited me to walk up to the Château Noir,[36] a place that had looked beautiful in his studies.

He came for me one sunny afternoon in a carrige he rented by the year so he could drive to his "motif" or to his studio in the country if he was too tired to walk. We set out joyously, following a route that became more and more impressive. Pine forests appeared at last and he made me get out so I could have a better look at the views with him. We explored the area together. In spite of his age, he was very agile walking among the rocks. I was careful not to help him at all. When he was in a difficult spot, he got down on all fours and crawled while chatting. "Rosa Bonheur was a blessed woman," he told me, "she knew how to give herself completely to painting."[37] This was the introduction to a discourse on women painters who are more concerned with romance than with art. Cézanne tried to convince me to stay longer in Aix so I could paint here with him. He showed me a *mas,* or farmhouse, which I could rent to store our belongings. The place was really surprising in its character and wildness, but I could not stay. I needed to get my family settled permanently. As we returned, he talked of Baudelaire. He recited *La Charogne* [The carcass][38] without any mistakes. He preferred Baudelaire to Hugo, whose verbosity

and pomposity he disliked. "I can go as far as *Contemplations*," he said, "but the bombast of *La Légende des siècles* bores me. As for the rest, I don't want to read any of it." Cézanne must have been thinking of Baudelaire when he imagined those unusual and excessively slender and elongated nudes who bathe or take refuge in the woods. On the back of the *Apothéose de Delacroix* (the sketch of which I spoke), I found these verses which are totally Baudelairean, although written by Cézanne:

> See the young woman with her voluptuous hips.
> How beautifully she stretches out in the meadow
> Her lithe body, splendid blossoming;
> No serpent is more supple
> And the shining sun complaisantly shoots
> Some golden rays on this delightful flesh.

As I read this poem, I could not help thinking of the *Grande femme nue couchée* [Large reclining nude]. These verses must date from the same period. Are there not the same magnificent color, shapely insouciance, and masterful lack of discretion which challenge the bourgeois, the very romantic side of the character of my old master.

V. WE LEAVE AIX AND I DO NOT SEE CÉZANNE UNTIL THE FOLLOWING YEAR.—HIS DEATH.

A palette! Such a captivating object in the life of an artist.[39]

Here is the way Cézanne's palette was prepared when I met him in Aix:

	Brilliant yellow		Viridian (Veronese green)
	Naples yellow	Greens	Emerald green
Yellows	Chrome yellow		Green earth
	Yellow ochre		
	Raw sienna		Cobalt blue
	Vermillion	Blues	Ultramarine blue
	Indian red (red earth)		Prussian blue
	Burnt sienna		Peach black
Reds	Madder lake		
	Carmine lake		
	Burnt crimson lake		

Obviously this color arrangement makes very extensive use of the chromatic circle so that from lead white which is at the top, to black at its base, it passes through a perfect spectrum from blues to greens and from

reds to yellows. Such a palette has the advantage of not involving too much mixing. It creates relief in the painting because it allows for distinctions of light and dark, that is to say, strong contrasts. There is nothing like it among the Impressionists, because their palette ends with blue and they lose the power of black. And this results in a lack of warmth in the shadows. Of course it is possible to create the desired effect of relief with white and black alone, but with a resulting loss of color. By adding black or white to the three primary colors, whether red, blue, or yellow, the artist can create a delightful range of color, but the large number of alterations these colors undergo robs them somewhat of their freshness. Intensity and brightness are lost to what is gained in harmony and depth.

Cézanne's palette is, therefore, the real painter's palette. The palette of a Rubens or a Delacroix could not have been much different. Its use was a great concern to my master. In the still life I made in his studio, I bowed as much as possible to his will so I could understand his methods better. He recommended that I begin lightly and with near-neutral tones.[40] Next I should proceed up through the color scale keeping the saturation as close as possible. I told him that since I was eighteen I had dreamed of knowing him and being his student, so that I could carry on after him. He wanted someone to carry on for him because, as far as he was concerned, he had only opened the path. "I'm too old, I haven't achieved my goal, and I won't be able to now. I remain the primitive of the way I discovered."[41]

I was not surprised to hear these wise words, because I knew well that my master loved his art above all else and worried about leaving behind a line of so-called students who would distort his ideas.

Cézanne believed so absolutely in his ideas that he had violent debates with his friend Solari. His housekeeper told me this story:

> One night someone came to get me just as I was going to bed. People were shouting and pounding their fists on the table in his house on the rue Boulegon. "Come quickly," the person told me. "Someone is trying to cut Monsieur Cézanne's throat!" The window was open when I arrived in front of the house and I recognized the two voices. They were the voices of Monsieur Solari and Monsieur Cézanne. Knowing all about these friends' constant arguments, I understood right away that this was not a question of crime but a discussion on art. I calmed down the people who had gathered in the street and went home to bed.

From time to time my master told me about Solari and once showed me a bust of his in front of the University of Aix. This bust left me with a fairly

negative opinion of his work. He was a celebrity locally and, it follows, only a mediocre, provincial artist. The little city of Aix, however, never thought of Cézanne as anything but a madman. It goes without saying that the Ecole des Beaux-Arts was there the order of the day, so the situation could not have been otherwise. Cézanne had such a deep-seated hatred for the school that he had a special way of saying "Bozards" which, even without his knowing it, revealed his profound disdain. Any person who studied at that school was an ass and an idiot in his eyes. His intense mistrust of certain people and human actions surely led to his misanthropy. One day he told me the following story:

> I had a gardener who had worked for me for some time. He had two daughters and when he came to work in my garden he always talked about them. I pretended interest in them since I was interested in him. He seemed like a good man. I didn't know how old these girls were; I thought they were very young. One day he arrives at my house with two magnificent creatures between eighteen and twenty. He introduces them saying, "Monsieur Cézanne, these are my daughters." I didn't know what to make of this introduction, but I have to be suspicious of people, knowing how vulnerable I am. I searched my pockets for my house key so I could lock myself inside. For some unknown reason I had left it in Aix. Not wanting to play a ridiculous role, I asked the gardener to get me an axe from the woodshed. When he brought it I asked him to break open the door, which he did with just a few blows. Then I went into my house and ran upstairs to lock myself in my studio.

Cézanne had resolved not to end up like so many old men, in shameless lechery. Everyone knew he had an income and he believed, correctly or not, that people tried to get close to him to take advantage of him. Even though he was a married man, since he lived alone, he thought that people would think he was vulnerable. One day, as we were leaving church he said to me, "Did you see Madame X . . . , how she stood in front of the font waiting for me? She is a widow and had her children with her. I could tell from the look on her face exactly what she wanted." All these stories ended with, "Life is terrifying!" He was truly as shy as a monk.

In Paris his best friend had been a cobbler. "This poor fellow had an unworthy wife who made babies all over town with any man who came along. He accepted them all, loved them all without the slightest prejudice. Nothing bothered him about her habits except the occasional taunts from drunks. He worked overtime to feed everyone. I liked him so much

that when I moved out of the house where he also lived, I gave him all my paintings."

His sister Mademoiselle Marie Cézanne, whom I never had the honor of meeting, took care of everything for him. She managed his household, gave him his spending money every week, and paid his bills. She performed these duties with loving devotion and, since she was a good Christian, she had an excellent moral influence on him. "I want to take confession," he told me one evening. "My sister recommends a Jesuit, an excellent man." He talked to me at length and I urged him to return to practicing his faith.[42] He was a little nervous, fearing "the claws." "The priests could get their claws into me. That's exactly what I don't want." I persuaded him that such an idea was only a prejudice and he agreed. Furthermore, he could always break free. So he went to the Jesuit priest and returned delighted. "Those people are really intelligent and they understand everything," he told me. Some time later, I think he received holy communion.

I was happy to find that he was such a believer and asked him, "Would you consider painting a Christ for me?" "I'd never dare," he answered. "First of all, it's been done by others better than I could do it, and also, it would be too difficult." Actually he had many painting projects in mind and this task would have become a work of the imagination for which he was ill-suited. I guess he died without attempting to carry out my suggestion. I never understood Cézanne's response. As far as I am concerned, I think that a believer should not hesitate to use his brush to serve his faith and his God.

We went together to the museum in Aix to see some paintings by Granet and two or three rooms of old masters. He liked Granet's painting[43] and overlooked the shortcomings of this rather mediocre painter, perhaps because of memories of his youth. Cézanne was ecstatic about *Le Martyre d'une Sainte,* by Mattia Preti called El Calabrese.[44] "That's how I used to dream of painting." This energetic painter, who was Spanish rather than Italian, thrilled him. We looked again at portraits in the manner of Largillière, paintings of the Fontainebleau School, and an exquisite child's head by Greuze.

The day we were to leave Aix was approaching. It made me miserable to see the time I could spend with my master dwindling away. Not daring to ask him to pose for me, I memorized his features and fixed his image on canvas in my studio the day before we left. I also made two photographs of him in his studio that day. He seemed irritated that we were leaving, but he made a drawing of us, gave me a little sketch to remind me

of my pose for the apotheosis of Delacroix. He also wanted me to send him a new photograph of it, since the first one was lost. He made me promise to return, to go to the pine forests near the Château Noir with him. He accompanied my family and me to the station and waited for the train to pull away before going back to his painting. We had tears in our eyes as he disappeared from view. Would we ever see him again? In what absolute solitude would he now find himself. There was no one near him who understood him and, aside from his family, we were perhaps the only ones who truly loved him.[45]

We decided [in 1905] to leave Naples by boat and sail to Marseilles to go see Cézanne. We talked about him a lot and wanted very much to visit with him again. This could be our last visit, as he seemed to be overwhelmed by illness and the summer heat, which he blamed for cerebral troubles.

One fine afternoon in late March, we took the boat that came from Greece and carried a thousand passengers. We had good weather until evening and, when we rounded Corsica, a violent *mistral* wind overtook us. We spent a night that was as perilous as it was miserable. When we were within sight of Marseilles, there was bright sunshine but the wind was blowing so hard that we could barely make out a few hills. Everything was enveloped in a great sandstorm. Overhead, the rigging of the boat hummed like an organ pipe. We could not dock at Marseilles and had to anchor at L'Estaque and be rowed ashore. The trip had been so awful that I had to delay my visit to Cézanne until the next morning. The next day I arrived in Aix by the earliest tram and went to surprise Cézanne in his studio outside of town. He seemed happy to see me (I had not told him I was coming) and he showed me his latest pictures. I was tremendously pleased to see, hanging on his studio wall, the landscape study I had made the previous year. It represented the beautiful view of Aix from the lower studio. The painting of the skulls was tacked to the wall, abandoned. He showed me his nudes, hardly changed at all from last year, in spite of his persistent work. The gestures of several of the nudes had changed a little and successive layers of paint had thickened the colors.

He asked about my family and said to me, "Paul and my wife are here. You will have lunch with us, won't you?" I think he was truly happy to introduce me to his son, whom he always spoke of with praise. "He is everything that I am not, an excellent man." We went to the rue Boulegon. Madame Brémond was busy making lunch. Cézanne introduced me to his

son and to Madame Cézanne. The meal was very lively; Cézanne was quite talkative. It gave him great pleasure to see his son. He interrupted himself all the time to look at his son and say, "Paul, you are a genius!"

Around one o'clock, a carriage rolled down the sleepy street and Madame Brémond announced that the coach had arrived to take Cézanne to his motif. "I was a little tired, so I ordered the carriage, but since you're here we're not in any hurry." He had the coachman wait. As we were finishing our luncheon, he dismissed the carriage and announced that he was going to Marseilles to see "the rest of the family." We went off to the tram and, during two hours of torrid heat, we chatted cheerfully. His radiant mien, healthy appearance, and carefree attitude delighted me. We talked about Puget.[46] "I understand that he had the *mistral* in him. He knew how to bring marble to life." The fierce wind blowing that day must have given him this idea. "It's been a long time since I've gone to Marseilles," he said. "I'm always working, but today I want to go pay my respects to Madame Bernard." I worried that the trip would be bad for his health, but he insisted.

We arrived in Marseilles rather late. He kissed my wife's hand and held the children on his knees. Then, as it was time for us to leave for the train to Paris, he wanted to accompany us to the station. With his son graciously looking after the children and watching over everything, we arrived at our train. A whistle drowned out our conversation and I was suddenly terribly sad. After a final handshake, we departed, leaving my old master and his son on the platform of the Marseilles station. This was our last goodbye.[47]

About a year later, while I was painting in my studio on the rue Cortot in Montmartre, my friend Louis Lormel came in and told me, "Cézanne is dead. I just read it in *Le Journal*." I did not receive this notice until eight days after he was buried:

> *You are requested to attend the funeral of*
> PAUL CÉZANNE
> Deceased in Aix, en Provence, with the sacraments of our
> Holy Mother Church, 23 October 1905,[48] aged 68.

I learned from Charles Gueri that he had collapsed while painting, as had been his fervent wish, according to his letters. In spite of my extreme sorrow, I was happy knowing that my old master had died in the arms of the church. I thought I should arrange a low mass for the repose of his soul under the auspices of *La Rénovation Esthétique*.[49] Most of our colleagues

attended. I was especially gratified by the presence of the painter Maurice Denis (author of "Homage to Cézanne").

I have recounted what I remember about Paul Cézanne. He is no longer among us, and he leaves a body of work which he felt never quite expressed all his ideas. He also leaves many works that others deem unfinished. But despite my master's overly severe judgment of his own works, despite critics' and other painters' rash condemnation of them as incomplete, I believe that the ten or fifteen finished still lifes and landscapes that he gave us are a lasting monument, raised by his struggle, to his own glory. In these works there exist a solid foundation of beautiful tonalities, finely used materials, local color qualities, singular harmony, and an eye perfectly attuned to reading chromatics which he called "color sensations." We must not dwell on works, such as his sketches, that he himself did not exhibit to the public. While it is true that everything by a rare artist like Cézanne is interesting, he cannot be judged by unfinished works. His painting progressed very slowly and involved long contemplation. He never placed one stroke of paint without thinking about it carefully. In spite of what appears to be an unevenness in his paintings, they will endure because of their solidity. He knew what he was doing and did what he wanted to do. In any case it is necessary to separate his awkward, strange, and at times crudely primitive works from his great ones. His extremely distinctive vision is often hidden beneath the appearances of rough form. If he paints a peasant, he makes him coarse. But if he does not seduce us through form, he does hold the secret of giving our eyes exquisite sensations. He did not care to render the spirit of things but wanted to give us the charm of their colors, their substance, above all in his *still lifes*. He needed time to *develop,* and he found it when he worked on his skulls, green fruit, or paper flowers. It is in this genre that he gave us the very best that he could do. I do not mean that his landscapes or figures should be overlooked, because I know of some that are rare in their enduring beauty. I fear, however, that there are a few of these in which one encounters areas that he did not have the time, the model, or the good health to perfect.

The failing of which Cézanne most complained was his vision. "I see overlapping planes,"[50] he told me, "and sometimes straight lines appear to me to fall." These faults, which I was considering as products of his willful disregard, he blamed on the weaknesses and bad habits of his vision. It was his constant preoccupation to find a way to better see the values. He talked frequently about Chardin's eyeglasses and his visor as a possible remedy, but he never tried them.

It is necessary for me to speak now about the shameful imitations of
this master, distortions committed in his name, and the total incomprehen-
sion of self-interested imitators. Those who understood him are to be
praised. But how many of us are there? How many are there who decided
to study this work and find something in it other than anomalies? It has
become stylish to place compotes askew, to imitate wooden-looking nap-
kins, to have lopsided glasses, and to place flat apples against a background
of flowers. Some saw in Cézanne only brutality, ignorance, clumsiness,
grayed tones, thick messes of paint. And they have striven disastrously to
imitate these mistakes in interpretation. Others saw him only as a rebel
and have dreamed of being an even greater one. In short, few have recog-
nized his wisdom, his logic, his harmony, the gentleness of his eye, his
studies of planes, his sense of space, and his desire for realization by com-
ing closer to nature. "Imitation and even a little *trompe l'oeil* are necessary,"
he said to me, "but that doesn't do any harm if there is art."[51]

It stands to reason that if Cézanne had been understood, today we
would have fewer inferior daubers' paintings on display in fashionable
shop windows claiming to be "the art of the future" and which are only
shadows of the present. There would be more true, humble, sincere artists
fully aware of the immense difficulty of the task which they have taken on
and who feel themselves unworthy. I believe that, for my part, the
influence of my old master, if it is ever discovered, will result in a return to
the great ones of earlier times, united by love of objective truth, and that
their motto will be, "We must become classical* again through nature."
Cézanne is a bridge over the beaten path by which Impressionism returns
to the Louvre and to profound life.

*Classical is a word Cézanne used haphazardly. I want to define it, at least in this
case. Classical means in harmony with tradition. Thus, Cézanne used to say, "Imag-
ine Poussin entirely redone after nature; that's what I mean by *classical*."[52] It is not a
question of bringing down the Romantics, but of rediscovering what the Roman-
tics themselves knew: the firm principles of the old masters. In any case, the lesson
to be learned is a more ample observation of nature and the understanding of clas-
sicism through nature, not from formulas of the studio. Because if the *laws* of art
are fertile, the *formulas* of the studio are death. Only through contact with nature
and through constant observation of nature does the artist become a creator.

FRANCIS JOURDAIN
1905

The son of Frantz Jourdain (an intimate of many of the great painters of the late nineteenth century, and himself an architect, theater designer, and writer), Francis Jourdain was born in 1876. He was a painter in his early years, but soon relinquished the art of painting for that of interior design, and he became a distinguished practitioner in that field. In the postwar period he wrote profusely about art. He died in 1958.

The visit to Cézanne, in company with Charles Camoin, took place in 1905: the exact date seems uncertain, but it must have been some months later than Bernard's February/March 1904 visit ("moins de deux ans avant sa mort," and so probably early in 1905; see Jourdain 1946, 5).

The present text (pages 8 to 11 from Cézanne, Paris, Braun, 1950*) was preceded by a slightly different account of the visit published in* Arts de France, *no. 5, 1946, under the title* A propos d'un peintre difficile: Cézanne, *but that version gives one or two details that are lacking from Jourdain's 1950 description of the Atelier des Lauves: for example, it is made clear that the gardener of the portrait seen in progress is "in a cap" (see Riviere and Schnerb, note 15).*

However we are also told (p. 6) that "he had decorated the vestibule with frescoes derisively signed Ingres": these are the Quatre saisons [Four Seasons] *of the Petit Palais, but incorrectly located by Jourdain, for they were still on the wall of the salon at the Jas de Bouffan in 1907, and were painted on to the plaster, like the portrait of Cézanne's father in the National Gallery, London, which accompanied them. (See also Vollard, note 1.) The*

reference is edited out of the 1950 text, which is possibly a more carefully considered account.

Excerpt from *Cézanne*

I belong, as I see it, to the generation that discovered Cézanne. I do not pretend, of course, that his fame owes anything at all to our insight. I simply mean that, around 1894, Cézanne's work was virtually impossible to see anywhere. We knew the works of Renoir, Monet, Degas, Pissarro, and Sisley through our regular visits to the Durand-Ruel Gallery. We had already followed, with fervent enthusiasm, the early work of Bonnard, Toulouse-Lautrec, and their friends at Le Barc de Boutteville gallery. But nowhere did we see the least work by this Cézanne who had, a long time before, renounced exhibiting and whose name our elders pronounced respectfully, even if they knew little of his work. They were much more willing to discuss the theories of Gauguin, the new Messiah, whose apostles were Paul Sérusier and Maurice Denis.

If everyone was so little and so badly informed about Cézanne's "ideas" (although this ignorance did not prevent anyone from ascribing quite a few theories to him), we knew nothing at all of the painting these ideas engendered. Léon-Paul Fargue[1] and I were very proud of having discovered a Cézanne landscape while turning over the paintings piled up at père Tanguy's. I must admit that we were much less moved by its majesty than we were by the agitated, exciting eloquence of our dear Van Gogh, that madman whose "moldy suns and putrefying skies" set ablaze the tiny shop on the rue Clauzel. Emile Bernard had taken us there. He was angry with Gauguin and a little jealous of the importance accorded to Gauguin's research which he himself claimed to have begun.[2] Bernard was probably the only one to understand how excessive this importance would seem when, at last, the forgotten man of Aix received his due.

Bernard was also one of the rare men who had enough curiosity to approach Cézanne. He has told in a touching way of his time spent with the solitary genius who was also a moody old churchwarden. Two years before Cézanne's death, I was given the opportunity to verify the truth of Bernard's written portrait.

Charles Camoin, whom I ran into in Marseilles, suggested that I accompany him the following day to Aix. He had done his military service there and never returned without going to see that singular artist whom he had had the nerve to visit and whose respectful friend he had become.

By this time Cézanne was already known as an irritable old eccentric, given to disconcerting whims.

I had never imagined that I would one day meet this man whose legend has given him the character of a mythical figure. I accepted Camoin's offer with an emotion that grew even stronger after my companion had rung the bell, when behind the door I heard the gravel crunch with the slow steps of a tired old man. The door opened. There was Cézanne! I saw the shining dome of his head from which several tufts of gray hair trailed over the worn collar of his paint-smeared jacket. I saw the worn shoes, the crumpled trousers, the ridiculous little tie knotted over his white shirt—well, not very white—whose buttonless, starched front hung open over his hairy chest. The look of suspicion which spoiled his magnificent gaze faded when he saw the face—half clown, half faun—of Camoin. He received us cordially. We went into the studio where Cézanne came only to work and where an indescribable disorder reigned, the pipe of an ancient water-pump climbing up toward a skull which, posed on a fake oriental carpet, composed a still-life motif.

Camoin was right in thinking that we would see the same two paintings on their easels that he had seen a year before. He noticed, however, that the *Portrait d'un jardinier* [Portrait of a Gardener] and the *Baigneuses* [Bathers] looked *less* finished than they had at the time of his last visit. Cézanne showed us two or three canvases. They were barely sketches. One, he told us, was the portrait of Monsieur Armand. "You know Monsieur Armand, don't you? He's very well known in Paris. He came to Aix to paint my portrait. I was embarrassed to pose for him, so I began to paint *his* portrait." We realized that he was talking about our colleague Hermann Paul[3] whom this abandoned sketch did not resemble in the least.

Cézanne, who lived with memories of his youth spent in Zola's company, made excuses for not being up to date on anything. He talked exuberantly about a Daumier lithograph pinned to the wall. He slapped his thigh and laughed till he cried, as if he were seeing this image for the first time. He showed us an awful album he had bought at a kiosk on the street in Paris. It was *Le nu au Louvre* [The Nude in the Louvre][4] and consisted of around fifteen hideously unfaithful reproductions. It took an extraordinary effort of the imagination to find the slightest trace of our beloved masterpieces in these glaringly lit horrors. Cézanne was ecstatic about them, gesticulating, waxing lyrical, and obviously thrilled to be able to break the silence into which his solitude had cast him.

I listened to him respectfully, completely ready to accept as definitive

and immortal the words which I had the rare privilege to hear. On our way back to Marseilles on the train, Camoin and I had to agree, as enthralled as we were, that coherence was not among the most evident virtues of Cézanne's statements. With a gently malicious smile, he exclaimed, "Enough of Impressionism, it's a joke!" Then he took up the subject of "the great Pissarro," as he called him, praising him highly, not because Pissarro distanced himself from Impressionism, but, completely to the contrary, because he was, in Cézanne's opinion, Impressionism's true master. Cézanne especially reproached Claude Monet for having tried to push his daughter into the arms of Cézanne's son. This suspicion, which I think was never verified, was, it seems, one of his obsessions.[5]

There was something morbid about his mistrust of people. Standing before his *Bathers,* he explained that, due to the secret surveillance that he, a practicing Catholic, was subjected to by the Jesuits, he had long ago given up the practice of having a nude model in his studio. "In any case," he added, tapping himself on the forehead, "painting is all in here!"[6] I was somewhat surprised to hear him say that one of his most constant concerns was to render the real distance between the eye and the object.[7] This did not seem very compatible with his assertion—reiterated for us—that he always tried "to bring Poussin back to life through nature."[8]

He confessed to us that he had driven to the same motif at least a hundred times with a load of materials and a canvas which, after becoming discouraged, he had abandoned under a tree. We couldn't forget that, on the other hand, he sometimes spent weeks and weeks copying and recopying some idiotic little drawing from the illustrated *Magasin Pittoresque.* Are the ways of all geniuses so unfathomable? As concerned as he was with objectivity, Cézanne probably was never absolutely conscious of the moment when he, nevertheless, became completely arbitrary. He probably didn't know about the conflict which raged in him between the natural and the imaginative. Surely, though, he was one of those who seek, with the most moving anguish, the equilibrium between instinct and reason, which it is the domain of genius to achieve.

RIVIÈRE AND SCHNERB

January 1905

Jacques Félix Simon Schnerb (1879–1915) was a painter, engraver, and writer on art, and from 1908 a regular exhibitor at both the Salon d'Automne and the Salon des Indépendants. Of R. P. Rivière very little seems to be known, but he and Schnerb contributed engravings (four and three, respectively) to the volume of eight Images d'après Mallarmé *published in 1896 (see* French Symbolist Painters, *catalogue of the London/Liverpool exhibition, 1972, 136).*

Rivière and Schnerb visited Cézanne in January 1905, and their article "L'atelier de Cézanne," here reprinted, appeared in La Grande Revue *on 25 December 1907 (pages 811 to 817). It offers a sensible and factual account of the late Cézanne and his theories; and in some respects is more satisfactory than any of the Bernard material, for there is little sign of the superimposition of an aesthetic ideology. Its theoretical passages are also more lucid than the comparable material transmitted by Larguier and Bernard, but this, of course, need not mean that it is a truer representation of Cézanne's intentions.*

The first of the footnotes appended by Rivière and Schnerb shows that they were aware of the Bernard Souvenirs . . . *of 1907, which appeared when this text was three-quarters written. There is little sign of "contamination" from the Bernard account, unless it has been well concealed, for verbal echoes are few, and, far more than Bernard's, this text has a condensed, well-integrated, and structured character. These factors tend to confirm its value as an independent report.*

84

"Cézanne's Studio" *(La Grande Revue)*

There are legends about Cézanne that paint him as a misanthrope, a kind of unapproachable bear. Long before his death, it was said that he did not paint anymore, that one had to tear his early work away from him. Even the best informed people could only vaguely describe where and how he lived. A satirist might even have said that he was a mythical being whose existence had never really been proved.

It seemed it might be interesting to report, then, several of the painter's statements taken from notes made during a visit with him. Cézanne, moreover, had intended to write his thoughts on painting, though he probably never did so.[1] Also, so many stupid things have been written about his works and, among those painters inspired by him, so few have understood the sheer scope of his work that it is useful to report as faithfully as possible the ideas of such a researcher.*

When we rang the bell at number 23 in the peaceful rue Boulegon in Aix, we were welcomed unpretentiously, in the Provençal manner, with the handshake of a colleague who asked for news from Paris, who couldn't stand for anyone to call him master, and who, when asked about his paintings, said, "I'm an old man; I paint pictures; what more do you want me to do?"

So he painted. He never worried about the care of his paintings and they were lying around in corners either rolled or still on their stretchers. Some rolled paintings had been left on chairs and were surely crushed. His studios, the one on the rue Boulegon and the one on the road to Aubassane in the country,[2] were in great disorder, chaotic disorder. The walls were bare and the light harsh. Half-empty tubes, brushes with long-dried paint, and lunch leftovers that had served as subjects for still lifes littered the tables. In one corner lay a whole collection of parasols, whose rough frames must have come from a vendor in town, the iron lance made by

*These notes were three-quarters finished when Monsieur Emile Bernard's "Souvenirs" appeared in *Mercure de France*. After his biographical note in *Hommes d'Aujourd'hui* (Vanier, vol. 8, no. 387) and after his article in *L'Occident* (July 1904), in which he showed that he possessed ground-breaking and increasingly clairvoyant judgment, Monsieur Emile Bernard tells us today of his stay in Aix, in Provence, at his master's side. He must be thanked for these pages on the man and the artist. In spite of many hesitations, we think we must issue, in the form of remarks limited only to Cézanne's technique, our modest contribution to the biography of the artist.

the neighboring blacksmith. Near them lay game-bags used to carry food to the countryside.

As Cézanne rarely had visitors and since he had almost no one in Aix with whom he could discuss painting, he expressed himself in the elliptical and often obscure language of people who live alone.* Certain of his statements were long-considered answers to questions which the difficulties of his art had forced him to ask himself and which his interviewer could not have proposed.

To bring some organization to the ideas which Cézanne expressed in no apparent order, it seems suitable to report successively those which refer to drawing, to color, to composition, and finally to general ideas about art.

As for drawing per se, that element which one can arbitrarily separate from color, Cézanne vigorously declared his horror of the photographic eye, of the precise and automatic drawing taught in the Ecole des Beaux-Arts, to which school, he told us, he had twice applied and been turned down. He was not defending the superficial incorrectness of his own drawing, this awkwardness which stems neither from negligence nor lack of talent, but which comes rather from excessive sincerity—if one can be permitted to use these two words together—from an overzealous defiance of purely manual skill and a distrust of all movement in which the eye alone directs the hand without the intervention of reason. Cézanne fully recognized the asymmetry of his bottles and the defective perspective of his plates. Showing us one of his watercolors, he corrected with a fingernail a bottle which was not vertical and he said, as if apologizing for himself, "I am a primitive, I have a lazy eye. I applied twice to the Ecole des Beaux-Arts, but I can't pull a composition together. If a head interests me, I make it too large."

But since Cézanne, right or wrong, never allowed himself the slightest insincerity, much as he regretted that his bottles were not upright, he did not redo them. Even if parts of his canvas remained blank in the course of his work, he left them that way rather than daub on just any color.

Cézanne did not use lines to represent forms. Contour existed for him only as the place where one form ended and another began. Look at his unfinished paintings; objects from the nearest plane are often left blank and

*As a painter, Cézanne was almost completely unknown to his fellow citizens of Aix. We should point out, however, a speech made at the Academy in Aix in April 1907, in which Monsieur Lucas de Montigny correctly refused to place Cézanne among the Impressionists.

their silhouette is indicated only by the ground on which they are profiled. Theoretically no brush stroke is allowed; a form is created only by its neighboring forms. The black brush strokes which often seem to outline shapes in Cézanne's paintings served not as an element to which color could be added, but simply a means of recovering more easily the entirety of an intended form by its contour before modeling it with color.

Color and modeling were inseparable for Cézanne, and from the point of view of his technique, they are probably the part of his art which he elaborated most profoundly, the area in which his persistent studies truly made him a master: "I want to render the cylindrical essence of objects."[3] One of his favorite sayings, which rang with unforgettable music in his Provençal accent, was "Everything is spherical and cylindrical." This statement demands an explanation.

In pronouncing this theory, Cézanne pointed to an apple or a perfectly spherical or cylindrical object as well as to a flat surface like a wall or the floor. To relate this principle to his paintings, one can verify that one of the causes of their solid appearance comes from the science that he applies to the modeling of his flat surfaces, whether a meadow or a table with some fruit placed on it.

To complete the examination of this theory, one must add that, with regard to the supposedly immobile eye of the painter, light rays coming from a given surface, flat or otherwise, are such that the amount of light the eye receives from one area is not the same for any of the other areas of this surface. A surface only appears unified in tone and value because our eye moves over it in order to grasp it completely. If a painter were to render that surface with a monochrome layer of paint on the canvas, he would reproduce it inaccurately.[4]

"I am not an artist who deals in values," Cézanne declared and, in truth, he modeled more by color than by value.[5] For Cézanne oppositions of light and shadow were, above all, oppositions of colors that both his observation and his reason had taught him to reproduce. Areas in direct light and those lit only by reflected light are colored differently, whatever their specific local color, according to a uniform law. It is through the opposition of warm and cool tones that the colors used by the painter—without any absolute luminous quality in themselves—come to represent light and shadow. The lightest color on the palette, white, for example, will become a color for shadow if the painter can juxtapose a lighter or more luminous tone. This is why Cézanne often repeated, "One doesn't *make* light, one *reproduces* it." One can only reproduce light's coloring effects.

Cézanne knew what a unique colorist's eye Claude Monet possessed, and to recall how his friend knew to color shadow, that is, the areas deprived of direct sunlight that received only the reflection of the sky, Cézanne said, "The sky is blue isn't it? It is Monet who discovered that."

Cézanne thus discerned the opposition of tones of light and shadow, even on flat surfaces of seemingly unified color. Also, certain of his watercolors, in which his analytical processes are especially visible, resemble three-color printing proofs badly out of register, like the effects obtained by isochromatic photography. One can recognize in such proofs, where the mixing of colors by superposition is imperfect, that each of the three primary colors is found in all the tones. Only the proportions differ.

Cézanne's entire working method is determined by this chromatic concept of modeling. If he mixed his colors on the palette and laid them on the canvas by simply juxtaposing them, and if he avoided blending two tones by a simple turn of the brush, it was because he saw modeling as a succession of colors progressing from warm to cool. His great interest lay in determining each of the colors exactly. He believed that to replace one of them with the mixture of two neighboring ones would not be art. There was no method in his efforts aimed a priori at conserving more freshness in his color, and yet it is just this freshness, this brightness, which his imitators have tried to copy. But they try to do it without returning to the profoundly instructive practice that created the freshness, that of logical observation substituted for empiricism.

Cézanne had acquired this science of color by both theoretical and applied research. "You must think, reflect on it," he advised. "The eye alone can't do it; you must think about it." In fact, modeling by color, which was his language, requires the use of a sophisticated array of colors that allows him to observe oppositions down to half-tones and to avoid white lights and black shadows. Rivière was surprised to see Cézanne using green to paint the grayish-white wall behind his model. "Work and reasoning," replied the artist, "must develop color sense. Look at Veronese; the work of his youth is gray. How warm it is later in *Les pélerins d'Emmaüs* [The Pilgrims at Emmaus!]."

Cézanne preferred to work during the hours when the low sun cast an especially warm light on objects. After ten in the morning, he stopped painting. "Day is on the wane," he would say. You see, he was less interested in painting the violent contrasts that the untamed sun imposes than the delicate transitions which model objects by almost imperceptible degrees. He painted modulated light rather than full sunlight.[6] For this artist,

who worked for several years on the same motif, a ray of sun or a reflection were only rather bothersome accidents of secondary importance. With his gaze, so eager to grasp form and what we might call the weight of things, he saw beyond the atmosphere, not satisfied with merely contemplating its multiple variations as the Impressionists had done.

As for composition, Cézanne does not seem to have been concerned with it, if one means by composition a premeditated assembling of objects to make up the subject of a painting and placing them in such a way as to produce a harmonious ensemble of lines, values, and colors, whether the artist cooperates objectively with his motif in choosing his point of view, or whether his imagination provides his motif subjectively. But isn't this more arrangement than composition?

According to Cézanne, composition must be developed through work. Any motif copied just as it presents itself to the view of the painter must be transformed through contemplation into a perfectly balanced whole, not by choice or elimination inspired by decorative taste, but by the logic of reproduction, by studying the balance of luminous areas and shaded ones.[7] It is here that the theory of the sphericity of objects in relation to the eye finds its full application; the motif is considered a part of nature both embraced and isolated by the gaze, creating a whole of that which is a fragment. "The painting must develop on the basis of nature," Cézanne emphasized. Logic, therefore, which observation alone could never entirely replace, composes the painting. Logic understands that no two points of the same visual ensemble, no more than any two points of the same shape, can reflect the same amount of light. And logic deduces through reasoning the maximum point of luminous intensity in the painting.[8]

When Cézanne had thus found the laws which made him master of his subject, the rest might seem like work outside his research, outside of all theory. But isn't all his work an analysis directed toward a synthesis, observation directed toward a scientific goal rather than a decorative one? Canvas was nothing more for this Provençal master than a blackboard on which a mathematician works out the solution to a problem. Perhaps it's as much due to this idea of work as to the lack of concern for making his work known that such a great number of Cézanne's paintings were left unfinished. For Cézanne, the one condition indispensable to true work was to be able to carry it out without material worries.[9] "Excuse me, have you an independent income?" he would ask a young artist who came seeking his counsel. "Well, then! Get to work, you've got to work to live." Certainly, he considered himself a student all his life, and his modesty is re-

vealed in these lines which he wrote to Roger Marx to thank him for his understanding and admiring review of the Autumn Salon of 1904.* "Having the temperament of a painter and the ideals of an artist, in other words, having a certain concept of nature, I needed to develop means of execution that would make me intelligible to the general public and allow me to occupy a suitable place in the history of art."[10]

We have already said how, after having studied the masters in the museum, Cézanne wished he could recover a direct vision with nature. "Pissarro," he used to say, "said that we should burn down the Louvre. He was right, but we can't do it!" And he made a gesture and groaned as if trying to avert a catastrophe. Thus he expressed both his hate of conventional work and his love for the old masters. Veronese was one of the artists about whom he thought the most at the end of his life. At home he had on his wall a photograph of Poussin's *Bergers d'Arcadie* [Arcadian Shepherds];[11] the beauty of the subject pleased him. He loved Poussin, in whom reason guided a great natural facility. Other preferences were surprising. "What an admirable painting!" he said of Gérard Dou's *Femme hydropique* [Woman with Dropsy].[12] He also had firm dislikes. "Jules Lefèvre,[13] these students of the Ecole, I hate them!" he exclaimed, his face turning red.

The visit we are reporting took place in January 1905. On view in Cézanne's studio at that time was a large painting of female bathers with eight figures, almost life-size, on which he had been working. "I hardly dare to admit it," he said, "I've been working on it since 1894.[14] I wish I could lay on thick paint like Courbet." He seemed to have returned to his early admiration for the master from the Franche-Comté, although he qualified his opinion by referring to him as a "real brute." Cézanne was also painting the portrait of a man, in profile, wearing a cap.[15] He told us, moreover, that he had always carried on parallel studies, work from nature and work from the imagination. He appeared to attach great importance to this portrait, saying, "If I succeed with this good fellow, it means that my theory will have proved true."

Gazette des Beaux-Arts, December 1904. We are grateful to Mr. Roger Marx for having communicated this letter, so important to complete the portrait of Cézanne.

Cézanne à son motif, oil, by Maurice Denis, 1906

MAURICE DENIS
January 1906

Denis, a painter of canvases and of murals, a book illustrator and writer on art, was born in 1870. He joined Sérusier (soon after the latter's visit in 1888 to Gauguin at Pont Aven) in forming the Nabi group, with the participation of Bonnard, Vuillard, Roussel, Ranson, and others. As the movement became influential, Denis contributed increasingly to the Symbolist reviews of the time; he always wrote prolifically, having begun in 1884 his Journal, *which he would keep up until his death in 1943. Fervently Catholic from the age of sixteen, he was always much concerned with religious art, and was a cofounder in 1919 of the Ateliers d'Art Sacré. His style throughout his life was decorative, tending toward flatness, for he early admired, not only the large-scale decorations of Puvis de Chavannes, but also the style of the Gauguin circle. In 1900 he painted an* Hommage à Cézanne *(Paris, Museé d'Orsay), which depicts a Cézanne still life formerly owned by Gauguin (RP418 V341), around which stand painters of Nabi and Symbolist persuasion, as well as Vollard and the writer Mellerio.*

Ker-Xavier Roussel (1867–1944) is in that group. A painter of Nabi pictures up to ca. 1900, Roussel became thereafter a maker of loosely Impressionist and freshly colored classical and pastoral decorations.

Roussel was Denis' companion on a tour through Provence in 1906:

before going on to see Cross, Signac, and Renoir, they visited Cézanne in January, probably between the 26th and 30th of that month. There is a painting by Denis of Cézanne working before the motif (Sainte-Victoire), accompanied by his visitors (Paris exhibition, 1970, no. 184, 66).

The Denis Journal *entry for this visit is given here (from pages 28 to 30 in the 1957 edition). Its style is brief and dense: a number of things hinted at here will be expanded and explained in Maurice Denis' article for* L'Occident *(September 1907), reprinted in* Thèories, *1920, and also in this volume.*

Excerpt from *Journal*

*A*ix. In Aix, it's Cézanne above all.

However, this town is worth a stay. I'd like to draw the fountains, the old yellow houses. It looks like Poussin's Rome.

The pediment on the grain market, the obelisk of Charles d'Anjou, the old bell tower with its Ceres at the window, the Boulevard Mirabeau, its steaming fountain. At the cathedral: the baptistry of Saint-Jean-de-Latran. I hear mass and curse the fact that for Roussel's conversion it wasn't enough to have faith, he had to feel it in the heart, to feel that God loves us . . . The beautiful façade of the cathedral.

At the museum, the Largillières, the Rigauds, the de la Tour, a small *Vieillard* [Old Man] by Rembrandt, a moving sketch, the Granets, whose watercolors especially please me. The *Thétis*.[1] Across from it is a small Greek bas relief: a horse with a nude man and a splendid woman. A beautiful figure of a seated woman, a small classical sculpture.

At the Jas de Bouffan, the pool Cézanne often painted, a sumptuous salon, gilded furniture, consoles, Chinese objects, a Veronese, and, on the wall, some Cézannes:[2] fiery, young, without great depth, Christ (after Navarete) [*sic*], black, white and red, the Lancret, hard and stifling, a portrait of an emperor, two very spirited heads. I am reminded of Claude and his ideas in Zola's *L'Oeuvre*.

Cézanne. At the door: "Ring for Monsieur Cézanne." We go upstairs, no one. Coming down, a person tells us, "He's at high mass at Saint-Sauveur." He was just walking out as we arrived: gray-green overcoat, stained jacket and vest, dirty hands, bare head. We introduce ourselves. He remembers having written to me, even my address. "I read *L'Occident*! Ah, the seven-

teenth century!"[3] (There's a beggar; we want to give him something.) "Enough,"[4] Cézanne cries, and, in a lower voice, "he's a drunk; drinking has its good points, but you mustn't overdo it. Ah, the Middle Ages; there is everything in the cathedrals. I loved Veronese and Zurbaran too, but the seventeenth century, that's perfection! So you went to the Jas de Bouffan? Those things aren't great, but they're painting. It's so hard!" He points to a rivulet in sunlight. "How do you make light? Reflections? What contrasts can you use? You have to find the gray.[5] Light isn't a thing that can be reproduced. It has to be represented by something else, by colors.[6] I was very pleased with myself when I discovered that. I wanted to make decorative landscapes like Hugo d'Alési,[7] yes, with my small sensibility. I'm looking for ways to apply the ideas of Couture, Gavarni, Traviès, Forain, but I don't much like A. Faivre . . .[8] Degas isn't much of a painter; he lacks 'that,'" he says, making an energetic gesture of drawing like Michelangelo.[9]

He loves the *Balthazar*[10] and talks about it. "How well-rounded the forehead is and all the detailed planes; and also the balance of the patches in the composition.[11] But above all, Delacroix!" The last time he was in the Louvre, however, though he hardly dares admit it, he found the sensation of light lacking in Delacroix. Daumier: "His aesthetics are too loose,[12] but how expressive he is! Pissarro: a sincere and lucid spirit. Monet: he really hit upon something big in 1869.[13] Since then, he's a success, but the work isn't as good.

"I look for light—the cylinder and the sphere.[14] I want to use color to make black and white,[15] to re-create what is given by the confusion of sensations. Sensations first and foremost!"[16]

He does not speak about modeling or values. "When I begin, I work easily. It's only afterward that I make corrections." He talks about his painting of the *Baigneuses*, which he has taken up again after many years. "When my figures come into my mind, I make them smaller with this," he said, showing us his hand. He talks about the contrasts in the *Noces de Cana* [The Marriage Feast at Cana],[17] making a diagram of it. He finds the same structure in Delacroix's *Bouquet* from Choquet's collection.

"For the painter, pride is everything. Even Mathô[18] in *Salammbô*, and the others, hardly compete. You have to have pride but not let it show too much; you have to be decent. But Gauguin was too proud; he shocked me. Renoir? He's too stiff.

"You have to have a method. My father was a good man. When people attacked him, he'd say, 'People have to play games.' That's what I search for

93

in painting. I don't have a doctrine like Bernard, but you have to have theories, sensations and theories. I wanted to copy nature, but I never could do it."

In his studio, *The Bergers d'Arcadie* [The Arcadian Shepherds], Chocquet's Delacroix, Daumier's *l'Amateur* [Collector], Delacroix's *Chasseur* [Hunter], some of Forain's *Figaro*[19] illustrations. He tells us, "I am a milestone, for others will come who . . . Well, at my age, you think of eternity. To paint until the end, but you've got to have religion. It wouldn't be natural to think of these things when you're young."

Maurice Denis to Marthe Denis

My dear Marthe, Sunday night

We are in Marseilles, but only to sleep tonight. I'm still quite emotional about our day in Aix, which I'll tell you about in detail. First of all, Aix is handsome: a city like Rome with magnificent old façades eroded by time, a fine museum, a beautiful cathedral, marvelous countryside. But what made the day was Cézanne.

We found him just as he was leaving high mass at the the cathedral. There he was, wearing his old, paint-smeared jacket. He practically walked right into us; we introduced ourselves and he remembered everything he knew about me, even my address. Then, he talked with us for half an hour and arranged to meet us again after lunch at his "motif."

It was some distance to his motif, a view of Mont Sainte-Victoire (a great, pointed mountain in the area). He goes there by carriage. We found him painting in the olive groves there. I drew him. He talked with Roussel, who was beaming with pleasure as I've never seen him before! Cézanne speaks very well; he knows what he's doing and what he's worth. He is unassuming and highly intelligent.

Later, he took us to his studio, then to his house, then to a café where we drank to his health. His son went with us and asked after you. As for the paintings, there are two or three interesting things in the works, but no more. Vollard must take them all as soon as they are finished

I've written only about Cézanne, but for me he's the most important thing today. [. . .]

Yours, Maurice

KARL ERNST OSTHAUS
1906

Osthaus (1874–1921) was the founder of the Folkwang Museum at Hagen, a collection notable for its holdings of French Impressionist paintings. The contents of the Folkwang were sold after the death of Osthaus in 1921, but were bought en bloc for a new Folkwang Museum at Essen, where they still are: they included the two Cézannes (RP690 V651 and RP797 V767) which Osthaus bought from Vollard in Paris shortly after his visit to the painter in 1906, a visit described in the following article.

This account is valuable for the few utterances of Cézanne which it records, once or twice left in the original French, and for the setting in which it places the aging painter, describing both the Provençal countryside and the town of Aix. It was originally published in German in Das Feuer (1920–21, pages 81 to 85), but there are translations by John Rewald of large parts of it into French in his monograph of 1939, and in Marianne for 22nd February 1939: the French version in the Macula edition of the present publication was based upon, and incorporated, that of John Rewald, which was included there through his generosity.

It is Theodore Reff's view (1960, 158) that there are derivations from Vollard in this article in the references to "an old invalid" as model for the Baigneuses, and to Poussin. However, as Professor Reff himself notes, there are other allusions to Poussin in Cézanne's recorded utterances (see index); and it is not unreasonable to believe, so various are they in phraseology, that they are all both independent and authentic. It may be noted that Osthaus finds it unlikely that it is the classicism of Poussin that appealed to Cézanne.

"A Visit to Paul Cézanne" (*Das Feuer*)

On April 13, 1906, my wife and I found ourselves standing in front of a simple bourgeois house on a narrow street in Aix-en-Provence. We hesitated a moment before ringing the bell, because in this house, far from the busy streets, the great master Cézanne lived in quiet seclusion.

When the door was opened for us, we entered into an apartment which told us nothing about the special character of its inhabitant.[1] We saw no paintings on any of the walls. Cézanne greeted us unpretentiously. Still standing, we told him that we were taking advantage of a trip to Tunisia in order to pay our respects, that we had admired his art a long time, and that we very much wanted to buy a painting for our collection.

The artist asked us several questions which gave us the opportunity to speak briefly about the goals and acquisitions of the Folkwang Museum. He was impressed by the names of the masters we told him were represented. He became talkative and began to explain his ideas about painting.

As illustrations he showed us several canvases and small sketches that had escaped greedy dealers[2] that he found in different parts of the house. They depicted masses of bushes, rocks, and mountains arranged in successive layers with clouds floating above. "The principal thing in painting," he said, "is finding the correct distance. It is color that expresses all changes in depth.[3] That's how to recognize talent in a painter." And having said this, he traced with his finger the edges of the painting's various planes.[4] He showed exactly where he had succeeded at suggesting depth and where he had not quite succeeded, where color simply remained color without having become the expression of distance. His words were so convincing, so lively, that I remembered thinking that never had my eye been so well educated in such a short time.[5] He was very pleased when I confessed that to him.

Then he spoke to us about painting in general. Was it out of courtesy for his German visitors that he placed Holbein above all others on his list of painters? In any case, he did it with such force that we never would have questioned his conviction.

"But Holbein," he exclaimed, "no one can touch him. That's why I cling to Poussin."[6] This declaration stunned me somewhat, because we are usually accustomed to thinking of the French baroque in terms of classicism. But Cézanne admired him as a painter, and later I understood his admiration for Poussin.

Among the moderns, Cézanne spoke with great warmth of Courbet. He admired in him the boundless talent for which no difficulty existed. "As great as Michelangelo," he said, but with this one condition, "he lacks 'elevation.'"[7]

These remarks magnificently completed his lesson on his own painting. They proved that the supreme law of all art was known and familiar to him: without "elevation" beyond the surface appearance of things, without grasping the eternal in nature, there was for him, in the end, no art.

He barely mentioned Van Gogh, Gauguin, and the neo-Impressionists.[8] "They make things easy for themselves," he said. Then in conclusion, he began to praise artists of his generation and training. Taking the posture of a great orator, with raised finger, he exclaimed, "Monet and Pissarro, the two great masters, those two stand alone."[9]

The noon hour approached, but he obviously did not consider our visit over. He insisted that we to come see him after lunch, in his studio in the country, where he was working on a painting.

On the way to the restaurant, we went into the cathedral which was decorated for Easter services with an incomparable collection of tapestries. How beautiful they were, living still in the heart of the culture that produced them!

The harmony of their colors did not express depth; on the contrary, the colors seemed so totally interwoven into the surface that we felt only that the space they decorated was agreeably solid. Nonetheless, the tapestries recalled the paintings of Cézanne. How can this kinship be explained? Was there in his paintings something which surpassed, perhaps without the master's knowledge, the impressionist vision of depth? The recent evolution of painting has taught something about this. More than the sense of space, it values the distribution of colors in the painting,[10] the bouquet woven by the master's hand, as if flowers were the point. His paintings are the first of our time that seem to exist only for color. And what he feels to be an "elevation" was perhaps nothing more than the essence of colors, that he causes to delight.

The afternoon would reveal to us the sources from which the master drew the charm of his works. Aix is a small medieval city with narrow streets and tall houses crowded around the cathedral. The new section is crossed by wide allées of plane trees, with gurgling fountains; the luminous vaults of the trees make one feel the nearness of the Riviera. Gentle hills rise all around. From the sunny paths which climb sinuously between stone walls, from time to time, thanks to open gates, one's view falls on a

97

marvelous countryside. The Alpes Maritimes encircle the city on the horizon, their peaks projecting up into an absolutely Elysian atmosphere. The winds of Provence seem peaceful here. All colors glow in a pure light. And this welcome brightness and sweet melancholy which spread over the countryside have become a specific characteristic of the paintings of the master of Aix. Yet he did not seize the soul of the country through colors alone; wherever one's eyes rest, one sees rising up the familiar mountainous curves found in his work. The entire landscape is a panorama which has given form to his paintings.

And so, guided by the spirit of this blessed countryside, we arrived at the artist's villa, which dominates the landscape from a high hill. Cézanne was already waiting for us. He asked us into the simple house, which was topped by a floor containing several empty rooms, and the large studio which was equally bare. It was here that, during his last years, he created most of his immortal works. On the easel stood a still life just barely begun and the great work of his old age, *Les Baigneuses.* The tall tree trunks leaned inward forming the cathedral vault under which the bathing scene took place.[11] We spoke about painting nudes. Cézanne complained about narrow provincial opinions which made it impossible to have a female model. "A sickly old man poses for all these women." The connoisseur of noble feminine beauty will one day possibly be consoled by the idea that the nudes in this painting are not of a more elevated origin. But for those who dare to keep in mind that the artist sought the image of nature only in order to find the spatial implications of color, this peculiar substitution will be easier to accept.

At the end of our visit to his studio the master brought chairs to the terrace in front of the house, where there was a splendid view over the city surrounded by mountains. We spoke at length of the beauty of the landscape and the roots which tie his art to this sun-filled country. Cézanne was in an extremely amiable mood and in excellent humor. He even promised, in spite of all the dealers who chased after him, to send us some paintings at Hagen[12] and, smiling, he allowed my wife to take a photograph to record our time together.

In the evening as we walked through the countryside, thousands of red tulips[13] spread their fire amid new green leaves, and countless numbers of larks rose singing in the clear sky.

The night express train tore us away from this paradise to convey us to the boat at Marseilles. Cézanne was unable to keep his promise to send us paintings in Hagen. He died that same year.

Later, in Paris, as we talked about our visit to Aix, people looked at us as if we had escaped from hell. Only then did we realize that Cézanne was considered by his admirers to be impossibly disagreeable and that they thought it wise to avoid him as one would a field of thistles.

PAUL CÉZANNE

This document was first published in 1973 by Adrien Chappuis in his catalogue raisonné of Cézanne's drawings (pages 49 to 52). Joachim Gasquet had, however, made use of it for his Cézanne, where he not only reproduced its Alfred de Vigny quotation in facsimile, but also referred to the album in a footnote (1926, 67). Its provenance, taken back to Joachim Gasquet and to his father Henri Gasquet, is given by Chappuis in detail, together with a full description, photographic illustrations of the document, and annotation of Cézanne's answers to questions.

For the album is a record of a middle-class parlor game of a still familiar kind: a set of questions designed to elicit, through their answers, the preferences, habits, and character of the person questioned. So pervasive were Cézanne's artistic interests that they emerge, even in these brief answers, in the form of echoes of phrases and notions to be found elsewhere in the texts of the present volume.

Dr. Chappuis (whose kindness made it possible for us to reprint this document) dated Mes Confidences *to the years 1866–69, and it may be that information transmitted by past owners must in this matter be granted the last word. If this date is to be criticized, then other evidence, such as the evolution of Cézanne's signature and handwriting, must be invoked. An early date, it should be said, would affect our whole view of Cézanne's aesthetic, for it would tend to prove that some of his basic tenets, now known only in late documents, were held for nearly forty years.*

Mes Confidences *is here placed at the end of our reprinted eyewitness*

texts to bring out the linguistic connections with late documents; but the date remains a matter of controversy. A puzzling alternative version of this questionnaire, with slightly different answers by Cézanne, exists. I have been unable to reassess this for the purposes of the present publication.

Since the original publication of Conversations with Cézanne, *Jean-Claude Lebensztejn has argued effectively for a* circa *1896 dating for* Mes Confidences *(see bibliography, Lebensztejn, 1995). Gowing (1977) had already favored a late date.*

My Confidences

First and Last Names: Paul Cézanne
Place of Birth: Aix-en-Provence
Place and Date of Interview: Third floor of 30 rue Saint Louis (ca. 1896)

1. Q: What is your favorite color?
 A. *General harmony.*[1]

2. Q: What is your favorite smell?
 A: *The smell of fields.*

3. Q: What flower do you find the most beautiful?
 A: *Scabiosa.*

4. W: What animal do you like best?
 A: No answer

5. Q: What color eyes and hair do you like best?
 A: No answer

6: Q: What do think is the highest virtue?
 A: *Friendship*

7. Q: What vice do you most hate?
 A: No answer

8. Q: What is your favorite thing to do?
 A: *To paint.*

9. Q: What is your favorite form of relaxation?
 A: *Swimming.*[2]

10. Q: In your opinion, what is the ideal of earthly happiness?
 A: *To have my own beautiful way of painting* (belle formule).[3]

11. Q: What fate would you most dread?
 A: *To be destitute.*[4]

12. Q: May we ask your age?
 A: No answer.

13. Q: What name would you prefer if you could have chosen for yourself?
 A: *My own.*

14. Q: What was the most beautiful moment of your life?
 A: No answer.

15: Q: What was the most painful?
 A: No answer.

16: Q: What do you most hope for?
 A: *Certainty.*

17. Q: Do you believe in friendship?
 A: *Yes.*

18. Q: What is your favorite time of day?
 A: *Morning.*

19. Q: Who is the historical figure you most admire?
 A: *Napoleon.*

20. Q: What character from a novel or the theater?
 A: *Frenhoffer* [*sic*].[5]

21. Q: In what region do you prefer to live?
 A: *Provence and Paris.*

22. Q: Who is your favorite author?
 A: *Racine*

23. Q: Who is your favorite painter?
 A: *Rubens.*

24. Q: Your favorite musician?
 A: *Weber.*

25. Q: What motto would you choose if you had to have one?
 A: No answer.

26. Q: In your opinion, what is the great masterpiece of nature?
 A: *Its infinite diversity.*[6]

27. Q: Of what place do you have the most pleasant memories?
 A: *The hills of Saint-Marc.*[7]

28. Q: What is your favorite food?
 A: *Potatoes with oil.*

29. Q: Do you prefer a firm or soft mattress?
 A: *In between.*

30. Q: Which foreigners are the most agreeable to you?
 A: *None.*

Write one of your own thoughts or a quotation whose meaning you agree with.

 A: *Lord, you have made me powerful and solitary.*
 Let me sleep the sleep of the earth. De Vigny[8]

INTERPRETATIONS

JOACHIM GASQUET

Joachim Gasquet (1873–1921) was the son of Henri Gasquet, a friend of Cézanne's since their schooldays. Joachim and Cézanne first met in March or April 1896, at about the time when the painter broke with Gustave Geffroy.

Gasquet was a writer and poet of effusive style, politically a man of the right, and a Provençal regionalist in his literary allegiances, being a member of the Félibres.

Cézanne and Gasquet (see Rewald, 1960, passim, for a full account of this) were on close terms up to 1900, but by early 1901 were no longer meeting frequently and were hardly in contact between then and 1904, when, however, they seem to have met once more, only to part in violent disagreement. During their years of friendship they must have conversed freely: Cézanne painted Gasquet's portrait in 1896 (Prague, Národní Galerie, RP809 V694), and wrote a considerable number of letters to him.

Gasquet's Cézanne was written, according to Marie Gasquet, his wife (1928, 56), in the winter of 1912–13. It was published in 1921, just before he died, and there was a second edition, textually identical, in 1926. The book constitutes one of the major problems in Cézanne studies. Its biographical section gives much invaluable information about the painter and about the Provençal milieu, vividly expressed. But "he wanted to make of Cézanne what Plato made of Socrates" (Jaloux, 1942, 75), and the three dialogues Ce qu'il m'a dit . . . , here reprinted complete from the 1926 edition, combine the authentic with the speculative.

Thus quotations from Bernard's Souvenirs, *from Maurice Denis' short article "Cézanne" (1907: reprinted in this volume), from Cézanne's letters to Camoin and to Gasquet himself, and from elsewhere (sources being sometimes indicated by Gasquet, but usually not) are mingled inextricably with Gasquet's own approximate and very personal version of Cézanne's discourse, in a high-flown prose remarkably like that of Gasquet's own publication* L'Art vainqueur *(1919). Theodore Reff (1960, 155–56) has given some examples of Gasquet's ruthless editorial procedures, and the notes given here indicate further instances. Some passages—similarly noted here—may be genuine reports of independent Cézanne utterances. It should also be borne in mind that Cézanne's own style of writing could vary, and at least one authentic letter (that written to Gasquet on 21st July 1896) matches briefly the eloquence of Gasquet himself (typical of a Félibre).*

In general, however, these imaginary conversations are more valuable for their atmosphere than for their reporting; but, unlike other texts, they remind us forcefully of that meridional literary culture upon which Cézanne fed, and which he also in many ways rejected.

A complete English translation of Gasquet's Cézanne *is now available: see the bibliography.*

<div align="center">

"What He Told Me . . ."
Excerpt from *Cézanne*

</div>

I have reported nearly all that I have learned, both directly from him during time we spent together and from others who visited him, all that I know about the life of Cézanne. His was the life of a saint. I have tried to discuss art theories as little as possible, reporting only one conversation to emphasize a hidden character trait and to shed some light on a facet of his mysterious soul. These are infinitely delicate matters. No matter how objective I try to be, a little bit of myself is bound unconsciously to find its way into my writing. Also, I am not a painter and, as respectful as I may be, I fear misrepresenting the profound lessons that can be taken from all his statements, in spite of my honest intentions. However, my faithful memory collected them religiously. I shall try to transcribe them as they are, with the help of his letters, both those written to me and those I have been able to borrow or which have been published by others to whom they were written, such as the precious correspondence provided by Emile Bernard in his *Souvenirs*. Whenever possible I shall transcribe

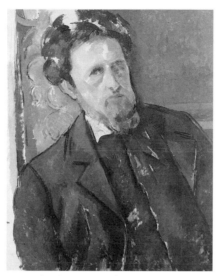

Portrait of Joachim Gasquet, oil, 1896

Cézanne's exact words. I shall invent nothing except for the order in which I present them. After long consideration, I have decided to group them into three long dialogues, the better to express their meaning. For the three imaginary conversations, I have collected all I have been able to remember of his ideas on painting from a hundred real conversations I had with him in the fields, in the Louvre, and in his studio. This is what he said and, I believe, what he thought.

THE MOTIF

Nature is seen more as depth than as surface.

That day, we surveyed the valley of the Arc from under a tall pine tree on the side of a green and red hill in the area of La Blaque, not far from Les Milles and three-quarters of an hour from Aix and the Jas de Bouffan. The sky was blue and fresh, an early autumn morning at the end of summer. The city, hidden by the side of a hill, could be discovered from its smoke. We turned our backs to the ponds and on the right one could see the horizons of Luyne and the Pilon du Roi, and imagine the sea. Before us, under the virgilian sun, lay Mont Sainte-Victoire—huge, delicately tinged with blue—the undulations of the Montaiguet, the Pont de l'Arc viaduct, houses, rustling trees and square fields, the countryside of Aix.

This is the landscape Cézanne painted. He worked on his brother-in-law's land, where he had set up his easel in the shade of a stand of pines. He had been working there for two months, on one picture in the morning and another in the afternoon. Work was going well; he was content. This session was nearly over.

Balance slowly infused his painting. His chosen image, meditated upon, linear in its logic, and which he must have quickly sketched out in charcoal, as was his habit, began to emerge from the colored patches that encompassed it on all sides. The landscape seemed to be fluttering, because Cézanne had slowly delimited each object, sampling, so to speak, each tone. Day after day he had imperceptibly and with a sure harmony brought together his color values. He linked them to one another in a veiled brightness. Volumes emerged, and the great canvas reached its maximum equilibrium and saturation of color, which, according to Elie Faure, are characteristic all of his paintings.[1] The old master smiled at me.

CÉZANNE: The sun shines and fills my heart with hope and joy.[2]

ME: You are happy this morning?

CÉZANNE: I have my motif . . . (He clasps his hands together.) A motif, you see, it is this . . .

ME: What?

CÉZANNE: Oh, yes! (He repeats his gesture, separates his hands, spreading his fingers apart, and brings them slowly, very slowly together again, then joins them, clenches them, intertwining his fingers.) That's what you have to attain. If I go too high or too low, all is lost. There must not be even one loose stitch, a gap where emotion, light, and truth can escape. Try to understand, I guide my entire painting together all the time. I bring together all the scattered elements with the same energy and the same faith. Everything we see is fleeting, isn't it? Nature is always the same, but nothing about her that we see endures. Our art must convey a glimmer of her endurance with the elements, the appearance of all her changes. It must give us the sense of her eternity. What is beneath her? Perhaps nothing. Perhaps everything. Everything, you understand? So, I join her wandering hands . . . I pick her tonalities, her colors, her nuances from the left, from the right, here, there, everywhere. I fix them; I bring them together . . . They form lines. They become objects, rocks, trees, without my thinking about it. They take on volume. They have color values. If these volumes and values correspond on my canvas and in my senses, to my planes and patches, that you also see before you, well, my painting joins its

hands together.³ Nature doesn't waver; it passes neither too high nor too low. It is true, it is dense, it is full . . . But if I have the least distraction, the slightest lapse, if I interpret too much one day, if today I get carried away with a theory that contradicts yesterday's, if I think while I am painting, if I intervene, then bang! All is lost; everything goes to hell.⁴

ME: What do you mean, "if you intervene"?

CÉZANNE: An artist is only a receptacle for sensations,⁵ a brain, a record-ing device . . . Damn it, a good machine, but fragile and complex, espe-cially where others are concerned . . . But if it intervenes, wretched thing, if it dares of its own will to intervene in what it should only *translate*, if its weakness infiltrates the work, the painting will be mediocre.

ME: So, in your opinion, the artist is inferior to nature?

CÉZANNE: No, that's not what I said. How do I explain this to you? Art is a harmony parallel to nature. What would you think of idiots who would tell you, the painter is always inferior to nature!⁶ They are parallel, if the artist doesn't intentionally intervene . . . hear me well. His entire will must be silent. He must silence all prejudice within himself. He must for-get, forget, be quiet, be a perfect echo. Then the full landscape will inscribe itself on his photographic plate. In order to fix it on his canvas, to exteri-orize it, his craft comes into action. But it must be a respectful craft which, itself also, is ready only to obey, to translate unconsciously so long as it knows its language well, the text it deciphers, these two parallel texts: na-ture seen and nature felt, the nature which is out there . . . (he indicates the blue and green plain) and the nature which is in here . . . (he taps himself on the forehead) both of which must unite in order to endure, to live a life half human, half divine, the life of art, listen a little . . . the life of God. The landscape is reflected, becomes human, and becomes conscious in me. I objectify it, project it, fix it on my canvas. The other day, you spoke to me of Kant. I probably can't say this clearly, but it seems to me that I'll be the subjective conscience of this landscape, just as my painting will be the objective conscience.⁷ Both my painting and the landscape are outside of me. One is chaotic, fleeting, confused, and without logical being, external to all logic. The other is permanent, tangible, organized, participating in the modality and drama of ideas . . . and in their individu-ality. Yes, I know, that's an interpretation . . . I didn't go to the university. I wouldn't dare talk like this in front of Dumesnil . . .⁸ Oh, God! How I envy your youth with everything bubbling up within you! But time pushes me on. Perhaps I was wrong to joke like that . . . Not theories! Works of art . . . Men can get lost in theories. It takes a hell of a lot of

energy, an almost inexhaustible vitality, to resist them. I ought to be more level-headed. At my age I should remember that getting carried away like this is bad for me. It always gets me into trouble.[9]

His mood darkened. He was often despondent after an outburst of enthusiasm like this. I did not dare try shake him out of his melancholy; he would only become enraged. He was suffering . . . After a long silence, he took up his brushes and looked back and forth from his canvas to his motif.

No, no. Look. That's not at all right. General harmony doesn't exist. This painting doesn't feel anything. Tell me what perfume emanates from it. What odor does it emit? Let's see.

ME: The smell of pine trees.

CÉZANNE: You say that because of the two tall pines spreading their branches in the foreground . . . But that's a visual sensation . . . Anyway, the totally blue odor of the pines which is harsh in the sun, must marry the green odor of the fields which freshen there each morning, with the odor of the stones, and the perfume of marble from Sainte-Victoire in the distance. I haven't gotten it yet. I have to realize it. And in colors, without words. Like Baudelaire and Zola who, through a simple juxtaposition of words, mysteriously perfume an entire verse or sentence. When sensation is at its fullest, it is in harmony with all existence.[10] The world spinning in the back of the brain causes the same movement that is perceived by the eyes, ears, mouth, and nose, each with its own poetry. And I believe that art puts us in that state of grace where universal emotion is somehow expressed to us precisely, but very naturally. We should find general harmony, like that expressed by colors, everywhere. Look, if I close my eyes and think of the hills of Saint-Marc, you know, my favorite corner of the world, they bring me the aroma of scabiosa, my favorite perfume. I hear all the green woodsy odors of the fields in Weber. In Racine's verses I feel a local color as in a Poussin. In the same way, an ode, a whisper, a rhythm of Ronsard unfolds under some of Rubens's purples.[11]

You know that while Flaubert was writing *Salammbô,* he said that he was seeing purple.[12] Well, when I was painting *Vieille au chapelet* [Old Woman with a Rosary], I saw a tone of Flaubert, an atmosphere, something indefinable, a bluish and russet color which emanated, it seemed to me, from *Madame Bovary.* In vain I tried reading Apuleius to chase away this obsession which I feared would be too literary and would hurt my painting. Nothing worked. This great bluish-red aura descended over me and sang in my soul. I was completely bathed in it.

ME: So it interposed itself between you and reality, between your eyes and the model?

CÉZANNE: Not at all. It floated as if somewhere else. I studied all the details of the clothing, the coif, the folds of the apron. I studied the cunning face. Only later did I realize that the face was reddish, the apron bluish, as if it wasn't until the painting was finished that I remembered the description of the old servant at the agricultural fair.[13] What I'm trying to explain is more mysterious. It's tangled up in the very roots of existence, in the intangible source of our sensations. It's the very thing which I believe makes up our temperament. Only the initial strength of temperament can carry a person to the goal he is striving to reach.[14] I told you earlier that when liberated, the brain of the artist, at the moment he creates, should be like a photographic plate, simply a recording device. But many skillful baths have brought this plate to the point of receptivity where it can be impregnated with the conscientious image of objects. Long labor, meditation, study, suffering, joy, and life have prepared it. Constant reflection on the methods of the old masters. And then, the atmosphere in which we live our lives, under this sun, think about this now . . . the accident of the sun's rays, the sun's movement, its penetration, and the incarnation of the sun across the world, who will ever paint that? It would be the physical history, the psychology of the earth. Everything, more or less, beings and things, we are only a little stored, organized solar warmth, a souvenir of the sun, a bit of phosphorous burning in the membranes of the world. You should have heard my friend Marion on that subject.[15]

As for me, I'd rather free this essence. It may be that the moral force scattered throughout the world represents its will to become the sun once again. That is its idea, its sentiment, its dream of God. Everywhere a ray of sun strikes on a darkened door. Everywhere a line delimits a tone, holds it prisoner. I want to liberate them. The great classical countries: our Provence, Greece, and Italy, as I imagine them, are where brightness is spiritual, where a landscape is an elusive smile of keen intelligence. The delicacy of our atmosphere is connected to the delicacy of our spirit. They go hand in hand. Color is the place where our brain meets the universe. That's why color seems so completely moving to real painters. Look at Sainte-Victoire. What animation, what overpowering thirst for sun! But what melancholy there is at night when inertia descends . . . These boulders were made of fire. There is still fire in them. In daylight the shadows seem to retreat, shivering, in fear of these stones. Up there is Plato's cave.

Notice how, when thick clouds pass over it, their shadow shudders over the rocks, as if they are being burned, suddenly swallowed up in fire. For a long time I was powerless, I didn't know how to paint Sainte-Victoire, because I imagined, just like all the others who don't know how to see, that shadows were concave. But look, it is convex; its edges recede from its center. Instead of becoming stronger, it evaporates, becomes fluid. Shadow participates in the blueness of the air's ambient breath. Over there at Le Pilon du Roi, you can see, on the contrary, how brightness creates a moist and shimmering illusion. It's the sea . . . And that's what one must paint. That's what one must know. That's the bath of knowledge, if I dare say so, into which we must dip our photographic plate.

In order to paint a landscape correctly, first I have to discover the geographic strata. Imagine that the history of the world dates from the day when two atoms met, when two whirlwinds, two chemicals joined together. I can see rising these rainbows, these cosmic prisms, this dawn of ourselves above nothingness. I immerse myself in them when I read Lucretius.[16] I breathe the virginity of the world in this fine rain. A sharp sense of nuances works on me. I feel myself colored by all the nuances of infinity. At that moment, I am as one with my painting. We are an iridescent chaos. I come before my motif and I lose myself in it. I dream, I wander. Silently the sun penetrates my being, like a faraway friend. It warms my idleness, fertilizes it. We germinate. When night falls again, it seems to me that I shall never paint, that I have never painted. I need night to tear my eyes away from the earth, from this corner of the earth into which I have melted. The next day, a beautiful morning, slowly geographical foundations appear, the layers, the major planes form themselves on my canvas. Mentally I compose the rocky skeleton. I can see the outcropping of stones under the water; the sky weighs on me. Everything falls into place. A pale palpitation envelops the linear elements. The red earths rise from an abyss. I begin to separate myself from the landscape, to see it. With the first sketch, I detach myself from these geological lines. Geometry measures the earth.[17] A feeling of tenderness comes over me. Some roots of this emotion raise the sap, the colors. It's a kind of deliverance. The soul's radiance, the gaze, exteriorized mystery are exchanged between earth and sun, ideal and reality, colors! An airborne, colorful logic quickly replaces the somber, stubborn geography. Everything becomes organized: trees, fields, houses. I see. By patches: the geographical strata, the preparatory work, the world of drawing all cave in, collapse as in a catastrophe. A cataclysm has carried it all away, regenerated it. A new era is born. The true one! The

one in which nothing escapes me, where everything is dense and fluid at the same time, natural. All that remains is color, and in color, brightness, clarity, the being who imagines them, this ascent from the earth toward the sun, this exhalation from the depths toward love. Genius would be to capture this ascension in a delicate equilibrium while also suggesting its flight. I want to use this idea, this burst of emotion, this smoke of existence above the universal fire.[18] My canvas is heavy, a heaviness weighs down my brushes. Everything drops. Everything falls toward the horizon. From my brain onto my canvas, from my canvas toward the earth. Heavily. Where is the air, the dense lightness? It would take genius to discover the amity of all these things in the open air, in the same ascent, in the same desire. A minute of the world goes by. To paint it in its reality! And to forget everything else. To become reality itself. To be the photographic plate. To render the image of what we see, forgetting everything that came before.[19]

ME: Is it possible?

CÉZANNE: I have tried.

He lowered his head, then raised it suddenly, dominating the landscape with his gaze, his eyes devouring his painting with a long caress. He smiles faintly.

Who knows? Everything is so simple and so complicated.

ME: You said it was necessary to forget everything. Why then this preparation and all this meditation before the landscape?

CÉZANNE: Because, unfortunately, I'm no longer innocent. We are civilized. We have academic concerns within us, whether we like it or not. I want to express myself lucidly in painting.[20] There is a kind of barbarism, even more despicable than the École itself, among the false primitives. It's impossible to be primitive today. We can't be; we are born with a certain facility.[21] We have to overcome it; it is the death of art. I think about the first men who engraved their dreams of the hunt on the vaults of caves or about those good Christians who painted their paradise in frescoes on cemetery walls, who created themselves, who created everything for themselves: their craft, their souls, their impressions. I want to be like them when I stand before a landscape. To draw religion from it.[22] It seems to me that on certain days I paint naïvely. I am the primitive of my own way.[23] With my clumsy faith, I'd like to listen a little, attain the method . . . represent fully. Because, it has been said in vain, the worst decadence is to play at ignorance and naïveté or senility. It's impossible not to know today, to learn by oneself. We acquire our craft at birth. Badly. And it's necessary to work on that. Everywhere, people wade in this vast secular school called society. And, yes, there is classicism, the kind those students of the Ecole

are taught, the kind of thing I hate most of all. Then I imagine that, just as for God, as someone said, if a little learning moves you away, a lot of learning leads you back. Yes, much learning leads us back to nature. Through an understood insufficiency of pure craft.

ME: Insufficient skill?

CÉZANNE: Yes, abstract skill. In the end it dries up under its own rhetoric which becomes forced and enervated. Look at the Bolognese artists.[24] They have no feeling anymore . . . The artist must never have an idea, a thought, a word in mind when he needs a sensation. Great words are thoughts that don't belong to you and clichés are the leprosy of art. Take mythology, one can trace it throughout painting. It's the history of an invading craft. When they painted goddesses, in the end, didn't they really just paint women? Look around the salons. If a fellow doesn't know how to render reflections of water on leaves, he paints in a nymph. Take Ingres's *La Source* [The Spring]! What does that have to do with water . . . And you, in literature, you shout and grind out pages about Venus, Zeus, and Apollo when you no longer can say with deep emotion the words: sea foam, clouds in the sky, heat of the sun. Do you believe in all this worn-out olympian claptrap? Well?

Nothing is beautiful except what is true; and only true things should be loved.[25]

ME: But what about Veronese, Rubens, Velasquez, Tintoretto, all the artists you love?

CÉZANNE: Oh, them! They had such vitality that they could make sap run in all those dead trees, their own sap, their own prodigious lives . . . Their flesh tastes of caresses, of warm blood . . . When Cellini shook the bleeding head of Perseus, he had truly murdered. He had felt a tepid flow of blood stick to his hands . . . One murder each year, that was his average. They had no other truth. These bodies of the gods and goddesses were in their blood. They glorified man in the face of the Madonnas and saints in whom they didn't believe. Think about how cold their religious painting is. Tintoretto constantly goes beyond his subjects and takes an interest in them. Titian's *St. Jerome* in Milan with all his animals, his snail, his rocks that cluster around him—is he an ascetic, a stoic, a philosopher, a saint? Who knows? He's a man. An old, bald man with his stone in his hand, ready to strike at the enigma, the magic flint, to make sparks of truth. Truth rises in all its reddish color from this ferocious painting. It doesn't fall from the arms of the cross, which we don't see at first, which is there because the painting was commissioned by some order or some church.

There is a painter . . . They are true pagans. In the Renaissance there is an explosion of unique truth, a love of painting and forms not to be seen again. The Jesuits came and everything was affected, pompous. One learns, one teaches everything. It took a revolution for us to rediscover nature, for Delacroix to paint his beach at Étretat, Corot his Roman hovels, Courbet his forest floors and his waves. And such a painfully long time and such great distances! They make do . . . Rousseau, Daubigny, and Millet. They compose landscapes like a history painting, I mean, from the outside. . . . They create the rhetoric of landscape, a phrase, passing sensations, the conspiracy of painting that, according to Rousseau, Dupré taught him. Even Corot. I prefer a more stable painting. They had not yet understood that nature exists more in depth than on the surface.[26] Because, listen, one can alter, decorate, caress the surface, but one can't touch depth without touching truth. A wholesome need to be true takes over. I would rather smash my canvas than invent or imagine a detail. I want to *know*.

ME: To know?

CÉZANNE: Yes, I want to know. To know so I can sense better, sense in order to know better. Even if I am the first in my craft, I want to be simple. Those who know are simple. The half-wise, the amateurs make half-creations. You know, basically, the only amateurs are those who make bad paintings. Manet told Gauguin that. I wouldn't want to be one of those amateurs. I want to be a true classic, to be come classic again through nature, through sensations.[27] Before, I was confused. Life! Life! I only talked of this one thing. I wanted to burn down the Louvre, poor fool! An artist must go to the Louvre via nature and return to nature via the Louvre . . .[28] But Zola really stabbed me in the back in *L'Oeuvre*, maybe you don't remember it, when he bawled, "Ah! Life! Life! To feel it and to render it in its reality, to love it for itself, to see in it the only true, eternal and changing beauty . . .

His memory failed him a minute, then he finished in one breath.

. . . Do not think stupidly about ennobling life by castrating it, or understanding that its so-called deformities are only the jokes of its characters . . . but make it live, and make men, the only way to become God."

He broke out laughing.

Well, that's enough of that . . . But there is something better. Simplicity, directness. Everything else is gibberish, self-deception. I was really carrying on this morning, I don't know why. Basically, I don't think of anything when I paint. I see colors. I paint; I enjoy transposing them just as I see them onto my canvas. They arrange themselves haphazardly, as they please.

Sometimes, that makes a painting. I am a brute. Very happy if I can be a brute . . .

He thinks.

Health is the first blessing for a painter, for everyone. What keeps me from realizing a picture, is that I'm not always in good health . . . I don't always feel good.

He watches me, looking at me sideways. A hidden anger is gnawing on him. He tries to calm it.

The old way is a Roman road. These Roman roads are always very well placed. Follow one of them. They had a feeling for the landscape; all of its directions make a picture. Our engineers don't give a damn about the landscape.[29]

He laughs.

And me! You know as well as I do that I'm in bad shape. It's the eyes, yes, my eyes . . . I see planes overlapping . . . Straight lines look like they are falling sometimes.[30] So what do you want me to do? All that is a joke.

He blinks.

If a painter has never painted gray, he is not a painter.

He feels me saddened. His kindness returns.

Listen, I was at Talloires. You want a temperate place, well, there's one! You want grays, well you've got them! And greens. All the greenish grays in the whole world. The surrounding hills are high enough, it seemed; they appear low, and it rains! . . . There's a lake between two gorges, a landscaped English lake. Sketchbook pages fall, already water-colored, from the trees. Surely that's still nature . . . But not as I see it.[31] Do you understand? . . . Gray on gray. You're not a painter if you haven't painted gray. Delacroix said that gray was the enemy of all painting, but he was wrong. You have to know how to paint gray to be a painter.

ME: Provence is often gray.

CÉZANNE: Never. Maybe silver. Blue, bluish . . . Never gray, not so much gray as glaring, yellow, flashy, like confetti that confuses all these observers who see nothing. Yes, the sun here is always bright, there's a harshness that reflects light and that makes you blink,[32] but feel how nuanced and mellow it always is. It's a slow rhythm.

N'aime que les jeux et la danse,	Love only games and dancing,
Ne cherche entout que la cadence,	Seek only cadence in everything,

as your friend Magallon says. It's very Provençal, no quick drumbeats. Everything is intensified but in the smoothest harmony. You just have to

let yourself go with it. If I were still young like you and the others, if I had the magnificent cerebral power of a Titian, who painted until he was a hundred—if the plague hadn't finished him off, that guy would still be painting—if I could, I would work all the time without tiring and you would see, I'd be the great master of the humble painters. Nature speaks to me. Well, no one has ever painted the landscape, man absent but entirely within the landscape. The great Buddhist production, nirvana, consolation without passions, without anecdotes, would only have to accumulate the colors to flower here! This land cradles you . . . Look, from far away, from Paris, I still feel it. Promise me that if I go away . . . though I'm hardly likely to get away what with my age and your being here . . . I ask you to write to me from time to time, so that I won't feel completely detached from this corner of the earth where I have always felt a rapport, even un-consciously. And do the same for others. To make them feel, without knowing . . . all Art! . . .[33] Yes, I have moved toward the logical develop-ment of what we see and feel from studying before nature, left off concen-trating on method. Methods for us are only a simple means to make the public feel what we ourselves feel and to make ourselves accepted. The great ones we admire did only that . . .[34] Why don't we have lunch?

The game-bag had been hung on a branch. The bottle was chilling in a stream. We sat near a little pond, in the sun-filled shade of the pines. Lunch was frugal, but like Phaedre under her plane tree beside the Ilissus, Cézanne talked while we ate. The countryside undulated under the blue caress of a hazy noon. White roads, bright roofs, stands of trees, the river between its two banks, everything seemed to participate in our conversation here at the foot of Sainte-Victoire. A dog appeared and my master threw him some bread crusts.

I'm really carrying on today. Yet, talking about art is almost always useless.[35]

ME: Don't you think it brings artists closer together?

CÉZANNE: Either you see a picture immediately or you never see it at all. Explanations don't help a bit. What good does it do to comment on it? All those things are imperfect, imprecise things. We talk as we do because it's amusing, like drinking a good bottle of wine. Otherwise, work which brings about progress in art is consolation enough for not being under-stood by idiots. Listen, a writer like you expresses himself in abstractions, while the painter renders his sensations, his perceptions concrete through drawing and color.[36] If his sensations and perceptions are not on the can-vas, visible to the eyes of others, then nothing you can say about them will make them comprehensible. I don't like literary painting. For an artist to

write what he thinks and what he does is to admit that his thought or gesture isn't made clear by drawing and color. And to want to force the expression of nature, to twist the trees, to make the stones grimace, like Gustave Doré, or even to refine like da Vinci, that's all still literature. There is a logic of color, damn it! The painter owes obedience to nothing else. Never to the logic of the brain; if he gives himself over to that, he is lost. Always the logic of the eyes. If he senses correctly, he will think correctly. Painting is first of all in vision. The material of our art lies there, in what our eyes think . . . Nature always finds the way to tell us what she means when we respect her.

ME: Nature signifies something to you? Isn't it what you read into it?

CÉZANNE: Perhaps . . . And even, in the end, you are right. I wanted to copy nature; I couldn't. I searched, turned, looked at it from every direction, but in vain. It's invincible, from all sides. But I was pleased with myself when I discovered that sunlight, for example, couldn't be reproduced, that I had to represent it by something else, by color.[37] Everything else, theories, drawing, which is a logic in its own way, a bastard logic, a mix between arithmetic, geometry, and color, drawing, which is a still life, and ideas and sensations themselves are only detours.

You think you are taking a short cut, but the way is longer. There is only one route for rendering everything, for translating everything: color. Color is biological, if I can put it that way. Color is living, all alone it breathes life into things. Basically, I am a man, yes? Whatever I do, I have the idea that that tree is a tree, that rock a rock, that dog a dog . . .

He stopped eating and talking suddenly. He looked as if someone or some idea just surprised him.

And yet, I don't know. With the farmers, you see, I doubted at times if they knew what a landscape or a tree was, yes, I did. You find that strange. Sometimes I have taken walks, I have followed the cart of a farmer who was going to sell his potatoes at the market. He had never seen Sainte-Victoire. They know what they have sown here and there, the distance of the route, what the weather will be tomorrow, if Sainte-Victoire has its hat on or not, they can smell it like beasts or like a dog knows what a piece of bread is, according to their needs. But that the trees are green, and that this green is a tree, that this earth is red, and that these crumbling reds are hills, I really don't believe that most of them feel it, that they know it, apart from their utilitarian unconsciousness. I must recover that instinct, without losing anything of myself, and the colors of the scattered fields must signify something for me as a harvest does for them. They feel spon-

taneously, before a yellow, the gesture of the harvest which must be begun, as I should know myself by instinct before the same ripening nuance, how to place on my canvas the corresponding tone to make a square field of wheat undulate. Stroke by stroke the earth comes alive again. Through my work, a beautiful landscape will grow in my field. Remember Courbet and his story of the bundles of wood? He stroked on his tone without knowing that this was firewood. He asked others what he was painting. They went to see. And it was firewood.[38] Thus it is for the world, the vast world. In order to paint in the essence of the world, the vast world, one has to have the eyes of a painter who, in a single color, sees the object, seizes it, and relates it to other objects within himself. The artist can never be too conscientious, or too sincere, or too submissive to nature. But he must be more or less master of his subject and, above all, of his means of expression. He must adapt them to his motif. He must not force it to conform to him, but he should conform to it, let it be born, let it germinate from within. He must paint what is before him and strive to express himself as logically as possible,[39] with a natural logic. I have never done anything else. You can't imagine the discoveries that await you this way. As for progress, only nature and an eye trained by contact with nature are required. All this becomes concentric by dint of looking and working.

ME: What do you mean by "concentric"?

CÉZANNE: I mean that in this orange that I am peeling, in an apple, a ball, a head, there is a culminating point, you see, and this point, in spite of terrible effects of light, shadow, color sensations, is always the closest to our eye. The edges of objects fade toward another point on the horizon.[40] When you have understood that . . .

He smiles.

Well, one has understood nothing if one is not a painter. Good God! Have I come up with some theories!

He takes a scrap of paper from his pocket.

I wrote to a painter whom you don't know, who came to see me and who himself formulated some theories. I told him, I wrote him, to sum up:

He reads in a slow, timid, but dogmatic voice:

"Render nature with the cylinder, the sphere, and the cone, arranged in perspective so that each side of an object or of a plane is directed toward a central point. Lines parallel to the horizon give breadth, that expanse of nature—or if you prefer, of the landscape—that the *Pater omnipotens oeterne Deus* spreads out before our eyes. Lines perpendicular to the horizon give depth. Now then, nature exists for us humans more as depth than as sur-

face. Therefore, into our vibrations of light, represented by reds and yellows, we need to introduce just enough blues so we can sense the air."[41]

Yes . . . I paint better than I write, don't I? I'm not about to replace Fromentin yet.

He crumples the paper into a ball and throws it away. I pick it up; he shrugs his shoulders.

One rainy day, I wrote it to someone who's also a painter. In this rainy season it's impossible to practice these theories I'm giving you out of doors, but I believe them to be basically correct, and perseverance leads us to perceive interiors like everything else. Detritus blocks our intelligence, which needs to be shaken up occasionally[42] All that I am telling you, the sphere, the cone, the cylinder, concave shadow, all my old song and dance, get me going and excite me on mornings when I am tired. I forget them quickly as soon as I start to *see*. We must not let these theories fall into the paws of amateurs. I can see what the Rosicrucians[43] or the run-of-the-mill daubers would do with that sort of thing. It's like Impressionism. They do everything in the Salons. Oh, very wisely. I, too, I don't hide it, was an Impressionist. Pissarro had an enormous influence on me. But I wanted to make of Impressionism something solid and enduring like the art in the museums. I told this to Maurice Denis.[44] Renoir is skillful. Pissarro is a peasant. Renoir painted on porcelain, you know, and a certain iridescence remained in his immense talent. What works he has created nevertheless. I don't like his landscapes. His vision is fuzzy. Sisley? . . . Yes. But Monet is an eye, the most prodigious eye in the history of painters.[45] I take my hat off to him. Courbet had his image already composed in his eye. Monet visited him, you know, in his youth on the Channel. But, listen, a green patch suffices to give us a landscape, as a flesh tone gives us a face or a human figure. Which means that we learned everything we do from Pissarro. He had the good luck to be born in the Antilles where he taught himself to paint without a teacher. So he told me. As early as '65 he had eliminated black and bitumen, sienna and the ochers; it's a fact. He told me never to paint with anything other than the three primary colors and their immediate derivatives. It's he who was really the first Impressionist. After all, Impressionism is the optical mixture of colors, you know, dividing colors on the canvas and bringing them together in the retina.[46] We had to go through that state. Monet's cliffs will endure as a great series, as well as a hundred other of his paintings. When I think that his *Eté* [Summer] was refused by the Salon! The jurors are all pigs. He'll be in the Louvre alongside Constable and Turner. Hell! He's even greater. He

painted the earth's iridescence. He painted water. You remember his Rouen cathedrals that we saw together. And what's all this gibberish you were telling me, like old Geffroy, that his painting was parallel to Renan, that it corresponded to the latest atomic hypotheses, to the biological flow, to the movement of everything? If you wish, but in the fleeting sensations of everything in Monet's paintings, you have to admit, there's a solidity, a skeleton. Oh, if you could see how he paints! His is the only eye, the only hand that can follow a sunset in all its transparent qualities, and then can shade its nuances on his canvas without having to go back over it. Then too, he's a great lord who pays for the grain stacks he likes. If a corner of a field looks good to him, he buys it. He's got a tall flunkey and some dogs to stand guard so no one can bother him. That's what I need. And he has students;[47] he's establishing an Impressionist tradition, making use of its characteristics! A school? No, no, a tradition. Poussin in nature.

He dreams.

As for me, you understand, I progress very slowly. Nature baffles me with its complexity, but I must constantly press forward. The Louvre is a good book to consult and I didn't fail to study it. But it must only serve as an intermediary. The artist must devote himself to the monumental and true study of the diversity of nature. I keep coming back to this: the painter must dedicate himself totally to the study of nature and try to produce paintings which enlighten.[48]

ME: Enlighten? Whom? Do you mean a social art, perhaps?

CÉZANNE: Oh, hell, no! That's a term that really scares me. But enlightenment for all, that's what I'm looking for . . . the understanding of nature from the point of view of the painted picture and the development of one's means of expression.[49] I want everyone to be able to express himself. I myself was telling you this morning that I need to know geology, how Sainte-Victoire is attached to the earth, the geological earth colors, all these things move me and make me better. Listen, when one doesn't paint indolently, but calmly and constantly, it's bound to lead to a kind of clairvoyance, which is very useful in firmly guiding us through life. Everything falls into place. Try to understand me, if my canvas is saturated with that vague cosmic religiosity that stirs me, that makes me better, it will touch others in an area of their sensitivity even they aren't aware of. I need to know geometry, planes, everything that keeps my mind straight. I ask myself, "Is shadow concave? What's that cone up there? Wait. Is there light?" I realized that shadows on Sainte-Victoire were convex, bulbous. You see it as I do. It's incredible! It's as I said. It gave me a huge shiver. If, through

the mystery of my colors, I make others experience the same thing[50] won't they feel a sense of the universal, more habitual perhaps, but much more fertile and delightful. The other night, returning to Aix, we spoke about Kant. I tried to put myself in your mind. Sensitive trees? What do we have in common with a tree? What is there in common between the way a pine tree appears to me and the way a pine is in reality? Hmm, if I painted that . . . wouldn't it be nature giving us our painting? . . . And sensitive trees! . . . And wouldn't there be a philosophy of appearances in this painting that would be more accessible than all the scientific tables, than all your noumena and phenomena? Looking at it, one would feel the relativity of all things in oneself, in man. I told myself, I would like to paint space and time and make them become forms of the sensibility of colors, since I sometimes imagine that colors are like great noumenal entities, living ideas, creatures of pure reason.[51] With whom we might correspond. Nature is not on the surface; it is in depth. Colors are the expression of this surface and this depth. They reveal the origins of the world. They are its life and the life of ideas. As for drawing, it's all abstraction.[52] Also, drawing can never be separated from color. It's as if you wanted to think without words, with pure figures or pure symbols. Drawing is an algebra, a form of writing. As soon as drawing is given life, as soon as it signifies sensations, it takes on color. The fullness of color always corresponds to the fullness of design.[53] In fact, can you show me anything that is drawn in nature? Where is it? Where? The things men build, straight, drawn, walls, houses, just look at them. Time and nature leave them all falling over in the end. Nature has a horror of the straight line. And blast the engineers! We are not road surveyors. They are uneasy with colors, those guys . . . While I . . . Yes, yes, sensation is the basis for everything.

He searches in his pockets again

Hand me my piece of paper.

He straightens it out, looks it over, then gives it back to me. He finds another scrap of paper.

I've noticed this before.

He reads.

"Color sensations, which make light in my painting, create abstractions that keep me from covering my canvas or defining the edges of objects where they delicately touch other objects. The fact that my image or picture appears unfinished results from this. On the other hand, planes fall one on top of the other, from which comes the neo-impressionist encircling of objects with a black line. We have to resist this unsound method

with all our strength. Using nature as our reference gives us the means of reaching our goal."[54]

ME: And that is?

CÉZANNE: Planes, colored planes! The colorful place where the essence of planes fuse, where prismatic heat is achieved, and planes meet in the sunlight. I make my planes with colors from my palette. Do you understand? It is necessary to see the planes . . . clearly . . . [55] and fit them together and fuse them. They must simultaneously tilt and interlock. Only the volumes count. You must have air between objects in order to paint well, just as you have to have sensations between ideas in order to think well. Bitumen is flat; logic is short. One paints in caves where there are no more planes. One chokes on syllogisms when there is no more intuition. Without volume, there are only cartoons. They have to take on volume, become convex. Do you understand? You have to relate contrasts in the correct juxtaposition of tones. The least error of the eye ruins everything. And it's awful for me; my eyes stay riveted to the tree trunk, to the clod of earth. It's painful for me to tear them away when something has a hold on me.

ME: Yes, I've noticed that. Sometimes, you let twenty minutes go by between two brush strokes.

CÉZANNE: And my eyes, you know, my wife tells me that they jump out of my head, they get all bloodshot . . . [56] A sort of drunkenness or trance makes me stagger as if I'm in a fog when I get up from my painting. Tell me I'm not just a little crazy. An obsession with painting . . . Frenhofer . . . Balthasar Claës . . . sometimes, you know, I have to ask myself.

I showed him his painting. Under a tall, unfinished pine, it deepened everywhere into a mystery of being, to the roots of the enigma, a chip of a broken diamond where the full sun of the world was refracted in the lightening of a balanced weight. An interior music arose from it. The mind filled the empty spaces. Not yet covered up, the reddish-brown of the linen gaped like the gaze of a blind man. The solemn greens, the pensive blues next to lighter tones, some areas still dull, responded to each other already and supported the entablature of the mountain. The lively ascent of the wind, the verdant columns of the sky, the two trees which, on the left and on the right, intertwined their friendly branches in a caress above the fields . . . From these beams of precise colors issued such a display that it made the master smile. He looked back over the immense landscape, completely similar, less human, but just as beautiful.

To copy, yes, copy . . . that's the only thing there is. But these temperaments! Painting recognizes them as her own. I myself want to lose myself in nature, grow again with her, as her, to have the stubborn colors of those

boulders, the rational perseverance of that mountain, the fluidity of the air, the warmth of the sun. A green would flow throughout my entire brain like the sap of the tree. There, before us, a great being of light and love, the flickering universe, the hesitation of things. I will be their Olympus, I will be their god. The ideal in the sky will marry in me. Listen now, colors are the sparkling flesh of ideas and of God, the transparency of mystery, the iridescence of the laws. Their opaline smile reanimates the dead face of the vanished world. Where is yesterday, the day before? The plain and the mountain I saw? Here, in this painting, in these colors. Better than in your poems because more material feeling takes part, the conscience of the world lives on in our paintings. They mark the steps of man. From the reindeer on the cavern walls to Monet's cliffs, to the walls of the hog butcher, one can follow the human path. From the hunters and fishermen who people the Egyptian underworld to the gallant scenes of Pompeii, the frescoes of Pisa and Sienna, and the mythological paintings of Veronese and Rubens a testimony rises, a spirit emanates. Everywhere it is the same and it is memory objectified, memory painted by man made concrete in what he sees. We don't really believe what we see. We see all that man has seen in painting, all he wanted to see. We are the same man. I'll add a link to this colored chain, my blue link. The contribution of true nature, the landscape that rediscovers intelligence, the positive reality of landscape, what we civilized people feel before a landscape, the landscape that Frank-ish tribes overran, where we talk about Darwin and Schopenhauer. The Hindu concept of natural nirvana consoling our senses at the last stage. The peace of wheat growing under the drama of the clouds. The unap-proachable, invisible divinity, the sun! . . . Systems, a system . . . yes, you have to have one. But it is this established system, to copy nature. We have a ready-made system and we forget to copy.

There are the great ones, the painters, the Venetians. Have you seen the gigantic Tintoretto in Venice where the earth and the sky, the globe of earth and water hangs above all the people, with the horizon that swirls about, the depths, the distant seafarers, and the soaring bodies, the whole immense roundness, the whole world, the planet tossed and falling and rolling in the ether? In his time! He foretold us. He already had this cos-mic obsession which devours us today. Yet, I am sure that when he painted it he was thinking of nothing but his ceiling, the balance of the volumes, of juxtaposing values, of painting well. But to paint well is to express one's epoch in the most advanced way, to be at the summit of the world, to have reached the summit of man's achievement, in spite of oneself.[57] Words

and colors have meaning. A painter who knows his grammar and who pushes his expression to the fullest without breaking it, who copies exactly what he sees, whether he means to or not, translates onto his canvas what the keenest mind of his time has conceived and is in the process of conceiving. Giotto corresponds to Dante, Tintoretto to Shakespeare, Poussin to Descartes, Delacroix . . . to whom? It's absurd to have a preconceived mythology, ready-made pictures of objects, and to copy that instead of nature, to copy imagination instead of the earth. False painters don't see that tree, your face, this dog; but *the* tree, *the* face, *the* dog. They see nothing. Nothing is ever the same. There's a sort of set, obscure prototype which they pass around from one to another, which always floats between their eyes, if they even have eyes, and the model. Yes, great laws, principles, are necessary, and after great shocks, intellectual emotions whose observations fling you innocently back to copying nature. I am an intellectual, if you will, but I am also a brute. I philosophize, I prate, I converse with you. But with my tubes of paint, my brushes in my hand, I am nothing but a painter, the last of the painters, a child. I sweat blood. I have forgotten everything I know. I paint. There are some people who think they are good citizens because they obey the laws. The honest man has his code of laws in his blood. The genius lives his own laws. Yes, the genius, who knows all the other principles, creates his own method.

ME: Method?

CÉZANNE: And it's always the same. The true one. He has to discover it, but it's basically always the same. Mine, you know, I have never had another one, is to hate what is merely imagined. I would rather be as dumb as an ox. My method, my code, is realism. But it's a realism that is full of grandeur, a naïve grandeur. That is the heroism of the era, . . . Courbet, Flaubert. Better yet, I am not a romantic. The immensity and the flow of the world in a little grain of sand, do you think that's impossible? The colored continuity of blood. Rubens.

He went over to a bush and picked up another canvas of the same motif, but more peaceful, more tender.

I am an old workhorse. My method is to love working.

He hung his game-bag on the tree. He took a drink straight from the bottle.

Rubens, Rubens . . . Listen, all that is not of our time. The sun is setting on the world. Painting is going with everything else. I'd be happy if people would just leave me alone and let me die working in my own little corner of the world.

He set up his canvas about ten yards from the other, in front of his new motif,

*his afternoon motif. He had all his brushes, and a second palette, already pre-
pared. He looked at the canvas. The sun was setting.*

ME: Who knows? Master . . .

CÉZANNE: Don't call me master.

ME: Perhaps we are at a great turning-point. You are the forerunner.

He stands up straight. His canvas attracts him like a beautiful face.

It is in you, possibly, in one of these paintings where people in the fu-
ture will try to find out what people today thought and felt, all those peo-
ple who don't know you.

*He sinks his neck down into his shoulders. He squints as he surveys the land-
scape. He chooses a brush. He goes over his palette with it; he holds it up; he
makes a stroke. He has forgotten all about me and about these future people I
was talking about, even the landscape itself, perhaps. He only sees colors now. I
have picked up my book, but it is Cézanne I would like to understand; I don't
read. He glances over at me one last time.*

CÉZANNE: Let's get to work!

THE LOUVRE

The ideal of earthly joy? . . . To have a beautiful formula.[58]

*We were leaving the Galerie des Machines, at the Salon. We had come to see
Rodin's Balzac.[59] Cézanne had bought a photograph of it to give me. . . . It was
eleven o'clock; we had a quick lunch and went to the Louvre, on the Passy-Hôtel
de Ville bus along the quays.*

*It was a fair, pensive spring day, an afternoon in Paris. Tender greens dotted
the trees. The Seine glittered in the sun. All our old history, beyond the bridges,
glistened over toward the Ile de la Cité. Dreamy young women strolled. We saw
them on the benches in the Tuilleries finishing their fried potatoes. Children ran
alongside carriages to offer young couples little bouquets of violets. Pedestrians bus-
tled toward the noise of the boulevards. Everywhere along the banks, everything was
tender, springlike, and calm. The Institute, the Louvre, Notre Dame were crowned
with a delicate halo. After a good coffee, Cézanne smiled and felt talkative.*

CÉZANNE: Well? Our old France is warming up in the sun and looks
out the window. Look . . . Tradition! I am more traditional than anyone
thinks. It's like Rodin. No one knows what he is really like deep down. He
is a man of the Middle Ages who does make great pieces, but he doesn't
see the whole. He needs to be framed, like these old sculptors, in the por-
tal of a cathedral. Rodin is a prodigious stone cutter, and with all his mod-
ern frissons, he will be successful making all the good statues anyone could

ever want; but he lacks ideas. He lacks a religion, a system, a faith. His gate of hell, the monument he's working on, someone suggested that to him and, you'll see, he'll never build it. Mirbeau, I think, is behind his *Balzac*. As an example, he captured him, held him with great intelligence, with his eyes that take in the world and close passionately on it, eyes that seem to have darkened in all the coffee Balzac continually drank. And his hands, under his great cape, dominate the whole life of this chaste man. It's wonderful! . . . And this massive block, you know, is made to be seen at night, lit violently from below, at the exit of the Théâtre Français or the Opera, in the late-night fever of Paris in which we imagine the novelist and his novels! . . . I don't want to belittle Rodin by what I'm saying, but listen. I like him. I admire him a lot; but he's very much of his time, like all of us. Well, we only make pieces; we don't know how to compose.[60]

ME: But don't you think that there is sometimes in a portrait like that of Rembrandt's mother, in a still life like Chardin's *La Raie*, and, I hardly dare say it, in your apples, as much art and thought as in a history scene or a Christian or mythological allegory?

CÉZANNE: That depends, that depends . . . You understand, if you compare a Chardin to a Lesueur, a portrait by Velasquez or Rembrandt to one of Jordaens's scenes of gluttony, or my apples to a Troyon landscape, it's incontestable. But wait. I'll wait till we get to the Louvre to answer you. I speak better about painting in front of paintings. Nothing is more dangerous for a painter, you know, than to go on about literature. If he gets into that, he's lost. I know something about it. The damage that Proudhon inflicted on Courbet, Zola wanted to do the same thing to me. Only Baudelaire spoke correctly about Delacroix and Constantin Guys.[61] I really like it that Flaubert, you know, in his letters, forbids himself to speak of an art whose technique he knows nothing about. That's Flaubert . . . It's not that I want painters to be ignorant. On the contrary. In the great epochs, they knew everything. Artists, in the old days, were the master teachers of the masses. Look at Notre Dame over there. Creation and the history of the world, dogmas, virtues, the life of the saints, arts and crafts, everything that was known at the time was taught by its portals and its stained glass windows. The same is true for all the cathedrals in France for that matter. The Middle Ages learned its faith through its eyes, like the mother of Villon . . .

Paradise where harps and lutes are heard . . .

It was real science, and it's all religious art. What your friend Abbé Tardif said one finds in St. Thomas, the people looked for in the portal

statues of their churches. This order, this hierarchy, this philosophy, look, it's all the science and knowledge in the world. And for us it is more real, because it is more beautiful and because we easily understand it. All this symbolism that we talk about, because we pretend that the cabala, too, has its place in the rose windows, all this intellectual mysticism sleeps in the rusty gothic stones. I don't know anything about it; I don't want to know anything. But there is still life in there . . . What do you want? When the forms of the Renaissance burst forth with the paganism of those impassioned times,[62] people could turn their eyes from the austere realism of their chapels, but the memory always stayed with them. This gave a stimulating bitterness to their lives. The rhetoric of the great productions never completely took hold. The people dislike oratorical painting as much as I do. Oh, they love the gallery of battle scenes at Versailles, yes, but they don't look at painting there. They read a kind of newspaper, a great mural newspaper, and Epinal prints, as in the Pantheon and its Saint Geneviève.[63] But in the Chateau, in the park, it never moved people as it did in the church or in the arena. They have a sense of grandeur deep within them. At home, in Provence, that sense of grandeur comes from the Romans. Here, in the north, from the cathedrals. It's exciting all the same. Listen, I am classical; I tell myself, I would like to be classical, but that bores me. Versailles gets on my nerves, the Cour Carrée bothers me.[64] Only the Place de la Concorde is beautiful! But look, see how complicated everything is, life and realism are far greater in the fifteenth and the sixteenth centuries than the elongations of the primitives. I don't like the primitives. I know Giotto only a little. I'd have to see him. I only like Rubens, Poussin, and the Venetians . . . Listen to me now, it's easier to signify God by a cross than by a facial expression.

We had arrived; we descended the tramway.

ME: If you had seen the Duccios in Siena . . . There is everything in those little scenes. Some are dramatic like a Tintoretto with greens and pale reds; others, like *Jesus before Pilate,* have a simple tragedy, they are composed with the same kind of purity as a play by Racine. And the women at the tomb, before the great angel, no antique bas–relief has their nobility and their triumphant despair. It's as beautiful as Nike buckling her sandal. If you had seen. . . .

CÉZANNE: I am too old now to go running around Italy. And yet, it seems to me that there is everything in the Louvre, that one can learn and love everything in the Louvre.

ME: Everything . . . except maybe frescoes, the Franciscan painting

movement in Umbria, and what was born of it: Masaccio, Gozzoli . . . But what could Italy and its art add to you? One could say that you came from Italy and that you have meditated on it all your life.[65]

CÉZANNE: I'll surprise you perhaps. I almost never go into the little room of primitives. It's just not painting to me. I am wrong; I'm probably wrong; I admit it; but what do you expect, when I have stood in front of Titian's *Concert champêtre* [Pastoral Concert] or *Jupiter et Antiope*, when I have the great moving crowd of the *Noces de Cana*, how should I look at the awkwardness of Cimabue, the naïve works of Fra Angelico, and even the perspectives of Uccello . . . There is no flesh on these ideas. I leave all that to Puvis. I like muscles, beautiful colors, blood. I am like Taine, and what's more, I am a painter. I am a sensualist.

We walked up the great Daru staircase.

Here. Look at that . . . the *Victoire de Samothrace*. She's an idea, she's a whole people, a heroic movement in the life of a people, yet the fabric clings to her legs, her wings flutter, her breasts swell. I don't need to see her head to imagine her look, because all the blood which beats, circulates, sings in her legs, her hips, throughout her body, has passed in torrents into my brain and has entered my heart. It is in motion, the motion of the entire woman, of the entire statue, of all Greece. When the head is gone, so what, the marble has bled . . . While up there in the primitives, you can chop the necks of all those little martyrs with the executioner's sword and there's a little vermilion, a few drops of blood . . . They have already flown bloodless up to God. Souls can't be painted. And here, Victory's wings, you don't even see them, I don't see them anymore. We don't think about them anymore, they seem so natural. Her body doesn't need them to be able to fly away in full triumph.[66] It has elan . . . Whereas the haloes of the virgins and saints surrounding Christ, one sees only them. They impose themselves on us. They embarrass me. What do you want? You can't paint souls. You paint bodies, and when bodies are well painted, then, damn it, the soul, if they have one, the soul radiates and shows through from everywhere.

We went into the little room of La Source.

Ingres doesn't have any blood either. He draws. The primitives drew. They colored, they made, on a large scale, colored drawings of the missal. Painting, what is called painting, was born with the Venetians. Taine tells us that in Florence all the painters were goldsmiths at first. They drew. Like Ingres . . . Oh! They are very beautiful: Ingres, Raphael, and that whole shop. I am no more stuck on one than the other. I have the pleasure of using line, when I want to. But line can be a hazard. Holbein, Clouet, or

Ingres have only line. Well, that's not enough.[67] Look at that *Source*. It is pure, tender, sweet, but it's platonic. It is a picture. It doesn't move around in the air. The cardboard rock doesn't exchange its rocky humidity with the marble of that moist flesh . . . or that should be moist. Where is the ambient lucidity? And since it is a spring, there should be some water, from the rock, from the leaves. It's glued on. He wanted so much to paint the ideal virgin, he was unable to paint a body at all. And it's not that this was impossible for him. Remember his portraits and his *Age d'or,* which I like. This was done in the spirit of the system. System and false spirit. David killed painting.[68] They introduced pouncing. They wanted to paint the ideal foot, the ideal hand, the perfect face and stomach, the supreme being. They banished character. What makes great painting is the character which it instills in all it creates, the wit, movement, and passion; and there are passionate serenities. They are afraid of them, or rather they never dreamed of them. Perhaps they were reacting against the passions, storms, and social brutality of their time.

ME: David was into all that up to his neck, however.

CÉZANNE: Yes, but I know of nothing colder than his *Marat*! What a petty hero! A man who had been his friend, who had just been assassinated, whom he should have glorified for all of Paris, for all of France, for all posterity. Did he just toss that sheet over him and wash him off in his bathtub? He was thinking about what people would say about the painter and not what they would think about Marat. It's a bad painting. And he had the cadaver right in front of his eyes! I like some parts of the *Sacre,* however, the child in the choir, the head between the candlesticks, one could say they were Renoirs. David was more comfortable with these up-starts than with the sacred heart of the one they carried through the streets of Paris! There's something sordid here; these are caricatures. They brought me up short, all the grinding mechanics of that mind. But that is painting!

We went into the Salon Carré. He stood in front of Noces de Cana. *His hat sitting on the back of his head, his overcoat trailing from his arm. One would have thought him in ecstasy.*

Now there is painting! The detail, the ensemble, the volumes, values, composition, thrills, everything is in it . . . Listen, it is breathtaking! What are we? Close your eyes, wait, don't think about anything. Open them . . . All you see is the great colored wave, hmm?—an iridescence, colors, a rich-ness of colors. That is what painting should give us, a harmonious warmth, an abyss into which the eye can sink, a silent germination. A state of grace

in colors. All these tones flow in your blood, don't they? You feel reinvigo-
rated by them. You are born into the real world. You become yourself; you
become painting . . . To love a painting, first you have to drink it in this
way, in long drafts; lose consciousness; descend with the painter into the
dark, complicated roots of objects, come up again with colors, bloom with
them in the sun. You have to know how to see, to feel, especially in front
of a great machine such as the one Veronese built. He was happy, you see.
And he made all those who understand him happy too. He is a unique
phenomenon. He painted as we look. With no more effort. His colors
dance; these torrents of tones flowed from his brain, like everything I am
saying flows from my mouth. He spoke in colors. It's thrilling. I know al-
most nothing about his life, yet it seems that I have always known him. I
see him stroll, go, come, love, in Venice, in front of his canvases, with his
friends. A beautiful smile, a warm face, a strong body. Things and people
enter into his soul with the sun. Nothing separates him from the light, and
without drawing, without abstractions, everything in color. They went out
one day, the colors, but dressed, no one knows why, in a sweet glory, com-
pletely happy as if they had breathed mysterious music. A music, the music
that radiates, you see, from this group in the middle, the music to which
the women and the dogs are listening, which the men feel in their strong
hands. This plentitude of thought in pleasure and of pleasure in health, you
know, I believe that is Veronese, the plentitude of the idea in color. He
covered his canvases with a vast grisaille, yes, as they all did then, and that
was his first device, like a piece of the earth before daybreak, from which
the spirit rises.

ME: Like you when you meditate on the geology of your landscapes,
which you sketch in your mind.

CÉZANNE: Oh, me! Listen, I'm nothing but a little child compared to
that . . . What I see, you understand, is their formidable skill, and so easy,
so natural for them. They had that talent in their hands and in their eyes,
from one studio to another. The underpainting, as I was saying . . . He pre-
pared an immense grisaille[69] . . . The fleshless, anatomical, skeletal idea of
the universe, the soft scaffolding which he needed, and which he was going
to dress with nuances, with his colors, his glazes, filling in shadows. A great
pale world, sketched, still in limbo. I can almost see it, here, between the
fabric of the canvas and the prismatic warmth of the sun . . . Today painters
lay on thick paint right away, they attack the canvas roughly like a mason,
and they believe themselves to be very strong, very sincere . . . Hell! We
have lost this science of preparation, this fluid vigor which the preparation

provides. To model, no, to modulate. You have to modulate . . .[70] Today painters paint over, scrape, scrape again, make it thick. It's a mortar. And, the most basic, the Japanese, you know, brutally outline their figures and objects with a coarse, schematic, heavy line, and fill in with flat colors all the way to the edges. It's as glaring as a poster, painted like a stencil.[71] It's lifeless. At the same time you see this dress, this woman, this being silhouetted against the table cloth—you see shadow where her smile begins, and where light caresses, drinks in, imbibes this shadow we don't know. All the tones blend into one another, all the volumes interlock. There is continuity . . . I don't deny that sometimes in nature, there are these abrupt effects of shadow and light in violent bands, but that's not what's interesting. Especially if it becomes a process. What is magnificent is to bathe a whole infinite, immense composition like this one in the same muted, warm brightness, to give the eye the lively impression that all these chests really breathe like you and me, but there golden air washes over them. Basically, I am sure, it is the underpaintings, the secret soul of the underpaintings, that hold everything together and give this strength and lightness to the ensemble. It is necessary to begin with a neutral.[72] Afterward, he could give it everything he had. Do you understand? Damn! Perfect elegance, exquisite elegance, the audacity of all the patterns, the fabrics that harmonize, arabesques that intertwine, gestures that extend. Is that enough? Tell me, is it enough? You can concentrate on details, but everything in the entire painting will always follow you, will always be there. You will feel it hum around your head, from the part you are studying. You can never take anything away from the ensemble . . . These were not painters of fragments, like us, not these painters. You always ask me what keeps us, after all, from loving even a Courbet or a Manet like a Rubens or a Rembrandt, what there is more of in this old painting . . . We need to have a pure heart, we need to find it today. Of course, *Enterrement à Ornans* [Burial at Ornans] is a well-made painting, and *Entrée des Croisés* [Return from the Crusades] and the ceiling in the Salon of Apollo as well, but in front of those or in front of Tintoretto's *Paradis* something in the moderns fails. What? . . . Tell me, what? We shall see; we shall see. Here, on the left, starting with that column, is it marble? And slowly, look all around the table with your eyes. Is it beautiful? Is it living? At the same time is it transfigured, triumphant, miraculous, of another world and yet totally real? The miracle is within, water changed into wine, the world changed into painting. We swim in the truth of the painting.[73] We are drunk, happy. For me, it's like a gust of colors is carrying me away, a music that slaps me in

the face, my entire craft which flows in my blood . . . Ah! They had a damn great skill, those fellows did! We are nothing, listen to me, old beasts, nothing. We aren't even good enough to understand. And to think that I wanted to burn it years ago! Out of a mania for originality, for invention. . . . When you don't know anything, you think that those who do know are trying to block your progress. Then, on the contrary, if you get to know them you see that instead of slowing you down, they take you by the hand and walk with you, and gently let you mumble your little story. Oh, the ideal would be to make studies after the great decorative masters Veronese and Rubens, but as one would do from nature . . . [74] Painting, you see, died with David, when it tried to be proper and polished. That's my greatest horror. Maybe David was the last who knew his craft, but what he did with it, good God. Trouser buttons for his *Remise des aigles* [Distribution of the Eagle Standards]? When he should have given us with great ceremony, in the style of Titian, the psychology of all those stableboys and rustics gathered around their crowned crook. Filthy Jacobin, filthy classic . . . You know what Taine says about the classic spirit! Really, David is an awful example. So self-righteous! He even managed to castrate, in his art, that libertine Ingres, who adored women even so. You have to learn your craft, only you have to learn it here, on your own, by studying these masters. I'm not talking about formulas or apprenticeships, alas now lost, all the material side of painting of which there is nothing to see here. That revolutionary destroyed the companionship of artists which helped so much in mastering skills quickly. Good studios provided that companionship. We need to have them back. But I'm talking about the masters. Whichever one you prefer, he should be only an orientation for you, otherwise you'll just be an imitator. If you have a feeling for nature, whoever you choose and whatever his talents, you'll have to break away in time. Another person's advice and methods should never make you change the way you feel. Even if you fall under the influence of someone older, you must believe that, as soon as you feel strong in yourself, your own emotion will emerge and take its place in the sun. You'll have the confidence you need to build on. Drawing is only a configuration of what you see. Michelangelo is a builder and Raphael is an artist who, as great as he is, is always restrained by the model. When he tries to get involved with ideas, he is inferior to his great rival.[75] You have to be like Michelangelo in his style; he's the one who distances himself from professors. Nothing is worse than the dictatorship of those professors who beat their ignorance and their vision into your head. You must choose your masters well, or

rather not choose them but use them all, compare them. I'd be as wary of a student who has only had one teacher as of a man who has only read one book. Jean-Dominique is talented, very talented![76] Yes, but he's also very dangerous. Just look at Flandrin, all of them, even Degas . . .

ME: Degas?

CÉZANNE: Degas is not enough of a painter; he doesn't have enough of that! . . . [77] With a little temperament a person can become a painter. All you need is a sense of art, and it is just this sense, without doubt, that terrifies the bourgeoisie. That's why institutions, stipends and honors are made only for idiots, pranksters, and rogues.[78] But I'm not talking about those people. Let them go to the Ecole, let them have a raft of professors. I don't give a damn. What I deplore is that all these youths in whom you believe, whom you were telling me about, don't rush to Italy, don't spend time here. And then throw themselves into nature. In art especially, theories developed and applied in contact with nature are everything.[79] I wouldn't want what happened to me to happen to them. I know, I know; if official salons are so inferior, the reason is clear, they can't get down to work until they've gone through long, drawn-out formalities. Sensation is the basis of everything, for a painter. I'll never stop repeating it. These are not the procedures I advocate. It would be better to bring more personal emotion, observation, and character to the task.[80] But there's the problem; theories are always easy. It's only proving theories that's hard.[81] Here, mainly, I think the painter learns to think. Before nature, he learns to see. It's grotesque to imagine that one grows like a mushroom when one has all the generations behind him. Why not profit from all this work? Why overlook this amazing contribution? The Louvre is the book from which we learn to read. We must not, however, be satisfied with memorizing the beautiful formulas of our illustrious predecessors. We have a dictionary, as Delacroix used to say, in which we can look up all the words. Let's go outside. Let's study nature in all its beauty, and try to grasp her spirit. Let's look for ways to express ourselves according to our personal temperament. Time and contemplation gradually modify our vision and in the end we achieve understanding.[82] Then we and your friends will be able to paint something like this, God willing . . . and compare this rainbow to that silvery harmony. (He pointed to *Noces de Cana,* then to *Jesus chez le Pharisien* across from it.)

That, for example, it's perhaps even more exciting . . . This range of silvers . . . the entire prism melting into the white . . . And, you know, what I love in all Veronese's paintings is that there's no long-winded story

involved in them. You love them if you love painting. You don't love them if you are looking for literature on the side, if you only enjoy anecdotes, and the subject . . . A painting doesn't represent anything; it must represent nothing, at first, except colors. . . . [83] I detest all these stories, this psychology, all these "peladaneries" about them. For God's sake, that is in a painting, the painters aren't imbeciles. But you have to see with your eyes—with your eyes—do you understand! The painter wants nothing more. His psychology, it is to find the two tones he needs. That is what he's wrapped up in. That is his story, his truth, his own keen insight. Because, you see, he is a painter. And not a poet, not a philosopher. Michelangelo didn't paint his sonnets in the Sistine Chapel any more than Giotto worked his canzone into the life of Saint Francis. That's just some monk's tall story. And when Delacroix wanted to force Shakespeare into his paintings, he was off the mark; he's the one who ended up flat on his face. That's why, when we came in here, I compared all this art, no matter how moving it is, from the Middle Ages, with my art, that of the Renaissance. You see, the liturgical symbolism of the Middle Ages is completely abstract. You have to think about it. The pagan symbolism of the Renaissance is completely natural. One turns nature away from its meaning to signify that we know only theological truth, The other, you feel this yourself, guides abstraction to reality, and reality is always natural. It has a sensual, universal meaning, if I dare say so. . . . I love the fact that the apple, which is symbolic in the hands of the Virgin of the primitives, becomes a toy for her child in the Renaissance. You wrote *Dionysos*, so you should remember Jacques de Voragine's story, that the night the Savior was born the vines flowered all over Palestine. Ah, *that's* the Renaissance, that is. We painters, we should paint the flowering vines rather than the whirlwinds of angels who announce the Messiah. We should paint only what we have seen or what we could see . . . Like Giorgione here.

We are in front of the Concert champêtre.

Let us embellish and ennoble our imaginations with a great carnal dream . . . But let us bathe them in nature. We must not try to find nature in our imaginations. We can't. You see, Manet, in *Dejeuner sur l'herbe* [Luncheon on the Grass], should have added that special something, that tingling sensation, that hint of nobility, that I-don't-know-what, which delights all the senses. Look at the flowing gold of the standing woman, the back of the other. They are alive and they are divine. The entire landscape in its ruddy coloring is like a supernatural pastoral poem, a moment of equilibrium perceiving the eternity of the universe, in its human joy.

And we are part of it, we appreciate all of life. As over there, come, I'll show you this *Cuisine des Anges* [The Angels' Kitchen]. There's a wonderful still life in it.

We arrive in front of the painting.

Murillo had to paint angels, but what youths these are! See how their feet nervously touch the stone. And, they are actually fit to clean those beautiful vegetables, the carrots and cabbages, fit to be reflected in the cauldrons . . . The painting was a commission, wasn't it? Murillo really let himself go, for once. He saw the scene . . . He saw radiant beings enter this convent kitchen, young celestial wagon-drivers, the beauty of youth, bursting with health, in the house of all these mystics, the enervated, tormented ones. See how he juxtaposes the praying saint's sallow thinness and hysterical ecstasy with the calm gestures, and radiant confidence of all the beautiful workers. And the pile of vegetables! You can go from turnips to wings without a change of atmosphere. Everything is real . . . And across from it is this sketch of the *Paradis.*

He takes me to it.

I haven't seen the great *Paradis* in Venice. I've seen very little Tintoretto, but, like El Greco I'm attracted to him, more powerfully because he seems more healthy. People are always talking to me about El Greco and I don't know him.[84] I would like to see some of his work . . . Yes, Tintoretto, Rubens, they are what it means to be a painter. As Beethoven is the musician or Plato the philosopher.

ME: You know Ruskin said that, from the point of view of painting, his *Adam et Eve* is the greatest work of art in the world.

CÉZANNE: I've only seen a photograph of it . . . I have looked through all I can find of his work.[85] It is gigantic. It has everything, from still life to God. It's an enormous ark. All forms of life are found in it, and in incredible pathos and passion and invention. If I had gone to Venice, it would have been to see Tintoretto. It seems you can only get to know him there . . . I remember in a *Tentation du Christ* at San Rocco, I think, an angel with full breasts, with bracelets, a homosexual demon with lesbian lust, presents stones to Christ. Nothing else so perverse has ever been painted. I don't know, but at your house, when you handed me the photo, it had an effect on me like a giant Verlaine, an Arétino with Rabelais's genius. Chaste and sensual, brutal and cerebral, wilful and inspired, I think he must have known everything except sentimentality, that Tintoretto, everything that creates joy and torment in man. Look at me, I can't talk about him without trembling. His portraits, incredible, made me think I knew

him . . . like one that Manet copied at the Uffizi Gallery, that is in the museum in Dijon . . .[86]

ME: One could think it a Cézanne.

CÉZANNE: Oh, I wish! You know, it seems to me that I knew him. I see him, broken by work, exhausted by colors, in this bedroom hung with purple in his little palace, like me in my mess at the Jas de Bouffan. But even in daytime he is always lit by a smoky lamp with his sort of marionette theater that he used to arrange his great compositions . . . This epic puppet master! When he left his easels, it seems, he went to that room, completely exhausted, knocked out, but still ferocious. He was a grouch, devoured by sacrilegious desires . . . Yes, yes . . . there was a terrible drama in his life . . . I don't dare speak of it . . . Still sweating terribly, he made his daughter lull him to sleep. He made her play the cello for hours. Alone with her, in all these red reflections . . . He sank into this world of flame in whose smoke our world disappears. I see him; I see him . . . Light casts off evil . . . And toward the end of his life, he, whose palette rivaled the rainbow, he said that he only loved black and white. His daughter had died . . . Black and white, because colors are evil, they torture, understand? I have eperienced this nostalgia . . . Who knows? We look for a definitive peace . . . That paradise. In order to paint this swirling, joyous pink, he had to suffer greatly greatly, I bet my piece of money on it! We are at the opposite pole here. Over there, Veronese's handsome prince. Here Tintoretto's enslavement. He was the kind of miserable person who loved everything, but whose fire and fever consumed all his desires as soon as they were born. See his sky . . . These good gods twist and turn. They don't have a calm paradise. Their rest is tempestuous. They perpetuate the impetus that has devoured them, all their lives, as it devoured him. They enjoy it now, after having suffered so much. I like that . . .

He gets closer to the painting.

And look at this white foot here, on the left. Look at the preparation, he underpainted all his flesh with white. Then with a red glaze, bang! look here on the side, he gave them life. White and black, "I only want to paint in white and black," he cried in the end. How could he have done it? How could he have done without his torture? One shouldn't be surprised by anything from a man like this. In his youth, he had the nerve to assert: I am Titian's color with Michelangelo's drawing. And he achieved it. Titian kicked him out the door.

ME: He is greater than Titian.

CÉZANNE: Yes, I appreciate your admiration for the more valiant Vene-

tians. But let's celebrate Tintoretto. Bring your friends here. Your need to find moral and intellectual support in work that we will certainly never surpass keeps you always on the alert, always in search of the means of interpretation. Tell them this. These means of interpretation will surely lead them to find in nature their means of expression, and the day they have them, they can be sure, they will find effortlessly and in nature the means used by the four or five great Venetian . . .[87]

He takes a few steps without seeing anything.

Ah! To have students! To pass on all my experience to someone. I am nothing; I have created nothing, but I have learned. To pass that on to someone, to reunite with all these great fellows of the last two centuries. In our modern chaos, the fixed point rediscovered. In vain . . . perhaps in vain.

He clenches his fists. He looks around with furious eyes.

And all those cretins! . . . A tradition, a tradition could begin with me; I'm not a nobody. To work with students, but students whom one teaches, you understand, who don't try to teach you. I knew that . . .

He turns around. He drags me along, I think, toward the Salle des Etats, which he calls the salon carré des modernes.

I don't want to be correct theoretically, but correct about nature. Ingres, in spite of his estyle, as we say in Aix, and of his admirers, is only a minor painter. The greatest ones, and you know them, are the Venetians and the Spanish.[88]

He goes to a window and looks out at the enfilade of trees in the sun.

That's not at all bad . . . Basically, whoever painted that simply, the Seine, Paris, a day in Paris, could be accepted into the Louvre with his head held high. It is necessary to be a good worker. Not to be only a painter. To have a formula and to realize it.

He looks at me, sad and sublime.

The ideal of heaven on earth . . . is to have a beautiful formula.[89]

And brusquely he leads me, walking quickly to the Salon Carré des Modernes. He stops in front of the Triomphe d'Homère. *He frowns.*

Yes, orange to show Achilles' anger and the flames of Troy, the green to signify Ulysses' voyages and the motion of the sea . . . But that is not a formula! Yes, yes, maybe the formula which you embrace, but for me! All the same, he stirred your heart with his garish painting, Jean-Dominique! I told Vollard one time to shock him that I thought Ingres was good. All the same, he's a damn good fellow . . . He's the most modern of the moderns. Do you know why I take my hat off to him? It's because he forced his

drawing of the thunder of God, his fantastic drawing down the throats of idiots who today think they understand it. But there are only two: Delacroix and Courbet. The rest are good for nothings!

And someone's missing here . . . Manet. He'll come, along with Monet and Renoir.

ME: And you.

CÉZANNE: Oh, me . . . Yes, maybe I'll be here as a bad example. When one has the glory to contribute something, what he contributes warps what others learn. And it's dreadful. I haven't done anything yet which would hold up next to those painters over there, you know.

ME: Your *Vieille au chapelet* [Old Woman with a Rosary], the great paintings of Sainte-Victoire . . .

CÉZANNE: Yes, yes, yes . . . Maybe the memory of a good man who saved painting from a false tradition, a man as independent as he was academic, and who had the vague dream of a renaissance in his art . . . maybe that will remain. And yet . . .

He walked up to Femmes d'Alger.

We are all there in this Delacroix. When I tell you about the joy of colors for colors' sake, look, this is what I am talking about. These pale pinks, these rough cushions, this slipper, all this limpid light somehow enters your eye the way a glass of wine slides down your throat, and suddenly you're drunk. No one knows how, but you feel lighter. These hues lighten and purify. If I had done something bad, I think that I would come look at this to get myself straightened out. And it's full. The tones enter one into another like silks.[90] Everything is sewn, woven together. And that's why it works. It is the first time that anyone painted volume since the old masters. And with Delacroix, it goes without saying, there is a certain something, a fever that the old masters lacked. It's the fortunate fever of convalescence, I think. With him, painting rises up from stagnation, from the Bologneses' morbidity. He pushes David aside. He paints by iridescence. He only needs to see a Constable to know all there is to know about landscape and he, too, sets up his easel facing the sea. His watercolors are miracles of tragedy or charm. They can only be compared to those of Barye, you know, the lions in the museum in Montpellier. And the still lifes, do you remember the one of the hunter, the game-bag, and the game in the country; the entire countryside played a part. I am not talking about grand compositions, we'll go in a while and look at his ceiling . . . And then, he is convinced that the sun exists and that he can dip his brushes in it and do the laundry in it. He knows how to differentiate. It's not like with Ingres, over there,

and all the others here. A silk is a fabric and a face is flesh. The same sun, the same emotion caresses, but they change. He knows how to drape a piece of cloth on the flank of this Negress that does not smell the same as the perfumed culotte of this Georgian, and it is in his colors that he knows and where he puts it. He contrasts. All these pungent tones, you see, with all their violence, and the clear harmony they contribute. He has a sense of being human, of life in movement and of warmth. Everything moves, glistens. Light! . . . In his interiors there is more warm light than in all of Corot's landscapes[91] and in these battles over there. Look . . . his shadow is tinged with color. He makes his shading pearly, which softens everything. And when he attacks in full daylight . . . His *Entrée des Croisés* [Entry of the Crusaders into Constantinople], it's frightening! You might as well say that you don't even see it at all. I mean, we don't see it anymore. I who tell you this, I have seen this painting die, fade, almost disappear. It's enough to make you cry. Count to ten, in ten years it will all be gone. One day nothing will remain of it. If you had seen the green sea, the green sky, they were so intense! And the smoke was more dramatic, and the ships that burned, and the entire group of horsemen could be seen. When he exhibited it, they cried out that one horse, this horse was rose. It was magnificent, in all its ruddy tones. But these damned romantics, in their disdain, used atrocious materials. The color merchants robbed them like babes in the woods. It's like Gericault's *Naufrage* [The Shipwreck of Don Juan], a superb work, but we can hardly see anything of it now. Here, there remains only the worn-out melancholy of the faces, the sadness of the horsemen, but all that, we remember all that was in Delacroix's colors, and now that the background is gone, it has lost its effect and its soul. I have seen these pale men wearing their crowns. They no longer advance into the light, into this Oriental air, this land of legend. Constantinople is like a Paris, like the façades of the city, see, under the barricade over there? But I saw it as Delacroix did, as Gautier did, as Flaubert saw it and in the unique magic of its color. Here, look, this is what proves better than anything else that Delacroix is a great painter, a hell of a great painter. This is not a trivial detail of the crusades, they were cannibals, as the story goes; it's not about their apparent humanity, it was the tragedy in his colors that made the painting and that fully expressed the rotted souls of these bleak victors. Then the beautiful dying Greek woman, the woman in silks abandoned in her rich attire, the beard of the old man, the caparisoned horses, and the somber shafts all have meaning in their symphonic fusions. The painting died, wept, snorted. In the colors. Now, only the image is left. Only colors

are real for the painter . . . It's as if you translated one of Racine's tragedies into prose. The *Femmes d'Alger*, they haven't changed. The *Entrée* was painted just as brilliantly. Have you seen the *Justice de Trajan* in Rouen— it's going all to hell too, flaking away, decaying. And in Lyon, the *Mort de Marc-Aurèle?* There is a green, the green coat, that's Delacroix! And the ceiling of Apollo and Saint Sulpice! Come on, say what you want, do whatever you want, they come from great ancestry. One can talk about Delacroix without blushing, even after Tintoretto and Rubens . . . Delacroix is perhaps romanticism itself. He is too filled with Shakespeare and Dante; he read too much Faust. He remains the most beautiful palette in France, and no one under our sky—listen to me now—had more charm and emotional power and vibrant color simultaneously than he. We all paint in his name, as you write in Hugo's.

ME: And Courbet?

CÉZANNE: A builder. He slapped on paint the way a plasterer slaps on stucco. A real color grinder. He built like a Roman mason. But he was also a real painter. There hasn't been another in our century who can beat him. And it was in vain that he rolled up his sleeves, pulled his hat down over his ears, blew up the Vendôme Column: for all that, his workmanship is classical, under his great blustering poses. He is profound, serene, velvety. I am mad about some of his gilded nudes, as golden as a harvest. His palette smells of wheat . . . Yes, yes, Proudhon turned his head with his realism, but basically, his famous realism resembles Delacroix's romanticism, for what it's worth; he only succeeded beating it with rough brush strokes into a few canvases, his flashiest, but certainly his least beautiful ones. And yet, he was more into his subject, his realism, than his craft. He always created compositions in his mind. His vision remained the vision of the old masters. It's like his palette knife, he used it only in landscapes. He is sophisticated, meticulous. You know Decamp's saying. Courbet is a clever one. He makes crude paintings, but puts a fine finish on them. And me, I say that it was force, genius that he put underneath the finish. And then ask Monet what Whistler owes Courbet, from the time when they were together in Deauville, when he painted Whistler's mistress. No matter how big he made things, he was subtle. He belongs in museums. His *Vanneuse* [Grain Sifter] in the museum in Nantes, a luxuriant blonde, with the great red-tinged sheet, the wheat dust, the woman's chignon twisted on her nape like the most beautiful Veronese, and her arm, that milky arm with sun on it, the arm of a peasant woman, polished like a washing stone. And yet, he had his sister pose for it. You can put that right up next to Velasquez,

it will hold its place, I give you my word. Is it made of flesh, is it dense, is it grainy? Is it lifelike? It stands out. You can see it.

ME: I remember it . . . Courbet is the great painter of the people.

CÉZANNE: And of nature. His great contribution was the introduction of lyricism—the smell of wet leaves, the mossy forest floor—into nineteenth-century painting. The murmur of the rain, the darkness of the woods, the sun's progress under trees, the sea, and snow. He painted snow like no one else! At your friend Mariéton's, I saw his stagecoach in the snow, this great white, flat landscape in a grayish twilight without any surface roughness, but completely soft and cottony. It was fantastic, a winter silence. Like the *Hallali* [Killing of the Stag] in the Besançon museum, in which the people are a little theatrical, perhaps, but without being too flat, in their hunting jackets; the dogs; the snow; the groom, who reminds me of the bombastic style, the heroism, the manner of the old masters. What more can you ask? And the sunset in the *Cerf* [The Deer] in Marseilles, that band of blood red, the pond, and the tree that seems to disappear with the beast, in the eyes of the beast . . . All his Savoyard lakes with the lapping water, in which the fog rising from the banks envelops the mountains . . . The great *Vagues* [Waves], the one in Berlin, is marvelous, one of the important creations of the century, much more exciting, more full-blown than the one here. Its green is much wetter, the orange much dirtier, with its windswept foam, and its tide which appears to come from the depth of the ages, its tattered sky, and its pale bitterness. It hits you right in the stomach. You have to step back. The entire room feels the spray.

He looks around. Above the Triomphe d'Homère *hangs the great forest scene* Combat des cerfs *[The Battle of the Stags].*

It's so badly hung you can't see it at all! Why would anyone give a painting, a real painting to the Louvre? And when will they bring the *Demoiselles de la Seine* here? Where are they?[92]

He half-closes his eyes and sees them in his mind.

You could say they were by Titian. But, no, it's Courbet. Let's not get them mixed up. These young women! There's an ardor, a breadth, a happy exhaustion, an abandon that Manet's *Dejeuner* lacks. The gloves, laces, crumpled silk of the skirt, and the russet tones, the swelling nape, the plump flesh. Nature looks cheap next to these women. The low, shortened sky, the humid landscape, the slanting perspective that makes us examine the women . . . The moistness, the warm pearls . . . It's alive! It's as rich as *Olympia* is meager, thin, cerebral . . . The two paintings of the century, perhaps . . . Baudelaire and Banville.[93] Opulent art and acute composition.

In *Olympia*, yes, there is something more, an air, an intelligence . . . but Courbet is thick, healthy, alive. We are sated with color; we choke on color.

Listen, it's a crime that this painting isn't here and that the *Enterrement* [The Burial at Ornans] has been sacrificed and buried in that hallway over there! You can't see it there. It should explode from the picture rail across from the *Croisés*, instead there's that piece of hack work, *Homère*. It's completely manufactured, after all! But the *Enterrement*, come see.

He takes my arm and pulls me with all the passion of youth, talking all the way.

It's said that he painted this after the death of his mother, that he closed himself up for a year at Ornans. These villagers posed for him without really posing. He had memorized them. They came together in a sort of attic where he painted. He blended his grief into these rough faces. It makes me think of Flaubert, but that's already been said. The legend is stronger than history. His mother was not dead. She posed for it; she's in one corner. But that tells you how moving this great machine is. It reinvents and reimagines life.

We walked under Delacroix's ceiling.

We'll come back and see this. Just give it a glance. Look, it's a storm, a veritable flight of lyricism, the dawn of our renaissance . . . A Michelangelo in precious stones . . . You know what I mean, the Michelangelo of the corners of the Sistine, of Judith. And pure fantasy! A Pindaric ode . . . The tiger and the reclining woman whose hair is being swallowed up by the sand. The full sea tossed onto a beach . . . You feel the movement. The rising and the life of the world in the sun and the fall of desire under the weight, and these monsters! What fantasy! I hear the bugle sound. Look, those arms forge light with hammer blows! With brush strokes Delacroix has painted our future and with it makes a ceiling. We'll come back.

He leads me on.

Yes, Flaubert took the novel form from Balzac. And perhaps Courbet got his romantic passions and his expressive veracity from Delacroix . . . Do you remember the trip that Flaubert's father took, in *Par les champs et par les grèves*, that burial he describes and the old woman who cries torrents? Each time I reread it, I think of Courbet. There's the same emotion, in the same art . . . Look.

We arrive. He is all red; he glows. His overcoat, which he holds by one sleeve, sweeps the floor. He stands up to his full height. He is exultant. I've never seen him like this. Cézanne, usually so timid, looks triumphantly right and left. The Louvre is his! In a corner he spots a copyist's ladder. He pounces on it.

At last! We'll see!

He drags the ladder over and climbs on it.

Come, come . . . Good God, this is beautiful!

The guards run calling to him.

Leave me alone. I'm looking at Courbet . . . If you'd put that in the light for me, I wouldn't bother you anymore.

He stamps on the little platform.

But no, look at this dog. It's Velasquez, yes, Velasquez! Philip's dog is less a dog, royal dog that he was . . . You've seen him. And this altar boy, those chubby red cheeks . . . Renoir should come see them.

He goes higher. He is intoxicated.

Gasquet! Gasquet! Only Courbet knows how to lay on black without making a hole in the canvas . . . only Courbet. Here, as in these rocks and there in those tree trunks! With one stroke he could paint an entire slice of life, the petty existence of one of these mugs, you see, and then he came back with pity and with the tender kindness of a giant who understands everything. Caricature is washed with tears. Oh! Leave me alone, you down there. Go find your director. I have a few words for him.

They all come running. He's delivering a veritable harangue!

It's a crime, in the name of God! No, in the end, it's true . . . We always go along with everything, but this is theft! We are the State. . . . *I am painting* . . . Which one of you understands Courbet? You hold him prisoner in this cave. I protest. I'll go to all the newspapers, I'll go to Vallès!

He's shouting more and more loudly.

Gasquet, you'll be someone one day; promise me that you will have this painting moved to its proper place in the Salon Carré, the Salon des Modernes, for God's sake, into the light, so people can see it.

The guards pick up his overcoat and his hat.

Leave me alone, you fellows, I'm coming down. We have a great work like this in France and we hide it . . . So let the people set the Louvre on fire, immediately, if they are afraid of beautiful art! To the Salon des Modernes, Gasquet, to the Salon des Modernes, you promise me . . .

He hurries down the ladder. He surveys the guards who have surrounded us with a superior look.

I am Cézanne.

He becomes redder and redder. He checks his pockets and thrusts some gold coins into the guards' hands. He hurries away, dragging me along with him. He has tears in his eyes.

THE STUDIO

"I have sworn to myself that I will die painting."

Cézanne was finishing his portrait of my father. I had sat in on the sessions. The studio was almost empty. The easel, the little taboret, the chair where my father was sitting, and the stove were its only furnishings. Cézanne stood as he worked. Canvases were piled up against the wall, in a corner. The soft, even light gave a blue tinge to the walls. Two or three plaster casts and some books sat on a wooden shelf. When I arrived, Cézanne would go get from the next room an old, worn armchair that had lost half its straw. My father smoked his pipe. We conversed.

Most of the time, even though he had his brushes and his palette in his hand, Cézanne looked at my father's face, examined it. He didn't paint. From time to time, with a trembling stroke of the brush, he laid on a thin touch, a bright stroke of blue which defined an expression or brought out and highlighted a fleeting aspect of his character. The following day I saw, on the canvas, the penetrating work accomplished the day before.[94]

That day, an afternoon at the end of winter, the air felt like spring around the Jas. The honey-sweet sky pressed against the windows. Cézanne opened one of the casements.

CÉZANNE: You won't be cold, Henri? The pasturage smells like almond trees. It's a nice day, but great God, I have to close the window . . . these damn reflections. A little nothing, you know. . . .

La peinture à l'huile	Painting in oil
C'est bien difficile	Is really difficult
Mais c'est bien plus beau	But it is more beautiful
Que la peinture à l'eau	Than painting with water

MY FATHER: You're singing? Things must be going well today.

CÉZANNE: Not bad . . . Doesn't posing bore you at all? Listen, don't tell anyone, but you are doing me a big favor. You have a good disposition.

MY FATHER, *joking:* Extraordinary.

CÉZANNE, *turning to me:* A moral disposition which I envy. He doesn't get angry, your father. Never. I'd like to show that, to find exactly the right colors to show that. A real moral support! I have looked for that in my life.

MY FATHER: My heart bleeds for you.

CÉZANNE: Ah! Each man knows what's hidden inside. As for me, I know you, because I am painting you. Listen, Henri. You have confidence.

That's my greatest hope, to have confidence![95] Each time I attack a canvas, I remember that I have always failed before. Then I worry myself sick. You, you know what's good and what's bad in life, and you go your own way. Me? I never know where I'm going, where I would like to go with this damned art. All the theories ruin you. Is it because I am so timid in life? Basically, when one has character, one has talent. I'm not saying that character is enough, that it is enough to be a good man, in order to be able to paint well. That would be too easy. But I don't believe that a reprobate can have artistic genius.

ME: Wagner.

CÉZANNE: I'm not a musician . . . And then, let's get this straight, a reprobate doesn't mean having the temperament of a devil and managing with that temperament to be someone. You're a friend, Henri, you know. We have to keep our hands clean. Artists, damn it, more or less all of us, are easily led astray. There are some who, in order to succeed, bend a little to the right and to the left . . . yes, but they . . . well, really those, I believe, are the ones who have no talent. You have to be incorruptible in your art, and in order to be *in* your art, you have to practice being incorruptible in your life. Isn't that right, Gasquet, old Boileau?

The verse always recognizes meanness of heart.

All in all, there is savoir faire, knowing how, and faire savoir, making known. When you know how to do something, you don't need to let people know. They'll know.

MY FATHER: But my son tells me that you don't have the standing or recognition you deserve.

CÉZANNE: Let him say whatever he wants. I have to stay home, see no one, and work. My standing, my standing! I should be pleased with myself, and I'm not. I'll never be; I can't be. Until the war, you know, I had terrible troubles; I lost hold of my life. It was only at L'Estaque, upon reflection, that I finally understood Pissarro, a painter like me, whom your son knows . . . He worked relentlessly. Insane love for work took me over. It wasn't as if I didn't work before, I always worked.[96] But what I always needed was a pal like you, whom I would never have talked to about painting, but who would understand me without my saying a word. Ah! Henri, when I paint you, when I see you there, it's takes me back more than forty years. I must say that fate introduced me to you. If I were younger, I would say that it's a great support and comfort for me, someone who is constant in his principles and opinions, it's wonderful. I feel all that when I see you smoke your pipe.

MY FATHER, *moved and embarrassed:* And what else?

CÉZANNE: What else? I am dedicated to the art movement which your son encourages and which he stands for and of which he is an example. You have no idea how enlivening it is for a forgotten old man like me, to find himself surrounded by young people who don't want to bury me immediately.[97]

He turns toward me.

CÉZANNE: Yes, yes, join together. Launch your review, your *Mois dorés,* your *Pays de France,* affirm the secular rights of our country. And remember all the initiatives that have stood the test. Listen, it isn't possible that the man who believes that he lives and has reached the summit of existence, intentionally or otherwise, would hinder the progress of those who are coming into life. All those who precede you are your security. In all orders. The road they covered is a sign for the way to follow and not a barrier to your steps. They have lived and, by this sole fact, they have experience. It doesn't belittle you to recognize the truth. You are young; you are fortunate; you have vitality . . .[98] Ah! Henri, remember when we were that age . . .! Your mother talks to me about it. In your house she is the mother of the wisdom you represent. I know she remembers the rue Suffren like it was our cradle. I can't think about that beautiful time gone by without an unexpected emotion and that emotion is probably the reason for the current spirit of understanding we enjoy today.[99] Oh! If I had a beautiful formula,[100] that's what I would paint in your face; that's what my colors would show, that's what would remain of your portrait. . . . Let's get back to business. Resume your pose.

We stop talking. My father draws on his pipe. Cézanne's hands are trembling. He paints several strokes. He paces back and forth in the studio. He stops again in front of his canvas.

MY FATHER: Did you see Ziem's exhibition?

CÉZANNE: There's another one who came from nowhere. All these fellows who travel to the Orient, to Venice, to Algeria looking for sun, don't they have a little country house near their own home? If you want to talk about a Provençal, let's talk about Puget. He's one who smells of garlic, even in Marseilles and Toulon, even at Versailles, under the bronze sun of Louis XIV. Puget has the mistral in him; he brings marble to life.[101] What's more, his sculpture is decorative, as sculpture ought to be. You remember at the Louvre everything we talked about in front of *Persée et Andromède:* the virgin's plump little body with her head resting against the great warrior's chest—it calls to mind Bossuet—and Puget's shadowy holes which

make highlights and put everything into relief, into color, as in Rembrandt's drawings where the quality of black alone creates all the vertigo of the prism. Puget invented that. Before him, sculpture was balanced, an entire block of crystallized light. He gave it color and shading. He used ambient shadow the way his contemporaries used shadows from below. Go see the effect he gets at Toulon under the balcony of the Caryatids. In photographs, the drawings of *Saint Sebastian* and of the great bishop of Gênes, are amazing, they speak. Classicism was still alive in him.

ME: What do you mean by classic?

CÉZANNE: I don't know . . . Everything and nothing.

ME: I have heard you say that you are classical or that you wanted to be.

He thinks a minute.

CÉZANNE: Imagine Poussin redone entirely after nature, that's the classical I mean.

He starts to paint again. The portrait is quite far along; two white squares remain on the cheek and on the forehead. The eyes are alive. Two fine blue strokes extend the brim of the hat almost to the edge of the canvas. He has begun to cover, to blend one of these strokes as he works on the background. A bird flies into the window.

MY FATHER: Come in.

CÉZANNE, *pursuing his thought*: What I don't allow is a classicism that is limiting. That limits you. I want the friendship of a master who gives me back myself. Every time I come away from looking at a Poussin, I know better what I am . . .

He stops painting and looking at his model. He resumes his thought.

He is a completely realized piece of French soil, a *Discourse on Method* in action, twenty or fifty years of French life fully and truthfully committed to canvas. And what's more and above all, his work is *painting*. He went to Rome, didn't he? He saw everything, loved everything, understood everything. Well, he transformed it, made it French, this antiquity, without losing anything of his freshness or his nature. He serenely perpetuated what he found beautiful in those who came before him. I, myself, would like to perpetuate him in the same way, to re-create him in his own time, without spoiling him, without spoiling either him or me, if I were classical, if I could become classical . . . But one never knows. Study modifies our vision to such an extent that the humble and colossal Pissarro justifies his anarchistic theories.[102] I work very slowly, as you can tell. Nature presents itself to me with complexity. The improvements to make are endless[103] without my muddling it up with a dreamed-of rationality. Damn it!

A Provençal Poussin, that would fit me like a glove. Twenty times I have wanted to repaint the theme of *Ruth et Booz* . . . I would like, as in the *Triomphe de Flore,* to match the curves of the women with the shoulders of the hills, as in *Automne,* to give a fruit picker the slenderness of an Olympian plant and the celestial ease of a Virgilian verse. Think what Puvis owes to this *Automne.* I would like to mix melancholy with the sun. There is a sadness in Provence that no one has expressed, but that Poussin would have personified, leaning on a tomb, under the poplars of Les Alyscamps . . . I would, like Poussin, paint logic into grass and tears into the sky. But you have to know how to rest content . . . You have to see your model and sense it exactly, and then if I express myself with distinction and force, I'll find my Poussin, my own classicism. There is taste. Taste is the best judge. It is rare.

ME: Like all that is beautiful.

CÉZANNE: Well, what I mean is that the artist speaks to a very limited number of individuals. And he always knows too many, basically, during his lifetime. He must live in his corner, with his motifs, his thoughts, and his models. To characterize . . . And above all, listen well, he must shun all opinion not based on the intelligent observation of his own temperament. He must avoid thinking like a writer. Your son understands me, Henri. That kind of thinking distracts the painter from his real goal, which is the true and direct study of nature, and leads him to waste too much time in intangible speculation.[104] I've said it a hundred times, those critics, those Huysmans! I always want to write them, all of them who haunt me, and tell them that there are three things which make up the basis of our craft, which you will never have and toward which I have been working for thirty-five years, three things: scruples, sincerity, submission. Scruples before ideas, sincerity before myself, and submission before the motif. Sainte-Beuve discovered absolute submission to the object in a *Lundi* on Gautier. You are the object, Henri, for a quarter of an hour. To be master of the model and his means of expression you only have to paint what you have in front of you and persevere logically.[105] Work without believing in anyone, become strong. The rest is garbage.

He picked up his palette again. He took quick, sharp looks at my father's face.

I'd like to see them, all of them who write about us here, right under your snout, with my paws filled with tubes of paint and brushes. They never would have thought . . . Oh the devil . . . they could never even suspect how in blending a nuanced green with a red you can make a mouth sad or make a cheek smile. I feel, with each brush stroke I give it, there's a

little of my blood mixed with a little of your father's blood, in the sun, in the light, in the color, and that there is a mysterious exchange, which he isn't aware of, which goes from his soul into my eye which re-creates it, and where he will recognize himself . . . If I were a painter, a great painter! Each touch of the brush should correspond here, on my canvas, to a breath of the world, of light, there, on his sideburns, on his cheek. We must live in harmony, my model, my colors, and me, together give nuance to the very minute that is passing by. If you believe that it's simple to paint a portrait . . . listen, first you have to have the model . . . The soul! . . . Geffroy made me try to paint the portrait of Clemenceau. I began it. Everything went well at first. He arrived, holding his little walking stick in his fingertips, swaggering, like a young man, his tie flying, a touch gray around the ears. . . . France was his. I worked; he talked. About everything. Dazzling, and hurtful as a shrew. He was full of little barbs. Everything was going well. At the third sitting, I hit a wall. You see, the model had worked on me, inside. It did me no good to try to imagine a bitter blue or some acid yellows, to sharpen up the lines between sittings. Nothing worked. A wall. I could see, I was seeing . . . Then one fine morning, I abandoned the whole damned thing: the canvas, the easel, Clemenceau, Geffroy . . . That man didn't believe in God. Do you understand, I had a clear conscience. Just try to go paint a portrait with all that going on![106]

MY FATHER: Hey, I believe you. Are you going to leave me in the lurch?

CÉZANNE: Oh, you? Heavens, no! You make me discover things. I copy you slowly, gently. I use the colors of friendship. *He turns toward me.*

You say that Elie Faure wrote a friendly book on Carrière . . .[107] When Carrière wraps all his families in the same tender mist, it's because he has an obscure sense of the emotions of colors. You've seen his first communion at the museum in Toulon, the good old men and that sort of soft dawn which swallows everything. But he doesn't go any further than his own sentiment. That provides the foundation, but you have to go beyond your own feelings, surpass them. You have dare to objectify your subject, to render honestly what you see, sacrificing what you feel, having sacrificed what you feel. You see, it is enough to feel, sentiment never gets lost. And it's not that I condemn it; on the contrary, I often say it, I said it even yesterday, to a young man, a soldier, Girier or Girieud, whom I was introduced to at Clement. In principle, an art without emotion is not art. But emotion is the principle, the beginning and the end; craft, the objective, and practice are the middle. Between you Henri, and me, I mean, between what makes up your personality and mine, there is a world, the sun,

events, what we have in common, our habits, our flesh, reflections. I have to dig through all that. That is where, if the slightest brush stroke goes awry, it changes everything. If I am only emotional, I slap your eye on sideways. But if I weave around your expression an infinite web of little blues, some browns that I see, that work together on my canvas, I make you look the way you look. One stroke after the other, one after the other. And if I were unemotional and cold, if I drew and painted as they do at the Ecole, I would no longer see anything. A mouth or a nose, according to the book, always the same, without soul, without mystery, without passion. Every time I stand in front of my easel, I am another man, and always Cézanne. How can those others imagine that with plumb-lines, academic drawings, and ready-made measurements established once and for all, they can grasp changing, shimmering matter? They turn into idiots, they stupify themselves; they turn into stone, hardened. A boulder in your mind's eye, a window, geometry... They would do better to study anatomy[108] which abruptly gives us a sense of how muscles work, of how skin moves, if they want to draw a man standing up without a model... Delacroix used to get up at four in the morning to go to the slaughter-house to see horses be flayed. Just look at the way the horses on his ceiling snort... that's anatomy! They don't see anything anymore. They never did see anything. The ruler, rules, drawing, their drawing. Everything is there for them, except nature's masterpiece—her infinite diversity.[109]

Look, Gasquet, your father, he is seated, isn't he? He's smoking his pipe. He's only listening with one ear. What's he thinking about? Gusts of sensations come to him, however. His eye isn't the same... An infinitesimal proportion, an atom of light has changed, from within, and yet the drapery is always the same, or almost always the same, as it falls from the windows.

So you see, this tiny little tone, this minuscule tone which shades beneath the eyelid, has moved. Good. I correct it. But then light green next to it looks too strong. I tone it down. And I am having one of my good days today. I am strong. I am in charge of my will. I continue with imperceptible strokes all around. The eye looks better. But the other one, then, looks a little crossed to me. It looks, looks at me. While this one looks at his life, his past, at you, at I don't know what all, something which is not me, which is not us...

MY FATHER: I was thinking of that trump card I held until the third trick yesterday.

CÉZANNE: You see? Well, Rembrandt, Rubens, Titian knew at once, how to melt their entire personality and all that flesh before them in a sublime

compromise and to animate it with their passion, and with others' resemblance in order to glorify their dream or their sadness. Exactly. I can't . . .

ME: It's because you admire others too much.

CÉZANNE: It's because I want to be real. . . . Like Flaubert. To grasp the truth in everything . . . to become self-effacing . . .

ME: Maybe that's not possible.

CÉZANNE: It's very difficult. In substituting myself for your father I would have my ensemble. And I would give myself indications of shadows and light . . . I would approach reality. I want reality completely. Otherwise, in my manner, I would be doing what I criticize the Beaux-Arts for. I would have my prototype in my brain, and I would trace reality onto it. What am I, anyway? I want to reach the reality in one's soul, to render it as it appears. And if I break my back, too bad. I will have tried. I will have blazed a trail. Others who are more solid, more subtle will come who will do for the figure what Monet did with landscape. They will photograph it, understand me on this, but they will photograph souls, characters, a man. And others then will derive from these impressions a great art, a psychology of color, a philosophy of Man.

Rubens tried to do that with his wife and his children, you know, the fantastic *Hélène Fourment* in the Louvre, all golden red, in her hat, with her little naked baby. And there's Titian's Paul III between his two nephews in the Naples museum, a page from Shakespeare.

ME: And Velasquez?

CÉZANNE: Ah! Velasquez is another story. He avenged himself. You must understand, this man painted in his corner, he was preparing Vulcan's furnace and the triumphs of Bacchus to cover all the walls of Spain's palaces. An idiot, trying to be nice, talks about him, takes him to see the king . . . Photography hadn't been invented at that time, so the king says, "Paint my portrait, standing, on a horse, my wife's, my daughter's, this madman, this beggar, this one, that one. . . ." Velasquez became the king's photographer, the toy of this psychotic. Then, he kept everything inside himself, his work, his great soul . . . He was in prison, with no possibility of escape. He avenged himself terribly. He painted them with all their flaws, their vices, their decadence. His hatred and his objectivity were one and the same. Like Flaubert and his Homais and his Bournisien, he painted his king and the king's jesters. He doesn't look like the portraits he painted, whereas one always recognizes Rubens and Rembrandt beneath all their faces . . . And there is also another precursor, Goya. With his *Maja*

vestida and *Maja desnuda*, love itself created the miracle. He was so fright-ening, so ugly. You have seen him in his portrait with his enormous stove-pipe hat. We are always successful with our portraits, because in them we are one, you see, with the model. He was terrible, Goya. When he had this duchess, this slender aristocrat, this brunette body in his arms, he didn't have to invent anything. He was in love. He painted the woman. A woman. And afterward, we find her everywhere. The moment of grace didn't last. His devouring imagination carried him away again, but the Duchess of Alba is everywhere, as an angel, a courtesan, a cigarette maker, in his work. Like Hélène Fourment for Rubens, or his daughter for the old Tintoretto. These are great imaginative geniuses, Shakespeares, Beethovens. I would like to be. . . .

ME: What?

He mumbles.

CÉZANNE: Nothing . . . Cézanne . . . And here, the pose is finished, Henri. That's enough for today. Here . . .

He goes to his pile of canvases, searches . . . He pulls out three still lifes, he lines them up against the wall on the floor. They dazzle; they are warm, pro-found, alive, like a supernatural wall surface and all rooted in the most common-place reality. In one of them, a compote and four apples sit on a cloth; a grape, a stemmed glass, as thin and tapered as a chalice, half full of wine; a pile of apples; a knife. All this is set against a floral tapestry. On the left, in a corner it is half signed . . . In another a roughly squared wooden table holds a large basket, an-other basket of fruits half wrapped in a napkin; pears; a coffee service: coffee pot, sugar, and a little pitcher; an earthenware jug decorated with lozenges. On the right, on a just-visible corner of the fireplace, a palette, a flask of turpentine and nearby some stretched canvases. In the background, on the slanting floor, a chair, a rustic chair whose back is cut off by the edge of the canvas. The third is elegant, tasteful, lucid, a work entirely French, decorative and yet sharp. On a background cloth with a muted floral pattern draped in wide pleats, stands a plaster Cupid, his arms missing. To his right is a plate of pears, to his left a pile of plums. In the background, unexpected and bourgeois, but of amazingly rich craftsmanship, of stunning execution, is a fireplace in the Prussian style, such as they still use in the country manors in Provence.

Here, what I have not yet been able to attain, what I feel that I'll never attain in the figure, in portraiture, I have perhaps come close to here . . . in these still lifes. I conformed scrupulously to the object. I copied. Listen, what kind of person do you pity most? The destitute being, yes?[110] Well, I

gave myself a little over to that. I won't be totally deprived if, as you like to tell me, after my death, people will be interested in me a little. . . . There . . . Look at those . . . Tell me frankly what you think . . . You too, Henri.

ME: But they are greater than anything that's been painted since the Venetians! There are some green fruits by Tintoretto, at San Rocco, on an edge of his *Crucifixion,* folded under and miraculously preserved in all their freshness, apples which look like yours. But how beautiful it is! How beautiful! There is more life in those fruits than in many faces.

CÉZANNE: There you go, getting carried away. I don't deceive myself. This basket here, I offered it to my coachman, to remember me by, for later, you understand. He takes good care of mother, this man. Well, he was happy, he thanked me heartily, but he left the painting. He forgot to take it with him. What can I say? Might as well paint, since it's my fate.

ME: Master . . .

He has a grand, calm gesture, skeptical arms which fall to his sides, a despairing face, an ironic look, but an invincible will.

CÉZANNE: I have sworn to myself that I will die painting, rather than slip into that degrading senility which menaces most old people who fall prey to the mind-devouring passions that destroy their reason.[111] God willing.

ME: And even if you don't have the certitude we have, that you are one of the greatest painters ever . . .

CÉZANNE: Hush.

ME: At least you have the consolation of your work.

CÉZANNE: That's all I love. And painting . . . It is so good and so dreadful to stand in front of an empty canvas. Look at that one, I have been working on it for months through tears and laughter, grinding my teeth. We were talking about portraits. People think a sugar bowl has no physiognomy or soul. But that changes every day here. You have to take them, cajole them, those little fellows. These glasses, these dishes, they talk among themselves. They whisper interminable secrets. I gave up on flowers; they fade too soon. Fruits are more faithful.[112] They love to have their portraits painted. They sit there and apologize for changing color. Their essence breathes with their perfume. They come to you with all their aromas and tell you about the fields that they left, about the rain that nourished them, about the dawns they watched. Describing the skin of a beautiful peach with pulpy strokes, the melancholy of an old apple, I perceive in the reflections they exchange the same warm shadow of renunciation, the

same love of the sun, the same memory of dew, a certain freshness . . . Why do we divide the world? Is it a reflection of our egotism? We want everything to serve us. There are days when it seems to me that the universe is no more than one flow, an air-borne river of reflections, of reflections around man's ideas. The prism is our prime pathway to God, our seven beatitudes, the celestial geography of the great eternal white, the diamond-encrusted zones of God. I bet you think I'm a little crazy, Henri.

MY FATHER: No, no. My son understands you.

CÉZANNE: Objects penetrate one another. They never cease to be alive. Do you understand? They spread themselves out imperceptibly among themselves by intimate reflections, as we do with our gazes and our words. Chardin was the first to see that, he painted the nuanced atmosphere of things. He was constantly lying in ambush. You remember his beautiful pastel in which he shows himself with a pair of spectacles, and a visor which served as a kind of awning. He's a sly one, that painter! Notice how placing that streak of light across his nose enhances the values.[113] Well, he noticed it before I did. He didn't overlook anything. He also caught this entire encounter with his atmosphere, the thinnest particles, this emotional dust which envelops every object. But it is a little dry. It is perhaps even a little too finely outlined. Draw, draw, yes damn it, draw, but it is reflected light which is all enveloping, reflected light is the envelope.[114] That's what I'm looking for. And basically, that's why I don't like these three still lifes any more, since I've been talking to you.

ME: What, master? On the contrary, the more you talk, the better I see, the more I love them, the more I understand them. They have come to life with all you have said.

CÉZANNE: Well, listen to me. When someone starts to run down Chardin, like I just did, they have to bring better results.

ME: But Chardin doesn't have this brightness. He would seem completely muted next to this bluish basket, this Cupid. There's a little resemblance to poor quality prints in Chardin, next to . . .

CÉZANNE: Quiet! You'll make me believe that you don't understand anything about what I try . . . *I* don't find that life-like and enveloped in an atmosphere.

He points to the plaster Cupid in his still life.

Here, look at that hair, this cheek, it is drawn, it's skillful; there, those eyes, that nose, it's painted. And in a good painting, such as I dream of, there is unity. Drawing and color are not distinct from one another. Little by little as one paints, one draws, and the more harmonious the colors, the

more precise the drawing will be. That I know, from experience. When color is at its richest, form is at its fullest. Contrasts and harmony between tones, that's the secret of drawing and modeling. . . [115] All the rest is poetry, which you have to have in your brain, maybe, but which you must never try to work into your painting. If you do, you'll have literature. Poetry will come of itself.

He goes to get a book from the shelf, his old Balzac. He flips through La Peau de chagrin.

Yes, you have your metaphors, your comparisons. Though it seems to me that you constantly multiply the use of "like." It's like us, when our drawing is too clearly visible. You mustn't tug at people's sleeves. But we, we have only our tones, visibility. Here, look, he talks about a table with food on it. He creates a still life, Balzac, but in the style of Veronese. A tablecloth. . . .

He reads: ". . . a tablecloth as white as new fallen snow and on which the place settings rise symmetrically, each one crowned by little blonde rolls."

Throughout my youth, I wanted to paint that, this tablecloth of fresh snow. I know now that I must paint only "place settings rise symmetrically" and "little blonde rolls." If I paint "crowned," I'm ruined. Do you understand? And if I truly balance and nuance my place settings and my rolls as from nature, you can be sure that the crowns, the snow, and all the flickering will be there too. Within the painter there are two things: the eye and the brain; they must serve each other. It's necessary to work to develop them mutually, but as a painter: the eye for its vision of nature and the brain for the logic of organized sensations which give one's means of expression.[116] I stick with that. I think I told you one day, before the motif, and I'll tell you again, "In an apple or a head, there is a culminating point and this point is always—in spite of the effect, the terrible effect: shadow or light, or color sensations—the point closest to our eyes. The edges of objects recede towards another point on the horizon."[117] It's my grand principle, my certitude, my discovery. The eye must concentrate and encompass, the brain will formulate. And then, I also noted that in the margins[118] of *Chef d'oeuvre inconnu* [The Unknown Masterpiece], an excellent book, if I may say so just between us, more poignant, more profound than *L'Oeuvre*, and a book that all painters should reread at least once a year. I noted that . . . Here it is, without argument. I express myself decisively . . .

He reads: "An optical sensation is produced in our organ of vision

which causes us to classify by *light,* half-tones and quarter-tones, the planes represented by color sensations . . ."

He snickers.

Light, therefore, does not exist for the painter.

He continues to read:

". . . We inevitably move from black to white. The first of these abstractions acts like a point of support for the eye as much as for the brain; we get bogged down, we never attain mastery, self-possession. During this period, we are drawn to the great works that come down to us through the ages, from which we take comfort and support, like a swimmer clinging to a board."

He tosses the book aside.

But as soon as we are painters, we swim far from the shore, in full color, in full reality. We wrestle with objects directly. They lift us up. A sugar bowl teaches as much about ourselves and our art as a Chardin or a Monticelli. It has more color. These are our paintings that become still lifes. Everything is more iridescent than our canvases. I only have to open my window to see the most beautiful Poussin and the most beautiful Monet in the world . . . filled shadow, painted shadow, assassinated light, horrors! the death of brightness. . . . We walk through a country of blind men. By what sense, with which senses do we perceive the sun? Night haunts our paintings, night which gropes along. Museums are Plato's caves. I would have engraved on museum doors: "Entry forbidden to painters. Sunlight is found outside." A painter begins to paint, what he calls painting, at age forty, a painter of our time. Others at this age, in the time when there were no museums, had almost completed their life's work. A painter today knows nothing. Until age forty, yes, he visits the museums regularly, I order him to. Afterward, he returns to these cemeteries simply to rest and meditate on his inability to paint and on death. Museums are despicable places. They stink of democracy and private schools. I paint my still lifes, these still lifes for my driver who doesn't want them; I paint so that the children on their grandfathers' knees will look at them while they eat their soup and babble. I do not paint them for the pride of the emperor of Germany and the vanity of oil barons in Chicago. They pay ten thousand francs for one of these idiocies; they would do better to give me the wall of a church, a room in a hospital or city hall, and tell me, "Get in there! Paint a wedding, a convalescence, a beautiful harvest." Then, maybe, I could get rid of what I have in my stomach, what I have had there since I was born, and that would be painting. But I'm dreaming, I'm getting drunk,

I'm getting carried away. What will that lead to? To keep me from working better? To work . . . that is the only thing. Painting, you see, Henri, is damned difficult . . . We always believe we've got the secret, but we never do. Your portrait, it is a piece, and you understand that it needs lots of work on the face, eyes that look, a mouth that speaks. Well, it's still nothing. To make paintings, you would need almost to be able to turn out a piece like that every day. Tintoretto did it, and Rubens. And there is not only the face. These still lifes are the same thing. They are also dense, multiple. Each kind of painting demands its own skill. One never knows one's craft. I would paint for a hundred years, a thousand years without stopping, if it seemed to me that I knew nothing.

The old masters, in the name of God, I don't know how they forced themselves to churn out so many kilometers of painted canvas. I exhaust myself, I knock myself out just covering fifty centimeters of canvas. But that doesn't matter. That's life. I want to die painting.

He falls abruptly into one of those reveries that are common with him. He looks at his closed fist. He observes there the patterns of light and shadow.

That's not all. All of that, listen, it's all a joke. What I want is to make with color what others do in black and white with the stump [the bit of twisted paper artists use to blend pastels or charcoal].[119]

Another great silence. Then he looks at me and I feel his eyes, which go through me, beyond me, to the end of time. They dazzle me. He smiles a great, resigned smile.

Someone else will accomplish what I have not been able to do . . . I am probably only the primitive of a new art.

Then, a sort of bewildered revulsion comes over him.

Life is terrifying!

And like a prayer, as night falls, I hear him murmur several times:

I want to die painting . . . to die painting . . .[120]

EMILE BERNARD
June 1921

As noted above in the introduction to Bernard's Lettre, *his later writings on Cézanne tend to relinquish the documentary sharpness of his first accounts, and indulge increasingly in aesthetic speculation and implausible reconstructions of Cézanne's thinking.*

The conversation here represented by excerpts (from pages 372, 374–75, 394–95, 396, and 397 of the Mercure de France *article) is a prime example of this. Its real purpose is to present Bernard's own aesthetic position, in defense of an art which is "mystical, platonic, imaginative," and of a mode of reasoning which, confronted by nature, "observes it, penetrates it, and contemplates the idea of it," and which "looks beyond it."*

Cézanne, in contrast to this, is shown as one for whom "truth is in nature"; Cézanne's own subtle balancing of "the eye and the brain," of reasoning against observation, often illustrated elsewhere in the texts of this volume, is virtually forgotten, and impossible sentiments are put into his mouth. Even so, Cézanne's total opposition to an idealizing art is often well expressed, if not in authentic terms.

The complete text of this "conversation" was included in the version of Souvenirs *edited by R. G. Michel in 1926 or 1925.*

"A Conversation with Cézanne"
(*Mercure de France*)

In 1904, during one of our walks in the countryside around Aix, I asked Cézanne:

What do you think of the Old Masters?

They are good. I used to go to the Louvre every morning when I lived in Paris,

but I became more devoted to nature than to the masters. You have to make your own vision.

What do you mean by that?

You have to develop an "optique"; you have to see nature as if no one before you had ever seen it.[1] [. . .]

I see, you are seeking art in nature, and nature is outside of you, in the spectacle perceived by your eyes. It's an act of submission, of humility from which you hope for complete power.

I'm not at all accustomed to reasoning so much.

For the masters we were speaking about, the exterior, accidental spectacles were only a call to their genius. They searched them to find truth in the world, a vision of the universe. It was in the depths of their feelings, in their thoughts and ideas, that they tried to see patterns for their work;[2] and thus each one of them created new paintings, new images applying the laws of art drawn from the laws of nature.

Perfect, but they replaced reality with imagination, and with abstraction[3] *which goes along with it. I have told you before, and I repeat, it is necessary to realize a concrete image of nature. That's what makes the painter; it is necessary to have a vision.* [. . .]

A cicada started to sing in the nearby field.

To paint means to sing like that cicada,[4] he told me.

I believe you, but that cicada only makes noise, and the artist aspires to harmony. Well, in order to discover it, isn't it necessary to have a presentiment of it and a love for it?

The study of art is very long and very poorly carried out. Today the painter must discover everything for himself, because the only schools that exist are very bad ones where the student is warped, where he learns nothing. First one must examine geometric figures: the cone, the cube,[5] *the cylinder, the sphere. When one knows how to render these objects in their form and planes, one knows how to paint.*

They are evidently contained in everything we see. They are the invisible scaffold. The masters used geometry, geometrics, and perspective as a base.

What did they mean by that?

Geometry evaluates solid bodies and determines their surfaces; flat projections establish the values of height, width, and depth; and perspective draws contours according to their distance from the spectator. These last two are mathematics ruled by invariable laws.

This teaching was evidently the best.

Beginning with a point, which is the origin of all lines, after passing through the circle and angles, they conclude with the study of surfaces; planes; spheres; concave, convex and complex objects; and the study of visual rays.[6] Can one find more positive support?

That's the most correct discovery of my long career.

We walked through the most serene of landscapes under a hot sun. From time to time, my old teacher pointed out a motif, saying:

Do you not believe that this landscape, rendered as an old master would have done, but with a vision heretofore unknown, would make a magnificent painting?

I remained silent, feeling that I should abstain from contradicting him at all. I meditated, I felt more and more acutely where Cézanne was correct and where he was wrong. His excessive devotion to nature[7] expressed itself in him as a completed painting. I myself saw it painted by him, with his thick impasto, his style, his color arrays, his hesitations, and his naïvetés. But I thought that the demonstration of my old master's error would be made in comparing his sincere attempts, drawn from the sensation of exterior things, with a painting by Claude Lorrain, with a Titian landscape, or, closer to us, with one of Corot's mysterious, elegiac compositions. I remained silent as we walked along. [. . .]

Two kinds of logic are found in man: narrow and infinite. The first looks at nature and stops there. The second sees nature, passes through it, and contemplates the idea of nature; it looks beyond. The first kind of logic is admired by our century. It observes, discovers, invents. [. . .]

Italian art[8] obeyed the superior logic and that is what made it alternately mystical, Platonic, and imaginative. After the sixteenth century, Flemish and Dutch art obeyed practical logic. [. . .]

The speculations of modern art, like those of science, which are a corollary, lie completely in the objective world, and without discernment of the underlying cause. The result for science is the absence of general truth; for art, the absence of beauty. [. . .]

Cézanne stopped. He regarded me with a terrible look in his eyes, where I thought I saw some tears. Then he turned around and said brusquely:

I am old . . . It is too late . . . The truth lies in nature; I will prove it!

Then he walked away, leaving me like a stranger in the middle of the road. He moved insensibly with a hurried step.

I did not know what to do. I was familiar with the extreme sensitivity

of my old master. Accustomed to living alone, at the least contradiction he could fly into a rage that resembled madness. I resolved not to press him and to let him walk away. Solitude and the walk would probably dissipate his bad mood. While I watched him distance himself, it seemed to me that I had just stood up for Art against the stubbornness of a solitary man who blocked his own path through the absolutism of his research. And this research seemed to me to set limits for itself within the strangest and most unexpected barriers [. . .].

MAURICE DENIS

Published in L'Occident *in September 1907 (then reprinted in* Theories, *1912, revised ed. 1920, pp. 245–61, from which we take it), this article presents, only twenty months after Maurice Denis' visit to Cézanne in 1906, a well thought-out, and in many ways sound, view of Cézanne and his art, making use not only of information collected during the visit (sometimes now expanded and interpreted) but also the Bernard* L'Occident *article of July 1904.*

Too much need not be made of the theme of classicism in Denis' argument: Cézanne here becomes classic by remote analogy, since he maintains "an equilibrium, [. . .] a balance between the object and the subject." He is again distinguished from the Synthetists because of this "appropriate balance between nature and style," and because "he does not compromise it with any abstraction." Similarly the parallel with Odilon Redon's Symbolism is of a very general character: "The subjects of Redon are more subjective, the subjects of Cézanne objective, but both express themselves in a method that has for its goal the creation of a concrete object, both beautiful and representative of a feeling."

Thus the earlier parts of this article serve primarily to set Cézanne against the background of contemporary artistic developments, and only incidentally to sharpen the view of Cézanne formed as a result of the 1906 visit. But Denis' penultimate section will be found (with its passages on the role of "baroque" drawing in Cézanne's work, on the meaning of Cézanne's geometrical statements, and on color and modulation) to be a sympathetic and precise account of Cézanne's principles and methods, for which the earlier texts in this volume will provide amplification and support.

"Cézanne" (Excerpt from *Théories*)

There is something paradoxical about Cézanne's fame; and it is not any easier to explain it than to explain Cézanne himself. Views of Cézanne are irremediably divided into two camps, those who love painting, and those who prefer its accessory charms, such as literature, to painting itself. I know, unfortunately, that it is chic to like painting. Discussions of this subject are no longer passionately sincere as they once were. There are too many questionable admirers. Snobbism and speculation have involved the public in the quarrels of the painters, and they take part according to the latest style or interest. Thus, with the complicity of a public naturally hostile but habitually well indoctrinated by the critics and dealers, one can succeed in achieving the apotheosis of a great artist who remains, however, for those who love him best, a difficult painter.

I have never heard an admirer of Cézanne give me clear and precise reasons for his admiration; and that is rare even among artists, among those who feel Cézanne's painting most personally. I have heard some words— quality, taste, importance, interest, classicism, beauty, style . . . For example, one can utter in a succinct statement a well-founded, easily understood opinion about Delacroix or Monet. But how difficult it is to be precise on the subject of Cézanne!

The mystery in which the Master of Aix-en-Provence has surrounded his life, only helps to deepen the obscurity of commentaries which, nonetheless, benefit his fame. He was timid, independent, and solitary. Exclusively occupied with his art, perpetually worried, and most often dissatisfied with himself, he escaped public curiosity until his last years. Those who invoke his name for the most part never knew him. The author of these pages admits that around 1890, at the time of his first visits to Tanguy's shop, he thought Cézanne was a myth, maybe even a pseudonym for an artist who specialized in other things, and he doubted his existence. Since that time, he had the honor to meet him in Aix; and the statements which he gathered, joined with those which Monsieur E. Bernard published in *L'Occident* (July 1904) will serve to throw some light on his aesthetics.

At the time of his death, magazine articles were unanimous on two points. Wherever the inspiration for these articles came from, I am certain that they can be taken for the exact reflection of the average opinion. These obituary notices at first admitted Cézanne's influence on a great number of young artists; then, that he had worked toward achieving a

style. Thus it is understood that Cézanne is a sort of classic and that youth holds him as a representative of classicism . . .

It is a pity that it is so difficult to say, without being too obscure, what classicism is . . .

When in the country, after a long separation, one enters one of our sad provincial museums, one of those cemeteries in which disintegration, abandonment, the odor of mildew, and silence add to the remoteness of time, one quickly distinguishes between two categories of works on display. The first are the remains of collectors' cabinets, the second, new galleries where State commissions have amassed mediocre new works, bought by chance at the annual salons according to studio intrigues or ministerial favors. That's when one is really and ingenuously sensitive to the contrast between the ancients and the moderns; and when an old piece by a Bolognese painter or a student of Lebrun, both powerful and synthetic, seems decidedly superior to the dry analyses and mediocre color photographs of our medal winners.

Imagine in this milieu—this is pure hypothesis—the presence of a Cézanne. This way we can understand him better. And first of all we wouldn't place him in the new galleries, since he would be so out of place among this trivia and vapidness. He would have to be reunited with the old masters to whom he seems related at first sight by his nobility and his style. Gauguin said when thinking about Cézanne: Nothing resembles a bad painting more than a masterpiece.[1] Bad painting or masterpiece, we can only understand him in comparison to the mediocrity of modern painting. And already we notice one of the characteristics of classicism, a certain Style, a certain order achieved by synthesis. Against the trend in modern paintings, a Cézanne is valued for itself, for his qualities of unity of composition, of color, and for saying all there is to say about painting. The news items and illustrations of paperback novels or epics, which cover the walls of the museum I am imagining, seek to interest us only by the subject represented. Then there are studies which try to establish the virtuosity of the artist. Good or bad, a canvas by Cézanne is truly a *painting*.

Let us imagine reunited, for another, less fanciful experience, three works of the same genre, three still lifes, a Manet, a Gauguin, and a Cézanne. We would quickly decipher Manet's objectivity: that he imitates nature "through a temperament,"[2] that he translates an *artistic* sensation. Gauguin is more subjective. His is a decorative, even hieratic, interpretation of nature. Standing before the Cézanne we dream only of painting;

neither the object represented nor the subjectivity of the artist gets our attention. We do not decide so quickly if it is an imitation or an interpretation of nature. We feel that this art is closer to Chardin than to Manet and Gauguin. And if, upon seeing the painting, we say it is a painting, a classical painting, the word begins to make very clear sense, that of a balance, a rapport between the object and the subject.

In the Museum in Berlin, for example, the effect produced by Cézanne[3] is very significant. As much as one appreciates Manet's *Serre* [The Conservatory], or Renoir's *Enfants Bérard,* or the admirable landscapes of Monet and Sisley, the presence of the Cézannes makes us compare, albeit unjustly, but by the curse of the contrast, the ensemble of modern productions by the Manets, Monets, Renoirs, and Sisleys; and contrasted to them, the paintings of Cézanne seem works of another era, as refined but more robust than the strongest productions of the Impressionist school.

Thus we define Cézanne first of all in reaction to modern painting, in reaction to Impressionism.

When he began, under the influence of Delacroix, of Daumier, of Courbet, it was old museum paintings that guided his first hesitant steps. The revolutionaries of his time barely experienced the influence of their elders. Cézanne copies them; and in his father's house, the Jas de Bouffan, one is surprised to find a large interpretation of a Lancret and a *Christ in Purgatory* after Navarete.[4]

It is necessary to differentiate between this first style inspired by the Spanish and the Bolognese painters, such as the rough portraits made with a palette knife in the Pellerin collection or the famous portrait of Emperère [*sic*];[5]—and the works of the second style, fresh and nuanced. During the two periods, Cézanne played the role of a reactant, precipitating the ephemeral elements of pure sensitivity of modern art, and he transforms into harmonious and enduring formulas those elements which satisfy his classical affinities. In the first period it is evident what Courbet, Delacroix, Daumier, Manet were for him and by what spontaneity of assimilation he develops in the sense of style some of their classical tendencies. No doubt, he doesn't achieve the calm beauty and plenitude of Titian, but he will join the Venetians by way of El Greco. "You are the first in the decadence of your art," Baudelaire wrote to Manet. Such is the weakness of modern art that Cézanne seems to us to bring health and a renaissance, while proposing an ideal related to Venetian decadence.

There is an instructive comparison between Cézanne and the nervous

and slightly mad El Greco who, through a contrary work, introduced into the triumphant maturity of the Venetian school the system of passionate dissonances and distortions which were the origin of Spanish painting. From these feverish final years of a great era was born the robust and healthy style of a Zurbaran, of a Velasquez. But while El Greco amused himself with refinements of naturalism and imagination, no doubt as the result of boredom with Titian's perfection, Cézanne inscribed his sensitivity in crude and rational syntheses in reaction to fading naturalism and romanticism.

This same moving conflict, this combination of style and sensitivity, is found in Cézanne's second period, but it was then the Impressionism of Monet and Pissaro that furnished the elements, that provoked his reactions and his classical transformation. He disciplined the contrasts of colors created by the study of pure light, the rainbow irisations of the new palette; he disciplined them and organized them with the same rigor as the oppositions of black and white of the preceding period. At the same time, for the summary modeling of his first figures he substituted the reasoned chromatics[6] of the figures and still lifes of this second style, which could be called his florid style.

Impressionism—and I mean by that much more the general movement which for twenty years has changed the aspect of modern painting than the particular art of Monet or Renoir—Impressionism had a synthetic tendency because its goal was to translate a sensation, to objectify a state of the soul; but its means were analytical because color was only the result of an infinity of contrasts. By decomposing the prism, the Impressionists composed light. They divided color; they multiplied its reflections and nuances. At last they substituted for so many different grays, the same number of colors. This is the fundamental vice of Impressionism. Manet's *Fifre* in four colors is necessarily more synthetic than the more charming Renoir whose plays of sun and shadow engender the fullest variety of nuances.* So, there is in a beautiful Cézanne as much simplicity, austerity, and grandeur as in Manet, and its nuances preserve the freshness and brightness which flower in Renoir's paintings. Several months before his death Cézanne told us, "I wanted to make of Impressionsim something solid and enduring like the art in museums."[7] That is why he also had so much admiration for the

*It is a question of the earlier Renoirs; it is known that this great artist developed and enlarged his synthesis of style and tradition during his last years.

early Pissarros and especially the first Monets—Monet being the only one among the living artists for whom he expressed great esteem.*[8]

Thus, first from a Latin instinct, by way of natural taste, and later fully conscious of his efforts and himself, he endeavored to create a kind of classicism from Impressionism. In perpetual reaction against the art of his time, his strong individuality provided both the nourishment and the pretext of his researches on style: from it he mined the materials of his work. At a time when the sensibility of the artist was engaged almost entirely in the unique logic of the work of art, and when improvisation—that *"spiritual vertigo which comes from the exaltation of the senses"* (Gustave Geffroy)— tended to destroy both obsolete academic conventions and necessary methods, Cézanne's art learned how to preserve the essential role of sensibility while substituting meditation for empiricism. As an example, instead of the chronometric notation of phenomena, he was able to preserve his emotion of the moment while laboring almost to excess, through determined and desired work, on his studies from nature. He *composed* his still lifes, varying by design the lines and masses, arranging draperies according to premeditated rhythms, avoiding accidents of chance, searching for plastic beauty, but without losing anything of the real model, of this initial model that one perceives unadorned in his sketches and watercolors. I mean this delicate symphony of juxtaposed tones, that his eye discovered first but that his mind soon spontaneously applied to the logical support of a composition, a plan, an architecture.

Let us note, however, that there is nothing less artificial than this effort toward a precise combination of style and sensibility. What others have searched for and sometimes found by imitating the old masters, the discipline that he himself demands of great artists of his time or the past, he discovered finally in himself. And here is the essential characteristic of Cézanne. His turn of mind and his *genius* do not permit him to profit directly from the old masters; he finds himself facing them in a situation analogous to the way he faced his contemporaries. His originality is stimulated by contact with those whom he imitates or who influence him. His persistent clumsiness and his blessed naïveté come from this fact, as does the incredible awkwardness to which his sincerity obliges him. For him, it is not a question to stylize a study as does a Puvis de Chavannes. He is completely and naturally a painter, completely spontaneously classical! If I dared to make a comparison with another art form, I would compare

*"Ah! The juries of 1867 were pigs! They refused Monet's painting!" I think this refers to *Summer* which still belongs to the artist.

Cézanne to Veronese the way I would compare the Mallarmé of *Hérodi-ade* to the Racine of *Bérénice*. With new elements or at least renewed, rejuvenated means, without any borrowing from the past except the necessary forms (here the mold of the Alexandrine and the tragedy, there the traditional conception of the composed painting) the poet and the painter revive the language of the Masters.

Both are scrupulous in conforming to the requirements of their art and in not surpassing its limits. Just as the writer was determined to owe all his poem's expression, aside from the ideas and the subject, to the pure domain of literature: sonority of the words, rhythm of the phrases, mobility of syntax—the painter was a painter above all else. Painting eternally oscillates between invention and imitation. Sometimes it copies and sometimes it imagines. These are its variations. But whether it pro-duces objective nature, or translates more especially the emotion of the artist, it must be an art of concrete beauty that our senses discover within the object of art itself, without regard to the subject represented, immediate satisfaction, and a pure aesthetic pleasure. Cézanne's is pre-cisely this essential art which is so difficult for the critic to define and whose realization seems impossible. He does not imitate objects precisely and he does not interest us in the accessory subjects of sentiment or thought. When he imagines a sketch, he assembles colors and forms out-side of any literary thoughts. His work is more akin to that of the weaver of Persian carpets than to that of a Delacroix, transposing into color harmonies, but with lyric or dramatic intentions, a scene from the Bible or from Shakespeare. His efforts are negative, if you will, but they bear witness to an unheard of instinct for painting. He is one who paints. One day Renoir said to me, "How does he do it? He puts two strokes of color on a canvas and already it's very good." The occasion for this selection is of little importance, nude figures improbably grouped in a nonexistent landscape, apples on lopsided plate against a background of common drapery. There is always a beautiful line, a beautiful equilibrium, a rich series of resonances and harmonies. Freshness, spontaneity, and the new-ness of his discoveries add interest to his slightest sketches. Sérusier said:[9]

> He is the pure painter. His style is a painter's style, his poetry is a painter's poetry. The use, even the concept of the object represented, disappears before the attraction of the colored form. About a com-mon painter's apple, one would say, 'I'll eat it.' Of one of Cézanne's apples, one says, 'it's beautiful!' One wouldn't dare peel it, one would like to copy it. That is what constitutes the spirituality of Cézanne.

Intentionally I didn't say 'idealism,' because the ideal apple would be the one that delights taste buds. Cézanne's apple speaks to the mind through the pathway of the eyes.

"You must notice one thing," Sérusier adds. "It is the absence of a subject. In his first style the subject was unimportant, sometimes childish. After his evolution, the subject disappeared; there is only a motif " (that's the word Cézanne used).

And that, too, is a priceless lesson . . . Haven't we mixed all the genres, mixed music, literature, painting? Again Cézanne reacts; he is a naïve artisan, a primitive who returns to the sources of his art, who respects its primordial givens and its necessities, is faithful to its fundamental elements, to what constitutes exclusively the art of painting. He isn't interested in all the rest, suspect refinements and deceptive methods. Before his motif he shuts out all that could distract him from painting, everything that could compromise his "little sensation," as he called it, using the phraseology of the aestheticians of his youth. He avoids both trompe-l'oeil and literature.

The preceding reflections permit us to explain how Cézanne relates to Symbolism. Synthetism, which became Symbolism through contact with Symbolist poets, was not originally a mystical or idealist movement. It was begun by landscape artists and still life artists, not by mystical painters at all. It involved, however, belief in a correspondence between exterior forms and subjective states. Instead of evoking our spiritual states through the subject depicted, the works themselves should transmit the initial sensation and perpetuate its emotion. Every work of art is a transposition, a passionate equivalent, a caricature of received sensation, or more generally, of a psychological fact.

"Nature," Cézanne said, "I wanted to copy nature; I wasn't able to. But I was pleased with myself when I discovered that sunlight, for example, could not be *reproduced*, but that I had to *represent* it by something else . . . by color."[10] This is the definition of Symbolism as we understood it around 1890. Our elders of that time, above all Gauguin, had boundless admiration for Cézanne. I add that they also had great esteem for Odilon Redon. Redon also searched outside of copied nature and sensations, for the plastic equivalents of his emotions and his dreams. He, too, tried to remain a painter, exclusively a painter while translating the light rays and shadows of his imagination.

If I insist here on talking of Odilon Redon, it is not only to render much merited homage to this artist and to try to pay him the debt of a

whole generation's recognition, but also in order to draw from the comparison of these two masters one more clarification in the definition of Cézanne. Yes, Redon is at the origin of Symbolism, in what concerns the plastic expression of the ideal; and on the other hand, Cézanne's example taught us to transpose sensation into elements of the work of art. Redon's subject is more subjective; Cézanne's is more objective, but both create by means of a method which has as its goal the creation of a concrete object that is both beautiful and represents a sensibility. The artist, as complex as his time and whom we are trying to explain, has found through this method his equilibrium, the profound unity of his efforts, the solution of his own paradoxes. The spectacle is moving in a Cézanne painting, most often unfinished, scraped with a knife, overlaid with turpentine-thinned pentimenti, repainted several times, encrusted to a state of relief. One finds in this labor the struggle for style and the passion for nature, the acquiescence to certain classical laws and the revolt of an unedited sensitivity; reason and inexperience, the need for harmony and the fever of original expression. Never does he subordinate his work to his technical means, "because the flesh," says Saint Paul, "has its desires contrary to those of the spirit, and the spirit has desires contrary to those of the flesh. They oppose one another so that you are not free to do what you want." Such is the eternal struggle of reason and sensitivity which creates saints and geniuses.

Let us agree that for Cézanne this struggle results at times in chaos. We have removed classical spontaneity from its own sensation. But realization does not occur without lapses. Already constrained by his need for synthesis to disconcerting simplifications, he continues to distort through necessity of expression and by scrupulous sincerity.* This serves to motivate the reproach of awkwardness often aimed at Cézanne and also explains the practice of naïveté and clumsiness, common with his disciples and imitators.

Surely, Tradition is not the business of scholarly correction and rhetoric as certain artists believe, who, under the pretext of continuing in the path of

*I have tried to demonstrate in an article in *Arts de la Vie* (July 1904) that the awkwardness of the Primitives consists of painting objects according to the usual familiarity they have with them, instead of painting them from a preconceived picturesque or aesthetic idea like the moderns. Since the picturesque is the element of nature *recognized* as proper to painting, it is natural that, from the moment an artist distances himself from recognized principles and paints with a sincere naïveté, he incurs the criticism of being ignorant or awkward.

Leonardo or Titian, succeed in making us miss Cabanel and Benjamin Constant. But it would also be completely childish to glorify Cézanne for his negligence and his imperfections. Let us try to escape the prejudices which cause Dreyfusism and depression. Let us not be duped by the spirit of paradox, of disorder and subtlety. The fact is that people judge disdainfully a work of patient execution; they admire nothing more than sketches, especially those whose perfunctory invention and rapid execution imply a kind of artistic nihilism. This is the myth of the unfinished. Surely André Suares's thought is correct: "In times of decadence, everyone is an anarchist, both those who are and those who pride themselves on not being anarchists. Because each one takes the law unto himself . . . We love order passionately, but the order that we create, not the order that we receive." The works of earlier artists remain a sure criterion for us: let's not look for others. Because enthusiastic critics preferred Cézanne to Chardin and Veronese, it is proper today to recognize his blank spaces, and simply to admit that he has suffered the repercussions of the disorder of our time. Such is the power of his invention, the sincerity of his gesture, that his clumsinesses hardly bother us and most often disappear into the general harmony. With equally beautiful qualities, Chardin and Veronese had the virtue and the knowledge to advance further in the execution of the work of art. They risked difficulties that are insurmountable for us: their supple fantasy accommodated itself to the laws of perspective and anatomy which we reject like the most awful shackles. They knew how to draw a straight line or a regular curve with a pencil. We should feel nostalgia for the ancien régime. The same upheavals which, in times gone by, overturned French order have favored romantic influences, the origin of the decadence in craft and the state of intellectual anarchy in which we flounder. Let us appreciate, therefore, that in a time when, according to Gustave Moreau, "all that is good has failed"—Cézanne has allowed us to see the possibility of a classical Renaissance and has given us works of such superiority of style.

What is most surprising in Cézanne's work is surely his research on form, or more precisely, on deformations: here one discovers the greatest hesitations and anguish in the artist's work. The large painting of the *Baigneuses*, left unfinished in his studio in Aix, is typical from this point of view. Begun again and worked on countless numbers of times during long years, it varied little in aspect or color, even the placement of the strokes seemed almost unchanged. On the other hand, the dimensions of the figures were

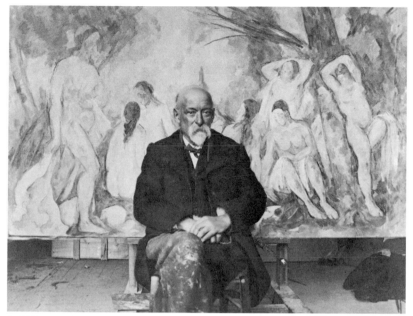

Paul Cézanne in his studio at Aix, in front of *Beigneuses* (detail); photo Emile Bernard, 1904

reworked several times. Sometimes they had attained natural height, some-times they were reduced to half-size: arms, torsos, and legs grew and dimin-ished in unimaginable proportions. This was the variable element of his work: his sense of form included neither silhouette nor fixed proportions.

In the beginning he did not understand line drawing and contour. In spite of the exclamation collected by Monsieur V. during his portrait sit-tings, "Jean Dominique is great!"[11] it is certain that he did not like Ingres. He said, "Degas is not enough a painter; he doesn't have enough of that!" —as with a nervous gesture, he imitated the turn of hand of the Italian muralists. He liked to talk about the caricaturists, Gavarni, Forain, and most of all Daumier. He loved their exuberant movement, bulging muscu-lature, the impetuosity of their hand, and the bravura of their pencil lines. He drew from Puget. He desired both ease and passion in his execution, and preferred without doubt the sleight of hand of the Bolognese to the precision of Ingres.[12]

On a wall of the Jas de Bouffan, now covered with hangings, he left some improvisations, first attempts of painted studies that seem to have been dashed off in a single session. In spite of the beautiful qualities of the

painting, it reminds one of Claude's bravado in *L'Oeuvre* and his speeches on *"temperament."* What were his preferred models at that time? Engravings after seventeenth-century Italian and Spanish artists. When I asked him what led him from that passionate execution to his patient technique of separate strokes, he answered, "It's because I can't render my sensation immediately; so I add color, *I add it as I can.* But when I begin, I always want to paint with thick paste like Manet, *creating form with the brush."*[13]

"There is no line," he said, "there is only modeling; there are only contrasts. When color is at its richest, form is at its fullest." (Cited by E. Bernard.)

Thus in his truly concrete perception of objects, form is not separate from color; they act upon one another; they are inseparable. And on the other hand, in execution, he wants to represent things as he sees them, with an identical brushstroke. If he does not succeed, it is due to the weakness of craft of which he complained; but also and above all it is due to his scruples as a colorist, as we saw earlier.

All his sense of abstraction—and one sees to what point the painter is involved in abstraction as a theoretician—all his faculty of abstraction goes only so far as to distinguish "the sphere, the cone, and the cylinder" as notable forms. All shapes lead back to these, the only ones he is able to consider. The multiplicity of his color scales varies everything infinitely. However, he does not go so far as the idea of the circle, triangle, or parallelogram. Those are abstractions which his eye and his brain refuse to accept. For him, forms are volumes.[14]

From then on all objects should gain their value especially from relief, placing themselves in planes at different distances from the viewer in the imaginary depth of the painting. A new antinomy threatens to diversify singularly "the flat surface covered with colors arranged in a certain order."[15] Colorist above all, Cézanne resolves this chaos through chromatics, or by transforming values of black and white into color values.

"I want to make with color what others make with black and white and the drawing stump," he told me.[16] He replaces light with color. This shadow is a color; this light, this half-tone are colors. The white of the tablecloth is a blue, a green, a rose; they mingle in the shadows with surrounding local colors. The light's harshness will be harmoniously transformed by a blue, a green, a dissonant pink. Thus he substitutes contrasts of colors for contrasts of tones. In this way, he untangles what he calls the "confusions of sensations." Throughout all the conversation from which I report to you here a few little snatches, he never once pronounced the

word *values*. His system certainly excludes affinities of values in the scholarly sense of the word, that is in the sense of atmospheric perspective.

Volume also finds expression in Cézanne in a scale of colors,[17] in a series of strokes. These strokes follow one another by contrasts or by analogies by which form is interrupted or continues. This was what he liked to call "modulation" rather than modeling. We know the shimmering and vigorous result of this system. I shall not describe the fullness of harmony and joyous light of these paintings. They are of silk, mother of pearl, velvet. Each *modulated* object expresses its curved outline more or less by the exaltation of color. If it is in shadow, its color relates to the colors of the background. The background is a fabric of tones sacrificed and destined to accompany the principal motif. But whatever the excuse, we also rediscover the process of chromatic sequences in which colors contrast with or become enmeshed with tones and half-tones. The entire canvas is a tapestry where each color *plays* separately and yet blends its resonance into the whole. The characteristic feature of Cézanne's paintings comes from this juxtaposition, this mosaic of separate colors that lightly flow together. "Painting," he said, "means to record these color sensations." (Cited by Bernard.) Such were the demands of his eye that he was forced to resort to these technical refinements to preserve the quality and flavor of his sensations, and to satisfy his need for harmony. In 1767 Bachaumont wrote of Chardin, "His style of painting is unusual. He puts colors one after the other, hardly mixing them so that his work somewhat resembles a mosaic or a piece of furniture covered in the kind of needlepoint known as 'square point.'" Cézanne's fruits and his unfinished figures are the best example of this method of painting, perhaps revived from Chardin. Some square strokes indicate the rounded form by delicate proximity to other colors; the contour appears only at the end, like a vehement gesture, a stroke thinned with turpentine, which accentuates and isolates the already visible form by weakening its color.

In this meeting of nuances is seen an effect of noble style, perspective planes disappear, the values (in the Ecole des Beaux-Arts sense), the atmospheric values diminish, become equalized. The decorative effect and the equilibrium of the composition appear so much better because atmospheric perspective is sacrificed. Venetian painting, with its more enveloping chiaroscuro, often presents this handsome aspect of unity of plan.* A curi-

*They discovered in 1905 at the Scuola di San Rocco a fragment of a Tintoretto frieze which, folded against the wall at the time of its installation, because it was

ous thing is that this is what most struck the first symbolists, Gauguin, Bernard, Anquetin, those who, after all, were the first to imitate Cézanne. Their system of synthesis allowed only flat color and a hard contour,[18] from which issues a whole series of decorative works of which it is not my place to speak ill. But how many of Cézanne's syntheses were more comprehensive, more concrete, and more lively!

To synthesize is not necessarily to simplify, if that means doing away with certain parts of the object. It means to simplify in the sense of *rendering intelligible*. It means, in short, to rank, to submit each painting to a single rhythm, to a dominant characteristic, to sacrifice, to subordinate—to generalize. It is not enough to *stylize* an object, as they say in Grasset's school, to make an ordinary copy of it, then to outline its exterior contour with a thick brush stroke. Simplification achieved in this manner is not synthesis.

"Synthesis," according to Sérusier, "consists of making all perceived shapes conform to the small number of shapes that we are capable of imagining: straight lines, a few angles, arcs of circles and of ellipse. Apart from that we get lost in the ocean of variety." This system is without doubt a mathematical equation for art; it does not lack grandeur. But it is not, whatever Sérusier might say, Cézanne's idea. He does not lose himself in the sea of variety; he knows how to elucidate and condense his impressions. His formulas are luminous, concise, and never abstract.

And that is one more way in which he is like the classics: he never compromises with abstraction the perfect balance between nature and style.[19] All his labor consists of preserving the sensation. This sensation includes the identity of color and of form, but his sensibility implies his style. Naturally and instinctively he joins, in his mind if not always on his canvas, the beauties and all the brightness of the modern colorists to the vigor of the old masters. Perhaps realization does not come without work, or without lapses. But for him, the order that he invents is necessary for expression.

He is at once the finale of the classical tradition and the result of the great crisis of liberty and light which gave modern art new life. He is the

too large, had retained all the freshness of its colors. It consists of apples painted in a pale green and a bright red on a background of leaves in Veronese green. *Everything in it is color*. One would think it a Cézanne. Perhaps it lacks the strokes of umber that would have darkened it in the end, and perhaps also it is only a preparation in tempera, but just as it is, this precious fragment demonstrates in Tintoretto an attempt at chromatism altogether similar to Cézanne's which I have just explained.

Poussin of Impressionism. He has the acute perception of a Parisian and is magnificent and abundant like an Italian muralist. He is orderly like a Frenchman and fevered like a Spaniard. He is a Chardin of decadence, and sometimes he surpasses Chardin. There is some El Greco in him too, and he often has the strength of Veronese. But whatever he is, he is natural, and all the scruples of his will, all his attention to his work have been to serve and to heighten his natural gifts.

We have tried here to *define* the painted work of art; we have not tried to express its poetry. All the magic of words will not suffice to explain, for those who might not have enjoyed it, the unforgettable impression that a beautiful work of Cézanne gives. Cézanne's charm cannot be described, nor can one describe the nobility of his landscapes, the freshness of his greens, the purity and depth of his blues, the delicacy of his flesh tones, or the brightness and velvetiness of his fruit. Few artists have had such an original sensibility—but that has been said of so many others in our time that it is better not to insist on this point; it is the most banal praise one can give an artist.—He liked to talk with evident modesty of his "little sensation," his "little sensibility." He complained that Gauguin stole it from him, and that he "took it with him on all the steamships." In truth, his art is so natural and so concrete, so alive and so spontaneous that it is difficult to be inspired by his technique and his methods without at the same time taking away a little of the best of himself. For Félibien,[20] speaking of painters, sensation is the application of things to the mind or the judgment that the mind possesses. The two operations, Aspect and Prospect, as Poussin called them, could hardly be more separate in Cézanne. To organize one's sensations* is a seventeenth-century discipline. It is the premeditated limiting of the artist's receptivity. But the true artist is like the true wise man, "a childlike and serious nature" (Ernest Renan). Between his work and his scruples, he accomplishes this miracle, preserving of all his freshness and naïveté.

*"In the painter there are two things: the eye and the brain, both should support one another; one must work toward their mutual development: the eye for the vision of nature, the brain for the logic of organized sensations that give us our means of expression." (Cited by E. Bernard, *loc. cit.*) Poussin wrote to Monsieur de Chantelou, "My temperament requires that I look for and love well-ordered things."

LAWRENCE GOWING
Cézanne: The Logic of Organized Sensations

One might write the history of that order of originality which this century identifies as the essence of art—and eventually it must be written—as a history of inveterate misunderstanding. We cannot claim that the view of Delacroix that inspired Cézanne represented a true evaluation of him. The guiding star that Cézanne followed shone far more steadily than the flawed jewel of Romanticism ever did. And Delacroix himself, how shallow his interpretation of Rubens! Then Rubens—was not his merely sensuous appreciation of physical rhythms as the basis of style a gross misconstruction of the philosophical meaning that the human body held for Michelangelo? And so on . . . Yet this succession of creative misunderstandings was as nothing by comparison with the way that the twentieth century used Cézanne. The interpretations to which his example was subjected in the years after 1906 converted art into something new, something he would certainly have accepted even less than he accepted Gauguin, an order of image and a function of style neither of which had ever existed before.

The fact that Cézanne was open to such a radical interpretation, embracing the whole foundation of art, is enough to show that something quite extraordinary and unparalleled happened in the work of the old solitary in the years after 1900. Yet if we interpret this happening simply as a hermetic style—a novel kind of fragmentation, the development of discontinuity into pattern, or the elevation of concords of color and line into harmonies that were sufficient in themselves—then we are certainly miss-

ing something that shines out of both Cézanne's late oil paintings and his watercolors, different as they are in other respects. Cézanne's undiminished concern with the existent world is equally evident in his own commentary on his art in his last years. But we are in a difficulty; we do not have the critical equipment to evaluate the existential tenor of a formal style. If we seek to understand the development after 1900 as part and parcel of the evolution that we can trace in the four previous decades, we remain at a loss. From the 1860s onward Cézanne was a painter of objects. While his contemporaries painted effects, Cézanne painted things. In 1896 Gustave Geffroy described "the ardor of his curiosity and his desire to possess the things that he sees and admires."[1] For the great part of his achievement he remained rooted, as none of his contemporaries were, in direct and daily contact with a native countryside.

But after 1900 separable physical objects in Cézanne's work increasingly merge into the flux of color. The subject of the late landscapes becomes, as it never was before, chiefly the breadth and depth of nature—"or, if you prefer, of the spectacle that the Pater Omnipotens Aeterne Deus spreads out before our eyes."[2] Modern opinion has sometimes regarded the allover weave of color in these pictures as akin to Impressionism—a throwback and thus a retreat from the compositions of 1890 and the classicism of modern art. I was once advised by a good artist that Cézanne had begun as a progressive and ended as a reactionary. There are indeed signs of a reminiscent mood in the work of Cézanne's last years. Some of his last watercolors had more in common with the kind of subject that he had dealt with at Auvers more than thirty years earlier than with anything in his art since. Thinking of Pissarro and Impressionism in 1906, "How far away it all seems," he wrote, "and yet how near."[3]

Nevertheless, Cézanne's work from 1900 onward is radically different from the object-based structures of earlier years. Few now find the visual language of the late work obscure in any ordinary sense, but some certainly impute by association qualities that would have astonished Cézanne. I remember a collector's resentful glare, not much more than a decade ago, as she showed me an earlier flowerpiece and remarked, "That was before Cézanne went modern!" It would have been no defense to point out that in his last years Cézanne was reaching out for a kind of modernity that did not exist, and still does not. He was very aware, in one mood at least, of the sacrifices entailed in the seeming discontinuity and fragmentation of the style to which, as if involuntarily, he was led. These were the very characteristics that suggested ways of perception and patterns which the

twentieth century has cherished most. The styles that Cézanne has inspired are hardly the promised land that he foresaw. In 1904 he resigned himself to being "the primitive of the way that I discovered,"[4] but if he had in mind, as is likely, a way that kept close to the naturalness of the real world, even this claim remains to be verified.

The vexed critical history of the late pictures in the seventy years since Cézanne's death, comparable to the fortunes of Beethoven's posthumous quartets, is significant. Comparing Cézanne's art of his thirties and of his sixties, we are in fact comparing two quite different kinds of rationale. The distinction was already clear to Maurice Denis when he wrote about Cézanne in 1907.[5] We turn from the logical mimetic theory of painting to another, one that is based on inherent meanings, for which, despite all that has happened, our critical framework is by comparison intuitive, based on a way of thought rather akin to free association. It yields the rich and satisfying returns that we find in modern art. A doubt remains; is this what Cézanne's powerful mind intended? Is this all that the fiercely prehensile eye was grasping at in the last years? If it was, we might think that the intense intellectual effort, with which the last utterances and the pictures too were stamped, was in a sense misdirected—even that some of Cézanne's remarks about his art contained an element of equivocation. It is not easy to think of Cézanne as the inventor of the kind of aesthetic double-talk that has been prevalent since. We recognize form that is voluminous without being solid, color that is luminous without light, representation that is apparently specific yet specifies nothing. We recognize, in fact, the contradictory kinds of reference that the paradoxes of our own art are built upon. In Cézanne, however, there is no paradox, but an order of pictorial statement full of an earnestness and a conviction that possess the single-minded moral dignity of tradition.

Cézanne himself was well aware how problematic his standpoint would be found. He developed an uncharacteristic longing for exegesis and explanation. A preoccupation with theory and with the status of theory filled his letters and his conversation. Posterity might have made better use of the lavish clues he offered. They are certainly needed. Contemplating the seminal works on which the twentieth century has depended so greatly, we are examining what aesthetic comprehension consists of in our age. We are considering what kind of sense we can claim to make of our own culture.

The move toward a disintegration of the object in some of the most memorable works of a painter so passionately attached to objects is the at-

traction and the riddle of Cézanne's last phase. The element that usurped its place, the patch of color in itself, had a history of its own in his art, one that is worth tracing. In the middle 1860s, when Cézanne for a time built pictures out of paint that was applied with a knife, in patches shaped by the knife-edge, his handling had an originality which has not always been understood. Among the Aix painters it is said to have caught on like an epidemic, and Pissarro appreciated it immediately; pictures like his still life at Toledo, Ohio, painted with the knife in the following year, show how well he understood its meaning. Earlier in the century knife-painting had been the mark of an attachment to what was actual and physical in a subject. It was so for Goya and for Constable and, in particular, for Courbet, who was Cézanne's inspiration. But only Cézanne realized that in the new context a picture that was touched with the knife should be painted with the knife throughout. He instinctively understood that in the new age the handling *was* the picture. The consistency of facture that Cézanne achieved makes a new kind of intrinsic material unity, which links the picture not only with the material significance of objects, but with the common consistency of the material world.

The innovation of 1866 had also a wider significance. It was the sign of a new aesthetic, the aesthetic of extreme standpoints and total solutions—the most indubitable of all the many intimations of it in the 1860s—which effectively and finally isolated the avant-garde. The steps in the development of the Impressionist style and its sequels marked, fundamentally, the progress of just this aesthetic. The longest and most plainly irreversible of them all was the extreme and elusive standpoint that Cézanne took up in his last years. It is interesting that it was the palette-knife style of 1866 that Cézanne remarked on as virile in later years, not the curling, snakelike brushstrokes of the paintings before and after it. Impressionism involved a dissolution of the paint patch. But patches of color with straight edges applied with the knife reappeared at the next crucial stage in the emergence of Cézanne's originality eleven years later, when he painted *L'Etang des Soeurs* (RP307 V174, in the Courtauld Gallery, London). It was in 1877 that color differentiation took its place as a chief medium of definition in Cézanne's art, and no picture has a more crucial place in his development.

Although the color patches applied with the knife in *L'Etang des Soeurs* may be regarded as a last reminiscence of Courbet, who had lately died, and of the style that Cézanne had based on him, the parallel alignments of color patches propound the kind of structure that his work came to depend on twenty years later. Color patches like those in *L'Etang des Soeurs*

appeared again, in watercolor first, around 1890. In the nineties the water-color style eliminated the material substance that remained the subject of the oil pictures. The objects and space that they represented were now translated into apparently immaterial relationships of color. The possibilities that emerged in the watercolors opened to oil painting in the late nineties. After 1895 groups of vertical brushstrokes formed into areas, at first irregular in shape, then more clearly and squarely bounded, at first delicately graded in color, then more and more widely differentiated—patches like detached facets, which drifted down and settled one against another between the points of precise figurative reference. But the increasing detachment and the relaxation of the need to describe and circumscribe the particular units of a design may conceal from us the fact that color patches still had a figurative function.

In one of the aphoristic "opinions" that Emile Bernard transcribed and published, with Cézanne's approval, in 1904, the figurative significance of the *tache* in the late style is described precisely.[6] "To read nature is to see it, as if through a veil, in terms of an interpretation in patches of color following one another according to a law of harmony. These major hues are thus analyzed through modulations. Painting is classifying one's sensations of color." Cézanne was a precise user of words. In his youth they had fascinated him, not only in his poetry but in his jokes, like the *Dictionnaire du langage Gautique* that he mailed to Zola when he was twenty. None of the painters of his time is likely to have been better educated—surely no other translated an idyll of Theocritus for pleasure. He certainly did not use the words "law," "harmony," "modulation" at all casually. He appears to have had in mind a system as reasoned as the descriptive method of earlier styles. The figurative reference is characterized quite poetically in the aphorism. There are other signs that his conversation was sometimes more literary and fanciful than his mature letters. Is it possible that he thought momentarily of comparing the color patches that portrayed the face of nature to the graded tones seen through the interstices of a lady's veil in the *grande époque*?

The appearance of a tonal homogeneity that recalls Impressionism in the years after 1900 is deceptive. The arrangement of color patches in the later pictures is certainly structured, but it never molds the form as color did in the eighties and early nineties. From the middle sixties, for more than thirty years, Cézanne's art had a solid physique, one that was remarkably constant, irrespective of subject. A grooved surface of rock or drapery is crowned by a dominating central block in the *Black Marble Clock* (RP136

V69) and the Baltimore *Mont Sainte-Victoire* (RP837 V766) alike, painted thirty years apart. The same formation was echoed for a little longer, with the grooved cliff at the Bibémus quarry, now capped with the domed top of a tree. The last paintings do not have this physical shape. The structure is no longer one that we can imagine built. It is a property of the juxtaposition of colors on the flat surface. During the same years Cézanne's own remarks about the solidity of three-dimensional form were quite positive. In one of his letters to Emile Bernard he described how the eye ranges over the shape that is seen. "The eye becomes concentric by looking and working. I mean to say that in an orange, an apple, a *boule* or a head, there is a culminating point and this point is always—in spite of the formidable effect of the light and shadow and the sensations of color—the point that is nearest the eye."[7]

In another letter he enunciated the traditional yet much debated principle that nature modeled itself on the sphere, the cylinder, and the cone.[8] With Cézanne this principle took on a special significance. Visitors to his studio in 1905 who found him, as he said, "applying himself to rendering the cylindrical aspect of things," reported that enunciating the formula he "would indicate indiscriminately an apple or another object that was actually spherical or cylindrical, or a flat surface such as a wall or floor."[9] This habit seems to have reflected an awareness of the fact that the line of vision from the eye meets a flat surface at every point at a different angle. At the right of a surface it is obviously seen more from the left; on the left the line of vision strikes it more from the right. The variation in the angles at which a flat surface presents itself to the eye is thus different only in degree from the angles at which the line of vision strikes a rounded surface. In this view flat planes share with forms of circular section a common property in the geometry of vision. Cézanne had a maxim to this effect, which his son reported to Léo Larguier: "Bodies seen in space are all convexes."[10] The varying angles of incidence of the lines of sight transmit to the eye light reflected from different sources—light necessarily of different colors. Cézanne's habit of pointing at a flat surface when he spoke of nature modeling itself on forms of circular section expressed, as his visitors concluded, a conviction that, notwithstanding the objective flatness of a plane, "if the painter spreads a single color over his canvas to represent it, he will reproduce it without truth." Cézanne's practice throughout his mature work conformed to the doctrine. Painting in the grounds of the Jas de Bouffan, for example, he often modulated the farmhouse wall as roundly as the tree trunks.

This application of Cézanne's principle illuminates another aspect of his thought. If, as it seems, he was exceptionally aware of the changing angle of incidence of the line of sight to lines that in actuality were straight, this explains a growing tendency to compensate for it. It accounts, for example, for the way horizontals in a landscape like the Zurich *Mont Sainte-Victoire* (RP916 V801) fall into increasingly deep parabolas the farther below the horizon they are placed. Compensations of this kind represent an abandonment of the prime hypothesis of plane perspective. We have here the best evidence of Cézanne's own attitude to a part of his practice that has been much discussed on little documentary foundation. Moreover, it informs us about an aspect of his art so obvious that it usually escapes discussion altogether. It seems that a hypersensitive alertness to the varying angles at which the cone of sight meets a surface stimulated him to imagine the corresponding varieties of light and color that were reflected. He was well aware that his mutations of color originated as much in theory as in observation. When one of his visitors was puzzled to find him painting a gray wall green, he explained that a sense of color was developed not only by work but by reasoning. In fact the need was both emotional and intellectual. The mutations of color with which he modulated surfaces that would have seemed to a less logical mind to require no modeling whatever were a necessity to him. It was this that Gauguin had failed to understand. Cézanne told Bernard, "I never wanted and will never accept a lack of modeling or gradation. *C'est un non-sens!*"[11] For him color modulation was the sense of painting.

We think of the significance of the affinities and contrasts as abstract. Cézanne himself referred to the color patches that he was using in 1905 as abstractions, and felt them to be in need of explanation. But he made it clear that they possessed a systematic figurative function, a function which though not descriptive was expository. The history of these expository systems of color, which appeared in the watercolors and ultimately permeated Cézanne's whole art, seems to begin soon after 1885—another of the points at which the direction of his work shifted, and evidently the time of an emotional reverse as well. It was a stage in Cézanne's progressive process of sublimation. The perceptual and material character of representation in the years before was eroded, so that the new images had an ascetic, almost impoverished look. It was subordinated to designs that were by contrast structural and bare of sensuous enrichment. The picture form was recognizably akin to the buildings which were among the first subjects of the phase at Gardanne. It was from this beginning that the architectural

Le cruchon vert (The Green Pitcher), watercolor, 1885–87

grandeur of the second half of Cézanne's work sprang. (It reminds one of an academic contemporary's comment on El Greco: "I call this laboring to be poor.") It was apparently at about this time that Cézanne made a watercolor exceptional in his work, *The Green Pitcher* (RWC192 VI138) in the Louvre. While modeling the pot in rather listless pencil patching, he suddenly abandoned the tonal method and stated the round shape in an arrangement of colors that was schematic rather than perceived. On either side of the *point culminant,* left blank on the paper—at first sight one could mistake it for the highlight on the pot, but it was nothing of the kind—the colors were arranged in order, first blue, then emerald green (to specify the material color of the pot), then yellow ocher. At this stage one hardly notices that a deliberate system is being employed, but close inspection leaves no doubt of it. No pot ever produced this logical sequence arranged like the blue, green, and yellow bands of the spectrum and spread out on paper in its natural order. On the contrary, the color sequence in the Louvre drawing produced the likeness of the pot, while a spot of complementary red at the base gave it its stance and the asymmetrical outline its pictorial poise, as if breasting a gentle current of space flowing away to the right into the distance.

In all these respects a work like *The Green Pitcher* propounded in ele-

mentary form the method and the way of thought that were to be developed and elaborated in the complex richness of Cézanne's later work. In oil paintings of the later eighties it appears that the color sequences in which form was modeled were increasingly independent of direct transcription of sense data. Across Mme Cézanne's cheek in the little portrait (RP576 V521) from the White Collection at Philadelphia, for example, the sequence is, first, green-blue, then carnation pink and a residue of almost bare canvas for the *point culminant,* then orange-pink and blue-green. The clear colors are abruptly stated so that they cannot be read as continuous modeling in light and dark. They convey the rounded surface metaphorically.

The watercolors of about the same time moved further in the same direction. Color patches spell out the form not tangibly but imaginatively, not forcefully but with a uniform and deliberate restraint. In drawings like the *Mont Sainte-Victoire* (RWC279 V1023) in the Courtauld collection, diluted tints are placed in a wide-spaced series—yellow-green, emerald, and blue-gray. It is an emergent logic in the order, rather than anything one can imagine observing on the spot, that reconstructs the mass of the trees and links it with the mountain behind. In the oil landscapes of the later eighties variations of color, playing over large areas that were at first sight amorphous, emerged as a vehicle of expression. Related color mutations were noted in groups of brushstrokes in contrasting directions, beginning to form into discrete patches, with no reference to separable objects, amounting sometimes to a whirling blizzard of color changes, which left an even deposit of apparently random color differentiation.

The method that developed in the next decade was both more systematic and more detached. It was in watercolor rather than in oil paint, with its implications of material substance, that Cézanne pursued his discovery that colors placed in order one against another carried an inherent suggestion of changes of plane. The series of colors, always in the order of the spectrum and always placed at regular intervals along it, mounted toward a culminating point; beyond that point, where it was repeated in the opposite order in the watercolors of the nineties, it gave a sense both of melodic response and of the continuous curvature of the surface. Cézanne was quite explicit about this; "the contrast and connection of colors," he told Bernard, "—there you have the secret of drawing and modeling." There was clearly a special value to him in the idea that nature was modeled on forms with a rounded section. The color series continually evoke the efflorescence of rounded surfaces. The system was sometimes complicated

by the superimpositions with which he orchestrated his theme. At other times watercolor was used for fragmentary rehearsals of the way that sequences of color might re-create the form along a crucial contour. But the principle remained essentially the same. In place of the observed data of light and shadow, even replacing the dynamic thrusts which had been the core of natural structures, watercolor evoked changes of surface and the ideal roundness of mass as if in a code, but one that was not merely symbolic. It capitalized natural, almost physical reactions to the relationships and the contrasts inherent in intervals of color.

Emile Bernard, who watched Cézanne at work on a watercolor of Mont Sainte-Victoire in 1904, described the way in which color patches were used, essentially, throughout the late work: "His method was remarkable, absolutely different from the usual way and extremely complicated. He began on the shadow with a single patch, which he then overlapped with a second, and a third, until these patches, hinging one to another like screens (*faisant écrans*), not only colored the object but molded its form. I realized then that it was a law of harmony that directed his work, and that the course these modulations took was fixed beforehand in his mind . . . He deduced general laws, then drew from them principles which he applied by a kind of convention, so that he interpreted rather than copied what he saw. His vision was much more in his brain than in his eye."[12]

Even works of the later 1890s, in which the color elements were still shaped by the motif rather than formed into sequences of separate and consistent patches, were basically organized in the same way. In one of the watercolors of rocks at the Château Noir (RWC432 V1042), which has affinities with the sandy-yellow and blue-violet polarity of color to which Cézanne tended around 1900, there is a spot of red exactly at the visual center, which marks the nearest point in the noble front of rock as the *point culminant* of the whole picture. Receding from it the colors compose a brilliant descant on the local hue, ending in violet blue. A related, simpler sheet in the Pulitzer Collection (RWC433 V1044) offers deepening echoes of a single progression; in both it is the color, not the description, that makes the form. The mass of trees in the watercolor (RWC509 V977) of a Provençal farmhouse at the Museum of Modern Art, which seems to date from the late 1890s, is rendered by a constellation of four colors, blue over green, then, to the right of them, yellow over a very pale wash of red. The tensions between them portray the shifting axis of the volumes.

The "opinions" recorded by Bernard included the maxim "One should not say modeling, one should say modulation." It is difficult to know how

many of the associations of the word *moduler* were intended. Perhaps all of them. The meaning of tempering, the employing of a standard measure, and the musical analogy itself may all have played some part. As a young man Cézanne had painted his sister playing the overture to *Tannhäuser;* in later years he named Weber as his favorite composer and liked to hear *Oberon* or *Euryanthe* in the evening. (Elaborate parallels between his method and music are apt to provoke *un soupir étouffé* more like a yawn than Baudelaire's romantic sigh.) Modulation implies a transition through clearly perceptible stages. Smooth monochromatic modeling always seemed to Cézanne a falsification. But it is possible that in later years he may have thought of shifts in the range of colors in his code, which sometimes seem to evoke changes in the direction of the curvature that is evoked, as comparable to changes of key. In the watercolor of the farm at the Museum of Modern Art, blue is nearly everywhere coupled with green. Where it gives place to the juxtaposition of yellow and red and the alignment of the form appears to change, it may be that Cézanne thought of himself as passing to the next scale. In any case the possibility is enough to show that this is a procedure in which reason and calculation are inseparable from the poetics. Similarly, the occurrence of a pale but definite pink near the middle of a form that is ostensibly green indicates how far these progressions are from any direct reliance on empirical data. Cézanne regarded everything, "art in particular"—but apparently everything else as well, as if he had some Neo-Platonic doctrine at the back of his mind—as "theory developed and applied in contact with nature."[13]

Sheets like the *Bridge under Trees* (RWC511) in the Weil Collection, St. Louis, show the sphere and cylinder in their ideal perfection. Specific local color virtually vanished. A single color series based on green and blue is consistently deployed as an equivalent to the great blossoming of form. *Bridge under Trees* must have been painted at about the time in 1897 when Cézanne sent Gasquet his definition of art as "a harmony parallel with nature." Here the musical reference was at least balanced by a more general sense of the word. The idea of color as harmony in Neo-Classical thought and perhaps in Cézanne's own goes back to antiquity. Pliny, writing of the beginnings of painting among the Greeks, drew exactly Cézanne's distinction: ". . . the range between light and shade they called *tonos*—strength; the relationships and transitions between colors they called harmony."[14]

At the end of the 1890s there were, in fact, two distinct systems of color in use in Cézanne's work. In the oil paintings color brought together (in general) the observations of nature—local hues, their mutual reflections,

Paysan assis (Seated Peasant with a Stick), oil, 1900–04

Paysan assis (Seated Peasant), watercolor, 1900–04

the atmosphere and light surrounding them—and presented their combinations and interpenetration in heightened form. The watercolors, on the other hand, translated form into metaphoric sequences of color, which operated through the gradations of color interval rather than identifying any local hue or effect of light that could be observed and transcribed from a subject. The distinction is clear in the difference between the watercolor (RWC491 V1089) and the oil painting (RP852 V713) of the *Seated Peasant with a Stick*. In the watercolor the key of blue modulating into yellow and pink formed a conventional system for the notation of the actual bulk. When the lumpy shapes of the model had been elucidated on paper Cézanne could proceed to the pyramidal formulations from which he built the structure on canvas—forms that taper upward from the elbows toward the head and downward to the hands, making a diamond shape, which was painted in the specific earthy colors of the subject (colors of which there is no sign in the watercolor) and reinforced by the pattern of the wallpaper behind. The painting, which appears more "real," with a more objective and material reference, is in fact more schematic. The drawing is straighter; the planes are flatter. It seems that the conventional coloration of the watercolor served a functional purpose. It was needed to grasp the actual volumes; it was a digestive system. Only when the complex solidity had been

grasped were the schematic structure and indeed the naturalness within reach. In this case the imposing simplicity of the painting was evidently arrived at in two stages. In other pictures the two processes, analytic and synthetic, were combined in a single operation. The pictures show complex permutations of metaphoric color with the hues that were specific to the subject. The combination of two quite different methods is enough to account for the immense labor, indeed the eventual impossibility, of completing a picture like the *Portrait of Vollard* (RP811 V696; see p. 9). The labor was shared by the sitter, and Vollard's famous record of it has led some to think that Cézanne was always a laborious painter. The size of his output is enough to show that his procedures were in essence far from labored. But the method in his last years was an increasingly deliberate one, as he brought together and coordinated the two processes.

Vollard's account of the sittings in 1899 provide incidentally the best evidence we have that Cézanne thought of relationships of color as actual conjunctions of form. Vollard ventured to mention two patches of bare canvas in the hands of his portrait—and received an answer that astonished and intimidated him. "If my study in the Louvre presently goes well, perhaps tomorrow I shall find the right color to fill the white spaces. Just understand, if I put something there at random, I should have to go over the whole picture again starting from that spot."[15] It is understandable that the gaps were not mentioned again, and the canvas remains bare at these points to this day. The studies that Cézanne made in the museum were pencil drawings, particularly from Baroque sculpture, which emphasized its rhythmic sequences—studies, in fact, of a style that would seem to have no point of contact with the rectilinear severity of Vollard's portrait. But for Cézanne the relationships of color—and color existed only in relationships; the story makes clear that he was unable to apply it in any other connection—were evidently akin to the physical articulation of forms that he drew in line in the museum. The linear sequences of the Baroque exercised the very faculty that was employed in his procedure of placing color patches side by side.

After 1900 Cézanne's figurative method married the material equation with the metaphoric system. But to regard these complex systems as entirely figurative hardly accounts for the independence of their parallel with nature. Repeatedly in art, before and since, an artist has found his figurative instrument so magical that he has come to glory in it as an order of reality in itself. As his style developed, Cézanne seems to become con-

cerned not only with form but with the fabric of color differentiation as such. He had always been interested in the segmented surfaces of foliage. It had often become the obsessive essence of a landscape. But by 1900 it seems quite uncertain whether the tilt of individual leaves was meant to be legible in a drawing like the study of foliage (RWC551 V1128) in the Museum of Modern Art. It seems rather that the brilliant vibration of red, emerald, and violet, repeating in every combination across the great sheet, reflects an absolute intoxication with color contrast as an order of reality in itself, a complete world. He finds in it a morphology of its own, endowing the stems that pass through it with a sexual thrust. Color contrasts become the internal life of art. He found that painting could make nothing else and needed nothing. "There is no such thing as line or modeling," he told Emile Bernard; "there are only contrasts." He lived by them. We can imagine him living among them. He saw the same fabric of color outside his window and painted it percolating through the iron tracery of the balcony in his watercolor *Le Balcon* (c. 1900) (RWC529 V1126), Philadelphia Museum of Art.

This self-sufficient fabric of color contrast, which is hardly legible as form in any specific or detailed sense, was occasionally the sufficient theme of watercolors in particular in the years around 1900. But side by side with this there is another use of color, forming sequences that we read, however metaphorically, quite naturally as volume. In one group of oil pictures, a little later, the colors fan out as if around the circumference of disks, which take on a general but indubitable volumetric meaning, making spherical segments that succeed one another diagonally across the canvas. In the *House on a Hill* (1904–06) from the Loeser Collection in Washington, it seems that one can locate precisely the successive *points culminants*. Some of these points are gray-blue; others are ocher-pink. Around these the sequences arrange themselves in spectrum order—one repeated progression is through emerald, cobalt, the blue-gray culmination, and violet; in another, crimson is succeeded by Venetian red, the pink apex, and golden ocher. In another picture, formerly in the Clark Collection, he used a similar formulation in another key for the trees mounting the hillside to the Château Noir. A related system remains perceptible in the *Blue Landscape* (RP882 V793), which seems to have been painted at Fontainebleau in 1905.

Our understanding of Cézanne's purpose is evidently incomplete if we do not follow the determination, of which he spoke so often, to read nature. It was one of his favorite phrases. It recurs in the letters; it was his constant objective. "Reading the model (*la lecture du modèle*) and realizing

it are sometimes very slow in coming for the artist."[16] The word echoes through the "opinions" transcribed by Bernard. He begins with a couple of remarks differentiating the " 'pernicious classicists' who deny nature or copy it with their minds made up" from Gothic art, which "belongs to the same family as we do." Then he begins his exhortation: "Let us read nature, let us realize our sensations in an aesthetic that is at once personal and traditional." So Bernard made him say, at all events, without provoking any complaint. Indeed, the record was approved "on the whole."[17] The observation ends: "The strongest will be the one who sees most deeply and realizes fully, like the great Venetians." Two observations later, he gives the definition that I have quoted: "To read nature is to see it . . . in terms of an interpretation in patches of color," and the fifteenth observation (which forms a conclusion, though Bernard added conversational remarks and paragraphs out of recent letters) notes that the doctrine "is all summed up in this: to possess sensations and to read nature."

To follow Cézanne's thought we have to feel the force of his terminology. Here too he seems to have been well aware of the situation. Over and over again the crux of his art theory was a definition of the terms that he was using or a meditation on the validity of definitions. Theory was indispensable to him, though from another standpoint it was obviously superfluous—totally useless. He told Bernard, who was the recipient not only of the largest part of his theoretical teaching but of his warnings against art talk, that he did not want to be right in theory but in nature.[18] In a jocular mood at a café, he announced to Aurenche that it was not his business to have ideas and to develop them.[19] But it was his business, and he remained haunted by the two parallel necessities. For painting one had to have both a way of seeing and a system of thought—both *une optique* and *une logique*.[20] Devoting oneself entirely to a study of nature, one tried "to produce pictures that are an instruction."[21] Fifteen years earlier, he had already explained his isolation: "I must tell you . . . that I had resolved to work in silence until the day when I should feel myself able to defend in theory the results of my attempts."[22] His regret in the last months of his life was that he could not "make plenty of specimens of my ideas and sensations." The two aspects of painting were inseparably coupled. They occupied him equally. "There are two things in the painter," he announced in the fifth of the "opinions" that Bernard recorded, "the eye and the mind; each of them should aid the other. It is necessary to work at their mutual development, in the eye by looking at nature, in the mind by the logic of organized sensations, which provides the means of expression."

Has any painter explained his artistic constitution more intelligently and exactly? Cézanne's terminology was precise; yet it is enigmatic in just the same way as the visual propositions in the late pictures. What did he mean by "sensations"? What did "realization" in fact involve? The late works are his own meditations on just these questions. Sensations were the root of everything for Cézanne. From the beginning to the end of his career, they were his pride and justification. In 1870, when he was interviewed for the *Album Stock* on submitting his entries for the Salon, the sensations of which he boasted seem to have comprised not only the data of sight but feelings also. "I paint as I see, as I feel—and I have very strong sensations. The others, too, feel and see as I do, but they don't dare . . . they produce Salon pictures . . ."[23] In his last years, they were sometimes still described in the same terms, as "the strong sensation of nature—and certainly I have that vividly."[24] The pride and the assurance that sensations gave him remained unaltered; they served him as a defense. "As sensations form the foundation of my business, I believe myself invulnerable."[25] Yet at the same time they were also being defined rather differently. The fifth "opinion" in 1904 established them as something organized by logic in the mind. So far from regarding them simply as sense data (as is often thought), he more than once implicitly distinguished them from perceptions.[26] The sensations for which he continued to seek an expression to the end of his life, as he explained to Henri Gasquet, the friend of his youth, were "the confused sensations which we bring with us when we are born."[27] The word had, in fact, a double meaning—contact with nature "revived within us the instincts, the artistic sensations (*sensations d'art*) that reside within us." The double meaning of the word corresponds to the dual significance attaching to the paint marks themselves in the late work. It is in the last two years of Cézanne's life that the sensations are identified precisely as color sensations,[28] the sensations of color that give light.[29] It was in view of these that he most regretted his age, as he told his son two months before he died.[30]

At this final stage sensations were thus senses of color which were as much innate as experienced. They were the chief object of the painter's efforts; they influenced all the "opinions" published by Bernard. Painting was first and foremost a matter of "realizing" them.

The idea of realization was central to Cézanne's purpose; his use of the word has a history in itself. One can trace the steps by which it took on a meaning rather beyond the general usage, and quite distinct from the

common meaning of completion. In his vocabulary it first appeared to mean simply the satisfaction of natural wishes. It was used in this sense in the letter to Chocquet, which propounded a touching landscape metaphor for the reverse that he had suffered in 1885 and his failure to secure "the realization of wishes for the simplest things which should really come about of their own accord . . ."[31] He used the same word in wishing Solari fulfillment of his "legitimate hopes" in his marriage.[32] The aspirations that fulfilled themselves naturally for others seemed doomed to difficulty and frustration for Cézanne. The erotic drive was sublimated in the pursuit of a consummation in art, which was eventually described as "to realize." It inherited the same emotional impetus and labored under a similar difficulty. The unsatisfied longings for either companionship or realization were indeed linked together in his thought. In his pathetic explanation to Gasquet of his self-inflicted isolation in his fifties, he wrote: ". . . the pleasure must be found in work. If it had been given to me to realize, I should have been one to relax in my corner with the few studio companions that I used to have a drink with . . ."[33] Eight years later, he had to explain to a correspondent, whose solicitude touched him deeply, that he did not have the "freedom of spirit" to write a letter "after a whole day working to overcome the difficulties of realizing from nature."[34] Cézanne's phrase was *réalisation sur nature*. The realization was *on* nature, like a variation or a descant. What was real in art was essentially separate and different from the actuality of nature. "What is one to think of those fools who tell one that the artist is subordinate to nature?" Cézanne had demanded of Gasquet nine years before. "Art is a harmony parallel to nature."[35] The faith shared by the Impressionists and the Realists before them, a belief that a condition of rightness in an image would transfer some virtue in the subject directly into art, was entirely opposed to his. Only the basis in observation remained, and the love of "this beautiful nature" which embraced everything visible, "man, woman, still life," so long as the light was right.[36] It was coupled not only with "a mistrust of the photographic eye, the automatic accuracy of drawing taught in the Ecole des Beaux-Arts," as visitors to his studio in 1905 reported, but a more sweeping disbelief in the whole conception of representation as a reflex action, isolated from intellectual interference and pursued as if stupidly, on which enlightened studio practice in the nineteenth century was supposed to have been based. It was "a mistrust of any movement in which the eye would direct the hand without reason intervening."[37] Again, it emerges that Cézanne's faith was not only in nature but in logic.

Cézanne was equally careful in speaking of representation. In his logical way he distinguished between representing and reproducing. The sun, for example, was something that one could only represent, not reproduce.[38] In general he preferred the idea of interpreting to that of representing, in its usual sense. To read nature was "to see it . . . in terms of an interpretation," as he told Bernard, and one of Gasquet's reports that rings truest recorded how Cézanne, casting about for a word to express just this distinction, lighted on it at last with relief: "I have it! It is an interpretation." His position was complicated by the fact that he remained equally aware of the opposite, traditional way in which an image worked, and this must have formed part—the intellectual ingredient—of his difficulty. In the same year, most likely, that he put to Bernard his basic definition of painting from nature, he also mentioned to him a need that seemed to contradict it. "Some imitation is necessary, and even a little deception of the eye. That does no harm if the art is there."[39]

For Cézanne, alert from youth to the derivations and overtones of words, it is evident that to realize, beyond its meaning of fulfillment, held its primary sense of making real. By 1904 no other sense of the word fits Cézanne's use of it. There were two stages in the operation. It was, first, "the reading of the model" and, second, "its realization" that were "sometimes very slow in coming for the artist."[40] First, tracing and construing form, then making it real. The reality of the subject itself, the actual motif, could not be transferred to art by imitation. It could only be made real through whatever was intrinsically real in painting, and the "opinions" are quite clear on what that was. It was the "logic of organizing," the "classifying" of the sensations that were as much inborn as perceived, the sensations of color. This personal understanding of what it meant to realize was more and more in the forefront of Cézanne's mind in his last years. It was the basis of the antithesis between "copying the object" and "realizing one's sensations." The antithesis itself had a history of its own. It has been noticed that its currency was due to critics of the older generation like Castagnary, who wrote in 1857 that "a realized work" was "not a copy and also not a partial imitation."[41] Castagnary, like Duranty and Champfleury, thought much about Constable and wrote about him. The remarks on art quoted in Leslie's *Memoirs,* a book that Castagnary read closely, contributed to the rationale of Naturalism in the 1860s. Cézanne's antithesis—even the lurking contradiction of which both painters were aware—descended from the definition that was found among Constable's papers: "What is painting but an imitative art? An art that is to *realise* and not to

feign."[42] The "opinion" that was dictated to Bernard was a close and appropriate echo of Constable's words: "Painting from nature is not copying the object, it is realizing one's sensations."

For Constable, most probably, the making real consisted in an image that was visibly made up of self-evidently real oil paint. For Cézanne the intrinsic reality of painting was not only the sense of color that was inborn and confirmed from nature; it resided in the logic, the organization, and the classification, which the sense of color was subjected to. The sixth "opinion," about interpretation in patches of color, makes it clear that the organization consisted in the order in which the patches "follow one another," which was to conform to "a law of harmony." In fact, in each sequence of colors that interprets the roundness of a volume in the late work, the patches almost invariably follow one another in the order of the spectrum, and consist in hues spaced quite evenly along it. It may be that the "law of harmony," as Cézanne finally regarded it, was simply the sequence of the spectrum, and the approximately equidistant placing in it of the notes which in a given key formed his scale. He spoke of it as if it constituted an inborn visual syntax.

The agony deepened in the last years with the sense that "my age and my health will never allow me to realize the dream of art that I have pursued all my life."[43] But now it was circumstance, not fate, that prevented it; a philosophic note is detectable. The fulfillment was slow, but the destination, whether or not there was time to reach it, was ordained. The Moses syndrome was forming, which was itself a feat of insight and a consolation.[44] The difficulties that were inevitable, for some artists at least, were the pains of a natural process like a birth; if one could not avoid them, one could at least become more lucid and believe that one improved a little every day, however painfully. Indeed, the eventual diagnosis of the pain was a part of the triumph. Picasso, thirty years later, went so far as to say: "It's not what the artist does that counts, but what he *is* . . . What forces our interest is Cézanne's anxiety—that's Cézanne's lesson . . ." Cézanne's letter to his son six weeks before his death continued: "With me, the realization of my sensations is always painful. I cannot attain the intensity that unfolds itself before my senses. I do not have the magnificent richness of coloring that animates nature." And nine days before the end: "I simply must realize after nature. My sketches, my pictures, if I were to do any, would be *constructions d'après* . . ."[45]

It is almost the last letter, and it completes the picture. Painting had to be a making-real that would parallel nature in its harmony and follow it in

Nature morte avec pommes et pêches (Still Life with Apples and Peaches), oil, c. 1905

structure. To make something as real as Cézanne needed he would have had to possess color that was as "magnificent," as great-making, as the color of nature, because that was what animated nature—what gave it life. So Cézanne had to have the life of nature inside him in order to construct and harmonize as nature did. His explicit aesthetic was also an imperative emotional need to the end.

In form the pictures done just before 1900 descend directly from the works of the previous ten years. It is the color that first shows the special character of the late works and the quality that remains characteristic of Cézanne until his death. The "great still lifes" which are said to have been painted in 1899 must be among the group of pictures that show a rounded ewer with a wide opening and Cézanne's tapestry curtain with the pattern of large yellow leaves against dark blue, or his other cloth with a red flower-pattern in square brown compartments, and occasionally both. They are grander, more deliberately arranged, with the draperies falling in cataracts of pattern down the designs, and sometimes larger than the

La Dame au livre (Seated Woman in Blue), oil, *La Dame en bleu* (Woman in Blue), oil, 1900–04
1900–04

earlier still lifes, but their design is not essentially different in kind. The color, however, is deep and intense, based on somber resonances that re-echo through the canvas. Usually there is a polarity of ginger and violet or orange and blue-green. The color is embedded in schemes with an almost congested material richness. In two or three of these pictures the crockery is exchanged—for the familiar ginger jar and sugarbowl in the Museum of Modern Art canvas (RP933 V738) and for a teapot in the example at Cardiff (RP934 V734)—and when it is, the mood alters too, and the still life takes on the character of an indoor landscape. The heaped-up cloth at Cardiff is as mountainous as the Sainte-Victoire massif. The portrait of Vollard on which Cézanne worked so long in 1899 has the same intense polarity of ginger and violet, but there it generates its own kind of design, aligned along rigid axes. The form grows ridged and furrowed in the labor of its consolidation out of color. Color if this kind is almost unparalleled in Cézanne's art before. Even the somber pictures of 1896, the *Old Woman with a Rosary* (RP808 V702) and *Lake Annecy* (RP805 V762), which is more schematic than any landscape painted solely from nature, are still dominated by deep blue with an atmospheric connotation. After 1899 the consistency is not primarily atmospheric. It is generated by a specifically pictorial pressure between complementary colors. In the characteristically rich *Still Life with Apples and Peaches* (RP 936) from the Meyer Collection

at Washington, for example, a greenish blue presses against orange-pink to model the flower holder; the orange-pink deepens across the canvas into a vibrant putty-color. The image is molded out of the progression from orange through green-blue into violet. Even the white, which is still clear in the torrent of drapery in the Louvre picture, has a liver-color in it.

Two little portraits of a lady in a tailored blue jacket with black lapels and a flowered black hat are like pendants to the "great" still lifes; they may have been among the pictures painted in the rue Boulegon at Aix before the studio on the Chemin des Lauves was finished in 1902. The first (RP945 V703), in the Phillips Collection at Washington, is massively modeled in light and dark and sharply characterized. (The curving folds are deeply creased, as in the portrait of Vollard.) In the second (RP944 V705, in the Hermitage Museum, St. Petersburg), although the chiaroscuro remains as deep, modulations of color take over the rendering of volume. The summits of the relief have patches of pink. From pink the progression passes to yellow-buff and emerald on the way to the local hue of cobalt blue, and thence to the surrounding black, loosely following the recession, but less as an exposition than as a descant. Far from systematic though the color is, its primacy and its codification involve a change in the role of the human subject. The lady's face appears transfixed, emptied of personal or expressive character. The features themselves and the red triangle of the cheek are isolated in the mask, like a pattern, as remote from any function or purpose as the red bouquet on the tablecloth. Neither character nor the human role as such greatly concerns Cézanne in his figure pictures after this, although there are echoes of past themes, a portrait in the style of about 1900 of a stolid young man in a violet-gray jacket with a book (RP788 V678), who as a youth a few years before had posed with a skull—far from eloquent by comparison with his previous role as a personification of melancholia—and, from two or three years later, a charming, indeed touchingly blank *Girl with a Doll* (RP896 V699), which took up again a theme exhibited in 1895.

Not long after the "great" still lifes, one would guess, the creation of form out of color modulations took a new turn in an exceptional watercolor (RWC565 V1540) now in the Louvre, a row of pears and apples with an enamel saucepan on a shelf; it has an astonishing brightness. The simplest progressions of primary colors are arranged in order: from red through yellow, then from yellow into green and from green to blue. The culminating point, "which is always nearest to the eye," is the violet-blue handle of the saucepan, projecting where the color scales converge. The *Pears* water-

Nature morte: pommes, poires et casserole (La Table de cuisine) (Still Life: Apples, Pears and Pot)
(The Kitchen Table), pencil and watercolor, 1900–04

color is striking, not only in its brightness, but because the formal content is so physical and sensual; it recalls the crouching Venus that Cézanne had drawn. The successors to such biomorphic modeling were as much among the rocks at the Château Noir, where his chief landscape motifs were found for two or three years after 1900, as in the bathers.

There was a last crisis after 1900, when Cézanne established himself in Aix, painfully aware of failing health and isolation. The letters express a sense of self-immolation and mortification, but they also record the heroic determination (he called it obstinacy) which he summoned to work through the dark mood by painting from nature, as he had before. Cézanne's last phase was the ultimate sublimation. How much sensuality there still was in the balance of his art is seen not only in the *Pears* but in the watercolor *Rocks near the Caves above Château Noir* (RWC435 V1043) at the Museum of Modern Art, painted at the Château Noir a little farther along the rocky bluff that had provided his majestic upright motifs before. The rounded lumps into which the sandstone is weathered cluster over a slanting cleft; it is the kind of place where one may feel that the *genius loci* has disturbingly developed a real physique, and Cézanne painted it like a body. The sandy yellow is present or latent everywhere. It is the top of one color-scale, which descends through green to violet; it is the middle of another, a deeper one, between red and blue-green; and it combines in a vibrant chord with a very pale, clear blue, which Cézanne raised to the same value

by adding (a rare expedient) white body-color to the ultramarine—as if the form was physically to palpitate with the meeting of hues. The contour adds roundness like a fierce caress; one finds oneself crediting an extraordinary, bodily bulk to the modulations from scale to scale, and sharing a sensual mood that has an undertone of violence.

In these years the tangle of rocks and undergrowth in the woods around the Château Noir seems to have provided motifs for Cézanne's meditations on the diversity and complication of nature. Landscape in itself, as he told Gasquet, was chaotic, transient, muddled, and quite outside the life of reason.[46] Yet the confusion of sensation that made progress so slow was as much within him as in nature. The real and immense study, which had to be undertaken, was the manifold image of nature.[47] The deep-toned oil paintings of *sous-bois* at the Château Noir, which succeeded the clear, bright differentiation in orange, emerald, and blue at Bibémus, show compound interpenetrations of umber and violet. A way out, again, seems first to appear in watercolors, like the great sheet at Newark (*The Forest—The Park at Château Noir,* RWC531 V1056), in which one can imagine that memories of the rhythmic sequences of Baroque sculpture sustained him once again. Branches like great sculptured locks of hair spring outward with centrifugal energy. The color creates the drawing, finding the edge and finding it differently, more exactly yet with more convulsive feeling, as each color in the progression is added to the last.

Again, a dichotomy of style emerges, reflecting the emotional issue that Cézanne had been facing since his twenties. There was an opposition between the bulging, biomorphic rhythms, which are half-destructive, and the light, yet calculated precision with which color patches are built along parallel lines into rectilinear structures. These structures sublimated the physical and sensual content of form into the successions of chromatic intervals. Cézanne's doctrine that "there is no such thing as line or modeling; there are only contrasts of color" was indispensable to his own beleaguered peace of mind.

Eventually success in realizing his sensations in relationships of color was identified as nothing less than the prerequisite of his own sense of identity. If he failed, a real annihilation lay in wait. He not only felt himself stronger than those around him, "presumed to dominate every situation," with a strength and a presumption that were built into the parameters of his style, but also, in another mood, the helpless victim of himself, as he had been since boyhood, appealing pathetically for the support of the friends who knew the contradictions of his nature. His friends did support

him; their companionship was the greatest boon of his life. Yet there was an instability in it; few friends could carry such a burden. Indeed, he was their helpless victim, too. Any of them might enter his room without knocking, arrive by the wrong train or travel in the wrong class, be too reserved or too talkative, and the good would turn bad in a moment; the annihilation would face him again. "Do you not see to what a sad state I am reduced?" he had written when the black mood threatened to engulf a precious friendship with the son of a companion of his youth. "Not master of myself, *a man who does not exist . . .*"[48]

The condition of self-mastery was "command of one's subject and one's means of expression."[49] Confidence and "getting the upper hand" depended in their turn on "attaining a good method of construction." The stylistic issue on which his whole art had turned had a deeply personal content. "As long as we are forced to proceed from black to white . . ." (model, that is to say, in chiaroscuro as Cézanne himself had done in his twenties) "we do not succeed in mastering ourselves or being in possession of ourselves."[50] More and more the logical reading of nature in terms of "patches of color following one another according to a law of harmony" was identified not only with mastery and self-mastery, but with survival itself. Lacking it, he feared for his reason.

The structured sequences of color patches, which became a confident basis for representation in the last three or four years of his life, seemed to provide the answer. We are still not altogether accustomed to this kind of representation. It is easy to mistake it for the styles that have grown out of it, in which color is either literal or independent. Cézanne's patches do not represent materials or facets or variations of tint. In themselves they do not represent anything. It is the relationships between them—relationships of affinity and contrast, the progressions from tone to tone in a color scale, and the modulations from scale to scale—that parallel the apprehension of the world. The sense of these color patches rests on their juxtapositions and their alignments one with another, so that they imply not only volumes but axes, armatures at right angles to the chromatic progressions which state the rounded surfaces of forms. Characteristically, in such works as the versions in watercolor (RWC640 V1566) and oil (RP950 V715) of the full-face pose of Vallier, the gardener who was like a projection of himself, they create an invisible upright scaffolding around which the hues fan out like a peacock's tail.

The pictures (e.g., *Trees Forming a Vault (Fontainebleau?)*, RWC632 V1063, *Trees Forming a Vault (Forest Road)*, RWC634) in which trees meet over-

head to form a vault (as Cézanne himself described them) have wedge-shaped color patches, like segments of a cone, which register at the same time both the actual directions of foliage and the imagined structures implied by the echoing incidence of each color. Much of the content of this style rests on implications of gradient that are as naturally inherent in color intervals as in musical intervals. The fact remains that a code of representation based on reactions to color that are inherent in the psychology of vision, rather than on denotative or descriptive reference, pays a price. There is an optimum size for the units that touch off the sense of color interval. The patches must be large enough to remain perceptible in their own right—which prevents them from particularizing specific objects. There was of course an alternative to the bare notation of color; Cézanne had reverted to it repeatedly since his youth. It was the linear flourish that marked the passion of the figurative act, and dramatized in exigent and repeated contours the old pursuit of descriptive rightness in an image, a quality by no means symbolic or abstracted but one that might prejudice the artist's detachment—perhaps even threaten the sublimation on which the creative balance rested. The ultimate figurative effectiveness of the interpretation in patches of color following one another solely according to a law of harmony was in doubt; if it failed, the autonomy of a reaction to nature as a creative method and the assumption on which the art of Cézanne's whole generation rested were in question. The "opinions" dictated to Bernard in 1904 had revolved around a central proposition. When the relationships of tones "are harmonious and complete . . . the picture develops modeling of its own accord." The idea descended from the Impressionist idea, as Pissarro expressed it, that "brushstrokes of the right value and color should produce the drawing" of *their* own accord.[51] It was the idea, which had preoccupied Delacroix in 1852, of an image as the product not of an act of will, but of a process that was analogous to the automatism of nature.

The issue was of crucial significance and, in other forms, it remains so; it concerns the status of the will in the making of art. The antithesis was mediated and resolved, as always by Cézanne, in front of nature, in the series of pictures which are in one aspect the most modest in his art, representing repeatedly the most obvious motif from a position at his own garden gate. Yet in analyzing his problem into terms in which it could be solved, if solution was possible, the series of pictures of Mont Sainte-Victoire from the Chemin des Lauves was as ambitious as anything in Cézanne's work, and it has proved to possess as deep a significance. It will be well to follow the story in detail.

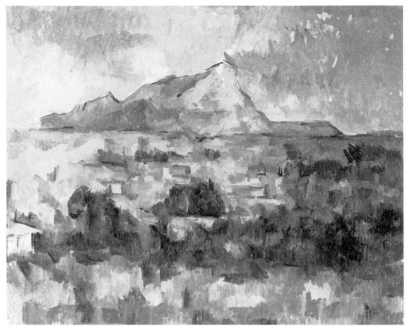

Mont Sainte-Victoire, oil, 1902–06

The series seems to begin with the version (RP913 V800) at Kansas City. The foreground is a sloping field in which the dry grass and the ocher earth are specified with their local colors. Rising from the field are a number of trees, the largest casting a pool of shadow. The lighted plains of foliage and vegetation are noted in subtly modeled ocher-green, gradu-ated into dark blue shadows. The modeling is almost tangible, and in the distance the mountain is sculptured in abrupt angular strokes, quite close to the style in which the other side of the massif was painted from the Route du Tholonet before 1900. The version shown above (RP914 V802, private collection, Switzerland) is much gentler. The differentiation is as much in light and dark as in color, and there is a good deal of highly specific drawing of contours. The mountain has its indented saddle, drawn in more detail than in any other picture—indeed a little exaggerated—and in the middle distance, to the left and in the center, the overhanging eaves of houses are precisely defined. The sky is sky-color, a hazy blue-gray with-out any sudden accent. The sky in the Kansas picture by contrast has mod-eled clouds, still very unobtrusive but clearly linked in shape and color—a

polarity of blue-green and ocher—with the trees in front. The Venturi 802 picture is quiet in mood, but the accents out of which the image is built are arranged as much on the surface as in depth, and in the foreground an essential step is taken: the broad cylindrical volumes which make up the trees are stated in a chromatic code, a continuous band of color modulation between yellow-green and violet stretching from side to side of the painting.

The color patches in Venturi 802 coalesce out of parallel vertical brushstrokes that unite the canvas. The patches themselves are ranged along the horizontal lines of the panorama. The value which the new style gave to the conjunction of the two axes of a picture was entirely deliberate. Cézanne wrote of it in the letter to Émile Bernard about picture structure in April 1904—and this may be quite close to the date of Venturi 802. "Lines parallel to the horizon give breadth, whether it is a section of nature, or, if you prefer, of the spectacle which the Pater Omnipotens Aeterne Deus spreads out before our eyes. The lines perpendicular to this horizon give depth but nature for us humans is more depth than surface, whence the need to introduce into our vibrations of light, represented by the reds and yellows, a sufficient amount of blueness to give the feeling of air." It is likely that the alignments of form along the axes of a picture always carry a specific content which is at the heart of pictorial meaning in the tradition that extends from Giotto to Mondrian. Cézanne is no exception, but his contribution in this respect, as in most others, was the crucial one. It is significant that he associated the vertical alignment with the significance of the natural scene to man. Thanks to his example, in which his philosophy was conceivably perceptible, the Cubists and Mondrian in the next generation built the human role vertically into the conception of an image as a conjunction of alignments.

But, quite apart from this comprehensive and philosophic structure, the surface homogeneity which the vertical brushstrokes enforced was indispensable to the development of the new kind of picture. One would guess that it was the lack of it in the *balayé* brushstrokes with which rather solid masses were brushed onto an incomplete canvas of this phase, *Mont Sainte-Victoire Seen from Les Lauves,* 1904–06 (RP917), that caused it to be abandoned. In the pictures that followed, the vertical handling generated a new cast of form. The detail of the landscape was reimagined in bands of color modulation, with sharp contrasts that gave an effect of pleated surfaces like folding screens arrayed across the plain, or upright prisms capped with pointed roofs, each refracting a segment of the spectrum. The most sparkling yet the most serene of them is the broad canvas (RP915 V804) in

the Annenberg Collection. In this the buildings in the middle of the plain still show some of the material realism of the previous decade and the light and shadow which delicately mark the receding surfaces of the mountain are also legible as solid form. The sky is now rendered in delicate mutations between jade green and violet-gray. It had become apparent that in the new kind of unity the sky must be landscape-color. The cloud shadows must be as green as the trees. But the material differentiation of one substance from another—sandy earth from angular rock and both of them from the impalpable sky—is still complete. The developed form of this style in the two Philadelphia versions (RP911 V799 and RP912 V798) is far more abstracted and abrupt. The whole scene was now rendered in an almost consistent range of color. The dark blue-green is not only the shadow on foliage; it is the basic color of definition throughout. But the linear marks no longer precisely define anything. They are detached accents—isolated deposits rather than the outlines of anything. The version in the Philadelphia Museum (RP912 V798) retains a little modeling in the sky. After that, in the version in a private collection (RP911 V799), the clouds break up into a notation of dots and dashes, the same kind of accent that builds up the crystalline forms of the landscape. The scattering of green in the sky is characteristic of these pictures. We become aware that affinity and correspondence in themselves were now Cézanne's conscious concern, the concern that apparently intensified during his time at Fontainebleau in 1905; it was described in a letter in August of the following year. The color modulation from golden ocher through intense emerald and blue into violet-gray has a strongly atmospheric implication which, as the values lighten into the distance, gives a sense of air and space, but the planes that are folded into facets to evoke the solidity of the foreground forms have a quality of agitation that disturbs the surface.

The version in Zurich (RP916 V801), which may represent the next development, translates the spatial illusion into a juxtaposition of color patches. The epigrammatic crystal shapes disappear; all the form and recession are embodied in the system of color. The progressions converge somberly in the center of the plain; the part played by the vivid emerald is reduced; it is the lower end of the scale, where touches of crimson lead to a dark violet-gray approaching black, that dominates the picture. The wide parabolas along which the series is ranged and repeated, then stated again, concentrate a sense of the real—lumpy, almost congested in the middle—yet the flatness of the surface remains unbroken. The formulation is all-embracing, yet its generality (and its very abstraction) is in a sense in-

conclusive. Works like the Zurich Mont Sainte-Victoire are based on a kind of ambivalence that forbade any precise description of separate things. Cézanne was acutely aware of the dilemma. He described it to Bernard in October 1905. "Now being old, nearly seventy years, the sensations of color, which give light, are for me the reason for the abstractions that do not allow me to cover my canvas entirely or to pursue the delimitation of objects where their points of contact are fine and delicate; from which it results that my image or picture is incomplete." But the alternative was still more unsatisfactory. "Otherwise the planes fall on top of one another," as they did in the styles which Cézanne described as Neo-Impressionism, though it seems that he had in mind rather the varieties of Synthetism, "which circumscribe the contours with a black line, a fault that must be fought at all costs. But nature, if consulted, gives us the means of attaining this end."

The consultation of nature that Cézanne carried out in the final years of his life engaged the whole force of his character. Tired and ill, he had to gather his strength for it with an immense effort. It appears that his time at Fontainebleau in the summer of 1905 had a special importance. The North had associations with a closer and more analytical reading of the whole compound experience of light, atmosphere, and natural shape. It must have reminded him afresh of the part that submission to nature had played at the turning point of his development more than thirty years before. It was probably in 1905 rather than 1904 that the *Blue Landscape* (RP882 V793) in St. Petersburg, surely a Northern scene, was painted. An energetic picture called *Beside the River* (RP920 V769), painted in the North in 1904 or 1905, pointed in the same direction. The intense blue of the river in the middle distance diffuses in choppy diamond patches across the landscape. The mood of Cézanne's work at Fontainebleau in 1905, to which he looked back in the following months, is typified by the watercolor of the Château in a Paris collection, *Le Château de Fontainbleau* (RWC628 V925). There was a new restlessness in the pursuit of linear definition. A tree trunk moved step by step back across the sheet through successive positions, until the relationships were adjusted to frame the distant view (which vibrated in sympathy) and accommodate the rhythm of a hanging branch. The serpentine line and the picturesque pattern of the near and the distant have a deceptively traditional look. We might expect a style as descriptive as that in which Mont Sainte-Victoire was framed in pine branches eighteen years before. Looking closer into the Fontainebleau

drawing, we find an advanced and complex abstraction of the information in overlapping codes, which include, as well as the color sequence, a graphic system too—a linear code for the passion of apprehending and grasping.

In the *Blue Landscape* the curving lines of hanging branches have again a muscular vigor that galvanizes the design. It is almost the largest pure landscape Cézanne painted in maturity, and the detached and fragmentary color patches that vexed him in the inconclusive pictures of 1905 are drawn together into a coherent whole, while the blue-black accents of shadow again mold rounded volumes. The *Blue Landscape,* though not noticeably incomplete by the standards of other paintings in the last years, must have exasperated the painter. Like other canvases it has been slashed in a mood of impatience. Cézanne was getting his fierce linear grappling hooks onto nature once more, for the last time. Cursive line, even a manual flourish, suddenly recovered its place in this style. The passion and richness of the result in the paintings and watercolors of 1906 mark them as a crowning achievement.

The visit of Maurice Denis and his friends to Cézanne at Aix in January 1906, which has often been misdated in the literature, produced a photograph and a painting that document the date of the version of Mont Sainte-Victoire from the Chemin des Lauves (RP932 V803), now in Moscow, and thus the watercolor connected with it (RWC587 V1030) in the Tate Gallery.[52] The version of the subject at Basel (RP931 V1529) must be close in date to the Moscow picture, and it is likely that the version in the Pearlman Collection, *Mont Sainte-Victoire Seen from Les Lauves* (RP910)— another upright picture, like the *Blue Landscape* and similarly asymmetrical, with a lateral movement in its design—belongs to the same phase. The Moscow picture is quite different from any other version. It was worked on until the patches took on the granular richness of repeated superimpositions of pigment. The light areas have mutations of red and ocher. From them the sequence passes through sparing touches of emerald fiercely punctuated with crimson, violet, violet-gray, and black. The handling is sharp and wiry. The painter's claws are out; repeated contours assert the tree trunks and branches. The mountain heaves its hump restlessly once again.

The watercolor in the Tate, where the S curves are more Baroque than ever, and the related drawing in Philadelphia for the Pearlman version (RWC588) show that originally, before the pigment became so loaded as to fix everything in the Moscow picture in a state of still incandescence, the fan-shaped foreground tree was like a converse echo of the distant mountain. Cézanne had used this device before. In a drawing of the eight-

ies (RWC263 V1547), the distant mountain glimpsed between trees was echoed by the same shape inverted in the shadow of a forking trunk in the foreground cast on the garden wall at the Jas de Bouffan. In the Tate watercolor a progression of golden yellow, green, and violet creates space, which radiates from the lively tree; it is gathered in again toward the peak at the top of the picture. In the painting this movement consolidates in a symmetrical array of color areas, but the echo between the near and the distant remains. In the Basel picture, too, the golden light is concentrated in the middle and the same dark coulisse on the left frames the view, but the path and the foothill extending to the right give the landscape a directional aspect, which is more subtly unfolded in the expanding space at the right of the Pearlman picture. The Pearlman version, with its flat ocher foreground, in some ways echoes the beginning of the series, but now everything is different. The vertical prisms of earlier formulations have split into little splinters—the same fragmentary intimations of color correspondence, with no three-dimensional connotation, that make light— and the lively likeness of a real place—in Cézanne's last landscape, *Le Cabanon de Jourdan* (RP947 V805). The graphic rhythm here is more convulsive and vivid than ever, but it is still surpassed by the wiry line out of which the contour is woven in the profile portrait of the gardener, Vallier, on which Cézanne was working a few days before his death. In the last months of his life Cézanne was still finding new motifs, yet they summed up all his work. The watercolor *Houses in the Valley* (RWC629 V1037) shows all the power of Cézanne's last style in the convulsively twisted line that harnesses bold modulations of ocher, yellow-green, and bright red-violet, yet that style is also capable of giving an enchanting naturalness to the shaded bank beside the little road.

The last watercolors have a gentler unity than those before. The correspondences of color melt together. The contained shadows in the tower of Saint-Sauveur dissolve into the purple of the distance. The foliage and fruit of Cézanne's apple tree form a festive garland across the view over the town from his studio garden. The line is more tense and muscular than ever, but there is nevertheless a dissolution of the separateness of things and a total reconciliation of differences which often marks a great artist's last works. At the bridge of Trois Sautets (RWC644 V1076) in the ferocious August heat, where the air was a little fresher down by the river, the splendid linear structure of his watercolor was linked with a pervading, mild luminosity, which reflected his own pleasure in the solution that he had reached. "I felt very well there yesterday. I started a watercolor in the style

Pont des Trois Sautets, pencil and watercolor, c. 1906

of those I did at Fontainebleau. It seems more harmonious to me. It is all a question of establishing as much interrelation as possible."[53] His words may stand as the motto of the last pictures. The gardener in profile has not only a look of Cézanne himself but the look of a Michelangelesque Moses—another of Cézanne's self-projections, and one without anything immodest in it. The prophetic grandeur was his own.

The epoch that Cézanne certainly began is marked most clearly by the fact that each artist, each originator, institutes a new dimension of understanding. The apparent arbitrariness of a continuous and unending process of redefinition, on the basis of a past which is itself in a perpetual state of rediscovery and revaluation, places some values in doubt. Cézanne demonstrated, as he intended, that the process is rational and sensible nevertheless. The means of expression continually concerned him in his last years.[54] His ultimate conception of painting was of an art of rational intelligibility. The ideal is not the least of our debts to him. He recognized the means of art as "simply the means of making the public feel what we feel ourselves."

NOTES AND BIBLIOGRAPHY

A note on bibliographical and other references, and on excerpted texts

1. For all bibliographical references, including page references to the remaining parts of publications here given in excerpt only, consult the Bibliography. For example, "*Rewald 1960*, p. x . . ." refers to "John Rewald, *Cézanne, Geffroy et Gasquet, suivi de Souvenirs sur Cézanne de Louis Aurenche et de Lettres inédites*, Paris, Quatre Chemins-Editart, 1960, p. x . . ."

2. For the texts published in this volume, references are abbreviated as follows:

 a) texts by authors represented here by one item only are identified by authors' names alone (*Geffroy, Vollard, Larguier, Borély, Jourdain, Rivière and Schnerb, Osthaus, Gasquet*).

 b) Emile Bernard's texts are identified thus:
 Bernard/*Lettre à sa mère*
 Bernard/*L'Occident*
 Bernard/*Souvenirs*
 Bernard/*Conversation*

 c) Cézanne's letters to Emile Bernard, here republished in chronological order in two groups, before and after Bernard's *L'Occident* article, are identified by number (Letter 1 to Bernard, etc.). References to Cézanne letters not republished here are by date of composition, and are retrievable via the publications listed in our bibliography under "Cézanne letters."

 The questionnaire answered by Cézanne is referred to as Cézanne, *Mes Confidences.*

 d) The Maurice Denis texts are referred to as
 Denis/*Journal*
 Denis/*Théories*

3. References to texts published in this volume employ the formula
 Geffroy
 Denis, *Théories*

4. Editorial omissions from original texts, or from quotations taken from them are shown by [. . .]. Elsewhere, " . . . ," unbracketed ellipses, reproduce, without omission, the typographical conventions of the original text.

5. References to Cézanne's work indicate the Rewald (RP and RWC), Chappuis (CD), and Venturi (V) catalogue raisonné numbers in parentheses following the title of the work.

NOTES

PREFACE

1. *L'oeil et le cerveau*: (the eye and the brain): Bernard, *L'Occident* (p. 30 above)
2. *de l'imitation et même un peu de trompe l'oeil*: Bernard, *Souvenirs* (p. 79 above)
3. *copier servilement l'objectif*: Larguier (p. 18 above)
4. *sensations colorantes*. Cézanne, Letter 6 to Bernard (p. 46 above)
5. *la configuration de ce que vous voyez*: Cézanne, letter to Camoin, 9th December 1904
6. *balancement des parties lumineuses et des parties ombrées*: Rivière and Schnerb (p. 89 above)
7. *somme suffisante de Bleutés*: Cézanne, letter 1 to Bernard (p. 29 above)
8. *gris-clair*: Vollard (p. 9 above)
9. *localités*: Borély (p. 20 above)
10. *passage du ton*: Bernard, *Souvenirs* (p. 63 above)
11. *Je n'ai pas de doctrine*: Denis, *Journal* (p. 94 above)
12. *formules larges, riches, savoureuses*: Jaloux (1920, 286)

INTRODUCTION

1. Thadée Natanson, "Paul Cézanne," *La revue blanche* 9 (1 December 1895): 500. All translations for this introduction are mine; given the specific interpretive context, my phrasing and tone may vary from identical passages independently translated by Julie Lawrence Cochran for this volume.
2. Paul Gsell, "Interview d'Octave Mirbeau par Paul Gsell" (1907), in Octave Mirbeau, *Combats esthétiques*, ed. Pierre Michel and Jean-François Nivet, 2 vols. (Paris: Séguier, 1993), 2:419.
3. Francis Jourdain, in *Tombeau de Cézanne* (Paris: Société Paul Cézanne, 1956), 34.
4. Maurice Denis, "Cézanne" (1907), *L'Occident* 12 (September 1907): 118. For

commentary on Denis's writings, see Maurice Denis, *Le ciel et l'Arcadie*, ed. Jean-Paul Bouillon (Paris: Hermann, 1993); Jean-Paul Bouillon, "Le modèle cézannien de Maurice Denis," in Françoise Cachin, Henri Loyrette, and Stéphan Guégan, *Cézanne aujourd'hui* (Paris: Réunion des musées nationaux, 1997), 145–64.

5. Théodore Duret, "Edouard Manet et les impressionnistes" (1906), in Henry Marcel, ed., *Histoire du paysage en France* (Paris: Laurens, 1908), 316; Gustave Geffroy, "Paul Cézanne" (1894), *La vie artistique*, 8 vols. (Paris: Dentu [vols. 1–4]; Floury [vols. 5–8], 1892–1903), 3:259. Barnett Newman thought the apples were "superapples . . . I saw them as cannonballs": "Interview with Emile de Antonio" (1970), in John P. O'Neill, ed., *Barnett Newman: Selected Writings and Interviews* (Berkeley: University of California Press, 1992), 303.

6. See Cézanne's words as reported by the journalist Stock, 20 March 1870: John Rewald, "Un article inédit sur Paul Cézanne en 1870," *Arts* (Paris), no. 473 (21–27 July 1954), 8. On Cézanne's "sensation," see Lawrence Gowing, "The Logic of Organized Sensations," in William Rubin, ed., *Cézanne: The Late Work* (New York: Museum of Modern Art, 1977), 55–71; Richard Shiff, "Sensation, Movement, Cézanne," in Terence Maloon, ed., *Classic Cézanne* (Sydney: Art Gallery of New South Wales, 1998), 13–27.

7. According to one witness, Cézanne intentionally acted strangely to ward people off; see Edmond Jaloux, *Les saisons littéraires*, 2 vols. (Fribourg: Editions de la librairie de l'Université, 1942), 1:75.

8. Cézanne, letter to Joachim Gasquet, 30 April 1896, in John Rewald, ed., *Paul Cézanne, correspondance* (Paris: Grasset, 1978), 249.

9. See Cézanne's letters to Louis Aurenche, 25 January 1904, and to his son Paul, 8 September 1906, *Paul Cézanne, correspondance*, 298, 324. On aspects of Cézanne's character, see also John Rewald, *Cézanne, Geffroy et Gasquet* (Paris: Quatre Chemins-Editart, 1959); Jean-Claude Lebensztejn, *Les couilles de Cézanne* (Paris: Séguier, 1995).

10. "Astonish Paris": Cézanne's words according to Gustave Geffroy, *Claude Monet, sa vie, son oeuvre*, 2 vols. (Paris: Crès, 1924), 2:68. Apples pervade the early commentary on Cézanne: one critic wrote that the artist "took no more interest in a human face than in an apple" (Charles Morice, "Le XXIe Salon des Indépendants," *Mercure de France* 54 [15 April 1905]: 552); as if in confirmation, Cézanne had insisted that a portrait sitter "be still like an apple" (Ambroise Vollard, *Paul Cézanne* [Paris: Crès, 1919 (1914)], 124). On the theme of apples, see Meyer Schapiro, "The Apples of Cézanne: An Essay on the Meaning of Still-life," *Modern Art, 19th and 20th Centuries* (New York: Braziller, 1978), 1–38; Wayne Andersen, "Schapiro's Cézanne: On the Scholarly Misreading of Images," *Common Knowledge* 4 (Fall 1995): 86–107.

11. Maurice Denis, "L'aventure posthume de Cézanne," *Prométhée* 6 (July 1939): 194.

12. Geffroy, "Paul Cézanne," *La vie artistique*, 3:249. Geffroy's collected writings on Cézanne are reprinted with commentary in Gustave Geffroy, *Paul Cézanne et autres textes*, ed. Christian Limousin (Paris: Séguier, 1995).

13. Georges Lecomte, *Ma traversée* (Paris: Laffont, 1949), 156.

14. On Cézanne's timidity and self-deprecation: Claude Monet, letter to Geffroy, 23 November 1894, in Geffroy, *Claude Monet, sa vie, son oeuvre*, 2:65; Joachim Gasquet, *Cézanne* (Paris: Bernheim-Jeune, 1926 [1921]), 95; Jaloux, *Les saisons littéraires*, 1:73–74. On his paranoia: Léo Larguier, "Journal des revues," *Antée* 2 (1 January 1907): 870. On his slashing of canvases: Jean Royère, "Sur Paul Cézanne," *La phalange* 1 (15 November 1906): 379. On his receptiveness: Cézanne, letter to Charles Camoin, 9 December 1904, *Paul Cézanne, correspondance*, 307; Gasquet, *Cézanne*, 97–98; Léo Larguier, *Le dimanche avec Paul Cézanne* (Paris: L'édition, 1925), 110. Although Cézanne appears to have allowed Camoin to join him at the motif, Camoin paradoxically testified that the master "did not tolerate anyone being around him" when he painted; see Brassaï, *Conversations avec Picasso* (Paris: Gallimard, 1997), 127.

15. Edmond Jaloux, "Souvenirs sur Paul Cézanne," *L'amour de l'art* 1 (December 1920): 285.

16. Raymond Bouyer, "Le procès de l'art moderne au Salon d'Automne," *Revue politique et littéraire* 2 (5 November 1904): 604–05.

17. For recent, extended accounts of the record, see Françoise Cachin and Joseph J. Rishel, *Cézanne* (Philadelphia: Philadelphia Museum of Art, 1996), 17–75; Terence Maloon and Murray Bail, "A Painter's Painter," in *Classic Cézanne*, 165–81.

18. Camoin, statement in Charles Morice, "Enquête sur les tendances actuelles des arts plastiques," *Mercure de France* 56 (1 August 1905): 353–54. On Camoin and Cézanne, see Alain Madeleine-Perdrillat, "Le 'père Cézanne' et le 'vaillant Marseillais Carlos Camoin,'" in Véronique Serrano and Claudine Grammont, eds., *Charles Camoin, rétrospective 1879–1965* (Marseille: Réunion des musées nationaux, 1997), 29–39. The entirety of Morice's survey is reprinted with commentary in Philippe Dagen, ed., *La peinture en 1905: l' "Enquête sur les tendances actuelles des arts plastiques" de Charles Morice* (Paris: Lettres modernes, 1986). On the various sources for the famous Cézanne-Poussin statement, see Theodore Reff, "Cézanne and Poussin," *Journal of the Warburg and Courtauld Institutes* 23 (1960): 150–74. On interpreting Cézanne's view of Poussin, see Richard Shiff, *Cézanne and the End of Impressionism: A Study of the Theory, Technique, and Critical Evaluation of Modern Art* (Chicago: University of Chicago Press, 1984), 175–84; Richard Shiff, "Cézanne and Poussin: How the Modern Claims the Classic," in Richard Kendall, ed., *Cézanne and Poussin: A Symposium* (Sheffield: Sheffield Academic Press, 1993), 51–68.

19. As support for the second, less common reading, see Bernard's forthright statement upon visiting Aix, letter to his mother, 5 February 1904: "Cézanne

speaks only of painting nature according to his personality and not according to [the idea of] art itself . . . He professes the theories of naturalism and impressionism"; Emile Bernard, "Un extraordinaire document sur Paul Cézanne," *Art-Documents* (Geneva), no. 50 (November 1954): 4.

20. Gsell, "Interview d'Octave Mirbeau par Paul Gsell," in Mirbeau, *Combats esthétiques*, 2:419.

21. Maurice Denis, "Cézanne," trans. Roger E. Fry, *Burlington Magazine* 16 (January, February 1910): 207–19, 275–80. Like many critics, Denis was in the habit of adjusting the language of his essays when they were republished; there are slight differences between his 1907 version of "Cézanne" (*L'Occident* 12 [September 1907]: 118–33), his 1912 version (*Théories, 1890–1910: Du symbolisme et de Gauguin vers un nouvel ordre classique* [Paris: Bibliothèque de l'Occident, 1912], 237–53), and his 1920 version (new edition of *Théories* [Paris: Rouart et Watelin, 1920], 245–61). See Shiff, *Cézanne and the End of Impressionism*, 138–39.

22. See Mirbeau's account, in "Interview d'Octave Mirbeau par Paul Gsell," *Combats esthétiques*, 2:420; also reported in Maurice Denis, *Journal*, 3 vols. (Paris: La Colombe, 1957–59), 2:46. On Monet's enthusiasm for Cézanne, see also Louis Vauxcelles, "Un après-midi chez Claude Monet," *L'art et les artistes* 2 (December 1905): 89.

23. See Jules Borély, "Cézanne à Aix," *L'art vivant* 2 (1 July 1926): 493; Cézanne, letter to Paule Conil, 1 September 1902, *Paul Cézanne, correspondance*, 290; Gasquet, *Cézanne*, 18.

24. Denis, "Cézanne," *L'Occident*, 124; "De Gauguin et de Van Gogh au classicisme" (1909); *Théories* (1920), 263.

25. Georges Lecomte, *L'art impressionniste d'après la collection privée de M. Durand-Ruel* (Paris: Chamerot et Renouard, 1892), 188.

26. Maurice Denis, "L'influence de Cézanne" (1920), *Nouvelles théories, sur l'art moderne, sur l'art sacré, 1914–1921* (Paris: Rouart et Watelin, 1922), 118. Reflecting on his own writings, Gasquet was resigned to the problem: "As objective as one wants to be, always a little of oneself unconsciously works its way in" (*Cézanne*, 127). Denis later commented that Gasquet's account of Cézanne's words, despite some invention, was true "in essence"; "L'aventure posthume de Cézanne," 195.

27. Marc Elder (Marcel Tendron), *A Giverny, chez Claude Monet* (Paris: Bernheim-Jeune, 1924), 48. Elder's book consists of a series of interviews with Monet, apparently conducted around 1920–22. An account of the same incident, probably also stemming from Monet, is given earlier in Octave Maus, "L'art au Salon d'automne," *Mercure de France* 65 (1 January 1907): 66–67.

28. Théodore Duret, "Biographie," in Octave Mirbeau, *Cézanne* (Paris: Bernheim-Jeune, 1914), 23. This passage appears in the revised edition of Duret's *Histoire des peintres impressionnistes* (Paris: Floury, 1919), 115, but not in the

first edition of 1906. In 1914, Duret may have been heeding the many references to Cézanne's Provençal culture on the part of artists and writers from that region. Cézanne's pronounced southern accent and mannerisms, however, had been a matter of comment, often derisive, as early as the 1860s (as in Edmond Duranty's stories "Le Peintre Marsabiel," 1867, and "Le Peintre Louis Martin," 1872; see Larguier, *Le dimanche avec Paul Cézanne*, 117–20). The artist's Provençal identity is the subject of a forthcoming book by Nina Athanassoglou-Kallmyer, *Cézanne and Provence*. See also Paul Smith, "Joachim Gasquet, Virgil and Cézanne's Landscape: 'My Beloved Golden Age,'" *Apollo* 148 (October 1998): 11–23.

29. Jaloux, "Souvenirs sur Paul Cézanne," 285–86; *Les saisons littéraires*, 104. See also Gasquet, *Cézanne*, 28. Camille Pissarro's son Lucien recalled some early instances of "Cézanne's malicious humor"; see W. S. Meadmore, *Lucien Pissarro, un coeur simple* (New York: Knopf, 1963), 26.

30. For example, John Rewald warns against taking at face value Cézanne's stated "approval" of Bernard's view of him, in his letter to Bernard, 26 May 1904; *Paul Cézanne, correspondance*, 302, n. 7.

31. Jaloux, *Les saisons littéraires*, 104; Larguier, *Le dimanche avec Paul Cézanne*, 32, 121; André Warnod, *Ceux de la Butte* (Paris: René Julliard, 1947), 248.

32. Emile Bernard, "Souvenirs sur Paul Cézanne et lettres inédites," *Mercure de France* 69 (16 October 1907): 614. Denis, like Bernard, was concerned to establish a new (or renewed) tradition; accordingly, when speaking to Denis in 1906, Cézanne referred to his having "staked out" a new path (*je suis un jalon*), another way of conceiving of himself as a "primitive" (Denis, *Journal*, 2:30).

33. See, for example, Cézanne, letters to Bernard, 15 April 1904, and to his son Paul, 13 and 22 September 1906, *Paul Cézanne, correspondance*, 300, 325, 327. It was the common view of Cézanne—here, in Monet's words—that "he was [both] very sensitive [to criticism] and had a vaunted opinion of his worth" (Elder, 47).

34. R. P. Rivière and J. F. Schnerb, "L'atelier de Cézanne," *La grande revue* 46 (25 December 1907): 813.

35. Emile Bernard, "Paul Cézanne," *Les hommes d'aujourd'hui* 8, no. 387 (February–March 1891): n.p. In 1894, Geffroy made the same comparison ("Paul Cézanne," 3:257).

36. See Maurice Le Blond, "Le mysticisme de la génération nouvelle," *Le rêve et l'idée* 1 (May 1894): 1. At the time Cézanne spoke with Bernard and with Rivière and Schnerb, the term "primitive" was also current because of the great exhibition "Les primitifs français," held in Paris in 1904.

37. Gasquet, *Cézanne*, 70.

38. Another example: When Cézanne wrote to thank the critic and administrator Roger Marx for a generous review of his submissions to the Salon d'automne of 1904, he repeated Marx's own metaphor, referring to his aesthetic contribution as no more than a "link" in the continuing chain of art history (letter

to Roger Marx, 23 January 1905, *Paul Cézanne, correspondance*, 312; Roger Marx, "Le Salon d'automne," *Gazette des beaux-arts* 32 [December 1904]: 459, 462–64). In turn, Gasquet seems to have embellished Marx's notion, which had become Cézanne's. He "quoted" the painter as having added a specifically "blue link," probably because Cézanne habitually stressed the importance of color (Gasquet, *Cézanne*, 154).

39. Francis Jourdain, *Cézanne* (Paris: Braun, 1950), 10.

40. Elder, 47–48. Coming from Monet, the statement was especially significant, for he was capable of devastating irony himself; see Léon Daudet, "Un prince de la lumière: Claude Monet," *L'Action française*, 8 December 1926, 1.

41. Denis, "L'aventure posthume de Cézanne," 195.

42. Jourdain, *Cézanne*, 10; Francis Jourdain, "A propos d'un peintre difficile: Cézanne," *Arts de France*, no. 5 (1946): 7.

43. Georges Lecomte, "Paul Cézanne," *Revue d'art* 1 (9 December 1899): 86.

44. On details of links perceived between Cézanne, Gauguin, and Poussin (and, additionally, Pierre Puvis de Chavannes), see Shiff, *Cézanne and the End of Impressionism*, 162–74.

45. Gasquet, *Cézanne*, 136.

46. Denis, "Cézanne," *L'Occident*, 128. On the sequence of the three bathers paintings, see Theodore Reff, "Painting and Theory in the Final Decade," in *Cézanne: The Late Work*, 38; John Rewald, *The Paintings of Paul Cézanne: A Catalogue Raisonné*, 2 vols. (New York: Abrams, 1996), 1:509.

47. Félicien Fagus, "Quarante tableaux de Cézanne," *La revue blanche* 20 (1 September 1899): 627.

48. Denis, "Cézanne," *L'Occident*, 124; Denis, *Journal*, 2:34–35.

49. See Shiff, "Sensation, Movement, Cézanne," 18–22.

50. Bernard, "Paul Cézanne," *Les hommes d'aujourd'hui*, n.p.; Emile Bernard, "Paul Cézanne," *L'Occident* 6 (July 1904): 21. Bernard's views had been affected by Gauguin's, who argued that the expressive power of Cézanne's painting (and other great art) derived from an essentially abstract use of color and line; see Gauguin's letter to Emile Schuffenecker, 14 January 1885, in Victor Merlhès, ed., *Correspondance de Paul Gauguin (1873–1888)* (Paris: Fondation Singer-Polignac, 1984), 87–89.

51. For Sérusier's statement, see Denis, "Cézanne," *L'Occident*, 125; Denis himself comments that "facing [a] Cézanne, we think only of the painting" (120). As in the case of Bernard, it was probably Gauguin who infused Sérusier with an interest in Cézanne. Using works he had purchased, Gauguin "lectured" on Cézanne to all who would listen. See Merete Bodelsen, "Gauguin, the Collector," *Burlington Magazine* 112 (September 1970): 606; Denis, "L'aventure posthume de Cézanne," 195.

52. Cézanne's complaint: Borély, "Cézanne à Aix," 493; Cézanne, letters to Camoin

(13 September 1903), Bernard (26 May 1904, undated 1905, 23 October 1905), and his son Paul (26 September 1906), *Paul Cézanne, correspondance*, 296, 302–3, 313–15, 328–29. Just as Cézanne faulted Bernard for relying on theory, Bernard later faulted Cézanne for willfully remaining naive and ignoring any theory that would regulate his essentially abstract technique: Emile Bernard, "Réflexions à propos du Salon d'automne," *La rénovation esthétique* 6 (December 1907): 59–66; "Réfutation de l'impressionnisme," *Mercure de France* 93 (16 September 1911): 273. Gasquet quoted Sérusier's statement; his discussion indicates that Cézanne's combination of naturalistic realism and formal abstraction remained inherently confusing (Gasquet, *Cézanne*, 95–96).

53. "Abstraction" had already been regarded in this way by Stéphane Mallarmé, an inspiration for Symbolism, who linked the concept to artistic naiveté when addressing Manet's painting in 1876 (in an essay that exists only in English): "[The eye] should abstract itself from memory, seeing only that which it looks upon, and that as for the first time; and the hand should become an impersonal abstraction guided only by the will, oblivious of all previous cunning" ("The Impressionists and Edouard Manet," *Art Monthly Review* 1 [30 September 1876]: 118).

54. Regarding "concrete images" as a means of clarifying "an essay too abstract," Denis applied the term to his own writing in 1909; "De Gauguin et de Van Gogh au classicisme," *Théories* (1920), 269.

55. Denis, "A propos de l'exposition de Charles Guérin" (1905), *Théories* (1920), 143–44. In an art like Cézanne's, decorative form, beautiful by any standard, would express "inner life" by representing "emotions or states of mind" induced by nature, "without the need of furnishing [its illusionistic] copy"; Denis, "De Gauguin et de Van Gogh au classicisme," *Théories* (1920), 267–68, 271 (original emphasis).

56. Denis, statement in Morice, "Enquête sur les tendances actuelles des arts plastiques," 356.

57. Denis, "De Gauguin, de Whistler et de l'excès des théories" (1905), *Théories* (1920), 208; "Le présent et l'avenir de la peinture française" (1916), *Nouvelles théories*, 29. See also Denis, "De Gauguin et de Van Gogh au classicisme," *Théories* (1920), 271–72.

58. Denis, "Cézanne," *L'Occident*, 132.

59. Denis, "De Gauguin et de Van Gogh au classicisme," *Théories* (1920), 270–71. One close observer found it "disturbing" that the writings of Denis and others were encouraging partisan division between followers of Cézanne and Gauguin, the former having "pointed the way," the latter having "realized" it; Charles Morice, "Art moderne: la grande querelle," *Mercure de France* 70 (1 December 1907): 547.

60. Denis, "L'influence de Cézanne," 281; Denis, "L'aventure posthume de Cé-

zanne," 194; see also Jourdain, *Cézanne*, 11–12. For Cézanne's attitude, see especially his letter to Bernard, 26 May 1904, *Paul Cézanne, correspondance*, 303: "The literary type [or theorist] expresses himself with abstractions, whereas the painter makes his sensations [and] perceptions concrete."

61. Denis, "L'aventure posthume de Cézanne," 194, 196; see also Denis, "L'influence de Cézanne," 284. Denis's prime example of Cézanne's slavishness was his work on Vollard's portrait; see Vollard, *Paul Cézanne*, 123–43. On Cézanne's incompletion, see Felix Bauman, Evelyn Benesch, Walter Feilchenfeldt, and Klaus Albrecht Schröder, eds., *Cézanne: Finished Unfinished* (Ostfildern: Hatje Cantz, 2000).

62. Denis, "L'aventure posthume de Cézanne," 196. "Even with the ancients, we prefer the unfinished to the finished work": Denis, "De Gauguin et de Van Gogh au classicisme," *Théories* (1920), 273.

63. Elder, 49.

64. Examples of the observation: Duret, *Histoire des peintres impressionnistes* (1906), 189; Jaloux, "Souvenirs sur Paul Cézanne," 286. On Morice's survey, see note 18.

65. Charles Morice, "Paul Cézanne," *Mercure de France* 65 (15 February 1907): 577, 593.

66. Morice, "Paul Cézanne," 593; Morice, "Le XXIe Salon des Indépendants," 552–53.

67. Morice, "Le XXIe Salon des Indépendants," 552; Charles Morice, "Le Salon d'automne," *Mercure de France* 58 (1 December 1905): 390.

68. Morice, "Paul Cézanne," 593–94.

69. Bernard, letter to Mme Bernard, 25 October 1906, "Lettres inédites du peintre Emile Bernard à sa femme à propos de la mort de son ami," *Art-Documents* (Geneva), no. 33 (June 1953): 13 (original emphasis); Cézanne, letters to Bernard, 23 October 1905, 21 September 1906, *Paul Cézanne, correspondance*, 315, 327.

GUSTAVE GEFFROY

1. "Isolation, that's what I deserve. At least that way no one can get his claws in me" (Bernard, *Souvenirs*).

2. Georges Clemenceau had founded the radical periodical *La Justice* in 1880, and Geffroy was a regular contributor to it. Clemenceau, having lost his seat in the Chamber of Deputies in 1893, was at this time devoting himself to political journalism. The writer Mirbeau, an early defender of Impressionism, had evolved politically from Bonapartism to an extreme individualism, and to anarchism (with which Geffroy also sympathized). Rodin, at the period of the Giverny meeting, was working slowly and with difficulty on his *Balzac* (a commission received through the influence of Zola), and was beginning work on his *Monument to Labor* (never completed); he had exhibited with

Monet in 1889. The group was in general free-thinking and of the left: see note 3.

3. Cézanne had, about the beginning of the decade, become a fervent Catholic and a regular church-goer: "[. . .] converted, he believes and practices. 'It's fear! . . . I feel I might have just four more days on earth: then what? I believe in an afterlife and I don't want to risk roasting *in aeternum*'" (letter of Paul Alexis to Emile Zola, 13th February 1891: see Alexis 1971, 400). Hence his discomfort among what he would have seen as a radical and irreligious clique.

4. See Vollard 1914, 112: Geffroy "talked about Clemenceau all the time, so I escaped to Aix."

5. See also Vollard 1914, 86 and 106. William Bouguereau (1805–1925): a successful Salon exhibitor, and celebrated painter of female nudes. See Rewald 1968 for Cézanne's numerous abortive Salon entries.

 The Geffroy portrait (RP791 V692) was worked on from April to June 1895, but finally abandoned only on 3rd April 1896. See Rewald 1960, 18. It was given to the Louvre in 1969. For a full account of this painting, see John Rewald's catalogue entry in Rubin 1977, 385–6.

6. Cézanne frequently painted from paper flowers (see also Vollard 1914, 101–2), but these, like real flowers, faded: "these wretched things; even they change color in the long run!"

7. Letter to his mother, 26th September 1874: "I must always work, not to arrive at a beautifully finished surface, which imbeciles so admire [. . .]. I should try to complete a canvas only for the pleasure of making it more true and more enlightened."

8. See letter 8 to Bernard, "[. . .] I pursue the realization of that part of nature that, spread out before our eyes, gives us the painting." See also the letter to his son of September 8, 1906: "[. . .] with me, the realization of my sensations is always very difficult."

9. In a further article of 16th November 1895, later reprinted in *La vie artistique*, 6e série, Paris, 1900, Geffroy wrote of Cézanne, "He will be in the Louvre."

 Cézanne's attitudes to his companions of the Impressionist generation were moody and inconsistent at this period. Thus, in mid-1895, probably just after leaving Paris and Geffroy (and on this episode in general, see Rewald 1968, 167–9): "Pissarro is an old beast, Monet is clever, but they have no fire . . . only I have temperament, only I know how to make a red . . . !!" (Pissarro, quoting Francisco Oller's account of Cézanne's own words, in a letter to his son Lucien, dated 20th January 1906; Pissarro 1950, 397). Of Renoir Cézanne said to Gasquet, probably between 1896 and 1901: "His vision is fuzzy." By the end of his life (see Borély notes 1 and 10 and Denis *Journal* note 13), although still generally disdainful of Impressionism itself, he was consistently praising particular phases of his companions' work.

10. Cézanne's contact with Gauguin had plainly been traumatic for him; he felt himself to have been exploited and plagiarized. They met at Pontoise in 1881 in Pissarro's company (see Rewald 1968, 118–19), and Gauguin had soon after asked Pissarro in a letter for Cézanne's "prescription for compressing the intense expression of all his sensations into a single and unique process" (Rewald 1961, 458). Certainly Gauguin, in paintings of the mid-eighties and onwards, culminating in some of the work done in Martinique in 1887 and at Arles in 1888, was employing a version (sometimes vertical) of Cézanne's systematic diagonal facture of the late 1870s and early 1880s, and of the Cézanne paintings which he owned (see Bodelsen 1962 and 1970) the majority exhibited this "constructive stroke" (described and discussed by Reff, 1962). The anti-Gauguin sentiments recorded by Geffroy probably condense a public outburst at Giverny, which Octave Mirbeau noted picturesquely (in Duret 1914) and Maurice Denis (1957, Volume II, 46) rather more concisely, after a verbal report from Mirbeau, as follows: "Lunch at Monet's; over dessert, Cézanne began to cry: Oh! That Gauguin! I had one little sensation, and he stole it from me. He took it to Brittany, to Martinique, to Tahiti, that's right, on all the steamships! That Gauguin!"

11. Baron Antoine Jean Gros (1771–1835), the painter of Napoleonic subjects, and a pupil of David. Cézanne liked to invoke the names of official painters, partly to shock, but also because he genuinely admired and envied some of them. His remark here is an habitual one, used to make clear his detachment from avant-gardes of any kind: thus, to Jourdain in 1904: "Enough of Impressionism; it's all a joke!"

12. Vermeer.

13. See the sentence, from Zola's novel *L'Oeuvre* [The Masterpiece], in which the painter Claude Lantier is related to, but not identical with, the Cézanne of the 1860s and early 1870s: "A painting of a single original carrot will be pregnant with revolution." Philippe Solari, it was claimed by Gasquet (1926, 46), often heard this phrase on Cézanne's lips. The reader will note often, in these texts, how Cézanne retains in old age vivid recollections of his early career.

AMBROISE VOLLARD

1. Cézanne maintained a qualified respect, mingled with humorous deprecation, for Ingres (1780–1867), whose *Jupiter et Thétis,* in the Musée Granet at Aix-en-Provence, he had caricatured in his *Sketchbooks from Youth* (CD 50, not in V). His early paintings *Saisons* [The Four Seasons], once in the family house, the Jas de Bouffan, and now in the Petit Palais, Paris, were signed "Ingres" in a jocular mood, for they are juvenilia and hardly Ingres-like in style. Ingres was the figurehead of that classicism which opposed the Romantics and Delacroix, whom Cézanne admired profoundly.

2. Cézanne drew constantly from plaster casts in the Museum of Comparative Sculpture at the Trocadéro: many drawings made there are recorded by Chappuis (1973).

3. Maurice Denis, in a *Journal* entry for 21st October 1899 (1957, Volume I, 157), provides another account, no doubt obtained verbally from Vollard: "If it is sunny, he complains and works little. He requires a gray day." Rivière and Schnerb give us the best explanation: "[. . .] he was less interested in painting the violent contrasts that the untamed sun creates than the delicate transitions that model objects by almost imperceptible degrees. He painted a modulated light rather than that of full sun. For this artist, who worked several months on the same picture, a ray of sun or a reflection were only rather bothersome accidents and of secondary importance."

The special qualities of "pale gray light" were widely understood; Cézanne himself had noticed the work of Guillemet in 1866 (letter to Pissarro, 23rd October): "The landscape is very beautiful here, much charm, and Guillemet made a study of it yesterday and today under a pale gray sky which was quite beautiful." See also Bracquemond (1855, 94), "In the absence of sun, in the colorlessness and the vague light of gray days, called daylight or diffuse light, color takes on a considerable importance."

4. The portrait (RP811, V696) is in the Petit-Palais Museum in Paris. See Rewald's commentary in Rubin, 1977, where the unlikelihood of its having needed 115 sittings is indicated.

LÉO LARGUIER

1. Perhaps Cézanne was not a collector on his own behalf, but he treasured the belongings of his father and mother. Gasquet describes him, sorrow-stricken over the burning of his father's furniture. "And I, who cared for them like the apple of my eye . . . " (1926, 17). Denis (*Journal,* 1957, Volume 1, 175–76) recounts how Cézanne, "having lost his mother whom he greatly loved [. . .] kept personal items which reminded him of her [. . .]. In a fit of jealousy one day, his wife destroyed all these souvenirs. Accustomed to his wife's foolishness, Cézanne came home, found everything gone, left the house, and stayed away in the country for several days."

2. The poems marked in Cézanne's copy of Baudelaire are perhaps evidence that his character still possessed that morbidly sensual and pessimistic substratum which had revealed itself in the imaginative compositions of the late sixties, and indeed *Une Charogne* [A Carcass] was the subject of a number of studies (1866–69) to be found on three sheets of drawings (CD 145–147, not in v). Bernard (*Souvenirs*) remembers him reciting the whole poem from memory.

Charles Camoin, like Larguier doing his military service at Aix, wrote to him (see Cézanne's letter to Camoin, 3rd February 1902) mentioning the

poem n. VI, *Les Phares* [The Beacons], and that poem does indeed list artists (Rubens, Puget, Delacroix) whom Cézanne often praised.

XIX, *L'Ideal*, refers to Gavarni, who would be mentioned to Maurice Denis (*Journal,* 1957,Volume II, 29).

3. See note 1 above.

4. Contrast Monet (to Geffroy): *I paint as a bird sings* (quoted by Douglas Cooper in catalogue of Claude Monet Exhibition, Edinburgh/London, 1957, 8).

5. "language [. . .] logic": an opposition of which Emile Bernard will make much in a different form (*Souvenirs*): "He insisted on the necessity of an 'optic' and a 'logic.' " "A mind that can organize powerfully" (Dictum XVIII above) had become essential for Cézanne at an early point in his career as he left behind the cruel, libidinous, and gloomy images of his work of the late sixties. At that time his friend Antoine Fortuné Marion had written (Barr, 1937, 57): "Cézanne still works hard and with all his determination to organize and control his temperament, to impose rules of a calm science upon it." Turbulent emotion would no longer be the basis of his art: in a letter to Zola (20th November 1878) he solicits agreement for the idea that painting is "a means of expression of sensations."

It has been suggested above (Geffroy, note 10) that an early formula for expressing his "little sensation" was the hatched facture borrowed and adapted by Gauguin. Now, towards 1900, "sensation" seeks new formal modes, for he writes to Henri Gasquet (3rd June 1899) of "these confused sensations we bring with us at birth." Joachim Gasquet, if we can trust his flamboyant report, tells us that Cézanne sees landscape as "chaotic, fleeting, confused, without logical life, beyond all reason." "I proceed very slowly. Nature presents itself to me with great complexity," he will tell Bernard (letter 2). Henceforth the "optic/logic" antithesis will be insisted upon: "the eye and the brain" (Bernard, *L'Occident*); "the eye [. . .] the thought" (Rivière and Schnerb).

The term *optique* was itself fashionable in artistic circles. Seurat and his friends spoke of *peinture optique* (Homer, 1964, 19), and a generation earlier Auguste Laugel published *L'optique et les arts* (1869).

6. Dicta XXV to XXX, together with XXXIII, ruminate upon (among other things) the theme that is most familiar from Bernard's report (*L'Occident*), "There is neither outline not modeling; there are only contrasts." Rivière and Schnerb express it most neatly: "There is no line; a shape is defined by its neighboring forms."

7. I have, guided by the *opinion* in Bernard *L'Occident*, emended this sentence, which was originally printed as "the secret of the drawing of modeling."

8. See letter 1 to Bernard: "Nature, for us, exists more in depth than on the surface." "All bodies seen in space are convex": see the phrasing of Rivière and Schnerb, "the theory of the sphericity of objects"; theirs is the best account of this notion of Cézanne's.

In general, for the idea and the terminology in both cases, see Fromentin (1876, 183): "All Dutch painting is concave."

9. "the effect" is a normal constituent of Cézanne's terminology, and the term occurs again in Dicta xxxv and xxxviii. See the letter to Zola (24th May 1883) "[. . .] the beautiful panorama of Marseilles and the islands all enveloped, towards evening, in a highly decorative effect" and the opinion recorded by Bernard (*L'Occident*), "The effect makes the painting; it unifies and focuses it."

Bracquemond (1885, 139): "The effect is the sole goal of art. This word means first of all sensation, perceived impression." See also Boime (1971, *passim*).

10. "Schools do not exist." See Courbet, as paraphrased by Castagnary (Courthion, 1948 and 1950, Volume II, 213): "It is not possible to have schools."

11. "to capture a harmony": for suggested meanings of this in terms of Cézanne's technique and practice, see Bernard *L'Occident*, note 17; and in particular Bernard *Souvenirs*, and note 17 to *Souvenirs*.

JULES BORÉLY

1. There is clear evidence of a consistent enthusiasm for Monet in Cézanne's late years (i.e., after 1900, for this contrasts with the remark quoted in our note 9 to Geffroy, though that may reflect only a passing temperamental outburst). It is evidenced strongly in this account of Borély's visit, but see also Denis *Journal*, (and the attached note 13) and Denis *Théories*, (and the attached note 8).

2. "I have a Delacroix:" see introduction to the Vollard text reprinted here, and Rewald 1969, 88–9.

3. "some principles and a method": evidence for spontaneous theorizing on Cézanne's part at this period.

4. "impressions": possibly the only occasion on which Cézanne uses this term with regard to his own paintings. But he had once written of "my little reputation as an impressionist painter" (letter to Marius Roux, c. 1878).

5. "localités" (local color): see the alleged quotation given by Bernard (1920), "Titian and all the Venetians worked in local colors; that's what makes them true colorists" (fuller text given in note 3 to letter 1 to Bernard).

6. The affection for Rubens pervades these late documents: but here it is his drawing above all that is admired, and the comment should be related to Denis' evidence on Cézanne's feeling for "baroque" drawing (*Journal* and *Théories*, and notes attached to both texts).

7. The canvas referred to in this paragraph may be the *Grandes Baigneuses* of the National Gallery, London (RP855 V721). The other work may be, or may be related to, *Seated Peasant* (RP852 V713), though that painting is dated c. 1900 in Rubin 1977.

8. This is true of a number of late *Sainte Victoire* paintings.

 The conversation recorded by Borély appears to begin on the way to and at the Atelier des Lauves (though the building was not completed until September); and to end in the rue Boulegon.

9. "a very blue sky": as compared to the need for "pale gray light" (Vollard, and note 3 attached to that text); it is possible that Cézanne preferred these latter conditions for portraits and still lifes (i.e., for studio paintings), rather than for landscapes.

10. "Monet . . . Renoir": see the almost exactly contemporary letter to Joachim Gasquet, "I despise all living painters except Monet and Renoir" (8th July, 1902).

11. If this does refer to Cézanne's own youthful verses (published in the 1937 Paris edition of the *Correspondence,* as well as in the later English editions), then it would seem to be the only reference to them in our reprinted texts, and encourages us to regard Borély's account as accurate.

12. "another and corresponding": see the texts referred to in note 10 to Denis *Théories.*

13. Cézanne here uses the term "classic" either eccentrically or ironically.

14. the *Iambes:* presumably Auguste Barbier.

15. "this academic": for the sentiment expressed here, see the anecdote in Royère (1906, 378, not reprinted in this volume), in which Gasquet responds thus to Royère's praise of Cézanne's painting—"You see, Cézanne, we are triumphant: now we have the academics with us!"

16. "the escapade" below must refer to Zola's involvement in the Dreyfus case. "like the good God": Matisse, in an interview with Jacques Guenne published in *Art Vivant* in 1925 (and hence earlier than Borély's article), said: "Cézanne, you see, is a sort of God of painting" (I owe this reference to Yve-Alain Bois).

17. See Cézanne's attitude to Degas as reported by Maurice Denis (*Journal*).

18. "To see like a newborn child!" see letter 8 to Bernard, "to render the image of what we see while forgetting all that we have seen before."

19. "I am a painter": yet he would again, on 4th February 1904, expound to Bernard the theories of naturalism and impressionism (Bernard *Lettre*).

EMILE BERNARD: LETTRE

1. This was the studio at Les Lauves, constructed between November 1901 and September 1902 (Rewald 1977, 95).

2. In the middle sixties Cézanne had been loosely associated with those painters defended by his friend Zola as "realists," "naturalists," or "actualists" in whose circle Impressionism was about to emerge. Marion writes to the musician Morstatt (12th April 1866; see Barr 1937, 46) of "All the realist school [. . .] Cézanne, Guillemet and the others."

3. In letter 7 to Bernard Cézanne would later describe Pissarro as "humble and colossal": clearly the epithet was habitual, and should warn us not to doubt too easily documents which *seem* to repeat one another, for he repeated himself.

4. Bernard's article in *L'Occident* will say the opposite of this: "every part is developed simultaneously." Unfinished paintings exist which may be regarded as illustrating both these statements.

CÉZANNE: LETTERS
TO EMILE BERNARD, APRIL TO JUNE 1904

1. The Jas de Bouffan, the house and estate which Cézanne had inherited from his father, was sold in 1899, and Cézanne lived thereafter in a rented apartment at 23, rue Boulegon, Aix (Rewald 1968, 171).

2. The whole passage from "Render nature" to "give depth" has given rise to a considerable literature (see Reff 1960, 169–70; Reff 1977, 46–8; and Gowing 1977). It is usually now taken to refer, in its first sentence, to the standard vanishing-point procedures of academic perspective, and to academic methods of inculcating the understanding of volumes through the study of simple solids. (On the latter, see Gowing in the catalogue of Edinburgh/London exhibition, 1954; 9; and compare also the remarks recorded by Coquiot, 1919, 136, "Look, Mr. Rougier [. . .]. You see that man in front of us [. . .]. Well! he is a cylinder, his arms don't count! Villars de Honnecourt, for that matter, an ancestor, had already, in the 13th century, enclosed people in geometric armatures!")

The perspective aspect is pursued here, however, for the second and third sentences may, correspondingly, be understood as referring to the grid of receding squares, made by horizontal lines and orthogonals, which frequently feature among the diagrams in perspective handbooks. There is no real objection to interpreting "perpendicular lines" as orthogonals, for, in "absolute" space, orthogonals are, of course perpendicular to the horizon lines: but Professor Reff has proposed an ingenious alternative meaning (1977, 46). As writers on this topic now agree, the main point of the passage is the stress it puts on the *volumes* of solid objects, and on Cézanne's interest in "depth."

An interesting, and possibly independent, variant of the "parallel lines" passage is to be found in Royère's German article of 1912, describing his visit (c. 1896) to Cézanne, and this variant is cited by Reff (1977, 46) in support of his interpretation of letter 1: "You see [. . .]. She [Sainte-Victoire] is far from us for a good reason; in herself she is massive enough. At the Beaux-Arts, one can learn, certainly, the laws of perspective, but one never sees the depth that results from the meeting of vertical and horizontal surfaces, and this is perspective itself." (Royère, 1912, 485.) Here again, the abstract laws of perspective are restated in an idiosyncratic and concrete form.

The religiosity of *Pater omnipotens* is, of course, especially for Bernard's benefit (see the notes in this volume introducing the Bernard *Lettre*), but need not have been insincere for all that.

3. This is a simple formulation of the principle of aerial perspective—the blueness of distant objects, increasing as their natural hues are filtered through greater densities of atmosphere. But the phrase "vibrations of light" is the sort of semiscientific terminology that we might more readily associate with Seurat and his circle.

 However, it is "sufficient blues" that Cézanne recommends, and no more than that. See his words to Jules Borély in 1902: "You see, between us and that tree there is a space, an atmosphere, I grant you; then there is that tree trunk palpable, resistant, a body . . . " (Borély). Though the effects of atmosphere on local color are acknowledged (and on practical consequences of this see Reff 1977, 47), the integrity, the solidity of the painted object must override all: "All painting is there to give way to the air or to resist it. To give way to it is to deny the local colors, to resist it is to give to the local colors their force, their variety. Titian and all the Venetians worked in local colors; that is what made them true colorists" (Bernard, 1920), though the status of this quotation is uncertain, as with all Bernard material after the 1907 *Souvenirs*.

4. See the introductory notes to the Bernard *Lettre* for Bernard's own connection with Van Gogh [Gog] and Gauguin. "Truly, you paint like a madman!" Cézanne is supposed to have said to Van Gogh (Bernard, 1908). Note 10 to Geffroy indicates Cézanne's attitude to Gauguin, and there is evidence that, in his last years, he habitually criticized these artists jointly as "neo-impressionists." See Osthaus (1920, 82), and letter 8 to Bernard.

5. "Père Goriot": see "honorary grandpapa" at the end of the next letter to Bernard. The reference is to the selfless and abused father of Balzac's novel, and so shows Cézanne in a familiar self-demeaning vein.

6. Bernard greatly admired Redon (Rewald 1962, 183)

7. To paint an *Apotheosis of Delacroix* was a long-standing intention of Cézanne: and studies for this project survive in pencil, pen and ink, watercolor, and oils, being dated across a range of years from 1873 to the early 1900s. See R. Ratcliffe's note in the exhibition catalogue *Watercolour and Pencil Drawings by Cézanne* (Newcastle/London exhibition 1973, 156–7), and also Bernard *Souvenirs*.

8. "the diversity of nature": see Cézanne *Mes Confidences*, question and answer 26.

9. (I follow John Rewald's footnote here.) This seems to refer to a photograph of Cézanne in his studio, taken by Bernard. If this is the photograph reproduced in Vollard (1914), and often elsewhere, then it offers evidence of the stage which the *Bathers* (RP856 V720), now in the Barnes Foundation,

Merion (Pennsylvania), had reached by early 1904. (Vollard misdates the photograph "1902".) Work on the painting is often estimated to have lasted from 1895 to 1906: its appearance is now somewhat different from what the photograph shows.

There are references to a large *Bathers* composition (but not always the same one) in several of the texts reprinted in this volume.

10. It is usually held (for example, Reff 1960, 153; and Gowing, Newcastle/London exhibition 1973, 24) that this opening sentence, and that of letter 5 to Bernard, expressing Cézanne's approval of Bernard's *L'Occident* article, give the article itself unique authority as an exposition of his ideas. The letters do not prove conclusively that Cézanne saw a draft of the article, but the exasperated first paragraph of the letter of 12th May makes it quite clear that Bernard was bombarding Cézanne with artistic theory.

11. The reference is to Chardin's pastel self-portrait of 1775, *Autoportrait à l'abat-jour* [Portrait of Chardin Wearing an Eyeshade], in the Louvre.

12. It may be noted that a *straight-edged* plane, used as an eyeshade in this way, also encourages the interpretation as curves of "straight" horizontals in the motif being viewed. This may help to explain one class of Cézannian "distortion."

13. Paul Cézanne, Junior and Madame Cézanne.

BERNARD: *L'OCCIDENT*

1. Tanguy. See notes prefacing Vollard.

2. See Bernard's *Lettre à sa mère* of 5th February 1904: (of Cézanne) "In art he speaks only of painting nature according to his personality and not according to art itself." At this early stage, the peculiar artistic character of Cézanne has not yet been reinterpreted to fit into Bernard's general view of things; and Bernard's self-contradictions are evident.

3. This sentence tortuously links, for Bernard's own doctrinaire purposes, the fact that Manet on the one hand admired and emulated Spanish seventeenth-century painting and (in the *Olympia* and the *Déjeuner sur l'herbe*) adapted Italian Renaissance compositions; and on the other came to be on close terms with Monet, painting a number of pictures of him and his family, one of which (now at Munich) is referred to later in the paragraph.

4. Cézanne is to be enlisted by Bernard, in the course of his writings, in the formulation of a revived classicism "drawn from nature," as he says here, and at the same time "in accord with tradition" (*Souvenirs*). But his views evolve, and by 1926 he will regard Cézanne as "anti-classic." This is demonstrated by Reff (1960, 152–4, but the whole of that article is relevant to this topic).

5. See note 3 to Cézanne's letter 1 to Bernard.

6. See Cézanne's letter of 25th July 1904: "Nature [. . .] educates the eye by its contact," written to Bernard just after receiving the *L'Occident* article.

7. See Larguier, note 5.

8. See Denis *Journal* (1957, Volume II, 29): "He speaks a great deal about the contrasts there are in *Les Noces de Cana*; he made a diagram of it."

9. The remark on Delacroix seems to be intended as a verbatim quotation. On Manet, compare Vollard's citation (1914, 22): "He spits color! . . . Yes, but he lacks harmony and temperament."

10. "a decorative conception": this is not an un-Cézannian notion: see the letters to Zola, 24th May 1883, "one has the beautiful panorama of Marseilles and all the islands, all enveloped in the evening in a very decorative effect"; to Camoin, 3 February 1902: "make studies after the great decorative masters, Veronese and Rubens, but as you would from nature." and also the remark to Maurice Denis in 1906 (*Journal*, 1957, Volume II, 29): "I would like to make decorative landscapes like Hugo d'Alesi, yes, with my small sensibility."

 For one current meaning of the term, see Bracquemond (1885, 192): "By extension one can say that it [decoration] is the supreme expression of the arts; that they enjoy fullness and free expression of all their qualities, its essence, the principle of ornamentation, freeing them from servile imitation of nature and permitting them to find within themselves the forms they have studied and created."

11. See note 4 to Bernard's *Lettre* of 5th February 1904.

12. Bernard's association with the formulation of synthetism should be recalled.

13. From letter 2 to Bernard.

14. This may be a fairly accurate report of a distinction made by Cézanne: see Denis (*Journal*, 1957, Volume II, 29), the passage ending "with nervous gestures of drawing like Michelangelo."

15. Lawrence Gowing (Newcastle/London exhibition 1973, 24) has acutely observed that the fifteen maxims that follow (up to "to read nature") seem to form a continuous exposition, cyclical in character, the fourteenth *opinion* referring back to the first, and redefining classicism, with the fifteenth acting as summary and conclusion. Two unrelated remarks follow, and then quotations from Cézanne's letters.

 There is also a definite relationship with the Larguier Dicta, for it will be found that, with differences of phraseology (some, but not all, caused by misprints), the eleventh *opinion* in Bernard closely parallels XXVIII to XXX in Larguier. Other *opinions* can be more loosely related to Larguier aphorisms, and the Larguier aphorisms also often strikingly echo statements in the autograph letters to Bernard.

 The "organized" nature of the *opinions* may simply show Bernard's own schematizing mind and hand. But the parallelisms between Larguier and Bernard are remarkable, and must spring *either* from the increasingly systematic nature of Cézanne's own thought in his last years, *or* from wholesale plagia-

rism by Larguier—whose publication of course postdates Bernard's. On present evidence, I believe the latter to be unlikely.

16. See Denis (*Journal,* 1957, Volume II, 28): "Ah! The Middle Ages; there is everything in the cathedrals!" and also Bernard (*Souvenirs*), "it is an old stone-cutter from here who made them a long time ago; he is dead." The significance of this last utterance about the sculpted saints of Saint Sauveur was pointed out to me by Professor Gowing: it may be taken as partly humorous. "[. . .] my helping of the Middle Ages" (*Souvenirs*) pursues the jocularity.

17. On this and the preceding paragraph Professor Gowing's study (1977) constitutes an extended and subtle commentary. *Modulation* is a fundamental notion for Cézanne (see below in the *opinions,* "one must not say to model, one must say to modulate," implying "gradation" by discrete quantities or leaps, and not by continuous tonal or coloristic change: the late watercolors, with their related, overlapping, but distinguishable color patches, illustrate the principle perfectly.

18. See letter 1 to Bernard

19. Dicta XXXIV and XLI in Larguier, reprinted in this volume, should be read in conjunction with this paragraph.

 I have emended this sentence, which originally gave "agreement of all" (*rapport de tous*), on the analogy of Dictum XXX, and guided by the repetition of this passage in Bernard *Souvenirs*. Similarly "one draws" (*on dessine*) has been printed above, correcting "or draws" (*ou dessine*), which is not found in the related texts.

20. "The effect": see Larguier note 9.

 "a dominant patch": the notion of dominants was a key one for Seurat and his circle (see Coquiet, 1926, 232–3; and Homer 1964, *passim*). But Cézanne may simply be propounding a traditional doctrine recommending the organization of certain kinds of picture around a compositional center of interest, a doctrine perhaps not applicable in a useful way to his own late paintings.

 Or, more probably, this may be one way of defining his "law of harmony" (sixth *opinion* above): i.e., a patch of particular color (and shape?) is the basis from which the painting as a whole is, by a sequence of variations, evolved. In this way, "relationships of tones . . . by themselves . . . will establish harmony" (Larguier, Dictum XXXIV). Lawrence Gowing, adopting a particular view about the law of harmony, cites a passage from Bernard (*Souvenirs*), which might support this explanation of the "dominant patch."

 Tache, here rendered in English as patch or stroke, a word significantly employed in the original French of that Bernard passage, is itself important in Cézanne's terminology, and his uses of the word encapsulate a large part

of his technical evolution. Like others, he had looked at Manet's *Olympia,* and, according to Vollard (whose information here was secondhand) called the picture "a beautiful patch" (1914, 34). Many painters, observing its lack of traditional chiaroscuro modeling, and a flatness like that of the *images of Epinal* or Japanese prints, made similar remarks: thus Courbet, "It is flat, it isn't modeled—like the Queen of Spades on a playing-card, just out of her bath" (cited by Albert Wolff in *figaro,* 1st May 1883), and Daumier: "it recalls Lancelot" (i.e., the knave of clubs in the French playing-card pack). Cézanne himself painted a *Femme couchée,* now lost (see Bernard *Souvenirs* and note 33 to *Souvenirs*), which was apparently Manet-like in color and treatment, and apparently itself depicted an *image d'Epinal* in the background.

Letters to Pissaro on 24th June 1874 and 2nd July 1876 seem still to indicate an equivocal interest in the flat "spot—the opposite of the modeled," however. And this limitation of the *tache* was widely recognized, so that Bracquemond (an exhibitor, with Cézanne, in the first impressionist exhibition of 1874) stresses in his treatise of 1885 (42) that "the more the patch takes on importance itself, the more the modeling disappears."

But Cézanne by the end of his life will say "I want to render the cylindrical essence of objects" (Rivière and Schnerb), and earlier, probably in 1904, complained of the lack of modeling or gradation in the "Chinese images" of Gauguin (*Souvenirs*).

Modulation, finally (see note 17 above) is that major technical invention of Cézanne's which reconciles the *tache* with solidity in the painted image. For his last word on that reconciliation (in another painter, Raphael, and by somewhat different means) see Maurice Denis (*Journal*).

The general background and most of the detailed evidence for this discussion of the term *tache* are derived from Badt (1965, 114–7), Rewald (1961, 207–10), and Boime (1971, 152).

21. "Word of Cambronne": Napoleon's famous five-letter reply, "merde," when asked to surrender at Cambronne. The rest of this section is composed entirely of quotations from letters 2 and 3 to Bernard of 12th May and 26th May, 1904.

22. "without concern": This is highly questionable. Geffroy (1894, 253): "the passion of his curiosity, of his desire to possess things that he sees and likes" and the letter to Gasquet of 21 July 1896: "I remember myself to you and to your good thoughts so that the chains which attach me to this old native soil, so vibrant, so bitter, reflecting a light so strong that it makes me blink and bewitches my eyes, won't break and set me free from the earth, so to speak, where, without even knowing it, I have been fully conscious."

23. From letter 2 to Bernard.

24. Eugène Carrière (1849–1906) painted, in the later part of his career, near

monochromatic warm-toned canvases in which the subjects appeared blurred and soft-edged, as if fog-enshrouded. Vollard ascribes to Cézanne a mocking remark on Carrière: (on a misty day) "He has the ideal weather to give himself over to his orgies of color!" (Vollard 1914, 118); see also Gasquet, 195–6.

25. Vollard's publications do not include a comprehensive catalogue, though Matisse commented approvingly on Vollard's thoroughness in photographing the Cézannes in his hands (Matisse 1972, 87): "Ambroise Vollard rendered a greater service by taking the initiative of having the paintings photographed. This step was extremely important because without it, others would surely have managed to 'finish' all the Cézannes, as they were accustomed to adding trees to all the Corots."

CÉZANNE: LETTERS
TO EMILE BERNARD, JULY 1904 TO SEPTEMBER 1906

1. The loose, disorderly writing of this letter and its inserted phrases may show that it was written in great turbulence of mind, but this cannot easily be demonstrated in a printed translation. It is suggested that this may be the reason for the somewhat curious expression *concentrique,* for which there seems otherwise to be no entirely satisfactory explanation. Thus, just as *contact* acquired, in the original, the misspelling *conctat* from its adjacence to *concentrique,* so *concentré* may, by contamination from *s'eduque,* have been written *concentrique* in error (*conctat* is found, however, with no such explanation offering itself, in letter 8 to Bernard).

The habitual misspelling is a curiosity, and will interest those who take a Freudian view of such lapses: the episode recounted by Bernard (in *Souvenirs*) may be studied in this connection: "He cannot stand for anyone to touch him."

As for *concentration,* it is also an important issue for Cézanne: see the Denis account (*Journal,* 1957, Volume I, 157) of the painting of the Vollard portrait: "For some time now, Vollard has posed every morning at Cézanne's. The minute Vollard moves, Cézanne complains that Vollard has made him lose the 'line of concentration.'"

2. The marginal insertion here, incoherent though it is, must have the same general sense as the passage on black and white in the following letter. See note below.

3. Another statement on the principle of vanishing-point perspective: but again emphasizing solid objects, stressing (see Rivière and Schnerb) "the sphericity of objects."

4. Perhaps an indication of an intuitive and nonsystematic view of the nature of color harmony.

5. This is a central statement of principle, asserting once and for all the primacy

of *color sensations* in his method over traditional tonal painting. But note here, how *plane* also introduces the sense of a precise distancing of the parts of the image, and even of corporeal solidity: See "the planes fall one atop the other" in letter 8 to Bernard.

Apparently, in his earliest days at the Académie Suisse, Cézanne would, according to Monet, place a black hat and a white handkerchief next to the model to aid him in gauging the tonal scale (Rewald 1961, 62 and 67, note 32). Now all that is far behind him, and Maurice Denis will report him as saying: "I want [. . .] to make with color what others make in black and white with the stump." Dictum XXVI in Larguier appears to offer a curious restatement of this in musical terms.

6. The term "formula" should be taken seriously in Cézanne's case. The word seems to have been widely used at this period. It may be that Gauguin's question to Pissarro, "Has Monsieur Cézanne found the exact formula?" collects Cézanne's own utterances, and perhaps Gauguin's plagiarism of Cézanne's *facture* (see note 10 to Geffroy) constituted the theft of a "formula." Larguier seems to have collected a statement (Dictum XXI) about "a formula of art," and the undoubtedly authentic answer in *Mes Confidences* to the question "what, according to you, is the ideal of earthly happiness?" is "to have a beautiful formula." We should consider the possibility that Cézanne, if he employed the "metaphoric" color system described by Lawrence Gowing (1977, 58–61), consciously regarded that system as his "beautiful formula."

7. Politically Pissarro sympathized with the anarchist movement, especially in the late 1880s, when his neo-impressionist associates were also of that persuasion (see Rewald 1962, 154–6).

8. "The general reflection" is an important notion for Cézanne. Dictum XXXII to Larguier sees the atmosphere as "the immutable screen upon which all oppositions of colors, all the accidents of light divide into separate elements," for "it makes the picture's envelope of atmosphere." Joachim Gasquet hears Cézanne say of the composition of an *Amour en platre,* "myself, I don't find that lifelike, enveloped in atmosphere." Gasquet, however, also records the disruptive effects of light through a shutter upon the Henri Gasquet portrait: "But great God! I have to close it again . . . These damned reflections . . ." (See also Bernard in *Souvenirs* on reflections at the Atelier des Lauves.)

Strong reflections, in other words, have the effect of "destroying local colors" (see note 3 to letter 1 to Bernard): hence the vital, unifying importance of "a pale gray light."

The "envelope" is a key technical notion for the impressionists in general, but fits uneasily into Cézanne's aesthetic: perhaps the point of a pale gray light is that with it the conflict between "local colors" and "envelope" is minimized.

9. See Gasquet on the device adopted by Cézanne, when painting the *Vieille au*

chapelet (London, National Gallery, 1895–6), in order to avoid disruptive associations: "I saw a tone like Flaubert's, an atmosphere, something undefinable, a bluish and russet color scheme that reminded me of Madame Bovary, I read Apuleius in vain, to try to chase this obsession which for a moment I was afraid was dangerous, too literary."

See also Gasquet, who, asking Cézanne the reason for "this preparation, all this meditation before the landscape" is told "because I am no longer innocent [...]. One can no longer be ignorant today."

10. "abstractions": not abstract forms in his art, but rather an intense preoccupation with "color sensations," which draws his attention away from the related (but distinct) problem of "defining the edges."

11. "neo-impressionism:" this (as John Rewald's footnote to this letter indicates) must mean not the Seurat circle but Bernard, Anquetin, Gauguin, and cloisonnisme in general, "which outlines forms with a black line." It may merely mean the "Gauguins and Gogs" (Van Gogh; letter 1 to Bernard), and for the same reason. See also Bernard *Souvenirs:* "that way I have a clear vision of the planes! [...] That's what Gauguin never understood." See also Osthaus. A practical demonstration of Cézanne's insistence on distinguishing planes from one another is given to Charles Camoin on his first visit to the painter, probably very late in 1901: "He immediately speaks to me about painting, he explains how the base of a lamp placed on the table stands out from the oilcloth background." (Camoin, 1920, 25.)

12. "The last sentence and the signature added in the earlier editions of these letters must have been written on an extra piece of paper which no longer exists" (note in catalogue of exhibition, Paris, Musée de l'Orangerie, *Impressionistes de la Collection Courtauld de Londres,* 1955).

BERNARD *SOUVENIRS*

1. "25 rue Boulegon": presumably an error for "23" (see introduction), though Camoin (1920, 25) also has "25."

2. Paul Alexis (1847–1901) was a writer of novels and plays and a journalist. He was a lifelong friend of Emile Zola, and, in his writing, a "naturalist." He was a schoolmate of Cézanne and Zola, and all three maintained contact, to varying degrees, in later life. There is a painting (RP151 V117) by Cézanne at São Paolo, Brazil, of Alexis reading to Zola (c. 1870).

3. Paul Signac (1863–1935): a member of Seurat's neo-impressionist circle, a practitioner of pointillism, and author of *D'Eugène Delacroix au Néo-Impressionisme,* 1899, previously published as articles in *La Revue Blanche.* This is possibly Cézanne's only reference to a named neo-impressionist (apart from Pissarro).

4. Cézanne's and Zola's decorations were added to the screen about 1859 (RP1 to 3, V3,1,2). Small parts of this screen (which in 1974 was on the New

York art market) are visible in the backgrounds of a number of Cézanne's paintings.

5. Philippe Solari (1840–1906) and Cézanne were friends from childhood, and were fellow pupils at the Ecole Spéciale de Dessin at Aix (where Cézanne was enrolled from 1858 to 1862). Solari became a sculptor, and both he and Cézanne belonged to Zola's Paris circle in the sixties. They maintained contact throughout their lives, and Solari made at least two busts of the painter in his later years: one is referred to in this paragraph; another (see letter to Solari, 24th September 1904) was being worked on later in the year, after Bernard's departure. Mack (1942) illustrates two, neither of which looks broken.

6. Nicolas Froment: a painter active from 1450 to 1490 in the south of France. The painting in Aix Cathedral here referred to is *Le Buisson ardent* [The Burning Bush] of 1476, one of his two documented works.

 La Tarasque: a fantastic animal effigy used in street processions on the feast of Pentecost in the South of France.

7. "The Dreyfus Affair": Cézanne was anti-Dreyfusard, whereas Monet and Pissarro joined Zola in supporting Dreyfus.

8. *L'Oeuvre:* in this novel by Zola (1886), the figure of Claude Lantier is a composite one, having traits drawn from Cézanne and Manet, as well as other artists of their generation, and even from Zola himself. The novel contributed to the estrangement of Cézanne and Zola in their later years, for a major theme in it is the artistic impotence of Lantier.

9. Perhaps this is a garbled memory (of Cézanne's) or an inaccurate report (of Bernard's) of Cézanne's intention to write with Zola a drama, presumably in French, to be entitled *Henry VIII d'Angleterre* (letter of 9th July 1858 to Zola).

10. *La Confession de Claude* (1865) contains fictionalized recollections of the youthful activities of Baille, Zola, and Cézanne.

11. "Bail" is Bernard's spelling of the name of Baptiste Baille (1841–1918), who was at school with Cézanne and Zola at the Collège Bourbon, Aix (which Cézanne attended from 1852 to 1858).

12. The studio on the Chemin des Lauves was constructed by a local architect, Mourgues, who decorated its exterior in an excessively picturesque style with wooden balconies and ceramic ornamentation. Cézanne, furious, had these decorations removed (Mack, 1942, 367).

13. Perhaps *Trois crânes sur un tapis d'Orient* [Three Skulls on an Oriental Rug], 1904, in a Swiss private collection (RP824 V759; plate 155 in Rubin, 1977).

14. atelier Suisse: a retired model named Suisse ran this studio in Paris, in which artists could draw from the nude for a small payment: they could work as they liked there, and no instruction was given.

15. Thomas Couture (1815–79): a painter of portraits and historical pictures. Manet was a pupil of his, and his teaching was much admired. A number of witnesses saw the reproduction of the *Orgie* (i.e., *Les Romains de la Décadence,*

now in the Louvre) in Cézanne's studio. The letter to Camoin of 13th Sep-
tember 1903 quotes Couture as saying: "Keep good company . . . Go to the
Louvre," though the source of this has apparently not been found. In 1906,
Cézanne says to Maurice Denis "I am trying to apply the ideas of Couture,
Gavarni, Traviès, Forain" (*Journal*).

16. See Gasquet: "What do you want me to do with the clumsiness of Cimabue,
the naïveté of Fra Angelico, even Uccello's perspective . . . There is no flesh on
these ideas."

17. This and the following paragraph form an extremely important eyewitness
account of Cézanne's watercolor technique, which has implications for his
method and theory in general. In particular it comes close to defining a "law
of harmony" of the kind proposed by Lawrence Gowing (1977, 59), which
"modulates" or "models" the "sphericity of objects" by sequences of related
hues running in spectrum order. See also note 20 below on "scales played on
the palette," and Bernard's description of pictures hardly begun, which were
only "some scales begun that time had interrupted."

It may be asked, however, whether "analogous harmonies" (to use Chev-
reul's term) will not *inevitably* arise from the conditions and techniques
Cézanne chose for his painting. The "metaphoric system" (Gowing) was per-
haps immanent rather than imposed, found rather than constructed: and
Lawrence Gowing, in writing of the "image as the product not of an act of
will, but of a process . . . analogous to the automatism of nature" (1977, 67),
perhaps indicates that this is the truth of it. And indeed to the opinion from
Bernard (*L'Occident*) that "when they [the tones] are harmoniously juxta-
posed and they are all there, the painting models itself," may be added the
Larguier Dictum xxxiv, "Harmony is produced by the appropriate place-
ment of colors. The more numerous and varied they are the greater is their
effect and the more pleasing they will be to the eye."

Cézanne's procedures are here likened to those of "the ancient tapestry-
makers" and the comparison was often enough made for Gasquet (1926, 70)
to place it among "those chance comparisons made by snobs"; see Denis
(*Théories*) who sees him as a "weaver of Persian carpets." (Chevreul, origina-
tor of the term "analogous harmonies" given above, was superintendent of the
Gobelins in the earlier part of the century, and an influential color theorist.)

18. It may be that the belief that Cézanne worked particularly slowly has arisen
because of his extreme nervousness and tentativeness in the presence of
spectators.

19. "trick [. . .] to pilfer": this, though referring to the last years of Cézanne's
life, recalls again the Gauguin episode of earlier years (Vollard 1914, 78: "He
accused him of trying to 'swipe his little sensation.'")

20. See also where Bernard lists the colors on Cézanne's palette. This, presum-
ably, is the range used for oil painting. However, both the watercolors *and*

the oils often *appear* to be carried out, in each individual case, with a small number of pigments. Certainly, in both media, the principle of avoiding mixtures is followed (though in both cases effects of transparency are to be found, one stroke or stroke-system lying upon, but not concealing, another under it). The motive was, it seems, to preserve always the integrity and the separate existence of each pigment, stroke, and patch. "Such a palette had the advantage of not requiring too much mixing."

21. This must have been for the exhibition organized by *La Libre Esthétique* from 25th February to 29th March 1904: the catalogue lists *nine* (not twenty) Cézannes, and five works by Maurice Denis. See also Denis *Journal,* note 12.

22. Reflections of the colors of one object upon another seem rare in mature Cézanne: perhaps here Bernard is talking of the "general reflection" which, at the "dark edges," Cézanne regularly (but not invariably), first delineates with a dark blue line (often painted over later, however), for these are the "parts which, deprived of direct sunlight, receive only a reflection of the sky" (Rivière and Schnerb). The transition of colors, starting at the dark edges, is then worked out across the surface of objects, possibly on the system that Lawrence Gowing suggested.

23. This no doubt a reference to the flat *images d'Epinal* aspect of the work of the Gauguin circle, which, of course, ignores the color transitions studied so persistently by Cézanne. The reference to Gauguin as an admirer must have been particularly galling. (At Le Pouldu in 1889–90, Gauguin, starting a painting, would say "Let's make a Cézanne" [Rewald, 1962, 308].)

 For Gasquet's views on the question of Chinese and Japanese art in relation to Cézanne, see note 71 attached to his text.

24. In the following passages, sections of the "opinions" (Bernard, *L'Occident*) will be recognized.

25. Perhaps his son Paul, who served as his intermediary with Vollard.

26. Cézanne did not go to Paris until 1861, but the reference to 1857 may either be an error, or apply to the country excursions with Baille and Zola, Zola's descriptions of which are cited by Rewald (1968, 4–5). The enthusiasm for Wagner, and the painting *Jeune fille au piano—L'Ouverture de Tannhaüser* (St. Petersburg, Hermitage Museum, RP149 V90), are discussed by Barr (1937, 52–7).

27. See Rewald (1968, 198 9). Frenhofer, in Balzac's *Chef-d'œuvre inconnu* [The Unknown Masterpiece], had said "There are no lines in nature; it is in modeling that one draws, that is to say, that one makes objects stand out from their milieu." For discussion of a Cézanne drawing which may represent Frenhofer, see Chappuis (CD128–129 V1575 and p. 350). See also Cézanne, *Mes Confidences* (question and answer 20).

 Gasquet similarly reports Cézanne speaking of Frenhofer, but with reference to Achille Emperaire, not to himself (1926, 39 and 67); Larguier (1947,

135), however, makes a point of saying that Cézanne never mentioned the *Chef-d'oeuvre inconnu.*

28. Compare with this table-talk of 1896 or 1897 cited by Edmond Jaloux (1918, 108): "See how the light tenderly loves the apricots; it consumes them entirely, it penetrates their flesh, it illuminates them all the way around! But light is stingy towards peaches, which it only illuminates half-way."

29. See letter 4 from Cézanne to Bernard.

30. For Cézanne's copies from the various volumes of Charles Blanc (*Histoire des peintres de toutes les écoles . . .*) and from the *Magasin Pittoresque,* see Chappuis 1973. See also Gasquet (1926, 107, 109, and 110).

31. See R. Ratcliffe's catalogue entry (Newcastle/London exhibition, 1973, 151) for a Cézanne copy after a Luca Signorelli drawing. Copies from two other Signorelli drawings are there referred to. (See Chappuis 1973: CD182, V p. 349; and CD183 and 995, neither of which is in Venturi.)

32. Louis Anquetin (1861–1932): a fellow pupil, with Bernard, of Cormon, and a friend of Van Gogh. A painter of greater talent than achievement, and an eclectic experimenter in various styles, impressionist and post-impressionist.

33. The *Femme couchée* (now lost) and the *Achille Emperaire* (Paris, Musée d'Orsay, RP139 V88) were submitted together to the Salon of 1870 and refused (Rewald, 1954). Both may offer evidence of a momentary interest of Cézanne's in the late 1860s in popular imagery and the flatness of *images d'Epinal,* for the *image naïve* depicted within the *Femme couchée* seems, as noted above, to have been an *image d'Epinal* (Bodelsen 1962, 208–11, and 1970, 605). Bernard the cloisonnist and synthetist would have found these paintings particularly interesting, but note also that he associated the *Femme couchée* in his mind with certain Baudelairean verses of Cézanne's, finding in both "a magisterial Baudelairean nonchalance that defies the bourgeois." In this he read the mood of the Cézanne of 1870 correctly, for the painter had said to Stock, author of the text on the 1870 Salon reprinted by Rewald: "Yes, my dear Mr. Stock, I paint as I see, as I feel —and I have very strong sensations— they too, they see and feel like me, but they don't dare . . . they do salon paintings . . . Me, I dare, Mr. Stock, I dare . . . I have the courage of my convictions . . . and he laughs well who laughs last." Similarly Denis (*Journal,* 1957 volume 11, 212): "around 1870, when Manet asked what he would send to the Salon, he replied, "a potful of shit. It is harrowing stupidity. And [. . .] the painting of this epoch [. . .] has the same tone, gross and foolish."

Achille Emperaire (1829–1892 or 1898), a boyhood friend of Cézanne's who also attended the Ecole Spéciale de Dessin at Aix and the Atelier Suisse, was poor throughout his life, and not successful, but Cézanne praised his work, and portrayed him in two paintings and a number of drawings. He was a dwarf and deformed.

34. See note 7 to letter 2 to Bernard, and also Bernard *Souvenirs.*

35. Paintings made from photographs include: a self-portrait of 1862–4 (RP72 V18); *Neige fondante à Fontainebleau* [Snow at Fontainebleau] 1879–80 (New York, Museum of Modern Art, RP413 V336); and *Le Grand Baigneur* [Male Bather], c. 1885 (New York, Museum of Modern Art, RP555 V548).

36. Château Noir is now usually given as a proper name. This is a building and property to the east of Aix. See Rewald (1977, *passim*).

37. See Cézanne on Rosa Bonheur's *Labourage nivernais* [Plowing in the Nivernais], 1849; now at Fontainebleau: "horribly lifelike" (Vollard 1914, 137).

 Rosa Bonheur (1822–1899) was internationally successful as a painter of animals.

38. See note 2 to Larguier.

39. See also Bernard *Souvenirs,* Part III and note 20.

40. This, presumably the technique for oil painting, may be compared with the description of Cézanne's watercolor procedures above.

41. "the primitive of the way I have discovered." See Rivière and Schnerb, and Maurice Denis (*Journal*).

42. "to return to the practice of the faith": but Cézanne was a practicing believer from about 1891. See note 3 to Geffroy.

 Nevertheless the humorous note is often struck, as in Bernard's text here: "Oh, vespers, I go to them to please my wife. My wife is in the hands of the curate, the curate is in the hands of the Jesuits, the Jesuits are in the hands of the pope, there's no end to it" (Denis, *Journal,* 1957, Volume II, 46, reporting from "le petit Jourdain" an utterance not found in either of Jourdain's articles on his 1905 visit).

43. François-Marius Granet (1775–1849): a native of Aix-en-Provence, and a pupil of David, and later the curator of the Versailles museum. A painter of landscapes of evocative but summary kind, and of genre scenes in ecclesiastical interiors.

44. Mattia Preti (1613–99), born in Calabria, active in Venice, Rome, Naples, and elsewhere in Italy; in Malta in the latter part of his life. A Caravaggesque and, later, Baroque painter.

45. Letters 1 to 6 to Bernard were originally included in the text here.

46. Pierre Puget (1620–94): French Baroque sculptor, after whose works Cézanne made a number of drawings (Chappuis 1973, passim).

47. Letters 7 to 9 to Bernard were originally included here.

48. The actual date of death was 22nd October 1906: Bernard's incorrect date is that of a letter from Cézanne, originally printed in the *Souvenirs* close to this death notice, but placed elsewhere in the present volume. The year given may, in this way, be a simple author's or typesetter's error: but the date of 23rd October was in fact used in "official" notices of the death for legal reasons (see Mack, 1942, 369). Cézanne died in his 68th year, aged 67 therefore.

49. Emile Bernard founded La Rénovation Esthétique in 1905, and the periodi-

cal of that name first appeared on 1st May 1905: some of the editions of Bernard's *Souvenirs sur Paul Cézanne* appeared under the same imprint.

50. See *Souvenirs* Part III: "I have a clear vision of these planes!" and letter 8 from Cézanne to Bernard: "the planes fall one atop the other."

51. This is apparently a verbatim record of a Cézanne utterance, and a number of such quotations, with no apparent origins in other documents, are to be found in both the *Souvenirs* and the earlier *L'Occident* article by Bernard.

This particular remark on verisimilitude should be contrasted with *L'Occident*, where Bernard presents Cézanne as a painter who "is satisfied with some harmonies of line and tonality taken from random objects."

52. Theodore Reff's article of 1960 constitutes a thorough examination of the question of Cézanne's alleged Poussinism, scrutinizing the documentary sources with exemplary severity. It is sometimes held that the article has eliminated all supposed verbal references by Cézanne to Poussin; but this is not so, for Reff accepts (1960, 152) this particular statement in the *Souvenirs,* while going on to criticize the distortions and elaborations to which it has been subjected. However Jourdain goes out of his way to say that Cézanne repeated to himself and Camoin (probably early in 1905) the intention to "bring Poussin back to life through nature." See also Osthaus, "A Visit to Paul Cézanne." Richard Shiff discusses the Cézanne/Poussin relationship in his introduction to this volume and in endnote 18.

JOURDAIN

1. Léon-Paul Fargue (1876–1947), a poet, famous as a conversationalist and a figure in Parisian nightlife, his best writings being inspired by the urban industrial scene, and particularly the streets of Paris.

2. This must refer to the dispute over Bernard's and Gauguin's respective parts in the formulation of synthetism (Rewald 1962, 195–6, 283, and *passim*).

3. Hermann Paul (1864–1940), a caricaturist and painter, visited Cézanne in 1905. A portrait of Cézanne by Hermann Paul is now in the Musée Granet at Aix.

4. According to Theodore Reff (1960, *Gazette des Beaux-Arts,* 308), this may have been Armand Silvestre's *Le nu au Louvre,* 1891.

5. On this rooted suspicion of Cézanne's "that people tried to get close to him to take advantage of him," see Bernard *Souvenirs* where two other anecdotes are given.

6. See "these confused sensations that we bring with us at birth" (letter to Henry Gasquet, 3rd June 1899); and "the instincts, the feelings of art that reside within us" (letter to Camoin, 13th September 1903).

7. See "nature exists for us humans more in depth than on the surface" (letter 1 to Bernard); and "the main thing, in a painting [. . .] is to find the correct distance" (Osthaus).

8. See note 52 to Bernard, *Souvenirs.*

RIVIÈRE AND SCHNERB

1. This should be linked with Larguier's statement that his collection of numbered sayings came from Paul Cézanne *fils* (though Larguier in 1947 says something different). There is therefore some evidence of a set intention to commit his ideas to paper. The author's assertion below that "these axioms were long-considered responses to questions that the difficulties of his art obliged him to ask himself" also seem to show how seriously by now visitors were obliged to take his theories. John Rewald reported to me that Marie Gasquet, whom he interviewed in February, 1935, remembered Joachim's repeated fruitless attempts to persuade Paul Cézanne *fils* to put his father's theories down on paper.

2. The Atelier des Lauves.

3. This and the next two paragraphs are the fullest statement of Cézanne's feeling for the solidity of objects. It is tempting to see in the commentary on "a flat surface" an awareness of curvilinear perspective; but the "modeling of flat surfaces" may simply be based on an awareness of the subtle and varied illumination and coloring which even a flat surface will almost always display.

4. For a discussion of this, see Gowing (1977, 57).

5. "He modeled more by color than by value," (Correcting *que la couleur* in the *Grande Revue* text).

 We are given here, and in the five paragraphs that follow, a final comprehensive account of the consequences of that earlier resolve by which "you replace modeling by a study of tones" (letter to Pissarro, 24th June 1874, see also "the antithesis of modeling" in a letter dated 2nd July 1876). It is in fact a redefinition of modelling, not its abolition, that takes place. Gradation gives way to discrete steps "the contrast of tones." Those discrete steps are not on a black-to-white value scale, for now "I want to make black and white with color" (Denis *Journal*). The "transition of tones" (see Bernard *Souvenirs*), is a different one now, not from black to white, but from the blue "shadowy edges," which "only receive light reflected from the sky" and "the sky is blue; isn't it? Well, that's what Monet discovered." We have finally, "a succession of tints going from warm to cool," and this requires on the palette "a very wide range of tones." (See Bernard *Souvenirs*.) But all this, including the resultant freshness of color, comes, Rivière and Schnerb say, not from an "a priori method" but from "logical observation substituted for empiricism." In Cézanne's own words, "The painting must develop on the basis of nature." See also note 17 to Bernard *Souvenirs*.

6. See Vollard and note 3 to Vollard.

7. Rivière and Schnerb's sophisticated account of Cézanne's composition, rejecting the notion of the piecemeal alteration of the objects and masses of the motif itself—which would constitute *composition* as normally understood, substitutes (apparently) the idea of a series of color adjustments which lead to

a balance of warm and cool colored patches. This may relate to Cézanne's view (given to Maurice Denis) of Raphael's *Baldassare Castiglione* portrait (Louvre), which is praised for its "detailed planes" and for "the balance of patches in the whole" (Denis, *Journal*).

8. "the maximum point of luminous intensity": it is difficult to relate this to Cézanne's practice: the phrase "dominant spot" in the "opinions" (Bernard, *L'Occident*) offers similar difficulties. If it were "the point of greatest intensity" in *each* object in the motif, and not in the picture as a whole, there would be no difficulty: it would then be a synonym for "culminating point" (letter 5 to Bernard).

9. See Cézanne, *Mes Confidences* (Answer 11: "To be destitute").

10. A complete text of this letter of 23rd January 1905, transcribed slightly differently, will be found in John Rewald's various editions of the correspondence.

11. Poussin's painting in the Louvre, after which there are two Cézanne drawings at Basle (CD1011 and 1012, V1393 and 1387).

12. The *Femme hydropique* of Gerard Dou (1613–1675) is in the Louvre.

13. Jules-Joseph Lefebvre (1836–1911) was a pupil of Léon Cogniet at the Ecole des Beaux-Arts, a winner of the Prix de Rome, and a medal-winning Salon exhibitor on several occasions. His career was successful in the extreme.

14. If the count of figures is right, this would be the Barnes Foundation (Merion, Pa.) *Baigneuses,* still being worked on between Emile Bernard's two visits of February 1904 and the end of March 1905. (RP856 V720).

15. Perhaps one of the portraits of Vallier (RP948 V716; or the Vallier in the National Gallery, Washington, RP949, not in Venturi, but intended for his revised edition; or RP951 V717).

DENIS *JOURNAL*

1. Ingres' *Jupiter et Thétis*. See also Vollard, note 1.

2. All these paintings on the walls of the Jas de Bouffan (though all have since been removed and dispersed) date from various times in the 1860s, i.e., when Cézanne was in his twenties. *Le Christ (d'après Navarete)* (RP145 V84): painted perhaps 1869–70) and after an illustration in Charles Blanc's *Histoire des peintres de toutes les écoles: école espagnole,* where the *Christ in Limbo* painting (Madrid, Prado), now given to Sebastiano del Piombo, was ascribed to "Navarette" [sic].

For the difficult question of the date of publication of the Charles Blanc illustration, and hence also of the drawing and the painting done after it, see R. Ratcliffe in the catalogue of the Newcastle/London exhibition, 1973, 152.

Le Lancret (RP23 V14): painted after *Le jeu de cache-cache* by Lancret.

"A portrait of an emperor": this must be an error (by Denis, or by the transcriber of his *Journal* for the 1957 publication) for *Portrait d'Emperaire* (RP141 V85) (1867–68), which shows the head of Cézanne's friend and cor-

responds therefore to the "large head with long hair, moustaches, a tuft of hair under the lower lip, and a small beard under the chin, which is the portrait of a painter of Aix, a sick little dwarf, of the name of Emperaire," seen in August 1907 by Léonce Bénédite, Curator of the National Museum of Luxembourg, beneath the "scène galante" (i.e. the Lancret composition). (See Mack 1942, 147, quoting *Archives du Louvre p. 30, 1907, 3 décembre.*) It is distinct from the *Emperaire* mentioned by Bernard (*Souvenirs*).

"Deux têtes très enlevées": RP155 V87, sometimes called *Contraste*.

3. *L'Occident:* Maurice Denis, had, from the first issue in 1901, been a regular contributor.

"the 17th century": "Hardly had we met him leaving morning mass under the porch at Saint-Saveur than he began to make a pompous speech in praise of the 17th century (referring to some ideas in *l'Occident*), Denis 1922, 118.

4. "Satis": enough! (Latin).

5. See the letter to Pissarro, 23rd October 1866: "You are perfectly right to speak of the gray that prevails in nature, but it is one very difficult to capture."

6. See letter 6 to Bernard, and note 5 to that letter.

7. Hugo d'Alési (died 1906) was a designer of colored posters for railway companies, representing picturesque scenes in France and abroad.

8. "The ideas of Couture, Gavarni, Traviès, Forain [. . .] I don't like A. Faivre very much . . . "

"Couture:" see note 15 to *Souvenirs.*

"Gavarni [. . .] Forain:" see Denis: ("He spoke willingly of the caricaturists, of Gavarni, of Forain, above all of Daumier. He loves the exuberance of movement, the bulging musculature, the impetuosity of the hand, the bravura of the pencil stroke." (see *Theories*).

Charles-Joseph Traviès de Villers (1804–1859), although also a painter, devoted himself largely to intense and even violent caricatures (in *Caricature* and *Charivari*) attacking the life and politics of the middle classes. Abel Faivre (1867–1945) was a painter and a contributor of caricatures to *Le Rire, Le Figaro*, and other Parisian illustrated papers.

9. "like Michelangelo": see Denis (*Théories*), "with a nervous gesture, he imitated the turn of hand of the Italian muralists."

10. "*Le Balthasar*": Raphael's portrait of Baldassare Castiglione, in the Louvre.

11. See "Any motif copied [. . .] must be transformed [. . .] into a perfectly balanced whole [. . .] by studying the balance of luminous areas and shaded ones" (Rivière and Schnerb).

12. This is perhaps a joke: Bernard, in 1904, had shown Cézanne the catalogue of the Brussels exhibition in which works by both Cézanne and Maurice Denis had been shown, and which was organized by La Libre Esthétique (see

note 21 to *Souvenirs*). No doubt Denis mentioned the exhibition to Cézanne during the 1906 visit.

13. Cézanne may have preferred the Monet of these years, as being "solid and [. . .] enduring, like the art of the museums" (see Denis *Théories*). It is possible that Cézanne always admired the opening phases of Impressionism more than its later development. Le Bail (Rewald, 1939, 283) reports him as saying of Pissarro, "If he had continued to paint as he was doing in 1870, he would have been the strongest of all of us." See also Osthaus, note 9 and Denis *Théories*, note 8.

14. "the cylinder and the sphere": see Cézanne's letter 1 to Bernard, and Rivière and Schnerb.

15. "to make black and white with color": see Cézanne's letter 6 to Emile Bernard and Rivière and Schnerb, "To model with color [. . .] in order to avoid the white lights and the black shadows."

16. "Sensation above all": see letter to his son, 15th October 1906: "the sensations form the basis of my work."

17. *les Noces de Cana:* Veronese's painting of 1563, in the Louvre.

18. Mathô: in Flaubert's *Salammbô* the proud Libyan leader of a rebellion of mercenaries in the Carthaginian army.

19. Forain regularly provided satirical illustrations for *Figaro* and a number of other newspapers and periodicals. (See Bernard *Souvenirs* and Gasquet, 1926, 113).

OSTHAUS

1. See Larguier, and note 1 to Larguier.

2. See Denis (*Journal*): "Vollard must take them all as soon as they are finished."

3. See Jourdain: "to make palpable the real distance between the eye and the object."

4. For the importance of outlines or contours, see Cézanne's letter 8 to Bernard: "abstractions that keep me from covering my canvas or defining the edges of objects where they delicately touch other objects." (See particularly notes 10 and 11.)

5. For the concept here, see letter 5 to Bernard, "Only nature and an eye trained by contact with nature are required."

6. Poussin: see note 52 to Bernard *Souvenirs*.

7. "elevation": Osthaus puts great emphasis on this word from Cézanne's mouth, giving it here in both German and French as *Erhebung (élévation)*. He repeats it later in the article. See introductory notes to Larquier.

8. See letters 1 and 8 to Bernard, and notes 4 and 11, respectively.

9. "Monet and Pissarro": see Denis *Journal* and note 13 to *Journal*. Note that this statement is in French in Osthaus' article, and so may well be a verbatim quotation.

10. See Rivière and Schnerb, note 7 and Denis *Journal*, "the balance of the patches in the composition."
11. Of the three large *Bathers* compositions, only that in the Philadelphia Museum of Art (RP857 V719) fits this description. For a detailed discussion of relationships between the three large *Bathers*, see Davies 1970, 22–4, and Reff 1977, 38–9, and now also the catalogue of the Basel exhibition of 1989 and Joseph Rishel in the catalogue of the Cézanne retrospective exhibition of 1995–96 (Paris, London, Philadelphia), 497–505 in the English language edition.
12. The Karl Ernst Osthaus Museum is at Hagen. But the Folkwang Museum, for which Osthaus purchased two paintings (RP690 V651 and RP797 V767), illustrations of which accompanied the text of this article in *Das Feuer*, is at Essen.
13. "tulips": in a letter of 19 May 1978, Adrien Chappuis wrote me "In 1937 my wife gathered a bouquet of these red tulips; this plant grows among the wheat in the spring. People there call them 'cocottes' (chicks). They have disappeared, killed by herbicides."

CÉZANNE *MY CONFIDENCES*

1. "general harmony": see Larguier (Dictum XXXII).
2. Swimming was a favorite pastime of Cézanne's youth (see Rewald 1968, Chapter I, *passim*).
3. See Cézanne's letter 7 to Bernard: "We must not however be content to retain the beautiful formulas of our illustrious predecessors." (I follow Adrien Chappuis' note here.) Also see Larguier, Dictum XXI.
4. See Rivière and Schnerb: " 'Excuse me, have you an independent income?' he asked the young artist."
5. Frenhofer: see Bernard *Souvenirs* and the related note 27.
6. See letter 2 of Cézanne to Bernard, "The real and prodigious study to undertake is the diversity of the picture that nature presents."
7. "the hills of St. Marc": to the northeast of Aix.
8. "De Vigny": the quotation is from his *Moïse*. See the letter to Vollard dated 9th January 1903, "I can't quite see the promised land. Will I be like the great chief of the Hebrews or will I reach there at all?" (This connection was made by Lawrence Gowing: Newcastle/London exhibition, 1973, 21). A drawing (c. 1858) in the *Carnet de jeunesse* gives a representation of Moses (CD1, not in V). There seems to be no entirely reliable recorded comment by Cézanne upon Nicolas Froment's *Buisson ardent* [Burning Bush] (1476) in Saint-Sauveur: Vollard (1914, 88) says he found it "crudely lifelike."

GASQUET

1. This is an interesting description of the development of a Cézanne oil painting, from the first sketchy outlines (which however seem usually to be in soft

pencil, not charcoal), to the emergence through the color patches, of the solid volumes of the image. Elie Faure: *Portraits d'hier, No. 28, Paul Cézanne*, Paris, Fabre, 1910; and *Paul Cézanne* in *L'Art Décoratif*, October 5th, 1911.

2. Source: letter to Gasquet, 13th June 1896.

3. The gesture described here, with interwoven fingers, has been discussed by Loran (1946, 15), and likened by Gowing (Edinburgh/London exhibition 1954, 10), to that in the Columbus (Ohio) *Portrait de Chocquet* (1877, RP296 V373).

4. The precariousness of his concentration is often stressed. See letter 8 to Bernard, where "the color sensations [. . .] are what create abstractions that keep me from covering my canvas" and Larguier (Dictum XI): "Genius is the ability to renew one's emotion by daily contact with nature."

5. Source: letter to Gasquet, 21st July 1896.

6. Source: letter to Gasquet, 26th September 1897. For "Art is [. . .] parallel to nature," no doubt a commonplace of the time, see Arsène Alexandre, quoting Puvis de Chavannes: "Painting is not merely an imitation of reality, but a parallel with nature."

7. "subjective [. . .] objective": these thoughts are distinctly non-Cézannian; see Gasquet (1919, 83), "Music reaches nature subjectively through man, poetry reaches man objectively in nature." As for Kant, even Bernard's largely ridiculous *Conversation avec Cézanne* (1921, 375) has the good sense to see Cézanne as opposed to the "German philosophers, for whom all is illusion, dream, mere appearances," though this cannot, of course, be taken as an authentic Cézanne quotation.

8. Dumesnil: the philosopher Georges-Edouard Dumesnil (1855–1916) taught in a number of places, and received his Sorbonne doctorate in 1892. He was Gasquet's teacher at Aix. Gasquet (1926, 113–4) says that Cézanne liked to discuss religion and philosophy with Dumesnil. Two letters of 30th January 1897 (to Philippe Solari and to Gasquet) indicate Cézanne's wish to present two paintings to Dumesnil.

9. Source: letter to Gasquet, 18th July 1897, here distorted.

10. This offers a remote echo, or caricature, of the eleventh opinion in Bernard, *L'Occident*: "when color is at its richest, form is at its fullest."

11. This paragraph interweaves a number of themes taken from *Mes Confidences*.
 The association of Ronsard with Rubens is also found in *L'art vainqueur* (65), where Gasquet writes of "the great decorative stanzas, à la Rubens, that he used."

12. Letter to Gasquet, 29th September 1896: "I reread Flaubert."

13. The reference is to Chapter 8 of *Madame Bovary*, which, since it states that "something of a monastic rigidity informed the expression on his face," may have led to Gasquet's erroneous assertion (1926, 112) that the subject of *La Vieille au chapelet* (RP808 V702) was an old defrocked nun. See the letter to Gasquet dated 12th May 1902 (Rewald 1960, 43) and associated footnote.

14. Source: letter to Camoin, 22nd February 1903, but appended to a piece of Gasquet's own prose: "the very roots of existence."

15. "my friend Marion": Cézanne had known Antoine Fortuné Marion (1846–1900) in his youth, and they had painted landscapes together, but in the 1860s, not, as Gasquet implies (1926, 81–2), as late as 1886–7. But it may be true that Cézanne absorbed some of Marion's professional interest in geology, for his *Carnet de Jeunesse* contains tabulated geological terms (Chappuis 1973, nos. 18 and 19) and geological diagrams (Chappuis nos. 24, 33, 35) in a hand which is not Cézanne's.

16. Lucretius: the Roman poet and expositor of the philosophy of atomism. Gasquet (1926, 20) claims to have heard Cézanne reciting lines of Lucretius and other poets by the score: but he may have derived the idea from Bernard's *Souvenirs*.

 Though there may be some attraction in the notion of an 'atomist' Cézanne (constructing paintings from separate and distinguishable strokes and patches), there is really no support for it at all in the sources, and indeed later in this same dialogue Gasquet's Cézanne will regard attempts to relate the Impressionism of Monet to the "latest atomist hypotheses" as ridiculous.

17. "geometry, the measure of the earth": In the intellectual fantasies of Cézanne's youthful circle, geometry was not seen as conflicting with creativity. In an interpolation by Baille in a letter of 26th July 1858 (from Cézanne to Zola), Cézanne is "the friend poetic, fantastic, Bacchic, erotic, ancient, physical, geometric [. . .], and he was going to write under my dictation, and sow in profusion both the forms of his rhetoric and the flowers of my geometry [. . .]"

18. Idealist conceptions, impossible for Cézanne.

19. Source: letter 8 to Bernard. But for the notion expressed here, see the Gasquet passage above, where Cézanne is made to read Apuleius to put to flight the Flaubertian associations which arose when he was painting the *Vieille au chapelet*.

20. Immediate source: letter to Camoin, 3rd February 1902. But the comment on "classical concerns" which is attached to this may be compared with Bernard (see his footnote at the end of *Souvenirs*), though the criterion for classicism (here lucidity, there tradition) differs.

21. See, in the letter to Henri Gasquet, 3rd June 1899, "These confused sensations we bring with us at birth."

22. "to draw religion from it": Gasquet, rather than Cézanne.

23. "the primitive of my own way": see Bernard, *Souvenirs*, "I remain the primitive of the way I have discovered."

24. See Denis, *Théories:* "He preferred without doubt the sleight of hand of the Bolognese to the precision of Ingres." But note that, in the *Journal* report, Cézanne does not refer to the Bolognese as such, and it is only through suc-

cessive and cumulated misunderstandings in Denis and Gasquet that the phrase is finally put into his mouth.

25. Boileau, *Epistre IXX* (A. M. le Marquis de Seignelay), verse 43.

26. Source: letter 1 to Bernard. The attitude to earlier French landscapists, expressed in the preceding sentences, is interesting, and perhaps Gasquet is here giving an authentic report.

27. Source: Bernard, *L'Occident,* or *Souvenirs.*

28. "to burn down the Louvre": ascribed to Cézanne again, in the biographical section of Gasquet's work (45), but to Pissarro by Cézanne himself in Rivière and Schnerb's report. For favorable attitudes to the Louvre, see letters 2 and 7 to Bernard.

29. See Bernard, *Souvenirs:* "his ideas on the real world, industry and the rest"; or again, "the town of Aix is spoiled." Gasquet (1926, 18) has a passage in which Cézanne complains about modern streetlighting, and this is supported by the letter to Mademoiselle Paule Conil of 1st September 1902: "What one calls progress is only the invasion of the bipeds, who don't stop until they have transformed everything into hateful embankments with gaslights and—even worse—with electric lighting."

30. Source: Bernard, *Souvenirs.*

31. A loose version of the first paragraph of the letter written to Gasquet from Talloires on 21st July 1896.

On "gray" in the following sentences, note that this has nothing to do with "pale gray light," and relates rather to another lifelong preoccupation. See Denis *Journal,* note 5.

32. A further derivation from the letter to Gasquet, 21st July 1896.

33. Further very loose variants of phrases in the letter of 21st July 1896.

34. From letter 9 to Bernard.

35. From letter 3 to Bernard.

36. Also from letter 3 to Bernard.

37. Although the ultimate source for these sentences (from "Nature . . . ") is the *Journal* of Maurice Denis, Gasquet's version is based upon that in Denis *Théories,* which itself conflates two separate *Journal* entries (1957, Vol. II, 48). See also note 6 to Denis *Journal.*

38. For another version of this anecdote, see the excerpts from the *Mémoires inédits* of Francis Wey in Courthion, 1948 and 1950, Volume II, 190–1.

39. Source: letter 3 to Bernard.

40. The whole preceding section (from "for progress") derives from letter 5 to Bernard.

41. The entire paragraph is from letter 1 to Bernard.

42. This paragraph (from "it is impossible") is from letter 7 to Bernard.

43. The Salons de la Rose-Croix were held every year from 1892 to 1897, and represented an attempt to create a school of symbolist painting occult and

mystical in style, but fundamentally Catholic in intention. Their organizer was Joséphin Péladan, a writer of novels and of art criticism: see Gasquet, where he makes Cézanne speak of *"péladaneries."*

44. Source: Denis *Théories*.

45. Source: Vollard, 1914, 87–8.

46. John Rewald has remarked (1960, 55) on the implausibility of the attribution of these divisionist views to Cézanne. Nevertheless letter 1 to Bernard ("the necessity of introducing into our vibrations of light, represented by the reds and the yellows, sufficient blues to make one feel the air") may indicate some knowledge of "the optical blending of colors."

47. There is some evidence that Cézanne, in his late years, thought about the development of his own work through students. See Bernard *Souvenirs*: "He told me that certainly he needs a follower." Gasquet makes a number of references to this theme (1926, 34, 104–5), and other, more reliable, reports (such as Denis, *Journal,* "I am a milestone, for others will come who . . .") tend to confirm that Cézanne thought along these lines.

48. This paragraph conflates parts of letters 2 and 3 to Bernard.

49. Source: letter 7 to Bernard.

50. See letter to Roger Marx, 23rd January 1905: "means of expression sufficient to be intelligible to the general public."

51. The idealism of this comes from Gasquet; it is impossible to attribute this discourse to Cézanne.

52. "Drawing itself is all abstraction": this remarkably echoes Larguier's Dictum XXVIII, "Pure drawing is an abstraction," not published until 1925.

53. "plenitude": the notion originates in Bernard *L'Occident* in the *Opinions,* which are later quoted in fragments in *Souvenirs*. Denis, *Théories,* again quotes (inaccurately) from Bernard. Gasquet's sentence is a distortion of one of these.

54. The whole of this paragraph is from letter 8 to Bernard.

55. "It is necessary to see the planes . . . clearly . . .": a variant upon Bernard, *Souvenirs,* "like that I have a clear vision of the planes!"

56. See Gasquet (1926, 101), "I can't tear them away . . . They are so glued to the point that I'm looking at that it seems to me they're going to bleed."

57. "to express one's epoch in the most advanced way": see Bernard *Souvenirs*: "Cézanne's was an intelligence passionate about the new." Gasquet and Bernard both fundamentally oversimplify here the nature of Cézanne's originality, and no authentic words of his support what they here imply.

58. This epigraph quotes from *Mes Confidences*.

59. Rodin's *Monument to Balzac* was first exhibited in plaster at the Salon of the Société Nationale des Artistes in 1898, and cast in bronze only posthumously. Rodin also organized a retrospective of his own work in a temporary pavil-

ion close to the Exposition Universelle in 1900, and Gasquet may be refer-
ring here to the Galerie des Machines at the Exposition.

In the biographical part of his book (75), Gasquet represents Cézanne as
an occasional mealtime companion of Rodin's in Paris: "I like very much what
he does. He is a man of strong feelings [. . .] He is fortunate. He succeeds."

60. See Rivière and Schnerb, "I don't make the whole: a head interests me, I
make it too big."

61. Baudelaire's *Le peintre de la vie moderne* (written 1859–60, published 1863) was
devoted to Guys.

There is evidence (letters of 13th and 28th September, 1906), that
Cézanne read Baudelaire on Delacroix in *L'art romantique*.

62. These views on the nature of pagan and Christian art are Gasquet's, not
(provably) Cézanne's. In *L'art vainqueur* (1919, 82–3), Gasquet, after speaking
of "a Christian art of death," asserts that "something of the pagan will always
reside in poetry." See also, earlier in these dialogues, the comment on Re-
naissance artists: "They are the true pagans."

63. The reference is to the mural paintings of Puvis de Chavannes, of whose
Sorbonne decorations (1886–89) Gasquet makes Cézanne say (1926, 75),
"what bad literature!"

64. "Versailles bores me": the subjectivism and inconsistency, and hence the un-
reliability of Gasquet may be gauged by comparing a passage from *L'art vain-
queur* (1919, 139–40): "Since the end of the last century, a Maurras, a
Cézanne, a Debussy only had to spend an afternoon in the gardens of Ver-
sailles [. . .] to return to harmony with our race's spirit of reason and to feel
fully to what degree of perfection the taste for order can lead the forces of
nature."

65. Comparisons of Cézanne to Masaccio seem not to have been uncommon
during his lifetime, Maurice Denis cites two examples: "Fabbri [. . .] tells
me that he feels that Masaccio is as noble as classical art, and that Cézanne is
the only painter of our time who is at all noble," *Journal*, 1957, Volume II, 84.
"In 1900, in Settignano, at the Gamberaia, there was a Miss Blood who
placed photographs of the Carmine frescoes and Cézannes side by side
[. . .]," *Journal*, 1959, Volume III, 140.

Note however that Gasquet's Cézanne rejects quattrocento painting (see
following passages). The Fabbri referred to is probably Egisto Fabbri, an im-
portant early collector of Cézanne's work, who by 1899 possessed sixteen of
his paintings.

66. The entire passage on the Winged Victory of Samothrace is in Gasquet's own
manner, and may be compared to the passage in *L'art vainqueur* (1919, 105 ff.)
on "the moving serenity of the Greeks."

67. The distinction made in this paragraph, between "what is called painting" on

the one hand, and "Ingres, Raphaël, and that whole shop" on the other, is a genuinely Cézannian one, and may be likened to the discourse on the "two plastiques" in Bernard, *L'Occident,* though it is not suggested that Gasquet is here depending on Bernard.

"I have the pleasure of using line, when I want to" should be related to the Denis commentary in *Théories* on the distinction, implied during the January 1906 visit (see *Journal* entry here reprinted), between the expressive and free drawing of the nineteenth-century caricaturists and of Puget and the Bolognese, and the restrained line of Degas and Ingres. Holbein is, in this dialogue of Gasquet's, grouped with "that whole shop"; note that this conflicts with the high praise given to Holbein during the Osthaus visit.

68. See Gasquet 1926, 107, "'that David!,' he said ironically." Yet he professed (also ironically, perhaps) to admire Gros, David's pupil (see Geffroy).

69. "an immense *grisaille*": for Cézanne's attitude to "the science of preparations," see Denis (*Journal*) on Veronese's *Les noces de Cana,* "he made a little sketch"; and also Bernard's account of Cézanne's own painting technique (*Souvenirs*): "He recommended that I begin lightly and with near-neutral tones."

70. "to modulate": the notion is found in Denis *Théories,* though its ultimate source is Bernard *L'Occident.*

71. In *Souvenirs* Bernard reports Cézanne as saying "Gauguin wasn't a painter, he only made some Chinese pictures." No doubt Cézanne had (among other things) the question of outlines in mind, and it has already been suggested that letter 8 to Bernard (see note 11 to that letter) in fact is making this same criticism of Gauguin.

On Cézanne's possible knowledge of Japanese prints, see Gasquet (1926, 70), who asserts that he had read the Goncourt volumes on Utamaro and Hokusai.

72. "It is necessary to begin neutral": see Bernard *Souvenirs,* quoted in note 69 above. The whole of the present passage, though it has fragments recognizably derived from Cézanne, is essentially a construction of Gasquet's.

73. See letter 8 to Bernard, "I owe you the truth in painting and I shall give it to you."

74. Source: letter to Charles Camoin, 3rd February 1902. The following passages pursue the anti-David theme already touched on earlier (see note 68 above).

75. Source: letter to Camoin, 9th December 1904.

76. See Vollard.

77. Source: Denis, *Théories* and ultimately the *Journal.*

78. The preceding three sentences are drawn from letter 5 to Bernard.

79. Source: letter to Camoin, 22nd February 1903.

80. Source: letter 7 to Bernard.

81. Source: letter 9 to Bernard.

82. Several of the preceding sentences derive from letter 7 to Bernard.

83. "A picture represents nothing.": an unlikely statement for Cézanne, and possibly derived by Gasquet from Maurice Denis' famous passage in *Art et critique*, 23rd August, 1890: "Remember that a painting—before becoming a warhorse, a nude woman, or any story—is essentially a flat surface covered with colors arranged in a certain order." (Reprinted in *Théories*, 1913 and 1920.)

 Cézanne's view on the damaging effect of literary associations was a subtle one, and it is wrong to see him as wishing to abolish subject-matter.

 For "péladaneries" in the next sentence, see note 43 above.

84. See Gasquet (1926, 70): "He hardly speaks of El Greco." Letter 5 to Bernard: "The great ones, you know them better than I, the Venetians and the Spanish."

85. See letter 6 to Bernard: "the greatest Venetians. We revere Tintoretto."

86. The Tintoretto self-portrait, of which Manet's copy has been at Dijon since 1898, is in the Louvre, not the Uffizi. Cézanne probably did know the original well, and perhaps its inscription in capital letters in a straight line across the top, IACOBUS TENTORETUS PICTOR VEN(E)TI(AN)US, influenced the stencilled inscription ACHILLE EMPERAIRE PEINTRE on the Emperaire portrait of the Jeu de Paume. Letter 3 to Bernard is signed *Pictor P. Cézanne*.

87. This paragraph is a slightly distorted version of a passage in letter 6 to Bernard.

88. A version of part of letter 5 to Bernard.

89. From *Mes Confidences* (question and answer 10).

90. For the textile analogy, see note 17 to *Souvenirs*.

91. According to Vollard (1914, 22), Cézanne said to Guillemet, an enthusiast for Corot: "Your Corot, you don't find that he lacks a little temperament?" The original French text adjusts the spelling, in order to give an idea of Cézanne's Provençal accent.

92. With Courbet, as with Delacroix, Gasquet is certainly in his dialogues expressing the *direction* of Cézanne's enthusiasms: but it seems hardly likely, on the available evidence, that he is reflecting their real substance. There is of course no doubt that in his early years Cézanne, as Bernard reminds us (*Souvenirs*), "tried to find himself [. . .] through Courbet and Manet." Comments on Courbet are few: "his style is a little heavy." (Vollard, 1914, 77, who records that he was, apart from that, enthusiastic); "He is an objective painter. He has his image ready-made in his vision." (Gasquet 1926, 40, where it is said that Cézanne was haunted by the name and legend of Courbet). Denis, depending on Vollard's verbal account, mentions Cézanne's love of Courbet, who, it is implied, is felt to be better at *réalisation* (*Journal*, 1957, Volume I, 157). Finally Rivière and Schnerb find him saying of the large *Baigneuses* in the Lauves studio in January 1905, "I wish I could lay on thick paint like Courbet." But his admiration is declining, and he calls Courbet a "real brute."

93. Gasquet (1926, 48) describes Cézanne bringing him a photograph of the

Olympia of Manet: "It is a new era for painting. Our Renaissance begins with this."

94. This account of portraiture continued from memory is curious: it is found also in the biographical section of the work where Vollard's as well as Henri Gasquet's portrait is said to have been worked on in this way (1926, 92).

Contrast Bernard in *Souvenirs:* "Cézanne's imagination was not great, but he had a very refined sense of composition. He did not know how to draw without a model—a serious obstacle to credible creation."

95. The letter to Henri Gasquet dated 23rd December 1898 similarly characterized him as a "support and a comfort." For "certainty," see *Mes Confidences* (question and answer 16).

96. Gasquet is here making Cézanne refer to "an upheaval, an interior crisis," which took place as Cézanne abandoned imaginary subject matter for real motifs, and which is described in some detail in the biography (1926, 62–4). Gasquet dates it 1871 (at L'Estaque), though Bernard in a passage of *Souvenirs* makes it at the age of forty (i.e. 1879).

It should be recalled also that a letter of Marion to Morstatt (late 1868) says that "Cézanne always works hard and with all his might to organize his temperament, to impose the laws of a calm science upon it." (Barr, 1937, 57) and indeed the "interior crisis" of which Gasquet writes may be regarded as having taken place at any point, or even repeatedly, in the decade lasting from the late 1860s to the late 1870s.

97. The preceding passages (from "it takes me back" derive from the letter to Henri Gasquet dated 23rd December 1898.

98. Much of the preceding section (from "Remember all the initiatives") derives from the letter to Gasquet dated 13th June 1896.

99. Source: letter to Henri Gasquet, 23rd December 1898.

100. "beautiful formula": derived, no doubt, from *Mes Confidences.* See note 6 to letter 7 to Bernard.

101. Source: Bernard *Souvenirs.*

102. Source: letter 7 to Bernard.

103. Source: letter 2 to Bernard.

104. Source: letter 2 to Bernard.

105. Source: letter 3 to Bernard (freely interpreted).

106. There seems to be no evidence for the anecdote of Clemenceau's portrait. For Cézanne's relations with the Geffroy-Clemenceau circle, see the Geffroy text reprinted here, with its introduction and notes, and particularly notes 2, 3 and 4.

107. Carrière: see note 24 to Bernard, *L'Occident.*

108. Bernard (*Souvenirs*) had seen a reprint of Tortebat's treatise on anatomy in Cézanne's studio.

109. Source: *Mes Confidences* (question and answer 26).

110. Source: *Mes Confidence* (question and answer 11).
111. Source: letter 9 to Bernard.
112. See the quotation from Vollard in note 6 to Geffroy.
113. Source: letter 4 to Bernard.
114. Derived from letter 7 to Bernard.
115. This passage (from "Drawing and color") derives most probably, inaccurate though it is, from Bernard, *Souvenirs,* itself dependent upon Bernard, *L'Occident.*
116. This passage (from "within the painter") is taken from Bernard, *L'Occident.* It does not appear in *Souvenirs.*
117. From letter 5 to Bernard. In the final sentence taken from the letter (which follows), *centre* has been read as *autre* (other). This is common to the 1921 and 1926 editions of Gasquet, and is in fact a tenable reading of the manuscript "un autre [point]" though Gasquet presumably contented himself with the versions given in *Souvenirs.*
118. For *Le chef-d'oeuvre inconnu,* see note 27 to *Souvenirs.* The following passages (to "the swimmer . . ."), far from being written on its margins, are from letter 6 to Bernard.
119. Source: Denis, *Théories.*
120. At the end of the text Gasquet added a facsimile of the lines from Alfred de Vigny's *Moïse* which Cézanne had written out in *Mes Confidences.*

BERNARD: *CONVERSATION*

1. See Borély: "to see like a newborn child! . . ."
2. This makes quite clear the idealistic nature of Bernard's conception of art.
3. This sentence rings true, even though it is most probably an invention.
4. "to paint means to sing like that cicada": not authentic, for "the artist does not note down his emotions as the bird sings his song: he composes" (Larguier, Dictum XIII).
5. An early, if not the earliest, case of the unwarranted introduction of the cube into the Cézanne literature. Contrast Bernard, *L'Occident,* where the tenth opinion provides the general source for this sentence. Another instance of the intrusive cube is apparently to be found in a Malevich text, *Des nouveaux systèmes dans l'art,* Vitebsk, 1919: "Cézanne became aware of the use of geometric forms in art and indicated very conscientiously the cone, the cube, and the sphere as characteristic variations on the principles upon which one must construct nature" (cited, in a French translation from the Russian, in *André Masson, le rebelle du surréalisme—Écrits,* ed. Françoise Will-Levaillant, Paris, Hermann, 1976, 193). I am indebted to Yve-Alain Bois for this reference.
6. The terminology is Albertian (as Bernard indicates in a part of the *Conversation* not reprinted here), deriving from the first book of the *Della pittura* of Leon Battista Alberti (1404–1472).

7. Again Bernard's idealist standpoint is evident. However, he is wrong in saying that this admiration "expressed itself to him as a completed painting": the process of painting was not passive, and Cézanne did not "slavishly copy the object" (Larguier, Dictum XLI), for "The painting must develop on the basis of nature" (Rivière and Schnerb).

8. The distinction between the "superior logic" of Italian art and the "practical logic" of the Flemish and Dutch was at this time fundamental for Bernard's aesthetic. Cézanne was clearly to be seen as guided by "practical logic," for he was, says Bernard elsewhere (1924, 35), "possessed by the Dutch idea of reality."

DENIS: *THÉORIES*

1. Bernard (1908, 604): "Nothing resembles a bad painting more than a masterpiece."

2. A reference to Zola's famous statement, "A work of art is a piece of creation seen through an artistic temperament," first published in the essay "Proudhon et Courbet" in the *Salut Public,* 26th July 1865. (Hemmings 1970, 153).

3. There were Cézanne paintings in the National Gallery, Berlin, from an early date: two, hung there in 1897, were removed at the order of the Kaiser (Rewald 1968, 220).

4. See note 2 to Denis, *Journal.*

5. The full-length painting of Achille Emperaire, now in the Musée d'Orsay.

6. Denis seems to be aware of the rational procedures described by Bernard (*Souvenirs*) in his comments on the "law of harmony." This article was apparently published just before the *Souvenirs,* however, so that it looks as if the two observers were quite independently struck by the *ordered* nature of Cézanne's mode of coloring.

7. This seems to be the sole source for this famous utterance: Denis may therefore have made notes additional to what appears in the *Journal.*

8. For the preference for early Monet and Pissarro, see Denis *Journal,* and note 13 to that text. See also Denis' own footnote here, and (for a general admiration of Monet in Cézanne's late years) see Borély, and the letter to Gasquet dated 8th July 1902.

9. Paul Sérusier (1864–1927), a student at the Académie Julian with Bonnard, Denis, and Ranson, joined them and others (soon after his stay at Pont Aven in 1888, when he painted the seminal picture *Le Talisman* under Gauguin's tutelage) in forming the Nabi group. He was on close terms with Maurice Denis, and they travelled together in Italy in 1895. A highly intellectual painter, Sérusier published his theories in 1921 in *ABC de la peinture* (later edition 1950, adding letters to and from Sérusier). This is not the source for the Sérusier remarks on Cézanne which Denis quotes.

10. This is apparently a conflation of three *Journal* entries: two cited in our reprinted *Journal* excerpt, and the other in *Journal,* 1957, Volume ɪɪ, 48, as follows: "I discovered that sunlight is something that cannot be reproduced, but it can be represented."

11. See Vollard, but his text cannot be the source, since it was published in 1914, after this essay. The *Journal* (1957, Volume ɪ, 157) has an entry which, though not citing this remark on Ingres, shows Denis to have been in contact with Vollard at the time of the painting of the Vollard portrait.

12. "Bolognese": not in fact referred to by Cézanne in 1906, during the visit of Roussel and Denis, and in the *Journal* account it is Denis who interprets a "nervous drawing gesture" as being "like Michelangelo."

In the present text, above, this becomes "the turn of hand of the Italian muralists," which Denis takes as justifying "the sleight of hand of the Bolognese." Gasquet (and note 24 to Gasquet) puts a very different remark on the Bolognese into Cézanne's mouth.

13. This paragraph comments acutely upon Cézanne's liking for fluent drawing (for which the 1906 *Journal* entry is the principal documentary evidence, though there are repeated references elsewhere to the examples from the nineteenth-century caricaturists on display in his studio). Denis validly links this interest to the pre-1870 styles of Cézanne, and here provides a plausible verbatim remark of Cézanne's (not in the *Journal* or elsewhere, and so again indicating that he may have kept some separate notes) which precisely characterizes the differences in technique between his early and his mature manner.

These two paragraphs also introduce the themes which Denis will develop into an elaborate article "L'influence de Cézanne" (*L'amour de l'art,* December 1920), elsewhere entitled *Cézanne et l'art baroque* (see Denis 1922 in bibliography).

14. Denis is the only early commentator to make this point clearly about the geometrical solids referred to in letter ɪ to Bernard, though even in that letter they are "put in perspective." Rivière and Schnerb, independently of the Bernard correspondence, reached a similar conclusion.

Jourdain, in a part of his 1950 text not reprinted in this volume, reproduces another recommendation of Cézanne's which similarly puts emphasis on his interest in solidity and volume (Jourdain 1950, 12): "when asked what studies he would recommend to a young painter, he replied without hesitation, 'Copy your stovepipe.' He considered it essential to observe carefully the modulation thanks to which reality of form can be expressed by following this process: highlight, gradation, half-tone, shadow, reflection. The stovepipe was not for Cézanne the cylinder of geometry but a cylindrical metal object, made by a tinsmith." Cézanne's *Le Poêle de l'atelier* (RP90 V64) c. 1865, is now in the National Gallery, London.

15. From the celebrated statement of 1890 (see note 83 to Gasquet).
16. An expanded version of the entry in the *Journal*, "I want to make black and white with color."
17. This sentence is a brilliant and concise re-statement of the theme of the Bernard passage (*Souvenirs*) on the "law of harmony," but is seemingly independent of it (see note 6 above).
18. See Cézanne, as reported in Bernard *Souvenirs*, attacking "the lack of modeling"; and in letter 8 in Bernard, attacking the dark outline in contours.
19. Denis here shares Cézanne's habitual attitude to abstraction: see note 3 in Bernard's *Conversation*.
20. André Félibien des Avaux (1619–1695): author of *Des principes de l'architecture, de la sculpture, de la peinture . . .* (1676), and of other theoretical works and biographies of artists. He was also an architect and a member of Poussin's circle in Rome.

LAWRENCE GOWING
CÉZANNE: THE LOGIC OF ORGANIZED SENSATIONS

1. Gustave Geffroy, "Cézanne," *La Vie artistique*, 3e série (Paris: Dentu, 1894), p. 253. I am indebted for this and other references to Michael Doran.
2. *Paul Cézanne, Letters*, ed. John Rewald, 4th ed. (New York: Hacker Art Books, 1976), April 15, 1904. The chief sources for the original texts of the letters, from which the present quotations are translated, are *Correspondance*, ed. John Rewald (Paris: Grasset, 1937), and John Rewald, *Cézanne, Geffroy, et Gasquet* (Paris: Quatre Chemins, 1960).
3. *Letters*, July 18, 1906.
4. Emile Bernard, *Souvenirs sur Paul Cézanne et lettres* (Paris: La Rénovation Esthétique, 1921), p. 65.
5. Maurice Denis, "Cézanne," *Théories, 1890–1910*, 4th ed. (Paris: Rouart et Watelin, 1920), p. 245; from *L'Occident*, September 1907.
6. Emile Bernard, "Paul Cézanne," *L'Occident*, July 1904, pp. 23–25.
7. *Letters*, July 25, 1904.
8. Ibid., May 15, 1904.
9. R. P. Rivière and J. F. Schnerb, "L'Atelier de Paul Cézanne," *La Grande Revue*, December 25, 1907, p. 313.
10. Léo Larguier, *Le Dimanche avec Paul Cézanne* (Paris: L'Edition, 1925), p. 136.
11. Bernard, *Souvenirs*, p. 39.
12. Ibid., pp. 29–30.
13. *Letters*, February 22, 1903.
14. K. Jex-Blake and Eugenie Sellers, *The Elder Pliny's Chapters on the History of Art* (Chicago: Ares, 1968), p. 97. (1st ed., London, 1896.)
15. Ambroise Vollard, *Paul Cézanne* (Paris, 1919), p. 129. (1st ed., 1914.)
16. *Letters*, December 9, 1904.

17. Ibid., May 26, 1904.

18. Ibid.

19. Larguier, *Le Dimanche,* p. 277.

20. Bernard, *Souvenirs,* p. 27.

21. *Letters,* May 26, 1904.

22. Ibid., November 27, 1889.

23. John Rewald, "Un Article inédit sur Paul Cézanne en 1870," *Arts* (Paris), July 21–27, 1954; cited in Rewald, *The History of Impressionism,* 4th ed. (New York: Museum of Modern Art, 1973), p. 246.

24. *Letters,* January 25, 1904.

25. Ibid., October 15, 1906.

26. Ibid., May 26, 1904.

27. Ibid., June 3, 1899.

28. Ibid., July 25 and December 23, 1904.

29. Ibid., October 23, 1905.

30. Ibid., August 23, 1906.

31. Ibid., May 11, 1886.

32. Ibid., November 2, 1897.

33. Ibid., April 30, 1896.

34. Ibid., January 29, 1904.

35. Ibid., September 26, 1897.

36. Ibid., January 17, 1905.

37. Rivière and Schnerb, loc. cit.

38. Maurice Denis, *Journal* (Paris: La Colombe, 1957–59), 2: 48.

39. Bernard, *Souvenirs,* p. 92.

40. *Letters,* December 9, 1904.

41. Jules Castagnary, *Philosophie du Salon de 1857* (Paris, 1858), pp. 8–9; quoted by Kurt Badt, *The Art of Cézanne* (Berkeley and Los Angeles: University of California Press, 1965), p. 200.

42. C. R. Leslie, *Memoirs of the Life of John Constable,* ed. J. Mayne (London: Phaidon, 1951), p. 275.

43. *Letters,* January 23, 1905.

44. Ibid., January 9, 1903. Cf. the lines from de Vigny's *Moïse* that Cézanne produced when asked for a quotation with which he agreed:

 Seigneur, vous m'aviez fait puissant et solitaire,
 Laissez-moi m'endormir du sommeil de la terre.

 Cited in "Mes Confidences," an album with questions answered by Cézanne, which probably dates from the artist's last years. See Adrien Chappuis, *The Drawings of Paul Cézanne* (Greenwich, Conn.: New York Graphic Society, 1973), 1:49 ff.

45. *Letters,* October 13, 1906.

46. Joachim Gasquet, *Cézanne,* 2nd ed. (Paris: Bernheim-Jeune, 1926), p. 132.

47. *Letters,* May 12, 1904.
48. Ibid., April 30, 1896.
49. Ibid., May 26, 1904.
50. Ibid., December 23, 1904.
51. Rewald, *History of Impressionism,* p. 456.
52. The evidence is summarized by Robert Ratcliffe, to whom the present writer is indebted throughout, in the catalog *Watercolours and Pencil Drawings by Cézanne* (London: Arts Council, 1973), p. 170, note 99. This appears strong enough to outweigh the information in A. Barskaya, *Paul Cézanne* (Leningrad: Aurora Art Publishers, 1975), pp. 190–91: "On the back of the subframe of the canvas was a label with the words 'Exposition 1905' and underneath on the right 'Vollard, 6 rue Laffitte' had been added with blue pencil . . . " If correctly recorded, the label might have indicated only that when with Vollard the canvas had been placed on a used stretcher.
53. *Letters,* August 14, 1906.
54. E.g., in the letters of January 23, 1905, and September 21, 1906.

BIBLIOGRAPHY

Alexandre, Arsène. *Puvis de Chavannes.* London: Newnes (s.d.).

Alexis, Paul. *"Naturalisme pas mort": lettres inédites de Paul Alexis a Emile Zola, 1871–1900,* presented and annotated with many documents by B. H. Bakker. Toronto: University of Toronto Press, 1971.

Badt, Kurt. *The Art of Cézanne.* London: Faber, 1965. Originally published in German in 1956.

Barr, Alfred. *Cézanne de'après les lettres de Marion à Morstatt, 1865–1868,* in *Gazette des Beaux-Arts,* January 1937.

Basel exhibition 1989. *Paul Cézanne: The Bathers,* by Mary Louise Krumrine, with contributions by Gottfried Boehm and Christian Geelhaar. London: Thames and Hudson in association with Kunstmuseum Basel/Eidolon, 1989.

Bernard, Emile. *Une lettre inedite du peintre Emile Bernard à sa mère a propos de sa premiere visite à Paul Cézanne* in *Art-Documents,* November 1954, reprinted in this volume.

———. "Paul Cézanne" in *L'Occident,* July 1904. Reprinted in its entirety in this volume.

———. *Souvenirs sur Paul Cézanne et lettres inédites* in *Mercure de France,* 1st October 1907 and 16th October 1907. Reprinted in this volume, but without the letters. Later editions: Paris: Société des Trente, 1912; La Rénovation Esthétique, 1921, and later editions (with addendum *Quinze ans après*); and R. G. Michel, 1926 or 1925, (with addenda "Quinze ans après," and "Une conversation avec Cézanne" from *Mercure de France,* 1921).

———. "Julien Tanguy, dit le "Père Tanguy" in *Mercure de France,* 16th December 1908.

————. "La technique de Paul Cézanne" in *L'Amour de l'Art*, 1920.

————. "Une conversation avec Cézanne" in *Mercure de France*, 1st June 1921. Extracts are reprinted in this volume.

————. *Propos sur l'art*. Edited by Anne Rivière. 2 vols. Paris, 1994.

Bodelsen, Merete. "Gauguin's Cézanne" in *Burlington Magazine*, May 1962.

————. "Gauguin, the Collector" in *Burlington Magazine*, September 1970.

Boime, Alfred. *The Academy and French Painting in the Nineteenth Century*. London: Phaidon, 1971.

Bois, Yve-Alain. "Cézanne: Words and Deeds," *October 84*, Spring 1998. First delivered at the symposia organized in connection with the 1995–96 Cézanne retrospective (Paris, London, Philadelphia).

Borély, Jules. "Cézanne à Aix" in *L'Art Vivant*, no. 22, 1926. Reprinted in its entirety in this volume.

Bracquemond, Félix. *Du dessin et de la couleur*. Paris: Charpentier, 1885.

Camoin, Charles. "Souvenirs sur Paul Cézanne" in *L'Amour de l'Art*, 1920.

Cézanne letters
 References in this book to Paul Cézanne's letters are made by date, linked to the name of the recipient. This will usually enable the reader to find the full text of a letter in any one of the various collected editions described below. The fullest collection now available is the 1976 English-language edition, the preface of which also lists publications giving French texts of most of the letters not printed in the 1937 French edition. It should be noted that John Rewald's *Cézanne, Geffroy, et Gasquet* (Rewald 1960 in this bibliography) is at present the sole source for full texts of many of the letters to Joachim Gasquet.

Cézanne, Paul. *Correspondance*, collected, annotated and with a preface by John Rewald. Paris: Grasset, 1937.

————. *Letters*, edited by John Rewald. Oxford: Cassirer, 1941.

————. *Briefs . . .* , herausgegeben von John Rewald. Zurich: Biogenese Verlag, 1962.

————. *Letters*, edited by John Rewald. Fourth edition, revised and enlarged. Oxford: Cassirer, 1976.

————. *Letters*, edited by John Rewald, revised and augmented edition, translated by Seymour Hacker. New York: Hacker Art Books, 1984.

Cézanne, *Mes Confidences*: see Chappuis.

Chappuis, Adrien. *The Drawings of Paul Cézanne: A Catalogue Raisonné . . .* 2 vols. London, Thames and Hudson, 1973. Paul Cézanne: *Mes Confidences*, first published in A. Chappuis' catalogue, is reprinted in the present volume.

Coquiot, Gustave. *Paul Cézanne*. Paris: Ollendorff, 1919.

————. *Seurat*. Paris: Albin Michel, 1924.

Courthion, Pierre, editor. *Courbet raconté par lui-meme et par ses amis*. 2 vols. Geneva: Cailler, 1948, 1950.

Davies, Martin. *National Gallery catalogues. French school: Early 19th Century, Impres-

sionists, Post-impressionists, etc. . . . with additions and some revisions by Cecil Gould. London: The National Gallery, 1970.

Denis, Maurice. *Théories: 1890–1910. Du symbolisme et de Gauguin vers un nouvel ordre classique.* 4th edition. Paris: Rouart et Watelin, 1920. First published in 1912. The article "Cézanne," itself first issued in *L'Occident* in September 1907, was included in *Théories,* and is reprinted in the present volume in its entirety.

———. *Nouvelles theories sur l'art moderne, sur l'art sacré, 1914–1921.* Paris: Rouart et Watelin, 1922. This contains the article "L'influence de Cézanne," first published in *L'Amour de l'Art* in December 1920. The table of contents lists it under a variant title, "Cézanne et l'art baroque."

———. *Journal: Tome I (1884 1904); Tome II (1905–1920).* 2 vols. Paris: La Colombe, 1957. An excerpt from Tome II is reprinted in this volume.

———. *Journal: Tome III (1921–1943).* Paris: La Colombe, 1959.

Duret, Théodore, and others. *Cézanne.* Paris: Bernheim-Jeune, 1914. Includes contributions by Léon Werth, Francis Jourdain, and Octave Mirbeau, as well as Duret.

Edinburgh / London exhibition 1954. London, Tate Gallery *An Exhibition of Paintings by Cézanne,* organized with the Edinburgh Festival Society by the Arts Council of Great Britain. London: Arts Council, 1954.

Edinburgh / London exhibition 1957. London, Tate Gallery. *An Exhibition of Paintings: Claude Monet,* organized by the Arts Council of Great Britain in association with the Edinburgh Festival Society. London, Arts Council, 1957.

Fromentin, Eugène. *Les maitres d'autrefois.* Paris, 1876.

Gasquet, Joachim. *L'art vainqueur.* Paris: Nouvelle Librairie Nationale, 1919.

———. *Cézanne.* Nouvelle édition. Paris: Bernheim-Jeune, 1926. First published in 1921. The dialogues "What He Said to Me . . . " are reprinted in this volume.

———. *Cézanne: A Memoir with Conversations.* New York: Thames and Hudson, 1991.

———. *Des chants de l'amour et des hymnes.* Paris: Flammarion, 1928. Includes (pp. 19–70) a biography of Gasquet by his widow, Marie Gasquet.

Geffroy, Gustave. *La vie artistique. Troisième série. Histoire de l'impressionisme.* Paris: Dentu, 1894.

———. *Claude Monet: sa vie, son temps, son oeuvre.* Paris: Crès, 1922. An extract is reprinted in this volume. A two-volume edition appeared in 1924 under the title *Claude Monet, sa vie, son oeuvre.*

Gowing, Lawrence. "The Logic of Organized Sensations," in Rubin, William, editor, *Cézanne: The Late Work, Essays . . . ,* New York, Museum of Modern Art, 1977. Reprinted in its entirety in this volume.

Hemmings, F. W. J. *Emile Zola.* 2nd edition, 1966, issued with corrections as an Oxford University Press paperback. London: Oxford University Press, 1970.

Homer, William Innes. *Seurat and the Science of Painting.* Cambridge (Mass.): the M.I.T. Press, 1964.

Jaloux, Edmond. *Fumées dans la campagne.* Paris: 1918.

———. "Souvenirs sur Paul Cézanne" in *L'Amour de l'Art,* December 1920.

———. *Les saisons littéraires,* 1896–1903. Fribourg: Editions de la Librairie de l'Université, 1942.

Jourdain, Francis. "A propos d'un peintre difficile: Cézanne" in *Arts de France,* No. 5, 1946.

———. *Cezanne.* (Collections Palettes). Paris: Braun, 1950. Extracts are reprinted in this volume.

Kendall, Richard. *Cézanne by Himself.* New Jersey: Book Sales Inc., 1994.

Larguier, Léo. *Le dimanche avec Paul Cézanne: souvenirs.* Paris: L'Edition, 1925. Extracts are reprinted in this volume.

———. *Cézanne, ou le drame de la peinture.* Paris: Denoël et Steele, 1936.

———. *Cézanne, ou la lutte avec l'ange de la peinture.* Paris, Julliard, 1947.

Lebensztejn, Jean-Claude. *Les couilles de Cézanne.* Paris: Nouvelles Editions Séguier, 1995.

London/Liverpool exhibition 1972. London, Hayward Gallery, and Liverpool, Walker Art Gallery. *French Symbolist Painters.* London, Arts Council of Great Britain, 1972.

Loran, Erle. *Cézanne's Composition: Analysis of His Form with Diagrams and Photographs of His Motifs.* Third edition. Berkeley and Los Angeles: University of California Press, 1963.

Mack, Gerstle. *Paul Cézanne.* New York: Knopf, 1942. First published in 1935.

Matisse, Henri. *Ecrits et propos sur l'art.* Texts, notes et index établis par Dominique Fourcade. (Collection Savoir). Paris: Hermann, 1972.

Newcastle/London exhibition 1973. Newcastle upon Tyne. Laing Art Gallery, and London, Hayward Gallery. *Watercolour and Pencil Drawings by Cézanne.* An exhibition organized by Northern Arts and the Arts Council. London, Arts Council of Great Britain, 1973.

Osthaus, Karl Ernst. "Cézanne" in *Das Feuer,* 1920–21. The translation in this volume is based on the French text published in *Conversations avec Cézanne,* which incorporated John Reward's 1939 version.

Paris exhibition 1970. Paris. Orangerie des Tuileries. *Maurice Denis.* Paris: Réunion des Musées Nationaux, 1970.

Paris, London, Philadelphia exhibition of 1995–96. *Cézanne.* Paris, Éditions de la Réunion des Musées Nationaux, 1995; London, Tate Gallery, 1996; Philadelphia Museum of Art, 1996.

Pissarro, Camille. *Lettres à son fils Lucien,* presentées par John Rewald. Paris: Albin Michel, 1950.

Ratcliffe, Robert. "Cézanne's Working Methods and their Theoretical Background." Unpublished thesis, Courtauld Institute of Art, University of London, 1960.

Reff, Theodore. "Cézanne and Poussin" in *Journal of the Warburg and Courtauld Institutes,* XXIII, 1960.

———. "Reproductions and Books in Cézanne's Studio" in *Gazette des Beaux-Arts,* November 1960.

————. "Cézanne's Constructive Stroke" in *Art Quarterly*, volume 25, 1962.

————. "Painting and Theory in the Final Decade," in Rubin, William, editor, *Cézanne: The Late Work, Essays.* New York: Museum of Modern Art, 1977.

Rewald, John. *Cézanne: sa vie, son oeuvre, son amitié pour Zola.* Paris: Albin Michel, 1939.

————. "Un article inédit sur Paul Cézanne en 1870" in *Arts, Spectacles*, no. 473, 21st to 27th July, 1954.

————. *Cézanne, Geffroy, et Gasquet, suivi de souvenirs sur Cézanne de Louis Aurenche et de lettres inédites.* Paris: Quatre Chemine-Editart, 1960.

————. *The History of Impressionism.* Revised and enlarged edition. New York: Museum of Modern Art, 1961. A subsequent, further revised edition of this work has been published.

————. *Post-impressionism from Van Gogh to Gauguin.* Second edition. New York: Museum of Modern Art, 1962.

————. *Paul Cézanne, A Biography.* New York: Abrams, 1986. This is the latest of several revised English versions of Rewald's biography of 1939 ("Rewald 1939" in this bibliography), itself an amplification of *Cézanne et Zola.* Paris: Sedrowski, 1936. The 1936 and 1939 volumes, and particularly the former, have fuller reference than the subsequent editions.

————. "Chocquet and Cézanne" in *Gazette des Beaux-Arts*, July–August 1969.

————. "The Last Motifs at Aix" in Rubin, William, editor, *Cézanne: The Late Work, Essays* . . . , New York: Museum of Modern Art, 1977.

————. *Paul Cézanne, The Watercolors: A Catalogue Raisonné.* Boston, New York: Graphic Society Books/Little Brown, and London: Thames and Hudson, 1983.

————. *The Paintings of Paul Cézanne: A Catalogue Raisonné.* John Rewald in collaboration with Walter Feilchenfeldt and Jayne Warman. 2 vols. New York: Abrams, and London: Thames and Hudson, 1996.

Rivière, R. P., and Schnerb, J. F. "L'atelier de Cézanne" in *La Grande Revue*, 25th December 1907. Reprinted in its entirety in this volume.

Royère, Jean. "Sur Paul Cézanne" in *La Phalange*, 15th November 1906.

————. "Paul Cézanne, Erinnerungen," in *Kunst und Künstler*, 10, 1912.

Rubin, William, editor. *Cézanne: The Late Work, Essays.* New York: Museum of Modern Art, 1977. *See also,* for individual essays from this compilation: Gowing 1977, Reff 1977, Rewald 1977.

Shiff, Richard. *Cézanne and the End of Impressionism.* Chicago and London: University of Chicago Press, 1984.

Venturi, Lionello. *Cézanne: son art, son oeuvre.* 2 vols. Paris: Rosenberg 1936.

Vollard, Ambroise. *Paul Cézanne.* Paris: Vollard, 1914. An excerpt is reprinted in this volume. Later editions (Paris: Crès) in 1919 and 1914, the latter described as "revised and augmented."

INDEX

Index of names of persons and places including names from literary works to which Cézanne made reference: Homais, Lantier, etc.

INDEX OF WORKS OF ART

INDEX OF PUBLICATIONS:
LITERARY WORKS, PERIODICALS, ETC.

Design:	Star Type, Berkeley
Composition:	Star Type, Berkeley
Text:	10 / 12 Bembo
Display:	Bembo
Printing:	Malloy Lithographing
Binding:	Malloy Lithographing